A Brush with History

A Brush w

PAINTINGS FROM THE NATI

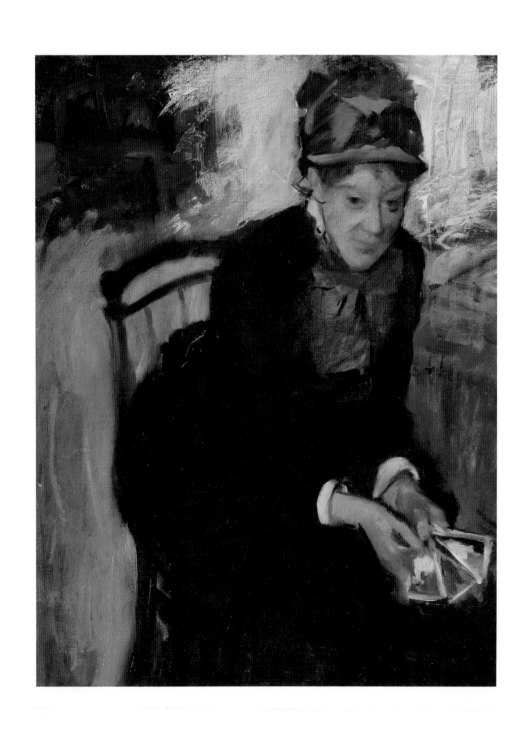

'th *History*

AL PORTRAIT GALLERY

Carolyn Kinder Carr and
Ellen G. Miles

Foreword by
Marc Pachter

With an essay by
Margaret C. S. Christman

National Portrait Gallery • Smithsonian Institution
Washington, D.C.

Tour Itinerary

North Carolina Museum of History, Raleigh
January 27–April 8, 2001

Tennessee State Museum, Nashville
May 4–July 1, 2001

The National Museum of Western Art, Tokyo, Japan
August 6–October 14, 2001

The Speed Art Museum, Louisville, Kentucky
November 20, 2001–January 27, 2002

Montgomery Museum of Fine Arts, Alabama
February 23–May 5, 2002

New Orleans Museum of Art, Louisiana
May 31–August 11, 2002

National Portrait Gallery, London, England
October 4, 2002–January 5, 2003

PORTRAIT OF A NATION
NATIONAL PORTRAIT GALLERY SMITHSONIAN

Distributed by the University Press of New England
Printed in Canada

©2001 by Smithsonian Institution. All rights reserved.

LIBRARY OF CONGRESS CATALOGING-IN-PUBLICATION DATA
National Portrait Gallery (Smithsonian Institution)
A brush with history: paintings from the National Portrait Gallery / Carolyn Kinder Carr
and Ellen G. Miles ; foreword by Marc Pachter; with an essay by Margaret C. S. Christman
p. cm.

Includes bibliographical references and index.
ISBN 1-58465-079-6 (hc) — ISBN 1-58465-080-X
1. Portrait painting, American—Catalogs. 2. Portrait painting—Washington (D.C.)—
Catalogs. 3. National Portrait Gallery (Smithsonian Institution)—Catalogs. I. Carr,
Carolyn Kinder. II. Miles, Ellen Gross, 1941– III. Pachter, Marc. IV. Christman,
Margaret C. S. V. Title.

ND1311 .N35 2000
757'.0973'074753–dc21 00-055453
British Library Cataloguing in Publication Data available, under the title *Americans:*
Paintings from the National Portrait Gallery Washington.

Edited by Frances K. Stevenson and Dru Dowdy
Photography by Rolland White and Marianne Gurley, except page 20, by Chris Lands
and page 85, by Eugene Mantie
Designed by Watermark Design Office, Alexandria, Virginia
Printed by Friesens, Altona, Manitoba

Cover: Benjamin Franklin (detail) by Joseph Siffred Duplessis. Oil on canvas, circa 1785.
Gift of The Morris and Gwendolyn Cafritz Foundation (NPG.87.43). Illustrated in
full as Cat. no. 7.

Title page: Mary Cassatt by Edgar Degas. Oil on canvas, circa 1880–1884. Gift of The
Morris and Gwendolyn Cafritz Foundation and the Regents' Major Acquisitions Fund,
Smithsonian Institution (NPG.84.34). Cat. no. 39.

Opposite: Michael Jackson by Andy Warhol. Oil on silkscreen on canvas, 1984. Gift of *Time*
magazine (NPG.86.TC14). ©Andy Warhol Foundation for the Visual Arts/ARS,
New York. Cat. no. 75.

Back cover: Lena Horne by Edward Biberman. Oil on canvas, 1947 (T/NPG.85.2).
Cat. no. 64.

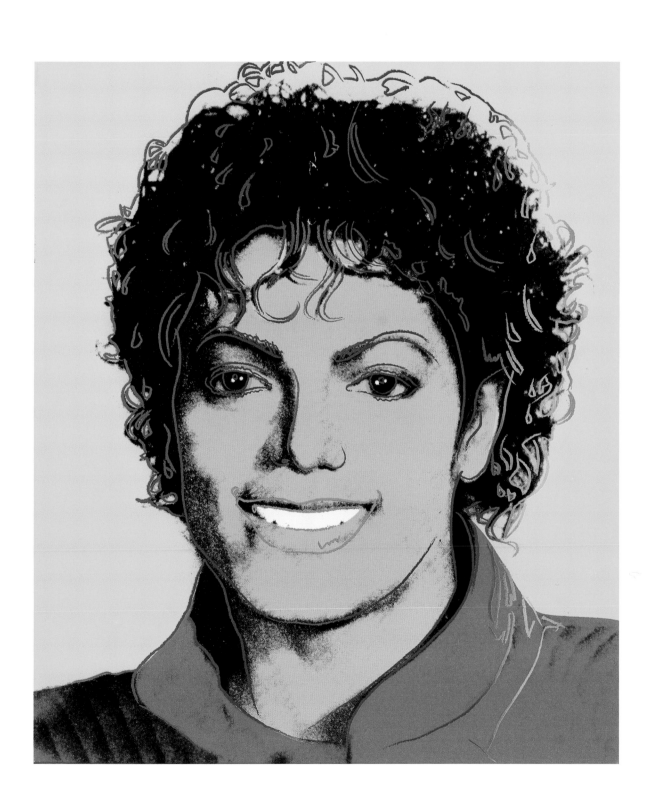

Contents

8 Foreword
 Marc Pachter

10 Preface

12 The National Portrait Gallery
 Margaret C. S. Christman

22 Fame and the Public Self in
 American Portraiture,
 1725–1865
 Ellen G. Miles

38 Painters, Patrons, and
 the Changing Face of
 American Portraiture,
 1865–1999
 Carolyn Kinder Carr

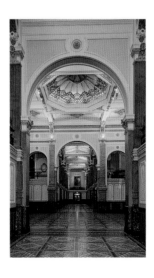

CATALOGUE

60 George Berkeley

62 Andrew Oliver

64 Anne Green

66 Charles Cotesworth Pinckney

68 John Singleton Copley

70 John Jay

72 Benjamin Franklin

74 Charles Willson Peale

76 Rubens Peale

78 William Wirt

80 Elizabeth Wirt

82 Juliana Westray Wood

84 Samuel F. B. Morse

86 Rufus King

88 Loammi Baldwin

90 Samuel Ringgold

92 Thomas Paul

94 Sequoyah

96 William Lloyd Garrison

98 Davy Crockett

100 Henry Clay

102 Frederick Douglass

104 John C. Calhoun

106 Dolley Madison

108 George Catlin

110 Harriet Beecher Stowe

112 Winfield Scott

114 Bayard Taylor

116 Gulian Verplanck

118 William James

120 Nathaniel Hawthorne

122 *Men of Progress*

124 Orestes Brownson

126 William T. Sherman

128 Edith Wharton

130 James McNeill Whistler

132 Philip H. Sheridan

134 Francis Millet

136 Mary Cassatt

138 Bret Harte

140 Thomas B. Clarke

142 H. H. Richardson

144 Juliette Gordon Low

146 Talcott Williams

148 Henry Cabot Lodge

150 Paul Wayland Bartlett

152 Charles Yerkes

154 Richard Watson Gilder

156 Samuel L. Clemens (Mark Twain)

158 Henry James

160 Lee Simonson

162 Nelson Aldrich

164 Willard Huntington Wright (S. S. Van Dine)

166 Francis P. Garvan

168 Thomas Hart Benton with his wife, Rita

170 Marianne Moore and her mother

172 Edward Weston

174 Tallulah Bankhead

176 George Gershwin

178 Martha Graham

180 George Washington Carver

182 George S. Patton

184 Elaine de Kooning

186 Lena Horne

188 Harold Rosenberg

190 Elsa Maxwell

192 Carl Sandburg

194 T. S. Eliot

196 Alice Roosevelt Longworth

198 Lincoln Kirstein

200 Virgil Thomson

202 Eliot Porter

204 Alice Neel

206 John Updike

208 Michael Jackson

210 M. F. K. Fisher

216 Index of Artists

Foreword

Martha Washington (1731–1802) and
George Washington (1732–1799)
by Gilbert Stuart (1755–1828)
Oil on canvas, each 121.9 x 94 cm
(48 x 37 in.), 1796
Owned jointly with the
Museum of Fine Arts, Boston
NPG.80.116 and NPG.80.115

THERE IS SOMETHING GRAND IN THE IDEA OF A NATIONAL place to remember great lives. But in 1962, when Congress established the National Portrait Gallery in Washington, D.C., there was some concern that it would be a difficult idea to achieve. Our English and Scottish colleagues had demonstrated the power of bringing together remarkable portraits of remarkable people to excite the eye and the spirit. In fact it was the national portrait galleries of Great Britain that had inspired the creation of our own American National Portrait Gallery. But they had the advantage of beginning to collect in the nineteenth century, the advantage of many decades in which to find and acquire the best. America had produced wonderful portraiture in its shorter history as a nation, but it seemed at first that older collections in museums and public institutions around the nation had acquired the lion's share. What was a portrait gallery without great portraits?

There was some advantage to this predicament. From the first, the National Portrait Gallery was compelled to be innovative in the creation of public programs that animated the lives of the men and women who had contributed so much to our society. This will continue to be critical to our success as a place to keep interesting Americans alive in our national memory. The Gallery was also inclined from the first to build a tradition of fine temporary exhibitions. If we did not at first own many significant portraits, we could certainly be the place to bring them together in exciting display. The inaugural exhibition when the Gallery opened to the public in October of 1968, "This New Man: A Discourse in Portraits," suggested the possibilities.

It is a tribute to my three predecessors as director and their colleagues among the curators and historians that early concerns about building the collection itself have turned out to be unfounded. Well before the Gallery opened to the public, it had established a Catalog of American Portraits, which became, as we now say, something of a "search engine" to locate important likenesses of Americans across the centuries. Building on that knowledge, the scholarship, doggedness, and persuasiveness of Portrait Gallery staff have resulted in the acquisition of works of the highest quality, which illuminate lives of lasting importance to generations of Americans. We are also indebted to the generosity of many donors who have

recognized the value of sharing their wonderful portraits with the nation.

The proof is in this catalogue. Here you'll find some of the finest examples from the Gallery's holdings, among them a number of national icons: Joseph Duplessis's magnificent painting of Benjamin Franklin, Edgar Degas's portrait of Mary Cassatt, John Singleton Copley's reflective self-portrait, and such vibrant examples of recent portraiture as Andy Warhol's Michael Jackson and Alex Katz's John Updike, among many others. They are treasures of a collection that now numbers more than eighteen thousand objects in all media. And we are able to share them with audiences outside Washington during a period when the magnificent building we occupy goes through a multi-year renovation.

Across the nearly forty years of our existence, the Gallery has not only built a wonderful collection of paintings—the focus of this exhibition—and of sculpture, and prints and drawings, but it has also deepened its range of portraiture. Photography, which we began to collect in the seventies, has become a particular strength of the collection, ranging from early daguerreotypes to recent large-format Polaroids. Drawings by major artists from Charles B. J. F. de Saint-Mémin to Philip Pearlstein, caricatures by satiric artists from Thomas Nast to Edward Sorel, lithographs, engravings, and posters all come together to record the personalities of the American past and present.

And we have come to understand portraiture in its broadest sense as a presentation of interesting lives well told. The Gallery adds to the wonderful visual insight of artists, programs that explore the genre of biography and its hold on the imagination of a growing reading public, performances in which great figures from the past are portrayed, documentary films that capture the spirit of a life, and, as we look to the future, the discovery of electronic forms of portraiture. Who can tell how we will portray Bill Gates and his successors, or for that matter the Americans whose contributions we cannot yet guess? These will be vibrant aspects of the twenty-first-century National Portrait Gallery.

And it is wonderful to launch this new era of the Portrait Gallery with an exhibition that demonstrates how much it has come to justify the hopes (and allay the fears) of its founders.

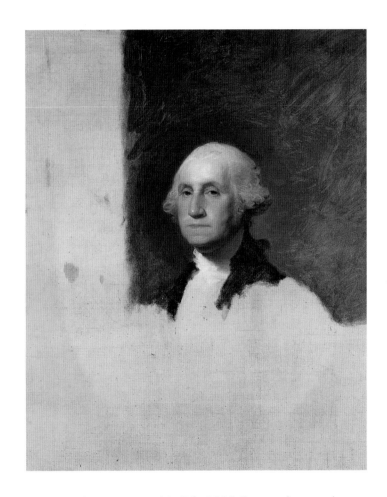

As a new director, arrived in July 2000, I can only marvel at that achievement. I am very grateful to Deputy Director Carolyn Carr and Curator of Painting and Sculpture Ellen Miles for making the selection of paintings set before us in this exhibition and recorded in this book. They provide a brief and telling history of American portraiture and of the portraiture of Americans provided by other traditions. And to Alan Fern, recently retired after eighteen years as director, and under whom I served for eight years as chief historian, I can only say thank you for devoting your energy, talent, and uncommon wit to the development of this wonderful place.

Marc Pachter
Director
National Portrait Gallery

Preface

As we walked through the familiar displays at the National Portrait Gallery selecting portraits for this exhibition, our primary ambition was to provide our audience with a delicious visual feast based on a selection of the museum's notable paintings. Our next goal was to use these remarkable works to address issues related to the history of portraiture in America. While each of our subjects is distinguished in his or her own right and each has played a major role in shaping the history of our country, their history is only one consideration. The criteria that we have applied to the creation of this exhibition changes the emphasis normally employed to acquire an object for the Gallery's collection; traditionally, the sitter's significance takes precedence over the object's artistic significance.

We faced some limitations that conditioned our final selection. Originally, we had intended to include sculpture as well as painting, but we eliminated sculpture from the show, because too many of the outstanding early pieces, such as John Frazee's 1827 self-portrait, were too fragile to travel to multiple venues. To eliminate them and concentrate only on later works or only those in bronze distorted the nature of our collection and the significant history of this medium in relation to portraiture. We also could not include presidential portraits in our selection, because an exhibition on the Hall of Presidents is traveling simultaneously. Where the Gallery possessed depth as well as strength— we own Gilbert Stuart's portraits of George and Martha Washington and those of this first couple by Rembrandt Peale, as well as glorious representations of Thomas Jefferson by both Mather Brown and Stuart—shared ownership or conservation problems kept these works from being a part of our final exhibition. Conservation problems also limited our ability to travel other key Gallery icons, such as the image of Pocahontas by an unidentified English artist. To signal the role that these and other works play in the museum's collection, we have made reference to some of them as text illustrations.

But even with these restrictions, our initial choices numbered far more than the seventy-five works in the present exhibition. Keeping in mind our primary goal of aesthetic importance, our choices then were shaped by issues of chronology, occupation, gender, and ethnicity. That is, we wanted to have a relatively even distribution of portraiture across the more than two centuries represented in the museum's collection. We also wanted to suggest the diversity of professions represented in our collection—statesmen, military leaders, inventors, industrialists, financiers, writers, actors, artists, musicians, scientists—for all these lively and diverse professions have contributed to the vitality of our nation. And we wanted to make certain that women and minorities did not remain invisible. When given a choice between two portraitists whose approach to portraiture was similar, or two portraits by the same artist, we would take the sitter into consideration. But to opt for Dolley Madison, that doyenne of presidential lore, or to include the knock-your-socks-off painting of Lena Horne (leaving our audience to know writer Dashiell Hammett only through a reproduction) were the kinds of choices we had no trouble making and feeling good about.

From the moment the Gallery opened to the public in 1968, our portraits have been accompanied by labels that sought to provide the public with a sense of the accomplishments of the sitter. During the past decade, the staff has upgraded the text to include a few words about the artist and, where known, the circumstances that led to the portrait. Many people have contributed to these short essays, beginning with the information gathered about the subject and the artist and presented by the curators to the museum's commissioners, who twice yearly approve all acquisitions. This research is often revisited and reformulated for the public, either as wall labels or in more extended published catalogue entries. Two individuals on the National Portrait Gallery staff, Senior Historian Frederick Voss and Associate Curator of Painting and Sculpture Brandon Brame Fortune,

have often been involved in this educational process, and they deserve special thanks for providing us with major segments of numerous catalogue entries.

In addition, we are heavily indebted to the work of three interns. In the summer of 1998 Zachary Intrater, a University of Chicago undergraduate, began by compiling research files on each portrait in the exhibition, based on materials in the curatorial and history files, and by initiating more extended research on several of the paintings. His efforts led us to realize that numerous objects that had entered the collection in the 1960s and 1970s needed to be reassessed in terms of recent research regarding the artist or the sitter. The following summer, Aleem A. Hossain, also an undergraduate at the University of Chicago, and Jennifer Greenhill, a graduate student in art history at Williams College, continued this research and drafted many of the catalogue essays. Aleem researched and drafted entries for the works made through the Civil War era, while Jennifer focused her research and writing from the 1870s to the present. We remain grateful for their work, their energy, and

their intellectual curiosity, which contributed in myriad ways to this publication. In turn, they—and we—thank Merl M. Moore for sharing information from his extensive and unique files on nineteenth-century American artists; David M. Reel, curator of art, West Point Museum, United States Military Academy; William T. Oedel of the University of Massachusetts at Amherst; Margaret Humberston of the Connecticut Valley Historical Museum; and Judy Throm of the Archives of American Art, Smithsonian Institution.

The staff at the National Portrait Gallery is not large, but each individual plays a crucial role in making an exhibition and publication such as this come to fruition. Thus, we would like to extend our appreciation to Publications Officer Frances Stevenson and Managing Editor Dru Dowdy for their watchful eyes and their careful coordination of this book; to Librarian Cecilia Chin and her staff for responding to our research needs and interlibrary loan requests; to Linda Thrift and the staff of the Center for Electronic Research and Outreach Services (CEROS) for their continual help with research questions; to Curator of Exhibitions Beverly Cox and her staff for their coordination of the traveling exhibition; to Registrar Suzanne Jenkins and her staff for getting these objects to each venue safely and on time; to Jeanette Stimpfel Winget and Leila Putzel, former assistants in our respective departments, who provided us with support in many ways; and finally, to Director Emeritus Alan Fern, who shares our enthusiasm for this project and the wonderful treasures of the National Portrait Gallery.

Carolyn Kinder Carr
Deputy Director and Chief Curator

Ellen G. Miles
Curator of Painting and Sculpture

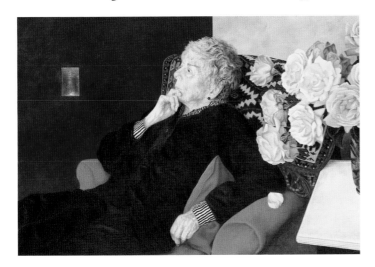

M.F.K. Fisher by Ginny Stanford.
Acrylic and silver leaf on canvas, 1991
(T/NPG.92.173.02). ©Ginny Stanford.
Cat. no. 76.

The National Portrait Gallery

Margaret C. S. Christman

As the new nation began its journey through history, Charles Willson Peale reasoned that it would be valuable for a republic to have the likenesses of those who had played a prominent part in the struggle for independence. In 1791 Congressman Theodore Sedgwick of Massachusetts related that Peale's "long gallery with nearly an hundred portraits of those characters, who have made the most distinguished figures during the american revolution," brought to his remembrance the great events in which these men—many of them no more living—had participated, and filled him with emotions that he could not describe. "I will say, however, till then I never so well knew the value of portraits."[1]

The portrait collection, kept up to date with the images of current officeholders and expanded over the years to include scientists, inventors, artists, and others, remained an appealing feature of Peale's Philadelphia Museum and held its own amid flora, fauna, mastodon bones, and worldwide curiosities. "I forgot birds, beasts, fishes and insects, to gaze on man," wrote future Supreme Court Justice Joseph Story, who visited in 1807. "I was engaged in etching the outlines of genius, when, perhaps, I ought to have been surveying the impalpable down of an insect, or the variegated plumage of a bird."[2]

Peale's great aspiration was that his museum be recognized and supported as a national establishment. In 1802 he asked his friend President Thomas Jefferson "whither the United States would give an encouragement and make provision for the establishment of this Museum in the City of Washington."[3] No one could be more sympathetic to Peale's aim than Jefferson, who himself maintained a museum of sorts at Monticello and who had his own collection of portraits of "principal American characters." Nonetheless, the President, ideologically committed to a frugal and limited government, candidly pointed out that "one of the great questions which has divided political opinion in this country is Whether Congress are authorized by the constitution to apply the public money to any but the purposes enumerated in the Constitution."[4]

In 1847, two decades after Peale's death, the Bank of the United States—to whom the stockholders of the Philadelphia Museum were heavily in debt—took possession of the "two hundred and eight portraits of revolutionary worthies and other distinguished men" and offered to sell them to the Smithsonian Institution.[5] But the Board of Regents of the fledgling institution—in existence only since August 1846—had a building under way and only the interest from the half-million-dollar James Smithson bequest at their disposal. "However highly the Board values the portraits of the distinguished men," the agent of the Bank was told, "and however much they would like to place them in their gallery of art, it is not in the power of the Board, consistently with existing arrangements and obligations to apply their funds to such an acquisition."[6]

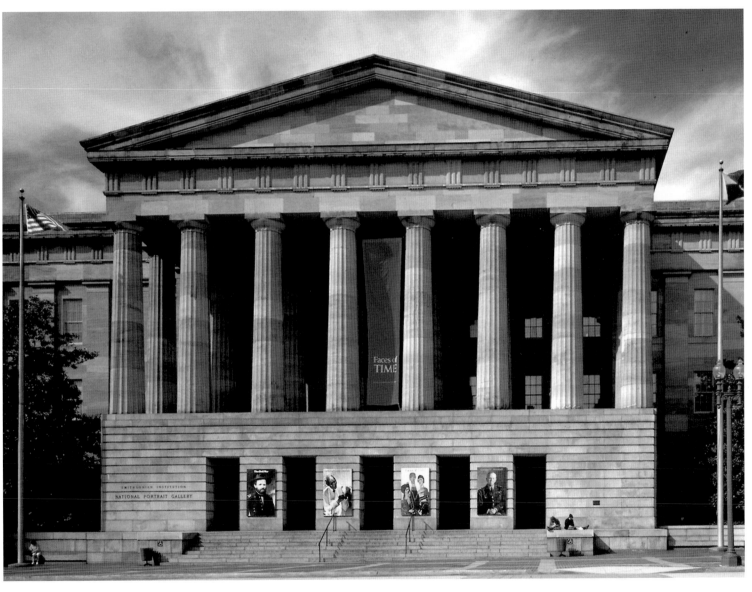

National Portrait Gallery,
Eighth and F Streets, Northwest,
Washington, D.C., 1998.
National Portrait Gallery,
Smithsonian Institution

When the Smithsonian was founded, there was no such thing as a national portrait gallery in the English-speaking world. The first one came in 1856 with the establishment of the National Portrait Gallery in London. In 1873, a "Historical and Portrait Gallery" was opened as part of the National Gallery of Ireland, followed by the National Portrait Gallery of Scotland, whose neo-Gothic building was dedicated in 1889, with the secretary for Scotland proclaiming—in a reference to Henry Wadsworth Longfellow's 1838 *A Psalm of Life*—"What we want is portraits of the men of whom Longfellow referred to as leaving footprints on the sands of time."[7]

The progress of the three European galleries, particularly the London institution, stirred interest in America. Robert C. Winthrop (1809–1894), longtime president of the Massachusetts Historical Society, remembering that he had been taken to see the beginnings of the National Portrait Gallery, London, wrote in 1886 that he was impressed with the idea of "the establishment of a National Portrait Gallery in Washington where the history of our country should be illustrated by a series of likenesses of those who have been eminent in its civil or military service, or in scientific or literary labors from our earliest colonial period or certainly from our constitutional era."[8] However, Winthrop, replaced in 1851 as senator from Massachusetts in favor of Charles Sumner, had long since lost his political influence.

In the annals of the Smithsonian, the first mention of a portrait gallery as such came from Regent Robert Adams Jr. (1846–1906), who represented Philadelphia (where the bulk of Charles Willson Peale's portraits of "celebrated personages" had found a home surrounding the Liberty Bell in the Assembly Room of Independence Hall) in Congress. When the third Smithsonian building, designed primarily for the natural history collection, was under way in 1904, Adams informed Smithsonian Secretary Samuel P. Langley that he had communicated with his fellow Regents, and "they were in favor of his proposition to use the rotunda in the new National Museum building for a National Portrait Gallery, and . . . if it had not been planned for such a purpose the plans must be changed."[9]

Langley responded that he was "personally very ready to see such a National Portrait Gallery in the new building," but that the architects had informed him that the proposal to place a portrait gallery in the rotunda was "wholly impracticable."[10] Charles D. Walcott, who succeeded Langley as Secretary in 1907, accepted a national portrait gallery as a part of his development program, but no definite steps were taken.

Meanwhile, the Smithsonian collection of art was allotted exhibition space in the Natural History Building. It became a separate bureau of the Smithsonian in 1920, and one of its eleven sections was referred to as the portrait gallery. Over the years, numerous pictures were set aside for this entity, a number of them specifically designated by their donors "in anticipation of the day when there shall be a national portrait gallery." But for a long time to come, the want of a building would thwart anticipation.

In the forefront of those interested in the establishment of a national portrait gallery was David Finley, the first director of the National Gallery of Art, which had been brought into being by Andrew Mellon's offer to the government of European masterpieces and a building in which to house them. The National Gallery had in its charge a group of American portraits that Mellon had considered suitable for a national portrait gallery, should such an institution be established within twenty years of his 1938 gift to the nation.

At Finley's instigation, Senator Theodore Francis Greene of Rhode Island introduced legislation in 1950 to transfer the District of Columbia's early-nineteenth-century city hall (then in use as a federal courthouse, but expected to be vacated soon) to the

Smithsonian Institution for use as a national portrait gallery "for the keeping and display of portraits of persons who have played an important part in the history and development of the United States." Greene informed Finley that President Harry S. Truman "expressed great sympathy with the plan and assured me he would help me in every way he could to bring it about."[11] But the President drew back when the General Services Administration protested that a large sum had already been expended to remodel the structure for critically needed office space. "Since it is not possible for the Government to provide a building," Finley lamented, "I fear it may be a very long time before such a Gallery can be established."[12] It would not be very long, however, before another distinguished old building—on the very site designated by Pierre Charles L'Enfant, in his 1791 plan for Washington, as the place to honor those who deserved the gratitude of the nation—would present an even greater potential for housing a national portrait gallery.

Early in 1953, bills were introduced in both the House and Senate for the demolition of the Old Patent Office Building, in order that a private developer might construct a parking garage. The Greek Revival structure, initially based on a plan submitted to President Andrew Jackson by the team of Ithiel Town and William Parker Elliott, was begun in 1836 under the supervision of Robert Mills, who made modifications to the exterior and who is credited with the interior design. Completed in 1867 under the direction of Thomas U. Walter, it had been occupied by the Civil Service Commission since 1932. The building's Great Hall, on the third floor of the south wing (completed in 1840), had been—in the years before the establishment of the Smithsonian and for some time thereafter—a grand space for the display of natural history specimens from government exploring expeditions; historic treasures, including the Declaration of Independence; George Washington's uniform; and Benjamin Franklin's printing press; as well as an assemblage of paintings and sculpture.

Finley, who was also chairman of the Fine Arts Commission, was quick to affirm that the Commission, as the federal reviewing agency, would not give its approval for the destruction of this "important historical and architectural monument." The American Institute of Architects, the Society of Architectural Historians, and the National Trust for Historic Preservation (whose chairman was David Finley) also raised an outcry.

Advocates for downtown parking persisted, and Finley, finding the administrator of the GSA unsympathetic to preserving the structure, talked directly to President Dwight D. Eisenhower, who advised GSA and the Bureau of the Budget that he was strongly in favor of saving the Patent Office Building. On June 1, 1956, the GSA (in conjunction with Smithsonian Secretary Leonard Carmichael, who had been much involved in plans for a portrait gallery) announced, "The Government is planning to preserve the Old Patent Office, one of the National Capital's finest architectural landmarks, first as an office building and later for use as a National Portrait Gallery."[13] In March 1958 a bill to transfer the Old Patent Office Building to the Smithsonian, and authorizing its necessary remodeling to make it suitable to house "certain art galleries," was enacted into law.[14] A decade would pass, however, before the building was made ready to open to the public in its new incarnation.

To establish the National Portrait Gallery as a separate bureau of the Smithsonian and to provide for a National Portrait Gallery Commission—charged with the responsibility for accepting portraits into the collection—a law was signed by President John F. Kennedy on April 27, 1962, bringing into being "a free public museum for the exhibition of and study of portraiture and statuary depicting men and women who have made significant contributions to the history, development, and culture of the people of the United States and of the artists who created such portraiture and statuary."[15] Incoming Smithsonian Secretary S. Dillon Ripley and the Portrait Gallery

Commission made it clear from the beginning that the determining factor for acquisitions should be the historical importance of the sitter rather than the merit of the artist. Admission, following the rule of the National Portrait Gallery, London, should be made "without prejudice to any political or religious party," nor should any candidate be excluded "on the grounds that he had great faults and did great harm."[16] The National Portrait Gallery was intended to be more than a hall of fame; it would be an institution illustrating the entire history of the country.

Charles Nagel, about to retire as director of the City Art Museum of St. Louis, became the Gallery's first director in July 1964. At the start there was no money at all for acquisitions, and when a purchase fund was secured, it was pitifully small. Scores of portraits that rightfully belonged in a national portrait gallery had long since become ensconced in other institutions. "We have a large task ahead," Nagel proclaimed, "and as has been said, are starting 100 years too late." In moments of pessimism, some of the commissioners talked of being forced to resort to copies, reproductions, and dioramas.

The founders envisioned the Gallery not only as a place for the collection and exhibition of pictures, but also as a research center for the accumulation of data on American portraits. What came to be called the Catalog of American Portraits early took advantage of automatic processing equipment, and in time sent out researchers to survey portraits in private and public hands throughout the United States. Over the years the Catalog has amassed information on upwards of one hundred thousand images.

One of the first scholarly enterprises contemplated by the Gallery was the publication of the papers of Charles Willson Peale, but funding to begin the large-scale undertaking was not aggressively pursued until 1974. By November 1980 the microfiche edition of the Peale Papers was finished, and in January 1984 Yale University Press published the

first of the seven projected volumes of selected papers.

On the exhibition front, Dillon Ripley insisted—and the Commissioners did not disagree—that liveliness must be pursued or "we'll be dead on our feet before we've begun." Ripley exhorted, "Let us by all means be scholars in our 'factory' behind the scenes. Let us by all means be resourceful showmen for the public."[17]

America's National Portrait Gallery opened its doors to the public on October 7, 1968, with a thematic exhibition, "This New Man: A Discourse in Portraits," meant to be "an inquiry into the American character." The majority of the 168 portraits had been borrowed from individuals and institutions throughout the country, as was also the case with the featured display of premier portraits of all the past Presidents of the United States. If nothing else, the opening presentations confirmed the belief that the National Portrait Gallery would command the prestige necessary to secure the loan of almost any major portrait held in the United States. During the next three decades, more than half of the borrowed pictures would enter the collection by way of gift or purchase.

Nagel, having gotten the Gallery off to a start, retired on June 30, 1969. "Now we shall need somebody with a vivid imagination and what Justice Holmes called native force," wrote Commissioner Catherine Drinker Bowen, "to dream up exhibitions that will include everything but the great falls of the Potomac right there in our rooms."[18] Such was found in the person of Marvin Sadik—who had made his mark as head of the Bowdoin College Museum of Art and the University of Connecticut Museum at Storrs—the director of the Gallery for the next twelve years.

To attract attention to a young museum situated apart from the major tourist attractions on the Mall, and in an area torn up by subway construction, an ambitious exhibition schedule was essential. In addition to two

major productions each year, a constant procession of smaller shows became the practice. All of the major exhibitions, Sadik decreed, should be accompanied by catalogues, and in time the smaller exhibitions were also documented by a publication of some sort.

Among the exhibitions exploring various facets of the American experience were "Portraits of the American Stage" (1971), "'If Elected' . . . Unsuccessful Candidates for the Presidency" (1972), "The Black Presence in the Era of the American Revolution" (1973), and "Champions of American Sport" (1981). "Augustus Saint-Gaudens: The Portrait Reliefs" (1969) and "American Portrait Drawings" (1980) recognized that part of the Gallery's mission was to deal with the art of portraiture; "The Life Portraits of John Quincy Adams" (1970) demonstrated the Gallery's commitment to iconography.

An effort was made in exhibitions to include a judicious use of related objects meant to suggest or create an ambiance—what one critic called "the perfect mix of portraits, artifacts, color and sound effects." But Sadik made clear that "sounds are fine and smells are fine and so is the whole multimedia business of triangulating in on a subject, but there's still something special about traditional portraiture."

Confident in the belief that there were hundreds of portraits of great Americans potentially available for acquisition, he declared, "the primary objective of the Gallery continues to be the building of a collection worthy of this Nation's history." By this time the Portrait Gallery had the largest purchase appropriation of any Smithsonian museum (aside from the Freer and the National Collection of Fine Arts, which had endowments), but the cost of major pictures outstripped available funds.

One of the treasures in the inaugural exhibition, borrowed from a private owner on the West Coast, was John Singleton Copley's 1780–1784 self-portrait. In 1977 the Gallery learned that it was for sale. This, "the quintessential American self-portrait by the first great American painter," Sadik determined the Gallery must have. "We bought the Copley self-portrait over the telephone without a nickel in the till," he later recounted. A grant from the Morris and Gwendolyn Cafritz Foundation paid the bill.

Sadik was avid in his quest of portraits of American Indians, and Sequoyah, the developer of the Cherokee alphabet, was a prime candidate for the collection. His portrait by Charles Bird King, one of the many Indians painted at the behest of the War Department, had hung in the Great Hall of the Patent Office until removed to the Smithsonian "castle" on the Mall, where most of the art collection was consumed by fire in 1865. After a considerable search, a copy of the King portrait of Sequoyah, painted by Henry Inman in the 1830s, was located, and the owner was persuaded to sell it to the Gallery.

An important gift of 761 profile engravings of men and women of the early Republic, executed by the French émigré artist Charles Balthazar Julien Févret de Saint-Mémin, came from Paul Mellon in 1974. That the Portrait Gallery intended a serious pursuit of works on paper was made manifest by the establishment of a Department of Prints later in that same year.

In 1978 the Gallery, as one wag expressed it, "put rouge on its cheeks" when it became the depository for the original artwork commissioned for the covers of *Time* magazine. These images of newsmakers of the modern era encompass men and women in all walks of life.

When legislation creating the Portrait Gallery was under consideration, the Smithsonian bowed to the Librarian of Congress's fears of competition and agreed to a provision that would bar the Gallery from collecting photographs. It soon became obvious that the restriction was an unnecessary roadblock, and in 1976 the Portrait

Gallery Act was amended to remove the prohibition. The representation of eminent mid-nineteenth-century Americans was greatly enhanced in 1981 with the acquisition of the Frederick Hill Meserve collection of more than five thousand Mathew Brady glass-plate negatives, a purchase made possible by a bill shepherded through Congress by Senator Barry Goldwater, a Smithsonian Regent and briefly chairman of the National Portrait Gallery Commission.

Marvin Sadik went on sabbatical in February 1981 and, after a brief return, resigned in June. During his absence, and until a new director could be chosen, Assistant Director Harold Francis Pfister served as acting director. Pfister had come to the Gallery in 1970, not long after his graduation from Harvard, and was assigned the task of compiling the first published checklist of the permanent collection. Among other activities, Pfister was curator of "Facing the Light: Historic American Portrait Daguerreotypes," held as part of the celebration of the Gallery's tenth anniversary in the fall of 1978 and marking the Gallery's first serious research effort in the field of photography.

Alan Fern, who had been in charge of special collections at the Library of Congress (manuscripts, rare books, maps, films, sound recordings, photographs, and prints), and earlier chief of the Prints and Photographs Division there, became the Portrait Gallery's third director on June 1, 1982. "I immediately began to consider," he recounted, "how this young museum compared with its older siblings around the world, and how we might demonstrate its relationship with similar collections to the American public."[19] Hearing that the palace at Versailles was to be closed for repairs, he seized the opportunity to arrange the exhibition "Masterpieces from Versailles: Three Centuries of French Portraiture" (1983). The second of the foreign portraiture shows, "Masterpieces from Gripsholm Castle: The Swedish National Portrait Collection" (1988), was organized in connection with the celebration of the three hundred and fiftieth anniversary of the Swedish colonization of North America. The third in the series of shows from other countries came about after the Gallery had sent an exhibition from its permanent collection to Tokyo and Sapporo, Japan, and Alan Fern later had occasion to discuss his interest in Japanese portraiture with Mr. and Mrs. Morisada Hosokawa. The Hosokawas offered the loan of their ancestral treasures, and Fern traveled to Japan to make a selection of portrait scrolls and other objects for "Noble Heritage: Five Centuries of Portraits from the Hosokawa Family" (1992).

During the Fern years, photographic shows have ranged from the daguerreotypes of Robert Cornelius of Philadelphia, America's first significant photographer, to the celebrity images of Annie Leibovitz. Among the print and drawing presentations have been "Miguel Covarrubias Caricatures" (1984), which showcased the work of the Mexican-born artist who came to fame in New York City during the 1920s, and "Celebrity Caricature in America" (1998), a landmark exhibition of the playful genre that flowered between the world wars. Artists not yet studied in depth have always had a place on the Gallery schedule, and exhibitions have been devoted to the paintings of the American Joseph Wright, William Edward West, and Chester Harding, among others, and the sculpture of John Frazee, the first native-born artist to work in marble. Increasing cognizance has been given to the work of twentieth-century artists, with one-artist shows highlighting the portraiture of sculptors Isamu Noguchi and Marisol, as well as photographers Irving Penn, Arnold Newman, and Hans Namuth.

Biography is integral to the Gallery's agenda, and the lives and accomplishments of notable Americans have been explored in exhibitions such as "The Godlike Black Dan" (1982), marking the two-hundredth anniversary of the birth of Daniel Webster; "Majestic in His Wrath" (1995), commemorating the one-hundredth year of Frederick Douglass's death; "Theodore Roosevelt: Icon of the American Century" (1998); and "Picturing Hemingway: A Writer in

His Time" (1999), part of the Ernest Hemingway centennial. Attention has been paid to popular culture in "On the Air: Pioneers of American Broadcasting" (1988) and "Red, Hot & Blue" (1996), a salute to the American musical.

When Charles Nagel had arrived as director, the collection comprised fewer than two hundred portraits. By the time Alan Fern took over, the numbers had risen to two thousand. "It is our first duty to acquire life portraits of significant figures of our political, industrial, social, and cultural history," Fern explained, "but wherever possible we would like these to be of high artistic quality." In a great many instances fortune has smiled upon the Gallery.

Thomas Eakins, arguably the greatest of American portraitists, seldom painted figures of national significance. But Deputy Director Carolyn Carr discovered a portrait of Talcott

Williams, a journalist of some renown, in the Washington apartment of a friend. The portrait entered the Gallery's collection through the sale and partial gift from Williams's descendants. A long-held wish for an outstanding portrait of Benjamin Franklin was realized with the purchase in France of Joseph Siffred Duplessis's painting originally owned by Franklin's affectionate Passy neighbor, Madame Brillon de Jouy. That greatest of rarities, a portrait of an eighteenth-century woman who had achieved distinction on her own merit, was added to the collection with the acquisition of Charles Willson Peale's portrait of Anne Catharine Hoof Green. Green was editor, after her husband's death, of the *Maryland Gazette* and the public printer of Maryland. Doubts that many of the founders had about the ability of a portrait gallery, starting so late in the day, to achieve a notable collection have long since been put to rest.

Permanent collection, second floor, 1999.
National Portrait Gallery, Smithsonian Institution

The Portrait Gallery at maturity is a place of multifaceted activity. A quest for portraits continues; research projects abound; books and catalogues are written and brought to press. From the conservation laboratory works of art emerge revitalized. School-children visit and the docents teach; student aides visit classrooms and nursing homes. Tours and films have been weekly events; lectures, symposia, drama, and music often complement exhibitions; jazz has been played in the courtyard, gospel songs sung, and the music of the Beatles performed. "Living Self-Portraits," a series of conversations (recorded on videotape) with men and women of lifetime achievement, has brought to the Gallery, among others, labor leader Harry Bridges, Olympic athlete Jesse Owens, theatrical producer George Abbott, author and congresswoman Clare Boothe Luce, photographer Gordon Parks, and *Washington Post* publisher Katharine Graham. Most recently the Gallery embraced a new dimension, assuming a place on the World Wide Web (http://www.npg.si.edu) where, among other features, the Catalog of American Portraits can be accessed and exhibitions viewed in virtual reality.

Throughout, the endeavor has been to follow the course Dillon Ripley laid out for the Gallery at its beginning. As he wrote in 1968, "Scholarly it must be, concentrating on a dimension in historical biography and iconography largely left uncharted by the great historical and biographical source books of the nation." He continued, "The second great purpose of this Gallery created in the 1960s is to explore all possible means of educating the visiting public in experiencing the personages that are to be portrayed."[20] More than thirty years later, the exploration continues apace in ways both innovative and traditional, keeping alive the sense of excitement felt at the first meeting of the Portrait Gallery Commission, when Catherine Drinker Bowen exclaimed, "I can't wait to see what happens next. ✳

Notes

1 Theodore Sedgwick to Pamela Sedgwick, January 9, 1791, Sedgwick Papers, Massachusetts Historical Society, Boston.

2 Charles Coleman Sellers, *Mr. Peale's Museum: Charles Willson Peale and the First Popular Museum of Natural Science and Art* (New York: W. W. Norton, 1980), p. 193.

3 Charles Willson Peale to Thomas Jefferson, January 12, 1802, in Lillian B. Miller et al., eds., *The Selected Papers of Charles Willson Peale and His Family*, vol. 2: *Charles Willson Peale: The Artist as Museum Keeper, 1791–1810* (New Haven: Yale University Press for the National Portrait Gallery, 1988), p. 388.

4 Jefferson to Peale, January 16, 1802, ibid., p. 389.

5 William J. Rhees, ed., *The Smithsonian Institution: Journals of the Board of Regents, Reports of Committees, Statistics, Etc.* (Washington, D.C.: Smithsonian Institution, 1879), p. 43.

6 Ibid., p. 44.

7 *The Scottish National Portrait Gallery* (Edinburgh: n.p., 1891), p. 92.

8 David E. Finley to Theodore Francis Green, December 21, 1950, enclosure citing Massachusetts Historical Society Proceedings, June 1886, Library of the National Portrait Gallery and the National Museum of American Art.

9 Richard Rathbun to Samuel P. Langley, June 6, 1904, Record Unit 50, Smithsonian Institution Archives.

10 Rathbun to Langley, June 13, 1904, ibid.

11 Green to Finley, June 15, 1951, NPG/NMAA Library.

12 Finley to Jess Larson, October 24, 1952, NPG/NMAA Library.

13 GSA news release, June 1, 1956, NPG/NMAA Library.

14 The National Portrait Gallery was to share the building with the National Collection of Fine Arts (the National Museum of American Art since 1980), which had lost its name to the National Gallery of Art endowed by Andrew Mellon and its building site to the National Air and Space Museum.

15 Public Law 87–43, Eighty-seventh Congress, S. 107, April 27, 1962.

16 Robert H. Thayer, report on meeting in Farmington, Connecticut, September 12, 1963, Box 70, Record Unit 99, Office of the Secretary, 1964–1971, Smithsonian Institution Archives.

17 S. Dillon Ripley to Charles Nagel, January 1968, NPG/NMAA Library.

18 Catherine Drinker Bowen to Ripley, October 7, 1968, NPG/NMAA Library.

19 Foreword to *Masterpieces from Gripsholm Castle: The Swedish National Portrait Collection* (Stockholm: National Swedish Art Museums, 1988), p. 7.

20 J. Benjamin Townsend, ed., *This New Man: A Discourse in Portraits* (Washington, D.C.: Smithsonian Institution Press for the National Portrait Gallery, 1968), pp. v, vi.

Fame and the Public Self in American Portraiture, 1725–1865

Ellen G. Miles

From the colonial era through the mid-nineteenth century, artists working in the American colonies and in the United States were often commissioned to make portraits of, or for, their patrons. The *New-York Historical Society's Dictionary of Artists in America* lists more than 10,000 artists, of which about 3,000 made portraits at some time in their careers.[1] The requests for portraits dominated American art through the 1820s, and continued to be a major aspect of the visual arts through the century. This emphasis is not clear from a reading of many histories of American art, which almost completely abandon the story of portraiture after about 1825 in favor of discussions of landscape paintings by Hudson River School artists, genre scenes by George Caleb Bingham and William Sidney Mount, and history paintings by John Trumbull and Emanuel Leutze. However, even these well-known painters made at least a few portraits in their long careers, and many other artists satisfied the incessant demand for portraits. One well-known early-nineteenth-century painter, Henry Inman, complained about the demand for portraits to C. Edwards Lester:

I myself have heard Inman say that, in his time, no man could succeed in America except as a portrait painter. "The taste of my 'customers,'" says he, "is limited chiefly to portraits. They will not commission me to execute Landscapes, which would possess a much greater value, and win me an infinitely higher fame. I cannot even get a chance to paint a landscape, unless I stick it into a portrait, where I sometimes manage to crowd in a bit of sky, or some old tree or green bank. Why, I should have starved long ago on any thing but portraits.

. . . The time will come when the rage for portraits in America will give way to a higher and purer taste."[2]

Today, this earlier American demand for portraits is often interpreted as ego gratification, or a search for symbols of social status on the part of the sitter. We look back from an era in which many images of individuals are available through photographs and video, and we project our modern self-awareness onto the sitters in these earlier paintings. These superficial interpretations are often based on a lack of information about the portraits that have survived, and the often subtle styles of communication in the genre of portraiture make the meanings of the images inaccessible, even when the identities of the sitters are known. However, before the era of photography, which began with the invention of the daguerreotype in 1839, portraits were the result of a very purposeful process. Most people were portrayed only once in their lifetime, if at all. And the portraits were usually made with particular audiences or viewers in mind, and reflect on or celebrate particular occasions or viewpoints. As English portrait painter Jonathan Richardson wrote in *An Essay on the Theory of Painting* (1715):

The Picture of an absent Relation, or Friend, helps to keep up those Sentiments which frequently languish by Absence and may be instrumental to maintain, and sometimes to augment Friendship, and Paternal, Filial, and Conjugal Love, and Duty. Upon the sight of a Portrait, the Character, and Master-strokes of the History of the Person it represents are apt to flow in upon the Mind, and to be the Subject of Conversation: So that to sit for one's Picture, is to have an Abstract of

Figure I.
David Rittenhouse (1732–1796) by Charles Willson Peale (1741–1827). Oil on canvas, 127 x 101.6 cm (50 x 40 in.), 1796. National Portrait Gallery, Smithsonian Institution; bequest of Stanley P. Sax

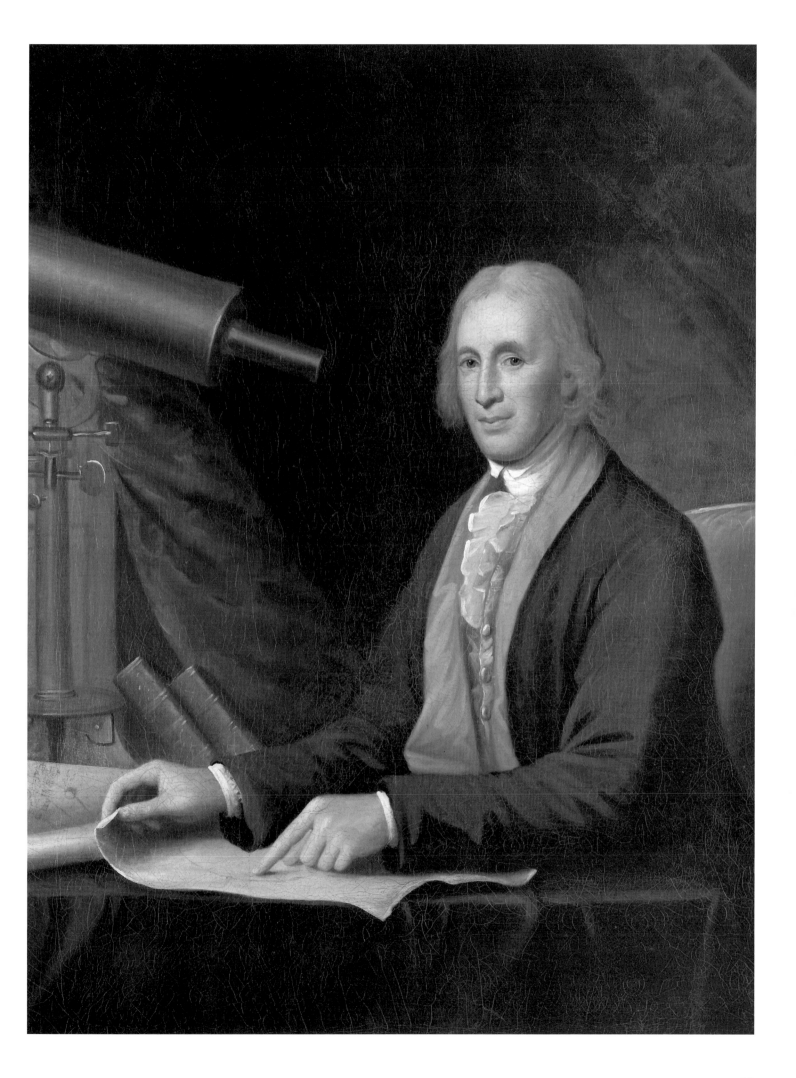

one's Life written, and published, and ourselves thus consign'd over to Honour, or Infamy.[3]

The Sitter and Social Aspects of Presentation

Most portraits resulted from a three-way relationship between the sitter, the patron or intended audience, and the artist. By investigating these avenues of documentation and interpretation, we can learn more about the purpose of the portrait, the sitter's viewpoint, and the artist's contribution. First and foremost with portraits comes the sitter, and social aspects of presentation. Portraits reflect theories about the character and personality of the period when they were made. A consistent belief throughout the period covered by this essay was that character could be read from a person's face, or the bumps on his or her head, or from facial expressions. An early-eighteenth-century statement of this view appears in the letter written by William Byrd II to Sir John Perceval, the first Earl of Egmont, in 1736 to thank him for the gift of his portrait. His comments indicate that he believed that character could be judged from a person's face, and that an artist could represent this in a portrait:

It [the portrait] is incomparably well done & the painter has not only hit your ayr, but some of the vertues too which usd [sic] to soften and enliven your features. So that every connoisseur that sees it, can see t'was drawn for a generous, benevolent, & worthy person. It is no wonder perhaps that I coud [sic] discern so many good things in the portrait, when I knew them so well in the original.[4]

Comments about people or portraits between the 1730s and the 1860s often indicate that people continued to be aware of prevailing theories of physiognomy or, later, phrenology. These theories emphasized that a viewer could see signs of character in a person's face or head, and thus in the representation of that face in a portrait. For example, in 1746, when Charles Cotesworth Pinckney [Cat. no. 4] was only three months old, his mother described him as "a fine little boy" with "black Eyes," and wrote that she was hopeful that she could detect "all his papas virtues already dawning on him."[5]

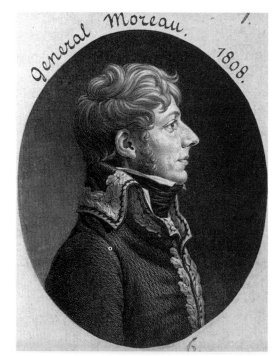

In 1776, Oliver Wolcott Sr., a delegate to the Continental Congress from Connecticut, wrote to his wife from Philadelphia that he had met David Rittenhouse, the Philadelphia scientist [Fig. 1]. "I saw Mr Rittenhouse and Viewed him with great Curiosity, but I saw no other Mark of Genius Stamped upon him than what is discoverable in an ordinary man."[6] The study of physiognomy received greater attention after the publication of the theories of Swiss theologian Johann Kaspar Lavater, who believed that the character of an individual could be interpreted from the shape of a profile, or silhouette, of a person's head. His theories were translated into English by the Reverend Henry Hunter as *Essays on Physiognomy: designed to Promote the Knowledge and the Love of Mankind* (3 vols.; London, 1788–1798), and by Thomas Holcroft as *Essays on Physiognomy: for the Promotion of the Knowledge and Love of Mankind* (3 vols.; London, 1789–1793). Not everyone agreed with Lavater's theories, as indicated by comments like that of Senator James A. Bayard, who in 1812 remarked on the French general-in-exile Jean-Victor Moreau [Fig. 2]. Bayard "railed at Lavater and his science, for he looked hard at the General, he said, but could find nothing remarkable or expressive in his countenance."[7] These attitudes were particularly important for political portraits—paintings that would be looked at to recognize the sitters' leadership

qualities. The portraits that Charles Willson Peale painted after the American Revolution for his museum were created with this in mind.[8] And portraits of George Washington were commissioned to convey his character to future generations. When artist William Joseph Williams offered to make a portrait of Washington for the Alexandria (Virginia) Masonic Lodge No. 22 if the lodge would request the sittings, the lodge voted in favor, writing to Washington that although his name was dear to "every good Mason," it would be "a source of the most refined gratification the tracing out and contemplating the various ornaments of his character in the resemblance of his person."[9]

In the nineteenth century, such judgments continued to be made about public figures, particularly as interest grew in phrenology, the pseudo-science that developed from the theories of Dr. Franz Joseph Gall in Vienna, who proposed that the characteristics of an individual could be determined by studying the shape of the skull. These theories gained adherents in the United States after the arrival of Gall's follower Johann Gaspar Spurzheim in 1832 and Scottish phrenologist George Coombe, who came to the United States in 1838 and stayed more than two years.[10] Abolitionist William Lloyd Garrison exemplifies these attitudes in his comments about his portrait, painted by Nathaniel Jocelyn for his brother Simeon Smith Jocelyn in 1833 [Cat. no. 19]. Simeon wrote to Garrison:

I have long thought that your friends and foes would view your portrait with interest; and as the Lord has been pleased to give you a head bearing none of the destructive disposition *which opposers ascribe to you, it may not be amiss to lead them by a view of the outward man to a more favorable examination of your principles. I am confident that this is the effect where your face is seen, and why not where its imitation should be viewed?*[11]

An anonymous review of abolitionists' portraits by Philadelphia African American artist Robert Douglass Jr., written in 1837, noted that he captured the sitters' characters in his

work: "There, too, is many a thoughtful brow, Marked by a soul that ne'er will bow, To tyrant power."[12] That same year, American phrenologists Orson and Lorenzo Fowler published *Phrenology Proved, Illustrated and Applied* and initiated a new periodical, the *American Phrenological Journal.* The belief that character could be viewed in a portrait led John Gross Barnard, the superintendent of the United States Military Academy at West Point, to write to Winfield Scott in 1855 for permission to have Robert Walter Weir paint a portrait of Scott for the academy [Cat. no. 27]:

The features of one who has done so much for his country, and so much to illustrate, before that Country, the value of the Military Academy, should be familiar to every Cadet and had in remembrance by every Graduate, and I deem the present opportunity to obtain a delineation of them too favorable to be permitted to escape.[13]

In this context, familiar testimonials about the accuracy of portraits can now be recognized as more than mere questions of the artist's ability to depict a person accurately. Comments about a perfect likeness become statements about whether the portrait conveyed the person's character or personality. John Neagle's portrait of Henry Clay [Cat. no. 21] was judged a success by many, including the sitter, who wrote to the artist:

I know that you took the greatest pains to produce the perfect likeness, studying thoroughly your subject, and carefully examining all the previous pictures of it, which were accessible to you. And it is the judgment of my family and friends that you have sketched the most perfect likeness of me that has been hitherto made. My opinion coincides with theirs. I think you have happily delineated the character, as well as the physical appearance, of your subject.[14]

One of Clay's biographers, John S. Littel of Philadelphia, applauded Neagle's portrait as "worthy of his subject and of his own professional fame" and as producing "almost with the fidelity of nature, the graceful person and beaming countenance of the man whose character and fame is the pride and glory of his country."[15]

A shorter testimonial was inscribed on the back of William Elwell's portrait of Dolley Madison [Cat. no. 24] by William Seaton, editor of the *National Intelligencer*, who later owned the portrait: "Mrs. Madison, aged 83 painted by W. S. Elwell in 1848. A Faithful portrait. W.W.S." A letter from Harriet Beecher Stowe's husband accompanied the exhibition of her portrait [Cat. no. 26] at the theater where the play based on her book *Uncle Tom's Cabin* was performed in 1853. The letter testified to the success of Alanson Fisher's image. Stowe was quoted as saying that he was

better satisfied with Mr. Fisher's portrait of Mrs. Stowe than with any other attempt of the kind which he has seen. Every feature is exactly copied, and the general expression is pleasant, life-like and natural. On the whole, to his eye, it is a handsome picture and a good likeness.[16]

Only a year later English historian Thomas Carlyle wrote his opinion about portraits as keys to the understanding of written biography. Writing to David Laing about a proposed exhibition of Scottish portraiture, Carlyle commented:

First of all, then, I have to tell you, as a fact of personal experience, that in all my poor Historical investigations it has been, and always is, one of the most primary wants to procure a bodily likeness of the personage inquired after; a good Portrait if such exists; failing that, even an indifferent if sincere one. In short, any representation, made by a faithful human creature, of that Face and Figure, which he saw with his eyes, and which I can never see with mine, is now valuable to me, and much better than none at all. . . . Often I have found a Portrait superior in real instruction to half-a-dozen written "Biographies," as Biographies are written;—or rather, let me say, I have found that the Portrait was as a small lighted candle by which the Biographies could for the first time be read, and some human interpretation be made of them.[17]

To the twentieth-century viewer, who questions the persuasive power of portraits and does not believe these now-discredited theories of physiognomy and phrenology, many images instead communicate information through the sitter's pose, gestures, and clothing, and through the details added to the background of the portrait. This information was often intentionally included by the artist at the patron's request. Many of the portraits in the Gallery's collection can be easily read in these terms. In John Smibert's portrait of Bishop George Berkeley, for example [Cat. no. 1], the sitter points to a promontory that is believed to represent Bermuda, the site of Berkeley's intended missionary school. It is a place that neither Smibert nor Berkeley would ever see, but it is used in the background as an iconic identifier of the time and context for the painting, which was done in London before the two men embarked for the American colonies. Charles Willson Peale's portrait of Anne Green [Cat. no. 3] shows her holding a copy of the *Maryland Gazette*, displaying the last page, with part of the colophon legible: "ANNAPOLIS: Printed by." Mrs. Green became publisher of the *Gazette*, the colony's only newspaper, in 1767, at the death of her husband, Maryland printer Jonas Green, who had published the weekly newspaper since 1745. The portrait clearly marks her new professional status. Gilbert Stuart's full-length portrait of George Washington [Fig. 3] has as its theme Washington as civic leader of the new republic of the United States. It is known as the "Lansdowne portrait" because it was painted for William Petty, the second Earl of Shelburne and the first Marquis of Lansdowne, British supporter of the American cause during the Revolution. The pose is that of a leader addressing an audience; the table, the books, the chair, and the background refer to the republic and its bright future, symbolized by the rainbow. The Reverend Thomas Paul, as painted by Thomas Badger in about 1825 [Cat. no. 17], is posed as a man preaching, and this is reinforced by the unusual architectural setting. The interior probably represents the African Meeting House on Beacon Hill in Boston, constructed in 1806 by the First African Baptist Church. Paul served as minister of the church for almost twenty-five years.

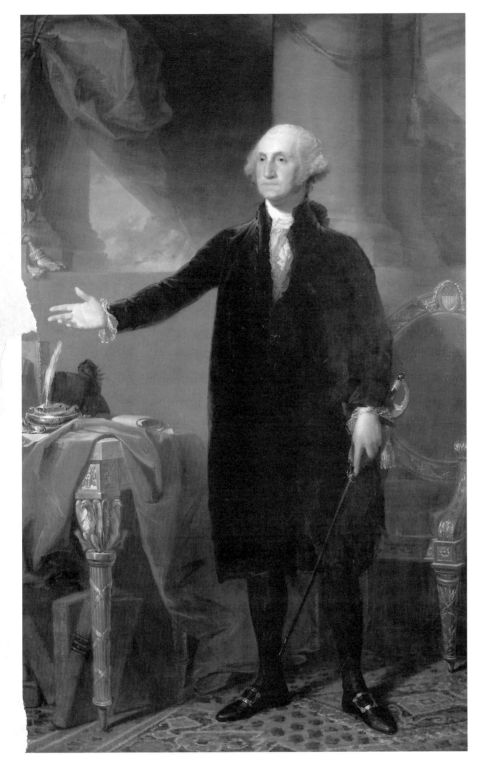

Figure 3.
George Washington (1732–1799)
by Gilbert Stuart (1755–1828).
Oil on canvas, 243.8 x 152.4 cm
(96 x 60 in.), 1796. National Portrait
Gallery, Smithsonian Institution;
anonymous loan

own drawings of Damascus, and undoubtedly described his clothing to Hicks, or perhaps even showed him the actual apparel. Some portraits stress less well-known aspects of a sitter's life. Because Daniel Huntington's portrait of Gulian Verplanck [Cat. no. 29] was painted for the New York Commissioners of Emigration, it includes a view of New York harbor with Castle Garden, the primary point of arrival for immigrants in the state. Verplanck was one of the original commissioners of the state board that oversaw immigration and provided relief for immigrants, and he was president of the board from 1848 until his death.

While clothing generally reflects the fashion of the times, occasionally a portrait, like Hicks's painting of Bayard Taylor, shows a sitter wearing an unusual type of apparel. Cephas Thompson's image of William Wirt [Cat. no. 10] portrays him in what appears to be a Roman toga. This neoclassical reference may allude to Wirt's oratorical skills or to his recent public service as a member of the Virginia House of Delegates. Aware of the close scrutiny that viewers gave portraits, men represented in uniform demanded exceptional accuracy. When Henry Benbridge painted Charles Cotesworth Pinckney in Charleston in about 1773, he was represented in a red coat, the uniform of the Light Infantry Company of the Charleston militia, a colonial (that is, British) unit. After Pinckney became a member of the first South Carolina Regiment, organized by the South Carolina Provincial Congress in 1775, the portrait was repainted to represent his new uniform. When John Vanderlyn depicted Samuel Ringgold [Cat. no. 16] in about 1825, he was serving on General Winfield Scott's staff in New York and is seen in a staff officer's blue dress uniform of that time.

The Patron and the Intended Audience

The portraits in the collections of the National Portrait Gallery provide examples of many of the reasons why portraits were made in the American colonies or the United States in the years from 1725 to 1865. This is true despite the fact that the Gallery

The sitter's role in designing the composition is well documented in the Gallery's portrait of Bayard Taylor, painted in 1855 by his friend Thomas Hicks [Cat. no. 28]. The portrait, which was painted in New York City, depicts Taylor in Egyptian clothing, with his guide Achmet. In the background is the city of Damascus. Taylor requested that the image of Achmet be included in the portrait and, since Achmet had never traveled to the United States, provided Hicks with a copy of a daguerreotype from which the portrait could be made. Taylor also supplied his

formed its collection to represent only Americans of national historical significance, and thus has a unique focus that would not be typical of portrait collections found in art museums or local and state historical societies. First, the collections include almost no sitters who are of only local or regional importance, and no unidentified sitters. Second, most of the portraits in the collection were made when the sitters were well known, and many were done because of the sitters' well-established reputations, or notoriety. Thus, for a museum collection, the Gallery has a larger than usual number of sitters whose portraits were made for public audiences. Nevertheless, the collections include examples of portraits made for more personal reasons.

One major reason for commissioning portraits throughout this period was to record the images of family members. The sitters in these instances were usually husband and wife, although other popular subjects included young men on reaching adulthood or obtaining an inheritance, young women of marriageable age, family members living at a distance from each other, and young children, including, in the early nineteenth century, recently deceased children. A few of the portraits in the Gallery's collection are typical of these private commissions, including the miniature of Varina Davis [Fig. 4], wife of Jefferson Davis. The exhibition includes one pair of pendant portraits, that of William Wirt and his second wife Elizabeth Gamble [Cat. nos. 10 and 11], painted by Cephas Thompson in 1809–1810, when the couple was settling into their new home in Richmond. Andrew Oliver's portrait [Cat. no. 2], one of three miniatures that John Singleton Copley painted of him in about 1758, was done for a family member. Henry Benbridge's portrait of Charles Cotesworth Pinckney [Cat. no. 4] was painted around the time that Pinckney married Sarah Middleton. Benbridge also painted her portrait (Gibbes Museum of Art).[18] The portrait of General William Tecumseh Sherman by George Peter Alexander Healy [Cat. no. 34] is also a family portrait, commissioned by

Figure 4.
Varina Howell Davis (1826–1906) by John Wood Dodge (1807–1893). Watercolor on ivory, 6.4 x 5.1 cm (2 1/2 x 2 in.), 1849. National Portrait Gallery, Smithsonian Institution; gift of Varina Webb Stewart

the general's wife, Ellen Sherman, at the end of the Civil War. In 1868, when Sherman was discussing Healy's planned composition of *The Peacemakers* with the artist, he commissioned a pendant portrait of his wife: "Whether this group will warrant an historical picture is for you to say. I want you to paint Mrs. Sherman at your best leisure, a picture to match mine, to be transmitted to our children."[19] Both portraits were subsequently owned by descendants, who gave them to the Smithsonian Institution.

Images were often painted for friends of the sitter as well as for family members. A number of portraits at the Gallery had these origins. The most famous example is probably the portrait of Benjamin Franklin by Joseph Siffred Duplessis [Cat. no. 7]. A version of the portrait that Duplessis painted in 1778 (Metropolitan Museum of Art), it was owned by Mme. Brillon de Jouy, Franklin's neighbor in Passy when Franklin was American minister to the French court, and was commissioned either by Franklin as a gift or by Mme. Brillon as a memento. By this time, Franklin, already frequently portrayed—sometimes well, sometimes badly—was inclined to recommend that people who wanted his likeness obtain copies of portraits that had already been painted:

I have at the request of Friends sat so much and so often to painters and Statuaries, that I am perfectly sick of it. I know of nothing so tedious as sitting

hours in one fix'd posture. I would nevertheless do it once more to oblige you if it was necessary, but there are already so many good Likenesses of the Face, that if the best of them is copied it will probably be better than a new one, and the body is only that of a lusty man which need not be drawn from the Life; any artist can add such a Body to the face. . . . Ornaments and emblems are best left to the Fancy of the Painter.[20]

Another eighteenth-century portrait of a political figure that was intended for a friend is the Gallery's portrait of John Jay [Cat. no. 6], one of two portraits of Jay begun by Gilbert Stuart in London in the winter of 1783–1784. Jay commissioned the two portraits for himself and his friend William Bingham. He wrote to Stuart on February 22, 1784: "In the Price I paid you for my Picture & the Copy of it for Mr. Bingham, I find no Provision was made for the Frame of the latter. . . . In the choice of the Frame be pleased to discover & be directed by Mr Binghams Fancy."[21] Stuart left the portraits unfinished, however, and they were completed later by John Trumbull. Stuart's portrait of Rufus King [Cat. no. 14] was part of an exchange of portraits between King and his close friend and political ally, Christopher Gore, both ardent Federalists. King sat for Stuart in 1819 while visiting Gore in Boston. A few weeks later, Gore asked how the completion of the portrait was coming: "It will gladden my remaining days, be they few or many."[22] (Gore was then sixty-one years old.) On receiving the portrait in March 1820, Gore wrote, "We have been highly gratified with your Picture—It is a good Picture, and on the whole a Likeness."[23] The portrait of Dolley Madison, widow of President James Madison, by William S. Elwell was later owned by her longtime friends, the Seatons. And the portrait of Frederick Douglass [Cat. no. 22], for which the artist remains unidentified, was owned by Alphonso Richard Janes, a friend of Douglass's and treasurer of the Rhode Island Anti-Slavery Society. The facts of this commission are not known.

However, other portraits in the exhibition were made with larger, more public audiences in mind. Chester Harding asked Davy Crockett to sit for his portrait in 1834 in Boston. Harding was not the first painter, or the last, to ask for sittings from a well-known person to attract attention to his skills as a portraitist. His portrait [Cat. no. 20] is one of five that Crockett sat for in 1833 and 1834, a testimony to the frontiersman's growing fame. Crockett, a member of the United States House of Representatives from Tennessee, was on a speaking tour when he arrived in Boston. Harding invited him "to visit his gallery of paintings, where he had a great many specimens of the fine arts; and finally he asked me to sit for him until he could get my likeness, which I did, during my stay, and he has it now, hung up among the rest of the fine arts."[24] Harding undoubtedly knew that having a portrait of Crockett on view in his gallery would attract visitors, who would be potential patrons. Another portrait that probably was painted for display in a picture gallery was that of the artist George Catlin, painted by English painter William Fisk in 1849 [Cat. no. 25]. The portrait, which depicts Catlin in the act of painting his Native American sitters' portraits, could have been intended for exhibition in his Indian Gallery. It was painted the year after Catlin published the catalogue of his paintings of Native Americans, which were on exhibition in London. Some portraits were commissioned for display in more overtly political contexts. In the 1840s, King Louis-Philippe of France commissioned American artist George Peter Alexander Healy to paint a series of portraits of famous American statesmen for Versailles. The version of Healy's portrait of John C. Calhoun that was painted for Louis-Philippe is dated 1846 (Musée National du Château de Versailles); the Gallery's example [Cat. no. 23] is undated, but was presumably painted around the same time. Another portrait intended for public display was that of Harriet Beecher Stowe [Cat. no. 26], painted by Alanson Fisher in 1853 because of the successful dramatization of her novel *Uncle Tom's Cabin.* Alexander H. Purdy, owner of the National Theatre in New York, where the play was produced, commissioned the

portrait to display in his theater, protecting it from potential damage by inserting plate glass in the frame. And while the origins of Robert W. Weir's portrait of General Winfield Scott are not documented, they may relate to Scott's financial support of the United States Soldiers' and Airmen's Home in Washington, D.C., which owns the largest version of this portrait.

This interest in portraits of people who were "in the news" led to the reproduction of portraits in engravings and lithographs, which could be made as multiples and sold more cheaply than a painted copy. Often the genesis of the portrait included the plan to reproduce it in some form of print. Rembrandt Peale's painting of actress Juliana Westray Wood was painted, engraved, and published soon after her husband, actor and theater manager William B. Wood, became a full partner in 1810 in the Chestnut Street Theatre Company in Philadelphia [Cat. no. 12]. The engraving, by David Edwin, was published in the March 1811 issue of the short-lived periodical *The Mirror of Taste and Dramatic Sensor*. The text that accompanied the engraving hints at a public interest in the private lives and morality of actors and actresses. Calling the image "a striking likeness," the author noted that the portrait "will no doubt be acceptable to our subscribers, not only as a handsome specimen of American arts, but as a striking resemblance of a lady whose public talents and private virtues have raised her to a very high rank in public estimation."[25] Publications of books that included biographies and engraved portraits were first produced in the United States in the early nineteenth century. The earliest was Joseph Delaplaine's incomplete *Repository of the Lives and Portraits of Distinguished American Characters*, of which only two volumes were published (Philadelphia, 1816–1818). This was followed by John and Joseph Sanderson's *Biography of the Signers to the Declaration of Independence*, in nine volumes (Philadelphia, 1820–1827), and by James Barton Longacre and James Herring's *National Portrait Gallery of Distinguished Americans*, in four volumes (Philadelphia, 1833–1839).[26] While

these publications sought out the best existing portrait of each person whose biography was included, in some cases portraits were painted specifically to be engraved. This was the case with Nathaniel Jocelyn's portrait of abolitionist William Lloyd Garrison. The artist's brother Simeon Jocelyn arranged for the portrait to be painted in order to engrave it and sell the prints to raise funds for the abolitionist cause. Garrison, in a letter written to Harriet Minot, reluctantly saw the logic in these efforts: "This sticking up one's face in print-shops, to be the 'observed of all observers,' is hardly consistent with genuine modesty, but I can in no other way get rid of the importunities of those who would pluck out their eyes to give me."[27] The desire on the part of some Americans to record the disappearing Native American populations led to a series of portraits that were made for public display in Washington, D.C. This collection of portraits of Native Americans was formed by Colonel Thomas Loraine McKenney, the commissioner of Indian affairs. Begun in 1822, it eventually included about 140 paintings. The portraits were reproduced in lithographs for the three-volume publication *The History of the Indian Tribes of North America, with Biographical Sketches and Anecdotes of the Principal Chiefs* (Philadelphia, 1838–1844), compiled by McKenney and James Hall. The process of reproducing them required that copies be painted, from which the lithographic images were drawn. Henry Inman was commissioned to paint the copies. His painting of Sequoyah [Cat. no. 18] was copied from the life portrait that Charles Bird King painted in Washington in 1828 and was the source of the lithograph in the publication [Fig. 5]. King's original work was destroyed by a fire at the Smithsonian Institution in 1865, along with most of the paintings in the collection.

Larger paintings that were also successfully reproduced in prints include a full-length portrait of Henry Clay, who was planning to run for President in 1844. The men who commissioned Philadelphia artist John Neagle in 1842 to paint the portrait were prominent Whig supporters [Cat. no. 21]. They present-

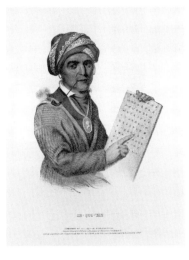

Figure 5.

Sequoyah (circa 1770–1843) by J. T. Bowen Lithography Co. (active 1834–1844?), after Henry Inman. Hand-colored lithograph, 27.4 x 22.5 cm (10 13/16 x 8 7/8 in.), 1837. National Portrait Gallery, Smithsonian Institution

Figure 6.

Henry Clay by John Sartain (1808–1897), after John Neagle. Mezzotint, 64 x 45.8 cm (25³/₁₆ x 18¹/₁₆ in.), 1843. National Portrait Gallery, Smithsonian Institution

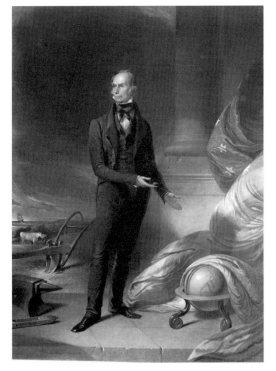

ed it to the National Clay Club at a public ceremony in Philadelphia the following spring. The imagery in the painting conveyed to viewers a summary of Clay's political positions and accomplishments. A widely distributed engraving of the portrait by John Sartain [Fig. 6] further helped to promote Clay's candidacy for President.[28] Sartain in 1862 also engraved *Men of Progress: American Inventors* [Fig. 7], painted by his friend Christian Schussele. He began work on the print even before the painting was completed; the contract for the engraving was signed on March 9, 1861. Jordan Mott, one of the

sitters, who later owned the small version of the painting that is now at the Gallery [see Cat. no. 32], lent the money for Sartain's fees.[29] When the engraving was finished, the painting was exhibited in New York. A flyer explained that the image represented

a number of the most distinguished inventors of this country, whose improvements in the various appliances that have now come to be essential in the mechanic arts, have changed the aspect of modern society, and caused the present age to be designated as an age of progress. . . . It is to such men as constitute this group that modern civilization owes its chief triumphs, and they should be all the more esteemed and honored that their path has been a rough and thorny one.[30]

Artists and Sittings

The Gallery's painting collection is not typical of a survey collection of American portraiture that one might find in a museum of American art. A greater percentage of the artists were nationally prominent in their times, since nationally significant sitters were more likely to have been painted by artists with more than local or regional spheres of patronage. Many of the artists, in addition, had the benefit of European training, which gave an academic, or schooled, technique to their work. Even when the reputations of some of the artists can be characterized as regional or local rather than national, their work has none of the stylistic hallmarks of

Figure 7.

Men of Progress: American Inventors by John Sartain (1808–1897), after Christian Schussele. Mezzotint and engraving, 67.7 x 101.6 cm (26⁵/₈ x 40 in.), 1862. National Portrait Gallery, Smithsonian Institution

naive, or "folk" artists. The styles of those "plain painters" indicate

that the primary rules of painting have been grasped and that further refinement will probably follow, as biographical study suggests. It is, then, not the nature of their work that sets plain painters apart from fine artists; it is a difference in the level of mastery over the conventions of technique.[31]

By contrast, the sophistication of the artists whose work is in the Gallery's collection is a reflection of the determining factor in forming the collection: the national significance of the sitter.

While there is no particular visual or stylistic argument in the selection of portraits for the collection, there are striking connections between many of the artists, especially in terms of the professional aspects of their careers, including training and materials. The dominant style of painting seen in American portraiture until about 1840 was English. This extended as well to the use of certain popular poses and gestures, and even to the sizes of the supporting canvases. A discussion of sizes serves to remind us that portraits made on commission were regarded by most artists as a product, priced according to materials and labor involved in their making. A number of the artists whose work is represented in this exhibition received at least some of their training in England, including the earliest, John Smibert, the Scottish artist who came to America in 1729 and settled in Boston. By that time, the compositional formulas that had developed in continental Europe in the Baroque era had been introduced into England by Sir Anthony Van Dyck, Sir Peter Lely, and Sir Godfrey Kneller. In this practice, portraits were composed in relationship to the largest image made, the life-size full-length, which was painted on a canvas that measured about 80 x 50 inches. (This discussion of canvas sizes will use inches, historically the measurement used for canvases in the English tradition.) While the exhibition does not include an early life-sized full-length portrait, Gilbert Stuart's "Lansdowne" portrait of George

Washington is of this type [see Fig. 3]. This large canvas offered more surface on which to paint backgrounds and other compositional elements that could convey information about the subject of the portrait. Matthew Harris Jouett quoted Stuart on this imagery:

Back grounds should contain whatever is necessary to illustrate the character of the person. The eye should see the application of the parts to the illustrate [sic] of the whole, but without seperating [sic] or attracting the attention from the main point. Back grounds point to dates and circumstances peculiarly of employment or profession, but the person should be so portrayd as to be read like the bible without notes, which in books are likened unto back grounds in painting. Too much parade in the background, like notes with a book to it, and as verry [sic] apt to fatigue by the constant shifting of the attention &c.[32]

The next smaller size, which measured 50 x 40 inches, was called a "half-length" in the eighteenth century because it was made by dividing a full-length canvas into two pieces. In this smaller surface, there was less room for descriptions of setting or other images in addition to the figure, which was usually shown to the knees. Of the paintings in this exhibition, those of John Jay, George Catlin, and Gulian Verplanck are half-length portraits. In turn the portrait size that was half of a half-length, or 30 x 25 inches, was called a "three-quarter-length" or, by some, a "bust." This size was very popular throughout the eighteenth and early nineteenth centuries. Normally it showed a waist-length figure without hands, or perhaps only one hand. Again, as the size of the canvas was reduced, the amount of imagery around the figure was lessened, so that the non-figurative imagery would not detract from the image of the sitter. Of the portraits in this exhibition, ten are on 30 x 25-inch canvases, including those of Charles Cotesworth Pickney, the Wirts, Sequoyah, William Lloyd Garrison, Nathaniel Hawthorne, Davy Crockett, and Dolley Madison. The portrait of Sequoyah, which depicts the sitter holding a tablet with the Cherokee alphabet written on it, has the most imagery for a canvas this size. The others have plain backgrounds in most

cases, and depend more heavily on the pose to give variety to the picture.

In the English tradition, another size was available between the half-length and the three-quarter-length. This was called a "kit-cat," after the series of portraits painted by Sir Godfrey Kneller between 1703 and 1721 of members of a Whig club in London. The size and proportions of this 36 x 28-inch canvas allowed the artist to include one of the sitter's hands, thus giving a gesture or action to the picture. There are six paintings of this size in the exhibition, of Bishop George Berkeley, Anne Green, Loammi Baldwin, John C. Calhoun, Harriet Beecher Stowe, and Winfield Scott. These portraits show more variety in the position of the sitter and the turn of the body than was possible in the smaller three-quarter-length. The prices for portraits varied in proportion to the size of the canvas and amount of the figure painted. For most painters, the prices in the English tradition doubled as one moved from smaller to larger canvases, the full-length being twice the next smaller size, or half-length, which in turn was twice the price of the 30 x 25-inch size.

Some Gallery portraits in the English tradition are not of these sizes, including four portraits or self-portraits of artists. Copley's self-portrait is on a square canvas [Cat. no. 5]. The two portraits of the Peales—Charles Willson Peale's self-portrait [Cat. no. 8], and the portrait of Rubens Peale by his brother Rembrandt Peale [Cat. no. 9]—are on smaller canvases that measure 25 by 20 inches, the size that Thomas Sully called a "head" size. Samuel F. B. Morse's self-portrait is even smaller, painted on millboard, a material that became popular in the nineteenth century [Cat. no. 13].[33] The two smallest portraits in the exhibition represent older traditions in terms of the support: Thomas Badger's portrait of Thomas Paul is on a small wood panel, and Copley's miniature of Andrew Oliver is in oil on copper, a form of miniature that was becoming less popular as it was gradually replaced by watercolor miniatures on ivory.

A small number of portraits have sizes that are of different proportions. These point to an artist's experience with, and preference for, French canvas sizes. In the French system, which was codified by the mid-eighteenth century, there were more sizes, and the result was a portrait canvas of slightly narrower proportions than the English canvas.[34] The portrait of Benjamin Franklin is certainly on a French canvas; it was painted in Paris by Joseph Siffred Duplessis, a French portrait painter. John Vanderlyn's portrait of Samuel Ringgold could also reflect the French tradition; Vanderlyn had spent almost two decades in Paris, and perhaps continued to use French canvas sizes, or French canvases themselves. George Peter Alexander Healy, like Vanderlyn, spent much of his career in France, and his portraits of Orestes Brownson [Cat. no. 33] and William T. Sherman [Cat. no. 34] are not typical of English sizes. John La Farge's portrait of William James [Cat. no. 30] may be another painting in the French tradition. Thomas Buchanan Read's portrait of Philip Henry Sheridan [Cat. no. 37], too, may be slightly different in size because of his training in Europe, in his case in Italy.

Most of the artists whose work is included here were American by birth. However, in their training, there were clear influences from European art on their work. Of the colonial artists, even the young John Singleton Copley, when painting his early portrait of Andrew Oliver, was working with direct experience of European paintings, which he could see in the collection of John Smibert, or English styles of portraiture, seen in the work of Smibert and Joseph Blackburn, another English artist painting in New England. Copley's later self-portrait was painted in London long after he had moved there, and at a time when he was transforming his style into a broader technique. Portraits in this exhibition by the two other colonial painters, Charles Willson Peale and Henry Benbridge, were made after these artists had studied in Europe, Peale in London and Benbridge in Italy. The poses and clothing of the sitters reflect this

sophisticated training. Americans of the next generation who also studied in Europe include some of the most famous of that era, Gilbert Stuart, John Trumbull, and Rembrandt Peale among them. Even many artists who were trained only in the United States benefited from the sophistication of others who had studied in Europe. For example, Nathaniel Jocelyn, John Neagle, and William S. Elwell were trained by artists who had studied abroad: Jocelyn with Samuel F. B. Morse, Neagle with several artists, including Gilbert Stuart, and Elwell with Chester Harding. However, Massachusetts painters Cephas Thompson, who perhaps was self-taught, and Thomas Badger, who was the pupil of Boston decorative painter John R. Penniman, had no opportunities to learn the more polished early-nineteenth-century European styles of painting. Some Americans, including Harding, followed some American training—often informal study with a well-known artist like Sully or Stuart—with European exposure to art exhibitions and artists' studios. John Vanderlyn was the first of these to study in France rather than England, as did later artists, including several who were acquainted in Paris with Thomas Couture: Thomas Hicks, George Peter Alexander Healy, and John La Farge. Both Robert W. Weir and Daniel Huntington studied instead in Italy. Thomas Buchanan Read was befriended by Washington Allston in Boston before going to Europe. While many of these artists were primarily, or exclusively, portrait painters, others, including Trumbull and Huntington, preferred history painting—depictions of scenes from the American or European past or present—but turned to portraiture as one of their talents that could guarantee an income. Since much of history painting involves depictions of the human figure, it is no surprise that these artists also excelled in portrait painting.

The hazards and pitfalls of being a portrait painter were described in great detail by John Neal, a self-taught American artist who was an early writer on American art. He commented on portrait painting in the United States in his essay, "Landscape and Portrait-Painting," published in *The Yankee* in 1829. One of the difficulties faced by a portrait painter was contending with "that prejudice, whereby portrait-painting or face-making, is regarded as a subordinate branch of the art." The artist was "obliged to preserve the likeness, and make a pleasant picture nevertheless." Also, unlike other artists, they could not choose their subjects and instead "must always be ready—no matter how disagreeable the subject may be." In addition, "Every body is a judge of portrait-painting, or a better judge of that than of anything else in the art, except still-life; add to which, the original is ever at hand for comparison, a standard, a trial-balance." He was "obliged to make a portrait of the dress, cloth, fur, velvet and all—to copy the very drapery, fold by fold and shadow by shadow, if he hopes to rank high." Finally, Neal commented, "People being much more ready to pay for a picture of themselves or their children, than for a picture of any thing else, the portrait branch is always overcrowded with adventurers, and cheap workmen; outcasts and bankrupts from every other department of the business."[35] Frances Trollope, an English visitor to the United States from 1827 to 1831, agreed with some of Neal's sentiments. In her book *Domestic Manners of the Americans* (1832), she described her response to a portrait of a lady by Charles Cromwell Ingham, which she saw at an exhibition. She criticized the artist (who in fact was born and trained in Ireland), writing that although

the picture is of very high finish, particularly the drapery, . . . the drawing is very defective, and the contour . . . hard and unfleshy. From all the conversations on painting, which I listened to in America, I found that the finish of drapery was considered as the highest excellence, and next to this, the resemblance in a portrait; I do not remember ever to have heard the words drawing *or* composition *used in any conversation on the subject.*[36]

One aspect of the business of being a portrait painter was the making of replicas or copies of portraits. The term "replica" is usually used to indicate that it is a copy of

the same artist's original, while the term "copy" is used to indicate that it reproduces the work of a different artist. Thus Weir's portraits of Winfield Scott are replicas of one portrait that was painted from life, whereas Inman's painting of Sequoyah is a copy of the life portrait by Charles Bird King. Painting replicas or copies was often the source of important income, particularly in the case of portraits of prominent Americans. Gilbert Stuart referred to the "Athenaeum" portraits of Washington as "hundred-dollar bills" because that was his price for a head-and-shoulders replica of the life portrait.[37] In most cases, replicas were commissioned by patrons, although in a few cases they were versions that the artists kept for display in their studios or for public exhibitions. Quite a few of the portraits in this National Portrait Gallery exhibition are one of two or more versions, and at times it is unclear which is the original and which is the replica. The portrait of George Berkeley, for example, exists in two versions, of which the first is owned by the National Portrait Gallery, London; the Smithsonian's National Portrait Gallery owns the second. The portrait of John Jay is one of several by Stuart, and one of two finished by Trumbull. However, the Smithsonian's image is unique because it was finished differently from the others. Others that are one of several versions include Copley's portrait of Andrew Oliver; Duplessis's portrait of Franklin; Morse's self-portrait; Stuart's image of Rufus King; Harding's portrait of Loammi Baldwin; Weir's portrait of Winfield Scott; Alanson Fisher's portrait of Harriet Beecher Stowe; Huntington's portrait of Gulian Verplanck; and Healy's portraits of John C. Calhoun, Orestes Brownson, and William T. Sherman. Read's painting of Sheridan exists in numerous examples, and even *Men of Progress* is one of two versions. Healy made the second versions of his portraits of Brownson and Sherman for exhibition. The dependence on patrons was one of the greatest hazards of the profession. This became a particular hardship during times of economic depression. In 1803 Charles Willson Peale described his brother James

Peale's difficulties, writing that he had "one miniature on hand and two portraits to be paid for in Grocery. I know not how other artists prosper, but suspect little is done."[38] During the national depressions of 1815–1821 and 1837–1843, even those portrait painters who had considerable local success and therefore rarely had to travel, like Philadelphia painter Thomas Sully, were forced to seek out sitters in other cities or lower their prices. Rembrandt Peale wrote to Sully in 1820: "I am Sorry to hear you could get work only by lowering your price, although probably Money is 25 per Cent more valuable than it was."[39] A number of eastern artists, including Samuel F. B. Morse, traveled south during these years, seeking commissions. To some artists, however, portrait painting could be a very successful business, as John Vanderlyn somewhat bitterly advised his nephew John Vanderlyn Jr. in 1825:

I heard with pleasure that you had made some very clever attempts in portraits where you are and which had given much satisfaction. A couple of years more spent in N. York must improve you in this occupation if you pay the least attention to it. . . . You may gain more money than you could by any Mechanical business, which you must know, is far more laborious, and less genteel and considered. Were I to begin life again, I should not hesitate to follow this plan, that is, to paint portraits cheap and slight, for the mass of folks can't judge of the merits of a well finished picture. . . . It would besides be the means of introducing a young man to the best society and if he was wise might be the means of establishing himself advantagiously in the world.[40]

The early and continued emphasis on portraits is a telling aspect of American culture through at least the era of the Civil War. Using portraits to express family allegiances, or the character and accomplishments of public figures, Americans created numerous paintings of individuals. These have now been left to modern audiences to view, puzzle over, and perhaps to understand as expressions of cultural values as well as demonstrations of the skills of the artists who made them. *

Notes

1 George C. Groce and David H. Wallace, *The New-York Historical Society's Dictionary of Artists in America, 1564 to 1860* (New Haven and London: Yale University Press, 1957).

2 C. Edwards Lester, *The Artists of America: A Series of Biographical Sketches of American Artists; with Portraits and Designs on Steel* (New York: Baker & Scribner, 1846), p. 43.

3 Jonathan Richardson, *An Essay on the Theory of Painting* (2d ed., 1725; reprint, Menston, Yorkshire: Scolar Press, 1971), pp. 13–14.

4 William Byrd II to John Perceval, Earl of Egmont, July 12, 1736, quoted by David Steinberg, "Facing Paintings and Painting Faces before Lavater," in Peter Benes, ed., *Painting and Portrait Making in the American Northeast*, Dublin Seminar for New England Folklife, Annual Proceedings, vol. 19 (Boston: Boston University, 1995), p. 206, from Marion Tinling, ed., *The Correspondence of the Three William Byrds of Westover, Virginia, 1684–1776* (Charlottesville: University Press of Virginia, 1977), vol. 2, p. 487.

5 Eliza Pinckney to "Miss Bartlett," circa May 1746, Elizabeth Pinckney Papers, Duke University Library, in Marvin R. Zahniser, *Charles Cotesworth Pinckney, Founding Father* (Chapel Hill: University of North Carolina Press, 1967), p. 8.

6 Oliver Wolcott to Laura Wolcott, March [8], 1776, in Paul H. Smith et al., eds., *Letters of Delegates to Congress, 1774–1789* (Washington, D.C.; Library of Congress, 1976–1983), vol. 3, p. 360, quoted in Brandon Brame Fortune with Deborah J. Warner, *Franklin & His Friends: Portraying the Man of Science in Eighteenth-Century America* (Washington, D.C.: National Portrait Gallery, in association with the University of Pennsylvania Press, 1999), p. 161.

7 Sir Augustus John Foster, *Jeffersonian America: Notes on the United States of America Collected in the Years 1805–6–7 and 11–12*, ed. Richard Beale Davis (San Marino, Calif.: Huntington Library, 1954), p. 63.

8 For a discussion of Peale's museum portraits as representations of the character of the sitters, see Brandon Brame Fortune, "Charles Willson Peale's Portrait Gallery: Persuasion and the Plain Style," *Word & Image* 6, no. 4 (1990): 308–24.

9 Elisha Cullen Dick, James Taylor, and Charles Simms to George Washington, August 29, 1793, in George Washington Papers, Manuscript Division, Library of Congress.

10 On phrenology in America, see especially John D. Davies, *Phrenology: Fad and Science; A 19th-Century American Crusade* (1955; reprint, Hamden, Conn.: Archon Books, 1971), and Charles Colbert, *A Measure of Perfection: Phrenology and the Fine Arts in America* (Chapel Hill and London: University of North Carolina Press, 1997).

11 Simeon Jocelyn to Garrison, March 29, 1833, quoted in *William Lloyd Garrison, 1805–1879: The Story of His Life Told by His Children*, vol. 1: *1805–1835* (New York: Century Co., 1885), p. 340.

12 "Lines on Seeing the Portraits of Abolitionists Painted by R. Douglass, Jr.," *The Genius of Universal Emancipation and Quarterly Anti-Slavery Review*, 5th ser., no. 1 (October 1837): 63, quoted in Richard J. Powell, "Cinque, Antislavery Portraiture and Patronage in Jacksonian America," *American Art* 11, no. 3 (fall 1997): 71.

13 Major General John Gross Barnard to Winfield Scott, September 24, 1855, letterbook, Archives, United States Military Academy, West Point, New York, courtesy of David M. Reel, curator of art, West Point Museum.

14 Henry Clay to John Neagle, May 29, 1843, in Robert Seager II and Melba Porter Hay, eds., *Papers of Henry Clay* (Lexington: University Press of Kentucky, 1991), vol. 9, p. 822.

15 John S. Littel, *The Clay Minstrel, or National Songster*, 2d ed. (Philadelphia: Thomas Cowperthwait, 1844), pp. 136–37, quoted in Robert W. Torchia, *John Neagle: Philadelphia Portrait Painter* (Philadelphia: Historical Society of Pennsylvania, 1989), p. 96.

16 *Evening Post* (New York), January 6, 1854.

17 Thomas Carlyle to David Laing, May 3, 1854, "Project of a National Exhibition of Scottish Portraits," in *Critical and Miscellaneous Essays, Collected and Republished* (New York: Scribner, Welford, and Co., 1872), vol. 7, pp. 129–30, quoted in Theodore Bolton and Irwin F. Cortelyou, *Ezra Ames of Albany: Portrait Painter, Craftsman, Royal Arch Mason, Banker, 1768–1836* (New York: New-York Historical Society, 1955), pp. xx, 135–36.

18 See Angela D. Mack and J. Thomas Savage, "Reflections of Refinement: Portraits of Charlestonians at Home and Abroad," in Maurie D. McInnis, in collaboration with Angela D. Mack, *In Pursuit of Refinement: Charlestonians Abroad, 1740–1860* (Columbia, S.C.: University of South Carolina Press, 1999), p. 30, fig. 15.

19 Sherman to Healy, January 13, 1868, quoted in Marie de Mare, *G. P. A. Healy, American Artist* (New York: David McKay Company, 1954), p. 241.

20 Franklin to Thomas Digges, June 25, 1780, quoted in Charles Coleman Sellers, *Benjamin Franklin in Portraiture* (New Haven and London: Yale University Press, 1962), p. 136.

21 Jay at Chaillot, near Paris, to Stuart in London, February 22, 1784, Joseph Downs Collection of Manuscripts and Printed Ephemera, Winterthur Library, Delaware.

22 Gore to King, October 19, 1819, in Charles R. King, ed., *Life and Correspondence of Rufus King* (New York: G. P. Putnam's Sons, 1894–1900), vol. 6, p. 231.

23 Gore to King, March 9, 1820, quoted in Charles A. Hammond and Stephen A. Wilbur, "*Gay and Graceful Style*": *A Catalogue of Objects Associated with Christopher and Rebecca Gore* (Waltham, Mass.: Gore Place Society, 1982), p. 19.

24 *An Account of Col. Crockett's Tour to the North and Down East . . .* (Philadelphia: E. L. Cary and A. Hart, 1835), p. 60. For a study of Crockett's portraits, see Frederick S. Voss, "Portraying an American Original: The Likenesses of Davy Crockett," *Southwestern Historical Quarterly* 91, no. 4 (April 1988): 457–82.

25 *The Mirror of Taste* 3, no. 3 (March 1811): 140.

26 On these important publications, see Gordon M. Marshall, "The Golden Age of Illustrated Biographies: Three Case Studies," in Wendy Wick Reaves, ed., *American Portrait Prints: Proceedings of the Tenth Annual American Print Conference* (Charlottesville: University Press of Virginia, 1984), pp. 29–82.

27 Garrison to Harriet Minot, April 9, 1833, quoted in *William Lloyd Garrison*, vol. 1, p. 339.

28 The painting's imagery is discussed by Robert Torchia in his chapter, "The *Henry Clay*: A Political Campaign Portrait," in *John Neagle*, pp. 93–108.

29 Ann Katharine Martinez, *The Life and Career of John Sartain (1808–1897): A Nineteenth-Century Philadelphia Printmaker* (Ann Arbor, Mich.: University Microfilms, 1986), pp. 131–35.

30 "On Exhibition, C. Schussele's Picture of Men of Progress: American Inventors," broadside advertisement (New York: Goupil & Co., 1862), photocopy in NPG curatorial files.

31 John Michael Vlach, *Plain Painters: Making Sense of American Folk Art* (Washington, D.C., and London: Smithsonian Institution Press, 1988), p. 32.

32 "Notes on Painting by Matthew Harris Jouett from Conversations with Gilbert Stuart in 1816," in John Hill Morgan, *Gilbert Stuart and His Pupils* (New York: New-York Historical Society, 1939), pp. 84–85.

33 See Alexander W. Katlan, *American Artists' Materials*, vol. 2: *A Guide to Stretchers, Panels, Millboards, and Stencil Marks*, ed. Peter Hastings Falk (Madison, Conn.: Sound View Press, 1992), pp. 262–63.

34 For French canvas sizes, see David Bomford et al., "Canvases and Primings for Impressionist Paintings," in *Art in the Making: Impressionism* (London: National Gallery, in association with Yale University Press, 1990), pp. 44–45.

35 John Neal, "Landscape and Portrait-Painting," *The Yankee*, n.s., I (1829), quoted in Harold Edward Dickson, *Observations on American Art: Selections from the Writings of John Neal (1793–1876)* (State College: State College of Pennsylvania, 1943), pp. 50–51.

36 Frances Trollope, *Domestic Manners of the Americans*, ed. Donald Smalley (New York: Alfred A. Knopf, 1949), p. 268.

37 George C. Mason, *The Life and Works of Gilbert Stuart* (New York: Charles Scribner's Sons, 1879), pp. 106, 141.

38 Quoted in Charles Coleman Sellers, "James Peale: A Light in Shadow, 1749–1831," *Four Generations of Commissions: The Peale Collection of the Maryland Historical Society* (Baltimore: Maryland Historical Society, 1975), p. 30.

39 Rembrandt Peale to Thomas Sully, July 4, 1820, in Lillian B. Miller et al., eds., *The Selected Papers of Charles Willson Peale and His Family*, vol. 3: *The Belfield Farm Years, 1810–1820* (New Haven and London: Yale University Press for the National Portrait Gallery, 1991), p. 834.

40 John Vanderlyn to John Vanderlyn Jr., September 9, 1825, quoted in Mary Black, Barbara C. Holdridge, and Lawrence B. Holdridge, *Ammi Phillips: Portrait Painter, 1788–1865* (New York: Clarkson N. Potter, 1968), p. 14.

Painters, Patrons, and the Changing Face of American Portraiture, 1865–1999

Carolyn Kinder Carr

The Civil War (1861–1865) irrevocably altered the social, political, and economic history of the United States, but its impact on American portraiture was negligible. The major portrait painters of the day and their patrons were located mainly in northern urban areas such as New York, Boston, and Philadelphia, or in midwestern centers such as Cincinnati, St. Louis, and Chicago. These cities and their inhabitants suffered neither the physical nor the financial ruin that devastated the South. Moreover, the majority of artists who had come to prominence in the 1830s, 1840s, and 1850s—among them Chester Harding, John Neagle, William Fisk, Nathaniel Jocelyn, Charles Loring Elliott, George Peter Alexander Healy, Thomas Buchanan Read, and Daniel Huntington—continued to be held in high regard by their artistic peers and to receive commissions from the prominent citizens of the day [Cat. nos. 15, 19, 20, 21, 23, 25, 29, 33, 34, and 37].

The longevity of many of these well-established artists served in part to perpetuate an aesthetically conservative strain in American portraiture well past the Civil War. Although some—Harding, Neagle, and Elliott, to cite only a few featured in the National Portrait Gallery's collection—were to die shortly after the end of the war, a substantial number of those who were known for their portraits at midcentury maintained flourishing careers well into the late 1870s and 1880s. George Caleb Bingham, William Morris Hunt, Sarah Miriam Peale, Jocelyn, and French immigrant Christian Schussele [Cat. no. 32] fit this category, while Thomas Hicks [Cat. no. 28], Francis Bicknell Carpenter, and Healy were professionally active nearly a quarter of a century later. The careers of Huntington [Fig. 1] and Norwegian immigrant Ole Peter Hansen Balling extended into the twentieth century.

The deference paid to those who had established careers prior to the Civil War is evident in the choice of artists selected to represent America in Paris at the 1867 Exposition Universelle.[1] Among the portraits in this show, which was dominated by landscape and history paintings, were works by Elliott, Healy, Hunt, and Huntington. Of these, Huntington's portrait of Gulian C. Verplanck is now in the National Portrait Gallery, as is a version of the Gallery's portrait of General William Tecumseh Sherman by Healy [Cat. nos. 29 and 34]. The only inkling of an aesthetic approach that would be of interest to a younger generation of painters was the appearance of three landscapes and *The White Girl* (*Symphony in White, No. 1: The White Girl*, National Gallery of Art) by James Abbott McNeill Whistler. But Whistler's presence was an anomaly. He became part of this exhibition because art agent George Lucas prevailed upon the New York City–dominated committee to include the American-born painter, who was then living in London.[2] Whistler's work was thus as much a beacon of political triumph as a bellwether of artistic change.

In 1876 the Centennial Exhibition was organized in Philadelphia to celebrate the

Figure 1.
Carl Schurz (1829–1906) by Daniel Huntington (1816–1906). Oil on canvas, 126.8 x 101.6 cm (49 15/16 x 40 in.), 1899. National Portrait Gallery, Smithsonian Institution

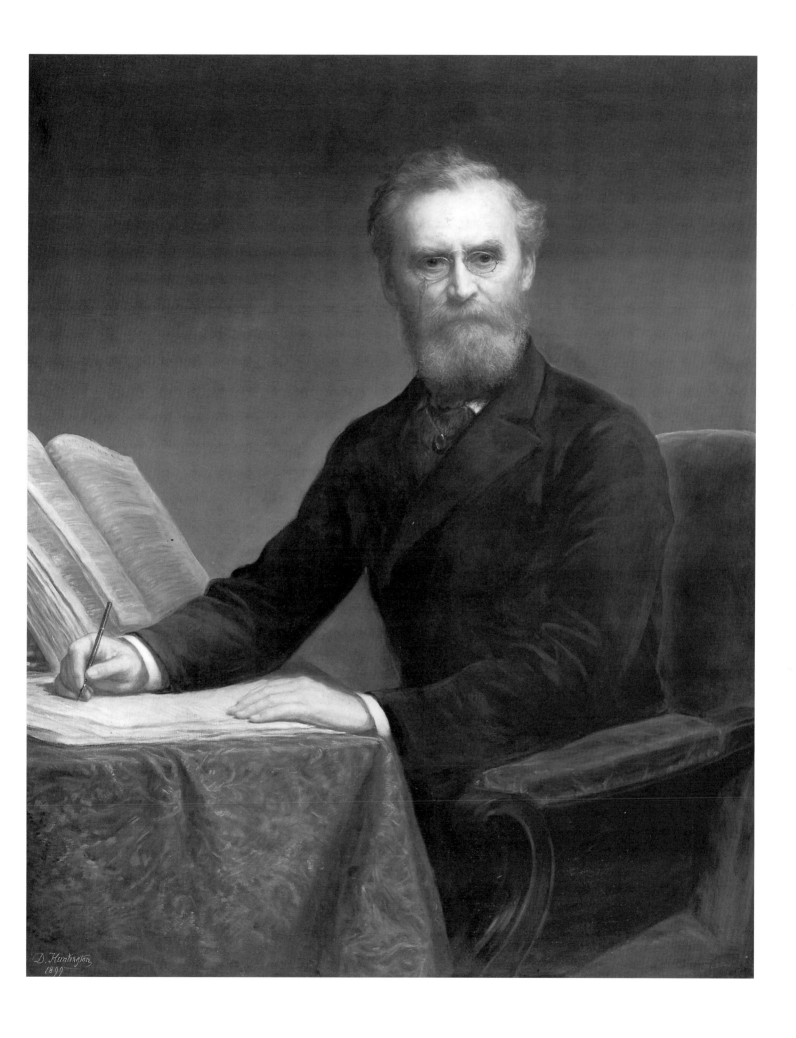

one-hundredth anniversary of the signing of the Declaration of Independence. Included among the many displays was the first major international art exhibition in America since the Civil War. Most of the artists who had shown in the 1867 Exposition Universelle were present in large numbers in the American pavilion.[3] Healy was represented by eight portraits, Huntington by three (as well as several history paintings and landscapes), and Elliott by four. Hunt had only one portrait on display, but Hicks (with four portraits) and Asher B. Durand (represented by landscapes, a figure study, and a portrait) were among the older practitioners of the art of likeness who had works on view. The desire of the organizers to stress the well established is further underscored by the strong retrospective element evident in the show. Numerous portraits by deceased artists dominated various galleries, among them John Smibert, John Singleton Copley, Gilbert Stuart, John Trumbull, John Vanderlyn, John Neagle, Chester Harding, Thomas Sully, Samuel F. B. Morse, and various members of the Peale family. Conversely, younger artists were a definite minority: Of those born in the 1840s, only Elizabeth Boott, Thomas Eakins, John La Farge, Elizabeth Gardner, and Anna Lea displayed portraits.[4]

Although the art at the 1876 Centennial perpetuated a stylistic point of view similar to that seen in the American presentation at the 1867 Exposition Universelle, seeds of change had nevertheless been sown at the Parisian show. American artists were devastated by the harsh assessment of their fellow countrymen. "Americans have no art at all!" wrote one European critic.[5] In response, the vast majority of younger, ambitious American artists still in their formative years sought to counter the criticism of their elders by embracing and assimilating European art. Thus, for the next three-plus decades, American artists, particularly those engaged with portraiture, felt, with rare exception, that they needed to train abroad in order to achieve at home. It is the work of these artists, and that of their European peers who painted the likenesses

of Americans, that would ultimately dominate American portraiture in the late nineteenth century.

European training for American artists was, of course, not new. Europe had long attracted American artists, particularly those who had made portrait painting a major facet of their work. In the late eighteenth and early nineteenth centuries, numerous American artists went to London to study, a center later eclipsed by Rome, especially for those interested in sculpture. In the early 1870s Antwerp's Royal Academy attracted George Willoughby Maynard and his friend Francis Davis Millet, but for many during this decade—among them Frank Duveneck, William Merritt Chase, and John White Alexander—Munich and its Royal Academy was the preferred location for artistic training [Figs. 2 and 3]. But unique to the late nineteenth century is both the pervasive interest in study abroad and the ascendency of Paris as the premier center of artistic instruction for Americans.

The lure of Paris and the taste for all things French—which began as a trickle in the 1830s, grew increasingly fashionable in the 1850s, and completely captivated the imagination of the American art world in the 1880s and 1890s—is evident not only in the number of American artists who came to study, but also in the number who exhibited at the salons sponsored by the Société Nationale des Artistes Français and, after 1890, the Société des Beaux-Arts.[6] The number of those who came to Paris in the latter decades of the nineteenth century as students and either returned frequently or remained as permanent or semi-permanent residents also attests to the immersions of these individuals in the life of this country.

The desire of artists to enter European academies, to study in the studios of recognized masters, and to learn from paintings in the various national museums was not out of step with the desire to assimilate European culture that was pervasive among the upper echelon of American society, that is, the

group that was the steady patron of European-trained portrait painters. Ironically, in the era between the Civil War and the beginning of World War I, when national pride grew in tandem with America's presence in the international arena, a symbol of America's transformation from a second-rate, agrarian stepchild to a major social and economic force in the international world was its ability to embrace and assimilate myriad facets of European culture, particularly its art and artists. The experiences of the artists represented in the collection of the National Portrait Gallery, and those of their patrons, are a mirror of the age.

Several American artists who made portraiture a major facet of their work were attracted to Paris, even before it became the premier city for study abroad. English-born Edward Harrison May, who had studied in New York with Daniel Huntington, entered the studio of genre and history painter Thomas Couture in 1851. Six years later, John La Farge enrolled briefly in Couture's classes, following in the footsteps of his subsequent American instructor, William Morris Hunt, who had arrived in Paris in 1846 to study with the Frenchman.[7] In the 1860s, Jean-Léon Gérôme, a noted history painter with a taste for Orientalism, was among the teachers favored by Americans studying abroad.

When, in 1865, Mary Cassatt was granted admission to his studio, she was the envy of her classmates at the Pennsylvania Academy of the Fine Arts.[8] Thomas Eakins, son of the drawing master at Philadelphia's Central High School and, like Cassatt, a former student at the Pennsylvania Academy, likewise favored instruction from Gérôme. Eager to learn from the best, he also augmented his training during the three years that he was in Paris with a brief sojourn in the studio of Léon-Joseph-Florentin Bonnat, the leading portrait painter of the time. Like most young artists, Eakins sought to enhance his studio work by traveling and studying the great masters of the past, and in 1869 he capped his stay in Europe with a six-month visit to Spain, where he gloried in the study of Velázquez at the Prado.[9]

By the time Cecilia Beaux, yet another major portrait painter who had sporadically attended classes at the Pennsylvania Academy, set forth in 1888 for the homeland of her émigré father, she was in the midst of a groundswell of American students. There, like other women artists who enjoyed financial support from home and talent sufficient for additional study abroad, she savored not only the excitement of this lively and dynamic modern city on the Seine, but relished the freedom from the domestic and social

constraints imposed upon single women living at home. For the next year and a half she studied at the Académie Julian and the Académie Colorossi (women were not permitted to study at the École des Beaux-Arts until 1897), where her highly skilled work was critiqued by leading academic realists of the day such as Tony-Robert Fleury, Adolphe-William Bouguereau, P. A. J. Dagnan-Bouveret, and Benjamin Constant. During the summer she took classes with American artists Thomas Alexander Harrison and Charles Lasar in Brittany at the artists' colony of Concarneau. Her behavior typified that of many who sought to integrate themselves into the Franco-American art world by forging strong contacts with other Americans who had been abroad longer and were better established in the local art scene.[10]

A large number of artists who trained abroad returned frequently. La Farge and Eakins were among the exceptions. La Farge returned only twice, once in 1874 and again in 1899; Eakins, limited economically after he resigned from his teaching job at the Pennsylvania Academy in 1886, never again. More typical was the experience of Maynard, Millet, Chase, and Beaux, who returned frequently to see or participate in current exhibitions of contemporary art, to refresh their memories of the art in the great national collections, to visit old friends, and to cultivate patrons, both Europeans and Americans living abroad. Many, of course, remained abroad for extended periods of time. John White Alexander, after his Munich training in the 1870s and a decade in New York, succumbed to the social and artistic enticements of Paris in 1891 and remained there for more than a decade.

An equally large number never resumed residency in America or did so only late in life. Edward Harrison May established his home in Paris in 1851 and died there.[11] Boston-born Charles Sprague Pearce, who studied from 1873 to 1876 with Léon Bonnat at the École des Beaux-Arts, moved permanently in 1885 to Auvers-sur-Oise, a small village northwest of Paris.[12] Sculptor Paul Wayland

Bartlett, the son of sculptor Truman Bartlett and subject of a portrait by his good friend Pearce, was taken to Paris at age nine and resided there for more than forty years. Despite their residency abroad, few were willing to completely sever ties to their native country; most willingly accepted American commissions and, anxious to find a market for their art, eagerly sent their work to American exhibitions.[13]

James McNeill Whistler, Mary Cassatt, and John Singer Sargent—among America's best-known portrait painters of the late nineteenth and early twentieth centuries, are also this country's best-known expatriate artists. Each lived abroad either all or most of his or her adult life, although their experiences and their relationships with the United States differed. Whistler, who was born in the small mill town of Lowell, Massachusetts, spent the better part of his adult life toggling between Paris and London and never returned to the United States after he left for study in Paris in 1855. Unlike most expatriates, he maintained a somewhat ambivalent attitude toward his country of birth, often remarking that nationality was not important.[14] But Whistler's desire to maintain neutrality in regard to his nationality did not prevent him from using his American heritage when and where he wished, beginning in 1867, when he inserted himself in the American section of the Exposition Universelle. He acknowledged his citizenship—if not the city of his birth—in his Paris Salon entries. Eager to test the American art market, he sent *Arrangement in Grey and Black: Portrait of the Painter's Mother* to exhibitions in Philadelphia and New York in 1882–1883; willingly contributed six paintings to Chicago for the 1893 World's Columbian Exposition; and recycled *The White Girl* yet again for the American section of the 1900 International Exposition in Paris. He clearly welcomed as well the loyal patronage of Detroit industrialist Charles Lang Freer. A charismatic, albeit difficult, individual with a nearly pathological penchant for press coverage, Whistler attracted a large following among

Figure 4.
Mary Cassatt (1844–1926), self-portrait. Watercolor and gouache over pencil on paper, 33 x 24.4 cm (13 x 9⁵/₈ in.), circa 1880. National Portrait Gallery, Smithsonian Institution

both European and American artists for his aesthetic theories. Two in the collection of the National Portrait Gallery who admired his work and attempted to emulate aspects of his style were Walter Greaves, an Englishman whom he had mentored [Cat. no. 36], and John White Alexander, an American whom he had met initially in Venice in the late 1870s [Cat. no. 49].[15] The mostly favorable critical response that Whistler received from his fellow artists and in the American press (despite his notorious disdain of critics) solidified his place in the canon of American art history. His residency was never an issue. The attitude of Americans toward Whistler was the same as that enunciated by Henry James, who said of Sargent when the question of his nationality was raised: "We shall be well advised to claim him."[16]

Mary Cassatt, unlike Whistler, never openly disavowed her native land, but she journeyed to America only twice after settling permanently in France in 1874—in 1898 and again in 1908. These infrequent visits, together with her more restrained persona, her seeming disinterest in commissions, her immersion in the French art world (initiated by her portraitist, Edgar Degas, who encouraged her to show in the Impressionists exhibitions in the late 1870s and early 1880s), and her relative indifference to the American art community in France, served to limit her impact on American art and artists during her lifetime [Fig. 4].[17] Early in her career, she sporadically sent works to exhibitions in America, but her visibility in this country remained muted until the mid-1890s. She gained some attention—not all of it favorable—for her mural for the Women's Building at the World's Columbian Exposition, but the complimentary reviews she received for her 1895 exhibition in the New York gallery of her Parisian art agent Paul Durand-Ruel were helpful in establishing her viability in America as an artist of note. Her work was collected in the United States by a loyal, albeit small, group of patrons, but after her death Cassatt was better known in this country as a champion of the French Impressionists than as the premier woman artist of her generation. In contrast to the mainstream position accorded to Whistler and Sargent, Cassatt's place in American art history as an artist of lasting stature is a relatively recent phenomenon, propelled in part by a burgeoning interest in women artists and a reexamination of their work.

Of these three painters of portraits, Sargent's ties to America were the strongest.[18] This fact is not without irony, for he was born in Florence to parents who had fled Philadelphia in 1855 for a peripatetic existence in Europe. Thus he was a native by parentage, not place. Sargent was twenty-one when he first sailed to America to visit his Philadelphia cousins and to see the 1876 Centennial Exhibition. Yet from the mid-1870s—first in Florence, where he met American artists Frank Fowler and Walter Launt Palmer while studying at the

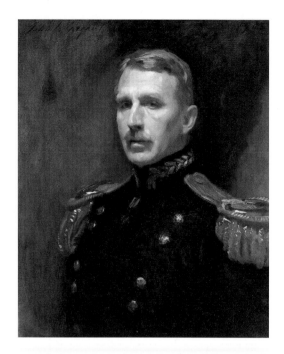

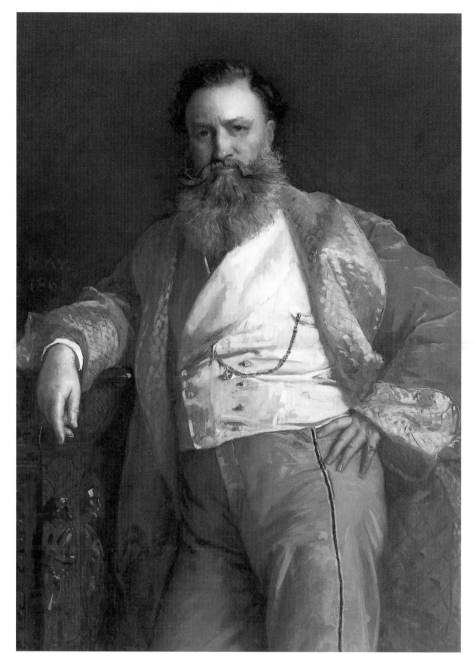

Accademia, and then in Paris, where he became close friends with J. Carroll Beckwith and Julian Alden Weir while enrolled in the class of Carolus-Duran (Charles-Émile Auguste Durand), Bonnat's rival as a master portraitist—Sargent actively courted connections with the American art world, both in this country and in Europe. He frequently participated in exhibitions in the major American art centers. The nine paintings he submitted to the American art exhibition at the World's Columbian Exposition symbolize the admiration of America for Sargent and Sargent for America.

Sargent, who enjoyed both recognition of his exceptional talent and the mystique of the expatriate artist, received frequent commissions from American patrons. During the numerous trips he made to the United States during the last three decades of his life to carry out these commissions, he traveled in the best of American society, painting not only Presidents and statesmen like Henry Cabot Lodge [Cat. no. 45], wealthy wives, and charming children, but also those he personally admired, such as Major General Leonard Wood [Fig. 5]. His ability to integrate his American and European artistic activities was a model that numerous other expatriate artists sought to emulate.

In the late nineteenth century, Americans who wished to demonstrate their success, as well as their sophistication, by commissioning a portrait either from a European or an American artist who had lived or trained abroad had several options available. They could sit for their portrait when an expatriate, such as Sargent, was traveling in America. Or they could elect to have their likeness taken abroad. Edith Wharton's parents probably thought they had the best of both worlds when, in 1870, during the fourth year of their French sojourn, they turned to fellow expatriate Edward Harrison May for their young daughter's portrait [Cat. no. 35].[19] Not only was he bilingual, but his notable client list, developed during the two decades he had lived in France, consisted of

Figure 5.
Leonard Wood (1860–1927) by John Singer Sargent (1856–1925). Oil on canvas, 76.5 x 63.8 cm (30 1/8 x 25 1/8 in.), 1903. National Portrait Gallery, Smithsonian Institution

Figure 6.
Isaac Singer (1811–1875) by Edward Harrison May (1824–1887). Oil on canvas, 130.2 x 97.8 cm (51 1/4 x 38 1/2 in.), 1869. National Portrait Gallery, Smithsonian Institution; gift of the Singer Company

members of the best families on both sides of the Atlantic. This duality of language and social integration, in addition to May's willingness to convey the essence of a tycoon, must have been among the factors that also led industrialist Isaac Singer to commission his portrait from May [Fig. 6].

Many living abroad who hoped to enhance their social standing through their choice of a portraitist often went directly to a foreign-born artist. When Levi P. Morton sought a portrait of himself and his wife in 1883 during his tenure as American minister to France, presumably he was attracted to Léon Bonnat as much for the favor he enjoyed among the French elite as for his exquisite technique [Fig. 7].[20] When Savannah, Georgia, native Juliette Gordon Low and her English-born husband William Mackay Low set up housekeeping in London shortly after their marriage, they almost immediately commissioned her portrait from Edward Hughes, who had established a reputation in Britain as a leading painter of the royal family [Cat. no. 43].[21] His connections undoubtedly facilitated the ease with which the young couple entered into the highest echelons of British society. Writer Bret Harte, who served as United States consul in Glasgow from 1880 to 1885, must have had similar aspirations for his portrait. Although Scotsman John Pettie, who took his likeness,

may have had less social cachet than Hughes, this did not deter Harte from posing and dressing in a manner that conveyed his ability to travel among gentlemen [Cat. no. 40].[22]

Another option for Americans who wished a portrait suitable for their station in life was to commission a likeness from a well-known foreign artist who was traveling in America. Aware of the potentially large client base that existed among the newly wealthy, numerous European portrait painters came to the United States. While Giovanni Boldini came only once, in 1897, many made frequent visits to this country a regular part of their schedule. The arrivals of Theobald Chartran, Joachim Sorolla y Bastida, and Raimundo de Madrazo y Garreta, to mention only a few with a flourishing trade in America, were duly noted in the social pages of East Coast newspapers.

The experience of Swedish painter Anders Zorn, who had trained primarily in Paris, is typical of the way in which many artists of foreign birth were embraced by wealthy Americans. The charming and gregarious Zorn, who first came to America as the Swedish commissioner to the World's Columbian Exposition in Chicago, quickly became fast friends with Bertha Honoré Palmer, president of the fair's Board of Lady

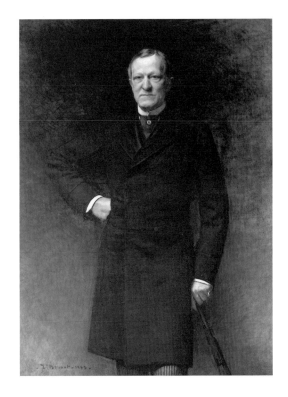

Figure 7.
Levi P. Morton (1824–1920) by Léon Bonnat (1833–1922). Oil on canvas, 144.7 x 105.7 cm (57 x 41⅝ in.), 1883. National Portrait Gallery, Smithsonian Institution; gift of Mrs. Eustis Emmet and Mrs. David E. Finley

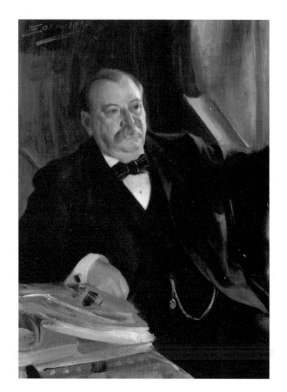

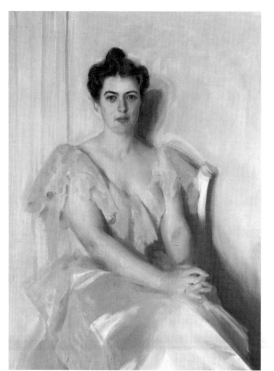

Figure 8a.
Grover Cleveland (1837–1908) by
Anders Zorn (1860–1920). Oil on
canvas, 121.9 x 91.4 cm (48 x 36 in.),
1899. National Portrait Gallery,
Smithsonian Institution; gift of the
Reverend Thomas G. Cleveland

Figure 8b.
Frances Folsom Cleveland
(1864–1947) by Anders Zorn
(1860–1920). Oil on canvas, 137.2 x
92.1 cm (54 x 36 1/4 in.), 1899.
National Portrait Gallery, Smithsonian
Institution; gift of Mrs. Frances Payne

Managers and wife of real-estate magnate
Potter Palmer. She, in turn, introduced him
to her various Chicago friends, just as Boston
collector Isabella Stewart Gardner, whom he
also met at the fair, introduced him to her
many acquaintances. After the fair, Zorn
returned to America on six occasions. During
his 1899 visit, he took the likeness of
President Grover Cleveland and that of his
charming and elegant wife, Frances Folsom
Cleveland [Figs. 8a and b]. The portrait of
patrician Nelson W. Aldrich, who served as
senator from Rhode Island for thirty years
and was a major spokesman for America's
business interests, was begun on Zorn's last
trip to the United States [Cat. no. 52].[23]

Zorn's reception in America was not unlike
that given to Hubert von Herkomer in the
1880s, during his two portrait campaigns in
America, one in 1882–1883 and the other
in 1885–1886. The German-born
Englishman, who had spent six childhood
years in this country, was welcomed with
dinners at private clubs, exhibitions at major
galleries in New York and Boston, lectures to
distinguished groups, and extensive commis-
sions. As with Zorn, satisfied clients intro-
duced Herkomer to others, which is probably
how he came to know the distinguished
architect H. H. Richardson [Cat. no. 42].
Legend has it that Herkomer initiated the

portrait, and to thank him, Richardson
created the exterior elevation designs for
Lululaund, the new house Herkomer was
planning in Bushey, Hertfordshire, England.[24]

The ease with which foreign portrait painters
found a hospitable welcome in America
persisted into the late 1920s, tempered only
in the 1930s by the Great Depression.
Hungarian-born Englishman Philip Alexius
de László developed a distinguished list of
American clients, which included not only
men of wealth, such as collector and philan-
thropist Francis P. Garvan [Cat. no. 54], but
also the politically well-positioned, among
whom was secretary of state, and later chief
justice of the Supreme Court, Charles Evans
Hughes [Fig. 9].[25]

Characterizing American portraiture in the
post–Civil War era through the first decade
of the twentieth century is not an easy task.
A crisp definition of what is uniquely
American about American portraiture of this
period is elusive, in part because so many
portraits of Americans were by Europeans,
and if not by foreigners, then by expatriate
Americans or Americans who had studied
abroad with the intention of assimilating the
aesthetic goals of European artists. Unlike
landscape and genre paintings, which can
take on an American cast by virtue of

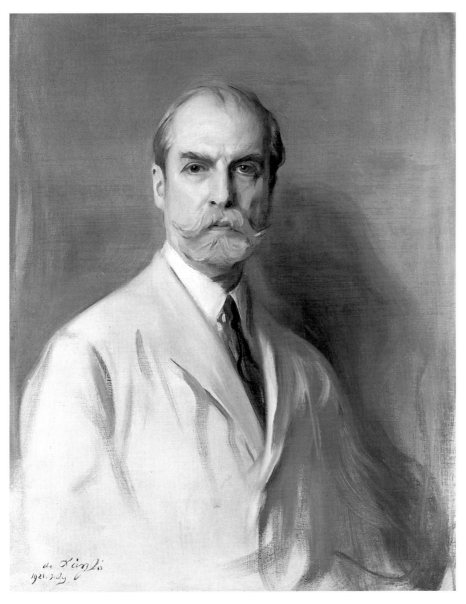

Figure 9.
Charles Evans Hughes (1862–1948)
by Philip Alexius de László (1869–1937).
Oil on canvas, 93.9 x 73.7 cm
(37 x 29 in.), 1921. National Portrait
Gallery, Smithsonian Institution; bequest
of Chauncey L. Waddell

Munich, Antwerp, and London—they paid close attention to anatomical accuracy. It is this that links artists as disparate as May, Eakins, and Pearce. But compared to their predecessors, most artists, in varying degrees, exhibited less of a concern for detail than a fascination with a painterly or bravura technique. Their admiration for the work of major seventeenth-century portraitists such as Diego Velázquez, Rembrandt van Rijn, and Frans Hals stemmed in part from a desire for a more tactile surface. Among many, overlaying this mix was an interest in Aestheticism, which emphasized the decorative and the successful harmony of formal elements over factual and narrative detail and description. As part of an international style, American portraiture was thus a synthesis of various influences.

The circumstances that brought a portrait into being also affect its appearance. Self-portraits and portraits initiated by an artist for his or her personal pleasure were usually modest in scale and often radical in approach, either in terms of technique or in the interpretation of the sitter's personality. On the other hand, a commissioned portrait—whether the commission was granted to an American who had studied abroad or to a European practicing in either his native country or in America—tended to be large (and thus suitable for hanging in the commodious spaces found in the homes of the well-to-do or in exhibition halls like those used for the Paris salon), less innovative stylistically, and usually intent on conveying the subject's wealth and/or position of authority. Numerous portraits in the collection of the National Portrait Gallery were commissioned by the subject or an admirer, but an equally large—if not larger—number were instigated by the artist. Of the latter, John La Farge's sketch of William James—later known as a distinguished philosopher but at the time a fellow student in the Newport, Rhode Island, painting classes of William Morris Hunt—is among the more stylistically radical [Cat. no. 30]. In his profile portrait of his friend, undertaken about 1859, La Farge created James's facial features by juxtaposing

location or legend, portraiture in this era is often subverted by the subject's costume; for a great many sitters, as a mark of wealth and sophistication, chose to be represented in continental dress. The witty and observant Henry James perhaps summed up the phenomenon best when he noted, "It sounds like a paradox, but it is a very simple truth, that when today we look for 'American art' we find it mainly in Paris. When we find it out of Paris, we at least find a good deal of Paris in it."[26]

Stylistically, only the broadest verbal brush is useful. But whether portraits were by or of Americans, it is apparent that ambitious artists of the late nineteenth and early twentieth centuries still considered a truthful rendering of the world the foundation of their work. Conditioned by training in European art academies—not only in Paris, but also in

broad areas of color. His technique, similar to his freely painted landscapes of the period and not unlike some of Hunt's figurative work of the same time, has its ultimate source in the teachings of Thomas Couture, who was a great admirer of the freshness of a sketch.[27] But unlike the French master, who would then have refined his *ébauche* (or sketch), La Farge seemingly enjoyed the allusive appearance of the painting, for he never embellished it with strong linear contours, as would have been typical for fashionable Boston portraits of the early 1860s. Without question, this sketch would have shocked the New England art world, had it been planned for public display.

Thomas Eakins's 1891 portrait of newspaper editor Talcott Williams would likewise have startled the Philadelphia art world, had it been planned for public exhibition, but for quite different reasons. The dark tonalities and the realistic physical description would have met local expectations, but Eakins's indifference to the material world of his sitter and his emphasis on the psychological character of his subject, suggested by the pose of the head, as well as the dramatic use of chiaroscuro, would have been criticized for its lack of decorum [Cat. no. 44].[28]

Edgar Degas's portrait of his colleague Mary Cassatt, taken in the early 1880s, challenged public taste on two accounts [Cat. no. 39]. Both the informal nature of the pose and the rough, unfinished background stand in antithesis to the studied poses and carefully articulated backgrounds that conditioned mainstream portraiture. To understand the degree to which Degas's portrait deviated from accepted nineteenth-century portrait conventions, one has only to look at Cassatt's own self-portrait, a charming but more conventional interpretation of a young, well-to-do female [see Fig. 4]. Cassatt herself, despite her interest in avant-garde art, never wholly accepted the casual demeanor of this portrait, which focuses on her psychological state of mind rather than her social status. As she confided to her agent when she came to sell the portrait in 1913, "I don't want to

leave this portrait by Degas to my family as one of me. It has some qualities as a work of art but it is so painful and represents me as such a repugnant person that I would not want anyone to know that I posed for it."[29]

Not all portraits undertaken by artists were, however, attempts to examine artistic issues and challenge accepted conventions. Many were meant as demonstration pieces, and these, because the artist hoped to use them to solicit future commissions, deviated little from the styles and attitudes found in commissioned work. When George Maynard portrayed his friend and fellow artist Francis Millet in the costume he wore in 1877 as a reporter in the Middle East for the *New York Herald* and the *London Daily News*, he sought to record his friend's recent notable and heroic activities [Cat. no. 38]. Maynard clearly considered the portrait a signature piece, for he entered it in the Paris Salon of 1879, presumably not only to further announce Millet's triumphs as a correspondent, but also to exhibit his own prowess as a portrait painter.[30] The desire to attract future clients must have likewise motivated Charles Sprague Pearce when he entered the portrait of his friend Paul Wayland Bartlett in the 1892 Paris Salon [Cat. no. 46].[31] Suave and sophisticated, with no hint of the dusty, industrial-like world of the studio that this serious and ambitious sculptor normally inhabited, Bartlett is rendered with great finesse and elegance. The subtly, sensuously painted portrait—a study in shades of black, gray, and cream—serves as testimony to the painterly skills that Pearce had acquired as a pupil of Bonnat. The message to any potential patron is that the artist can create an image suitable for a gentleman of position.

Cecilia Beaux was a far more established artist than Maynard or Pearce when she undertook as a gesture of friendship the portrait of Richard Watson Gilder, who, as the editor of *Century Magazine*, was a mainstay of the New York cultural world [Cat. no. 48]. Although this work is more modest in scale than many of her commissioned portraits of the decade, the elegant, fluid brushwork,

and the manner in which Beaux employs it to express the psychic energy of her subject, are not only characteristic of her best work, but also typical of the growing taste among the public for a luscious, painterly style. Beaux, who recognized the painting as a signature piece, often borrowed her gift to Gilder for public display, beginning in 1904, when it was shown at the Pennsylvania Academy's annual exhibition and hung next to Sargent's portrait of Alexander Cassatt.[32] The juxtaposition was fitting, for American art critics frequently and favorably compared Beaux's portraits with those by Sargent.[33]

Frenchman Jacques-Émile Blanche, like Beaux, was well established when, in 1908, he invited the keen-witted and tart-tongued expatriate author Henry James, whom he had previously met in Rome and known in London, to dinner at his house in Passy. There, encouraged by another guest and expatriate author Edith Wharton, he offered to undertake James's likeness [Cat. no. 50].[34] Although it was a friendly gesture, one can only suspect that Blanche's motivation was also to use this portrait to entice future clients, presumably other Americans living abroad who might not be familiar with his work. Hence, his technique, quite academic in its depiction of the sitter, does not deviate from the style that had won him so many clients.

When Gilbert Stuart had received permission to paint a portrait of Revolutionary War hero and first President of the United States George Washington, he confessed to fellow painter John Dowling Herbert that "I expect to make a fortune by Washington."[35] He thus openly acknowledged what artists had long known, despite protests to the contrary— that the reputation of their sitter was an important factor in determining their own reputation. The usefulness of Henry James's widespread popularity could not have been lost on Blanche. Nor could John White Alexander have been oblivious to the role that a portrait of novelist and essayist Samuel Langhorne Clemens, known to all Americans as Mark Twain, could play in announcing his return to America after a

decade in Paris [Cat. no. 49]. Alexander's full-length painting, identified as a "sketch" in his 1916 memorial exhibition at the Carnegie Institute of Art in Pittsburgh, was the perfect calling card.[36] But unlike Blanche, who did not challenge the status quo in terms of his treatment of James, Alexander seems eager to declare his modernity with this portrait. The tall, elongated figure of Twain floats on the forward plane of the roughly textured canvas and is rendered with seemingly quick and facile brush strokes. The composition, together with the pale gray, green, and cream tonalities of the painting, made known to those who might seek a portraitist that this was a cutting-edge artist in close contact with the esteemed James McNeill Whistler.[37]

Charles Ulrich's portrait of Thomas B. Clarke and Jan Van Beers's portrait of Charles Tyson Yerkes were also both artist-initiated portraits, but undertaken as gifts to the sitter. In 1884 Ulrich, a German immigrant, submitted In the Land of Promise— Castle Garden to the annual exhibition at the National Academy of Design and won the first Thomas B. Clarke Prize for Best American Figure Composition. In gratitude, he presented Clarke with a small, exquisitely rendered portrait in which the use of impasto accents and bravura brushwork speaks to his training in Munich's Royal Academy [Cat. no. 41].[38] Van Beers, a Flemish-born painter who had established a studio in Paris, was equally grateful to Chicago financier and streetcar magnate Charles Yerkes. Not only was Yerkes a consistent and loyal patron, but he had loaned ten paintings by Van Beers from his personal collection to the World's Columbian Exposition. In appreciation, Van Beers sent Yerkes a small portrait that shows him seated before a landscape by the artist with letters and a book about art on the table beside him [Cat. no. 47].[39] As gifts, neither portrait was wholly an expression of private and personal interests, but a painterly exercise meant to please the recipient. Both, which allude to the recipient's prosperity, are technically polished; as gestures of thanks, their size is all that separates them from a commissioned work.

By the end of the first decade of the twentieth century, major changes were beginning to take place in the look of American art, including portraiture. Stylistic transformations are inevitably more evolutionary than revolutionary, for older artists usually continue to paint in a manner that previously brought them public accolades, but by 1913, the year of the famous exhibition in the New York City Armory, America's most progressive artists were exploring new aesthetic attitudes. Three painters in the collection of the National Portrait Gallery who were part of the changing approach to portraiture were Lee Simonson, Stanton MacDonald-Wright, and Marguerite Zorach.[40] Their work, in which the style of the artist is as important as the literal likeness of the individual, is a major hallmark of much significant American portrait painting during the remaining decades of the twentieth century.

Each of these painters of portraits, like American artists of the preceding generation, was eager to go to Europe to further his or her artistic training. When they arrived in France— MacDonald-Wright in 1907, Zorach in 1908, Simonson in 1909—they did not look at the work of the academic painters, as most of their predecessors had done, but were captivated instead by artists such as Paul Cézanne and Henri Matisse. MacDonald-Wright used Cézanne's 1894 portrait of art critic Gustave Geffroy as a model for his portrait of his brother, art critic Willard Huntington Wright, who wrote under the name of S. S. Van Dine.[41] Like his hero, MacDonald-Wright eschews traditional perspective, a somber palette, and photographic realism, and employs instead Cézanne's technique of rendering optical reality in terms of planes of warm and cool colors [Cat. no. 53]. Simonson's inspiration was Matisse, and in his brilliantly painted self-portrait, he turned to the Fauve paintings of this master for his notion of the emotional and expressionistic use of color [Cat. no. 51]. Zorach's psychologically charged portrait of her friend, poet Marianne Moore, speaks to her fascination with the various pictorial devices related to both cubism and expressionism [Cat. no. 56].

Diverse aspects of modern European art continued to inform American portraiture during the 1920s and 1930s. The hard-edged forms, the high-keyed colors, the stylized landscape, and the abrupt spatial transitions in Thomas Hart Benton's *Self-Portrait with Rita* [Cat. no. 55] suggest that this painter, formerly an abstract artist associated with Stanton MacDonald-Wright's Synchromist group, had absorbed the proto-surrealistic impulses found in the work of such artists as the Italian painter Giorgio de Chirico. Peter Krasnow's brightly colored portrait of photographer Edward Weston [Cat. no. 57], which employs a heavy black outline around individual forms, both evokes the manner of the German Expressionists and alludes as well to the artist's familiarity with the broadly conceived and intensely outlined style of Mexican muralist Diego Rivera. Arthur Kaufmann's German heritage likewise reveals itself in his expressionistic portrait of composer George Gershwin [Cat. no. 59]. The pastel palette and fluid brushwork in English artist Augustus John's depiction of Tallulah Bankhead [Cat. no. 58] and William Glackens's self-portrait [Fig. 10] connote the continuing influence of the French Impressionists in portraits of Americans, whether done here or abroad.

Despite the persistence of twentieth-century European styles in American portraiture, numerous American artists in the decades between the two world wars increasingly sought to diminish the hegemony of European art and to create an art that was more uniquely American. The call for a distinctly American art, which had begun in the teens, had become a rousing chorus by the 1930s. Edward Hopper, better known for his urban scenes than his portraiture, summed up the attitude of his generation when he stated in the catalogue for his 1933 Museum of Modern Art exhibition that American artists should divorce themselves from French precedents. "Any further relation of such a character can only mean humiliation to us," he wrote. "After all we are not French and never can be and any attempt to be so is to deny

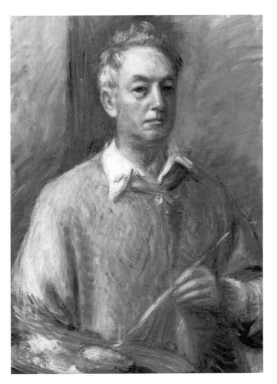

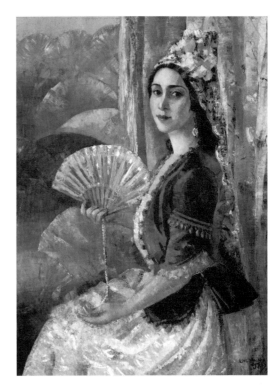

our inheritance and try to impose upon ourselves a character that can be nothing but a veneer upon the surface."[42] Thus, in opposition to the artistic and philosophical approach of late-nineteenth-century artists, many in the generation of artists who came to maturity in the years between the two world wars sought separation rather than assimilation.

The search for an American look in art and its subset of portraiture was abetted by the Great Depression and the advent of World War II. A dearth of commissions from the rich, many of whom had lost much of their wealth in the stock market crash of 1929, diminished the number of European artists traveling to America specifically for commissions. A lack of resources and unstable political conditions on the Continent—not to mention a mindset change—also limited the number of American artists who went abroad for further study. Society portraits, as well as those that paid deference to business leaders and government officials, continued to be undertaken, but these works, many of which emulated the kind of photographic realism favored decades earlier, numbered far fewer than in the glory days of the late nineteenth and early twentieth centuries. Moreover, they rarely attracted America's most ambitious artists.[43]

Physical and psychological distance may have aided the desire for a distinctly American portraiture, but its characteristics are difficult to define. Clearly, no single visual mode unites American portraiture of this era. And clearly, vestiges of European stylistic traditions remained a staple of American portraiture in the years between the wars—as they have throughout the twentieth century [Fig. 11]. The essence appears to lie in the conjunction of approach and sitter. Repeatedly, innovative artists of the era eschewed not only traditional, carefully crafted realism but also the traditional, well-connected patron. Instead, they turned to others as heroes of modern life and used these subjects to serve as vehicles for explorations of more contemporary visual modes.

Many sought their subjects among others engaged in various artistic endeavors, themselves included. Artists have, of course, always been drawn to those in the arts as subjects—witness Maximilien Colin's commanding portrait of Minnie Maddern Fiske [Fig. 12] or Edward Simmons's elegant image of Alla Nazimova [Fig. 13]. But the consistency with which the most modern-appearing paintings are identified with those in the arts seems special to those seeking an American look to their portraiture. Paul Meltsner's dramatic, stylized rendering of

the angular and attenuated body of dancer Martha Graham [Cat. no. 60] and Edward Biberman's macabre vision of mystery writer Dashiell Hammett [Fig. 14], as well as his electric interpretation of chanteuse Lena Horne [Cat. no. 64], are each representative of the way in which many of the more daring artists wedded cutting-edge celebrities in allied fields with their expression of more modern visual impulses.

Others sought to explore America's unique democratic heritage, which had been more apparent in photography than in painting in the nineteenth century. Men and women whose achievements were unrelated to the mere accumulation of wealth and its attendant social prestige found recognition and visibility in painted portraiture. This is particularly evident in the collection assembled by the Harmon

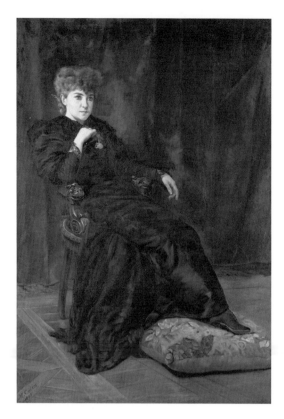

Figure 12.
Minnie Maddern Fiske (1865–1932) by Maximilien Colin (1862–post 1893). Oil on canvas, 182.6 x 122.6 cm (71 $^{7}/_{8}$ x 48 $^{1}/_{4}$ in.), 1893. National Portrait Gallery, Smithsonian Institution; gift of Mr. and Mrs. Walter Schnormeier

Figure 13.
Alla Nazimova (1879–1945) by Edward Emerson Simmons (1852–1931). Oil on canvas, 61 x 61 cm (24 x 24 in.), 1910. National Portrait Gallery, Smithsonian Institution; gift of Val Lewton

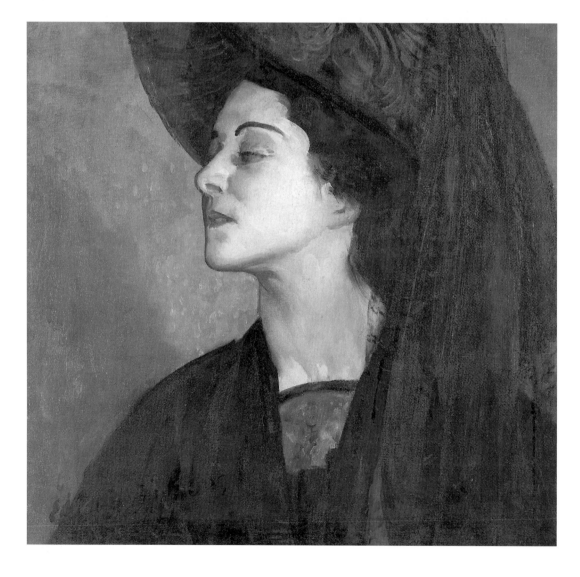

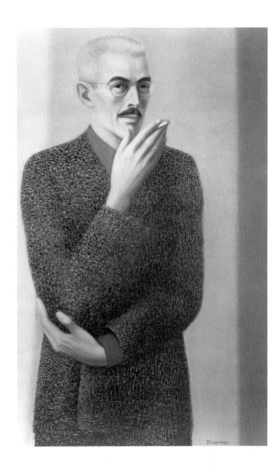

Figure 14.
Dashiell Hammett (1894–1961) by
Edward Biberman (1904–1986). Oil on
canvas, 101.6 x 76.2 cm (40 x 30 in.),
1937. National Portrait Gallery,
Smithsonian Institution

Figure 15.
Joe Louis (1914–1981) by Betsy Graves
Reyneau (1888–1964). Oil on canvas,
164.5 x 86.4 cm (64³/4 x 34 in.), 1946.
National Portrait Gallery, Smithsonian
Institution; gift of the Harmon
Foundation

Foundation. Its focus was portraits of African Americans, among them scientist and university president George Washington Carver [Cat. no. 61], union organizer A. Philip Randolph, singer Marian Anderson, and boxer Joe Louis [Fig. 15].[44] These portraits were undertaken in the 1940s, mainly by Betsy Graves Reyneau, although African American artist Laura Wheeler Waring contributed a number of images. Of the two, Reyneau was often the more stylistically adventuresome, but common to both of these women was a simplified approach to figuration. They minimized meticulous modeling and worked in a broadly conceived manner that has much in common with the stylistic attitudes found in mural painting supported during the 1930s by the Works Progress Administration.

The years immediately after World War II saw a change in American art that profoundly affected American portraiture. The long-standing desire to create a uniquely American style found its ultimate realization in the late 1940s, in the work of the Abstract Expressionists and other abstract painters associated with the New York School. These artists, among them painters Jackson Pollock, Willem de Kooning, Franz Kline, Mark Rothko, and Barnett Newman, shunned realism and sought subject matter primarily in the internal rather than the external world. For most, although not all, the act of painting was of primary importance. Regrettably, portraiture, which demands that the artist deal with an object in the external world— the sitter—essentially had little or no place within the philosophical context of America's most avant-garde painters.[45]

Although portraiture could not find a place in mainstream artistic thinking of the late 1940s and early 1950s, the demand for likenesses still existed. Artists devised numerous strategies to respond to requests for portraits. One solution was to work in a traditional style made popular in an earlier era. Nowhere is this more evident than in the portraits of American war heroes such as those of General Mark Clark [Fig. 16] and General George Patton [Cat. no. 62]. In these, each

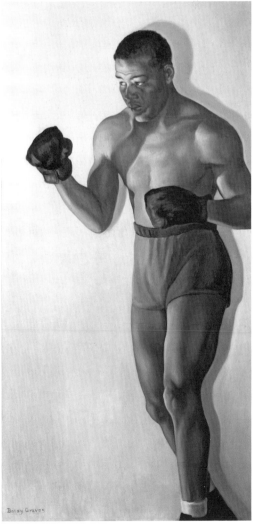

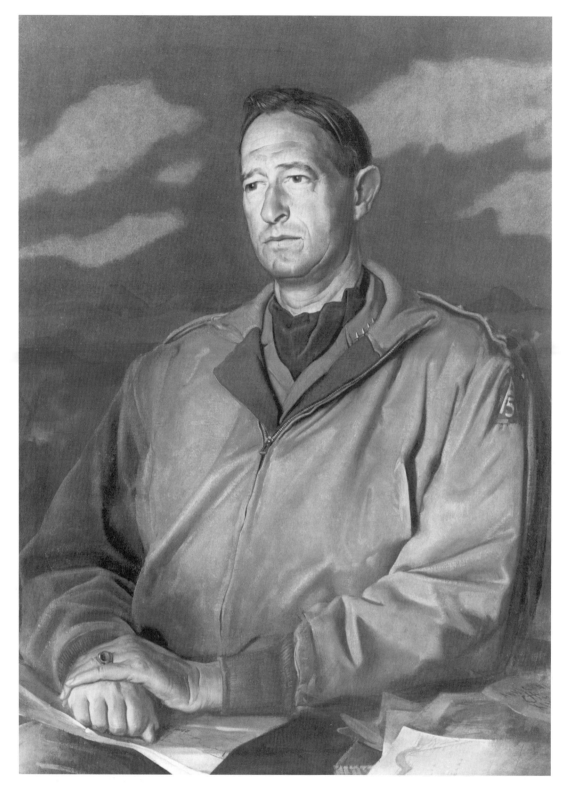

artist has used meticulous draftsmanship to render his subject. Indeed, the consistency with which tried and true techniques, particularly a photographic-like realism, are employed to render our war heroes suggests a subliminal message that among the beneficiaries of recent military victories in Europe were age-old cultural traditions.

Peter Hurd's answer to the mainstream of abstraction was to work in tempera, a medium favored by fifteenth-century Flemish painters like Jan Van Eyck. In Hurd's portrait of Alice Roosevelt Longworth, he used the element of meticulous detail associated with work in this medium to capture the intellect, wit, and forthrightness of this former grande dame of Washington society [Cat. no. 69]. Jamie Wyeth, Hurd's nephew, used oil, but this same careful sense of craftsmanship is apparent in his dramatically posed portrait of art patron and ballet enthusiast Lincoln Kirstein [Cat. no. 70]. Sir Gerald Kelly was lucky: as an Englishman he never had to cope

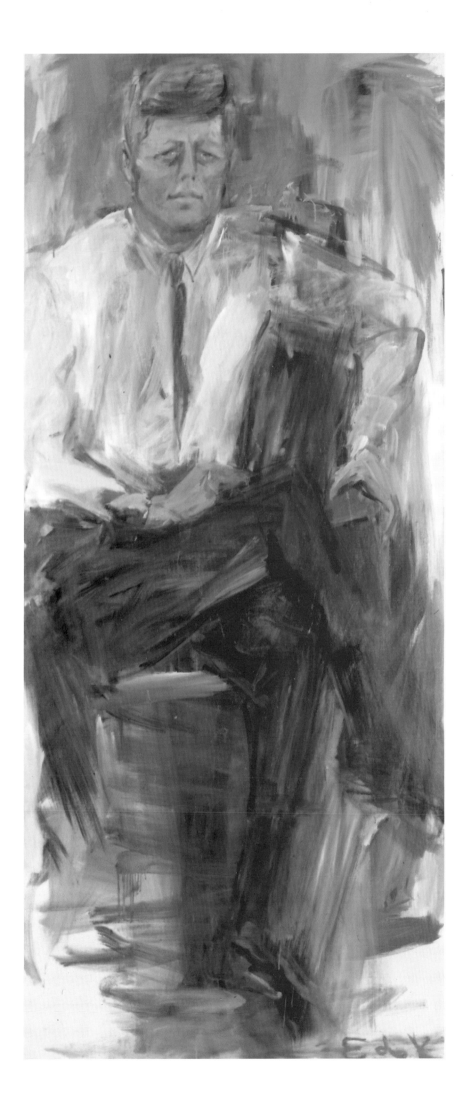

with the overwhelming presence of abstraction, since figuration remained in the stylistic forefront of his homeland. Rebelling against nothing, he used painterly realism to create the amusing but nevertheless telling portrait of expatriate author T. S. Eliot [Cat. no. 68].

Several painters attempted to reconcile the seemingly irreconcilable demands of portraiture and Abstract Expressionism, among them Elaine de Kooning [Fig. 17]. Her own 1946 self-portrait, which reveals her innate talent for capturing detail, gesture, and pose, is characteristic of her early style [Cat. no. 63]. Not until a decade later, when she undertook the portrait of her friend, art critic Harold Rosenberg, was de Kooning able to merge her love of drawing with her affinity for abstraction [Cat. no. 65]. She began this portrait using a sketch she had made while she and the subject were sitting in her studio talking about art. Then, working from memory and her sketch, she proceeded with quick, sweeping, gestural brush strokes to depict Rosenberg's tall, looming presence and magnetic charm on the large, unstretched canvas she had laid on the floor. Her psychological involvement in the act of painting Rosenberg's portrait as she circled the mural-sized canvas was thus not much different from Pollock's approach to making his wholly abstract work.

Fairfield Porter, who came to artistic maturity in the late 1940s and early 1950s, was also close friends with many of the Abstract Expressionists. In portraits of his friends and family, like that of his brother, photographer Eliot Porter, he rendered the sitter in broad patches of vivid color as a means of reconciling abstract formal qualities with his interest in the figure [Cat. no. 72]. In this portrait one is reminded of the early work of Mark Rothko, for both he and Porter were interested in color as light and its inherent ability to evoke an emotional and psychological state of mind. What separates the two is not only Porter's delight in the specific rather than the sublime, but also his willingness to

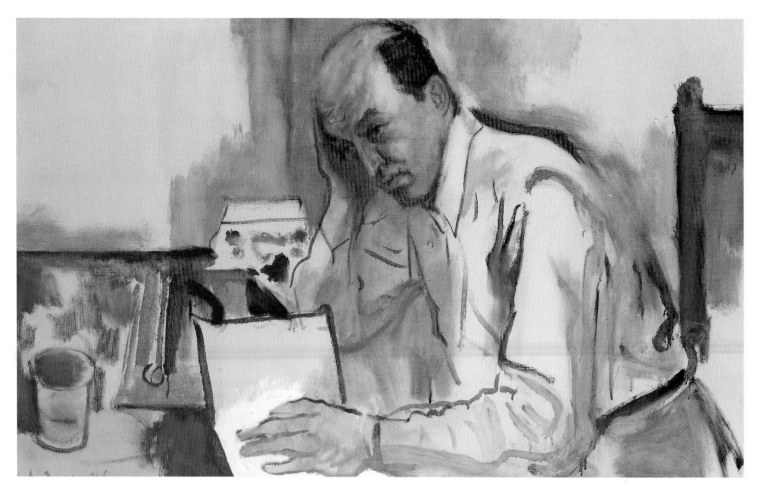

suppress abstraction in order to give priority to the main elements of portraiture—recognizable form and characteristic gestures.

A vast number of artists, either in this country or abroad, particularly those who had come of artistic age in the 1930s and early 1940s, continued to employ an approach to figuration that had its roots in European modernism. Czech-born René Bouché, known for his celebrity portraits, many of which were done on commission from *Vogue* or as covers for *Time,* moved among a variety of established stylistic techniques to express the personality of his sitters. For his portrait of art critic Clement Greenberg, he used a loose, linear, sketch-like style and a pale, Impressionist-like palette, perhaps allusive to the more elusive and evocative nature of Greenberg's writings [Fig. 18]. For his portrait of hostess Elsa Maxwell, he employed a brilliant red background and crisp outlines to speak to her intense energy and no-nonsense approach to entertaining [Cat. no. 66]. In the 1960s, William Smith combined two traditions when he mixed painterly expressionism with photographic-like realism for his por-

trait of writer Carl Sandburg [Cat. no. 67]. Ginny Stanford's brilliantly colored portrait of author M. F. K. Fisher, who was known for her elegant, verbally delicious writing about food, harks back to an early-twentieth-century School of Paris palette [Cat. no. 76].

Alice Neel, who began her career in the 1930s, was a lifelong rebel, and as if to exemplify her independent nature, she never gave up painting the figure, even in the heyday of abstraction.[46] Using the heritage of figurative expressionism to make portraits that are personally telling, she captured the restless energy of Nobel Prize–winning scientist Linus Pauling [Fig. 19] and the thoughtful complacency of composer Virgil Thomson with simple lines and brilliant colors [Cat. no. 71]. Her keen eye for significant gesture and revealing physiognomic detail is evident also in her self-portrait done four years before her death [Cat. no. 73], as well as in her portraits of Helen Lynd and Frank O'Hara. The shallow space within which she inevitably places her subjects—itself a hallmark of the twentieth century—heightens the emotional interaction between subject and observer.

Figure 18.
Clement Greenberg (1909–1994) by René Bouché (1905–1963). Oil on canvas, 76 x 122.1 cm (29 15/16 x 48 1/16 in.), 1955. National Portrait Gallery, Smithsonian Institution; gift of Denise Bouché Fitch

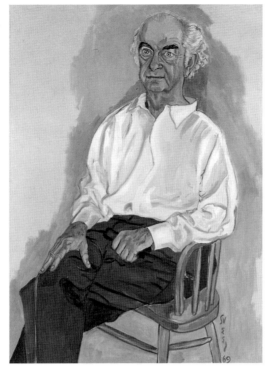

transformed the three-dimensionality of the real world into a two-dimensional form. Warhol invariably gravitated to photographs of celebrities who had appeared repeatedly in the mass media, for he sought to capitalize on their iconic status. Warhol, in opposition to Katz, repeatedly mocked the direct involvement of the artist with the work of art by mechanically reproducing his images. In making a portrait, such as the one of Michael Jackson [Cat. no. 75], the photographic image is usually silkscreened onto the canvas by a master technician. Warhol deliberately limited his art-making role to choosing the image of Jackson, perhaps picking the colors, and signing his name. For Warhol, the selection, rather than the making of the image, was the crucial artistic act.[48]

The 1960s were marked by a desire on the part of many artists to take a position contrary to Abstract Expressionism—to prove that one could be an avant-garde artist without being abstract. To achieve this goal, numerous younger artists, among them Alex Katz and Andy Warhol, developed a variety of strategies to make cutting-edge art without being deprived of the figure as legitimate subject matter. Of concern to both of them is the notion, fundamental to much of avant-garde twentieth-century art, that the canvas is a flat surface and that its integrity should be maintained. Of interest to neither of them was a psychological interpretation of the subject. The challenge for Katz, as Irving Sandler points out, was to "paint *the portrait* by relying on perceptual information."[47] To reconcile the inherent dichotomy between likeness and abstraction, Katz usually began by working from a quick sketch. Then, as in his portrait of John Updike, he employed broad, flat, over-scaled forms to render an image that has the look of commercially made billboard art in order to achieve an abstract pattern of shapes on the canvas [Cat. no. 74].

Warhol, to achieve this desired flatness, used photographs as a source of his imagery. For him, part of the attraction of a photograph was that it had already

In the nineteenth century, many feared that photography, because of its ability to capture a faithful likeness, would destroy the need for a painted portrait. But clearly this did not happen. Quite the contrary—not only did the two mediums successfully coexist, but the last decades of the nineteenth century were the glory days of grand-manner portraiture. The painted likeness continued to be revered, not merely as a way of honoring and memorializing America's heroes and notable citizens, but also as a symbol of personal achievement. Similarly, in the past half-century, when abstraction was in its heyday and portraiture was banished from the art historical mainstream, the art of likeness has not only survived but flourished. The reexamination and recognition of portraiture's viability and vitality in the late twentieth century contribute to a richer notion of American art than what often appears in simplistic discussions of the art of the recent past. While the National Portrait Gallery pays homage to the men and women who have contributed to the history and culture of our nation, its collection also serves to broaden the definition of important American art and to show how portraiture has endured and prospered during the last half-century.

No one can predict the future, so no one can predict the nature of portraiture in the century to come. Clearly, film, video, and the computer will be increasingly employed to depict the life and character of an individual. And in all likelihood, technologies not even present today will be placed in the service of portraiture. But painting will presumably persevere. Just as it has served successfully in the past to describe the personality and accomplishments of an individual, it will undoubtedly be used by future generations to speak to these same issues. While the manner in which artists will make images that capture the notables of their time, in the style of their time, is uncertain, the constant demand for likeness is not. ✳

Notes

1 Carol Troyen, "Innocents Abroad: American Painters at the 1867 Exposition Universelle, Paris," *American Art Journal* 16, no. 4 (autumn 1984): 3–29. The 1867 show in Paris was selected by a committee appointed by members of New York's National Academy of Design. It included eighty-two paintings. Sixteen paintings are clearly identified as portraits.

2 Ibid., p. 8. The selection committee was surprised by this response. As Troyen points out (p. 4), "a new, patriotic self-assurance had for the moment displaced the nation's deep-seated cultural insecurity and, full of naive enthusiasm," the committee felt that it was sending its "best contemporary art to be measured against Europe's greatest modern masters."

3 United States Centennial Commission, *Official Catalogue of the International Exhibition of 1876: Department IV, Art Gallery and Annexes* (Philadelphia: John R. Nagle, 1876), pp. 17–59.

4 Eakins, the best represented of this group, showed *The Chess Players, Dr. Rand, Portrait (Elizabeth at the Piano)*, and two watercolors in the numerous main galleries reserved for American art. His masterpiece, *Portrait of Professor Gross*, now better known as *The Gross Clinic* (Jefferson Medical College, Philadelphia), seen as insufficiently decorous, was relegated to the United States Army Post Hospital exhibit. See Lloyd Goodrich, *Thomas Eakins*, (Cambridge, Mass.: Harvard University Press, 1982), vol. I, pp. 130–33.

5 Troyen, "Innocents Abroad," p. 16.

6 See H. Barbara Weinberg, *The Lure of Paris: Nineteenth-Century American Painters and Their French Teachers* (New York: Abbeville Press, 1991), and Lois Marie Fink, *American Art in the Nineteenth-Century Paris Salons* (Washington, D.C.: National Museum of American Art; Cambridge and New York: Cambridge University Press, 1990).

7 Weinberg, *Lure of Paris*, p. 45. For a useful chronology and summary of the early activities of John La Farge, see Henry Adams et al., *John La Farge: Essays* (New York: Abbeville Press, 1987), pp. 239ff.; for William Morris Hunt, see Sally Webster, *William Morris Hunt, 1824–1879* (Cambridge and New York: Cambridge University Press, 1991), p. 3. For the influence of Couture on American

painters see, in addition to Weinberg, Marchal Landgren, *American Pupils of Thomas Couture* (College Park, Md.: University of Maryland Art Gallery, 1970). For the close relationship between William and Henry James and John La Farge, see Henry Adams, "William James, Henry James, John La Farge and the Foundations of Radical Empiricism," *American Art Journal* 17, no. 1 (winter 1985): 60–67.

8 Andrew J. Walker, "Mary Cassatt's Modern Education: The United States, France, Italy, and Spain," in Judith Barter et al., *Mary Cassatt: Modern Woman* (Chicago: Art Institute of Chicago, 1998), p. 22 n. 3 and p. 336.

9 Goodrich, *Eakins*, pp. 17–64.

10 Tara Leigh Tappert, "Choices—The Life and Career of Cecilia Beaux: A Professional Biography" (Ph.D. diss., George Washington University, 1990), vol. I, pp. 143–239.

11 Rossiter Johnson, ed., *The Twentieth Century Biographical Dictionary of Notable Americans* (Boston: Biographical Society, 1904), vol. 7, unpaged.

12 D. Dodge Thompson, "Charles Sprague Pearce," *Antiques* 144 (November 1993): 682–89.

13 Thomas P. Somma, "Paul Wayland Bartlett and the Apotheosis of Democracy, 1908–1916: The Pediment for the House Wing of the United States Capitol" (Ph.D. diss., University of Delaware, 1990), pp. 97–172.

14 Nicolai Cikovsky Jr., "Whistler and America," in Richard Dorment and Margaret F. MacDonald et al., *James McNeill Whistler* (London: Tate Gallery, 1994), pp. 29–38.

15 For Whistler's relationship to Walter Greaves, see Tom Pocock, *Chelsea Reach: The Brutal Friendship of Whistler and Walter Greaves* (London: Hodder & Stoughton, 1970). For a discussion of Greaves's numerous images of Whistler, see Eric Denker, *In Pursuit of the Butterfly: Portraits of James McNeill Whistler* (Washington, D.C.: National Portrait Gallery, in association with University of Washington Press, 1995), pp. 97–109. For Alexander's relationship to Whistler, see Sandra Leff, *John White Alexander (1856–1915): Fin de Siècle American* (New York: Graham Gallery, October 21–December 12, 1980), pp. 8–9.

16 Henry James, "John S. Sargent," *Harper's New Monthly Magazine* 75 (October 1887): 683.

17 Cassatt participated in three of the eight Impressionist exhibitions (1879, 1881, and 1886). For the most recent appraisal of her life, see Barter et al., *Cassatt.*

18 For an overview of Sargent's life and work, see Patricia Hills et al., *John Singer Sargent* (New York: Whitney Museum of American Art, in association with Harry N. Abrams, 1986).

19 A brief summary of Edith Wharton's life in France is captured in Shari Benstock, *No Gifts from Chance: A Biography of Edith Wharton* (New York: Charles Scribner's and Sons, 1994).

20 Levi P. Morton's career is detailed by Robert McNutt McElroy, *Levi Parsons Morton: Banker, Diplomat, and Statesman* (London and New York: G. P. Putnam's Sons, 1930).

21 Alice Hughes, *My Father and I* (London: Thornton Butterworth, 1923). For a synopsis of Low's early life, see Melissa A. L. Biegert, "Woman Scout: The Empowerment of Juliette Gordon Low, 1860–1927" (Ph.D. diss., University of Texas at Austin, 1998).

22 For an overview of Harte's life, including the time he spent in London, see Henry Childs Morton, *The Life of Bret Harte: With Some Account of the California Pioneers* (Boston: Houghton Mifflin, 1911), and Martin Hardie, *John Pettie, R.A., H.R.S.A.* (London: Adam and Charles Black, 1908), pp. 161 and 246. Gary Scharnhorst, ed.,

Selected Letters of Bret Harte (Norman and London: University of Oklahoma Press, 1997), p. 344, includes specific references to the painting and exhibiting of Harte's portrait.

23 For a brief history of Zorn and his experiences in America, see Douglas K. S. Hyland, *Zorn: Paintings, Graphics, and Sculpture* (Birmingham, Ala.: Museum of Art, 1986).

24 Lee M. Edwards, "Hubert Herkomer in America," *American Art Journal* 21, no. 3 (1989): 48–73.

25 De László's training and career are detailed in Derek Plint Clifford, *The Paintings of P. A. de László* (London: Literary Services & Productions, 1969).

26 Henry James, "John S. Sargent" (1893) in John L. Sweeney, ed., *The Painter's Eye: Notes and Essays on the Pictorial Arts by Henry James* (London: Rupert Hart-Davis, 1956), p. 216.

27 "You may produce a fine *ébauche*, which captivates those who see it, which your friends and colleagues sincerely admire, yet you feel obligated to put more into it and finish it off. You are paralyzed by the success of the unfinished work. . . . When this happens to you, you should stop, take another canvas and copy the *ébauche* on to it. Keep the original which was such a success, use it as a guide and unhesitatingly put anything you like into the copy" (Thomas Couture, quoted in J. Martha Hoppin, "William Morris Hunt: Aspects of His Work" [Ph.D. diss., Harvard University, 1974], p. 179).

28 As Goodrich notes in *Eakins*, pp. 130–33, a lack of decorum was what kept *The Gross Clinic* out of the main exhibition galleries at the 1875 Philadelphia Centennial Exposition. For a discussion of Eakins's "modern" approach to portraiture, see Elizabeth Johns, *Thomas Eakins: The Heroism of Modern Life* (Princeton, N.J.: Princeton University Press, 1983). For the life of Talcott Williams, see Elizabeth Dunbar, *Talcott Williams: Gentleman of the Fourth Estate* (Brooklyn, N.Y.: G. E. Stechert, 1936).

29 Quoted in Jean Sutherland Boggs, *Portraits by Degas* (Berkeley: University of California Press, 1962), p. 51.

30 Fink, *Paris Salons*, p. 371.

31 Ibid., p. 179.

32 Tara Leigh Tappert, *Cecilia Beaux and the Art of Portraiture* (Washington, D.C., and London: Smithsonian Institution Press for the National Portrait Gallery, 1992), p. 88.

33 Tappert, "Choices," vol. 2, pp. 430ff.

34 Jacques-Émile Blanche, *Portraits of a Lifetime: The Late Victorian Era, the Edwardian Pageant, 1870–1914*, ed. and trans. Walter Clement (London: J. M. Dent & Sons, 1937), provides details of his career and his friendship with James; Edith Wharton's role in James's portrait by Blanche is described by R. W. B. Lewis in *Edith Wharton: A Biography* (New York: Harper and Row, 1975), p. 217.

35 Quoted in Ellen G. Miles, *George and Martha Washington: Portraits from the Presidential Years* (Washington, D.C.: National Portrait Gallery, in association with the University Press of Virginia, 1999), p. 38.

36 Carnegie Institute, *Catalogue of Paintings: John White Alexander Memorial Exhibition* (Pittsburgh: Carnegie Institute, Department of Fine Arts, March 1916), no. 36, p. 33.

37 A similar motivation lay behind the work of Walter Greaves, who more than thirty years earlier, in the 1870s, began the first of a large series of portraits of his mentor, in the hopes of telling the world of his affiliation with the then-young but nevertheless notorious Whistler. See n. 15.

38 H. Barbara Weinberg, "Thomas B. Clarke: Foremost Patron of American Art from 1872 to 1899," *American Art Journal* 8, no. 1 (May 1976): 52–83.

39 Three paintings by Van Beers (one consisting of eight panels) hung in the Belgian section of the Fine Arts Pavilion and one was lent to the "Loan Exhibition of Masterpieces by Foreign Artists," organized by Sara Tyson Hallowell; see World's Columbian Exposition, *Official Catalogue: Fine Arts* (Chicago: W. B. Conkey, 1893).

40 Of the three, only Zorach actually participated in the Armory Show. See Association of American Painters and Sculptors, *The Armory Show: International Exhibition of Modern Art, 1913* (New York: Arno Press, 1972).

41 John Loughery, *Alias S. S. Van Dine* (New York: Charles Scribner's Sons, 1992), p. 81. As Loughery noted, in using Cézanne's portrait of Geffroy (the journalist who was the first to write in support of the artist) as his model, he was looking for more than stylistic affinity, for "Willard, it seems was to be the Geffroy to Stanton's Cézanne."

42 Edward Hopper, quoted in Museum of Modern Art, *Edward Hopper: Retrospective Exhibition* (New York: Museum of Modern Art, 1933), p. 18.

43 Moreover, the many artists who immigrated to America in the late 1920s and the early 1930s were from a social and economic class that had not shared in the best Europe had to offer (as distinct from many who traveled here in the late nineteenth century or those who came in the early 1940s as war refugees). Although schooled in the major twentieth-century traditions, the vast majority sought, as part of their physical and psychological emigration, to transcend rather than perpetuate their aesthetic past.

44 An overview of the Harmon Foundation and its collection is presented in Gary A. Reynolds and Beryl J. Wright, *Against the Odds: African American Artists and the Harmon Foundation* (Newark, N.J.: Newark Museum of Art, 1989). *Breaking Racial Barriers: African Americans in the Harmon Foundation Collection* (Washington, D.C.: National Portrait Gallery, in association with Pomegranate Artbooks, 1997) illustrates the works from the Harmon Foundation in the National Portrait Gallery's collection.

45 Abstraction and portraiture can coexist, as is evident from Marius de Zayas's abstractions such as his drawing of Agnes Meyer, now in the collection of the National Portrait Gallery. See Wendy Wick Reaves, *Celebrity Caricature in America* (New Haven: Yale University Press, in association with the National Portrait Gallery, 1998), pp. 85–99. Willem de Kooning's *Marilyn* (Whitney Museum of American Art) is a example of a portrait by a leading Abstract Expressionist. But the philosophical underpinnings of these two works are quite different: de Zayas was attempting to express the persona of the sitter, while de Kooning's *Marilyn* was very much an expression of his feelings projected on a well-known subject. For an overview of Abstract Expressionism and its philosophical underpinnings, see Irving Sandler, *Triumph of American Painting: A History of Abstract Expressionism* (New York: Praeger Publishers, 1970).

46 See Patricia Hills, *Alice Neel* (New York: Harry N. Abrams, 1983), and Pamela Allara, *Pictures of People: Alice Neel's American Portrait Gallery* (Hanover, N. H.: University Press of New England, 1998).

47 Irving Sandler, *Alex Katz: A Retrospective* (New York: Harry N. Abrams, 1998).

48 Carter Ratcliff, *Andy Warhol* (New York: Abbeville Press, 1983).

I

George Berkeley 1685–1753
Clergyman

John Smibert 1688–1751
Oil on canvas, 102.9 x 75.6 cm
(40½ x 29¾ in.), 1727?
Gift of The Morris and
Gwendolyn Cafritz Foundation
NPG.89.25

Born in Ireland and educated at Trinity College, Dublin, where he held several college offices and earned a doctor of divinity degree, Anglican clergyman George Berkeley was widely respected for his intellect. After spending several years in England and Italy (1713–1720), he returned to Ireland, where he became the dean of Derry in 1724. Despairing of a corrupt Europe and anticipating a bright and virtuous future for the New World, he advocated establishing an American missionary college in his *Proposal for the Better Supplying of Churches in Our Foreign Plantations . . . By a College to be erected in the . . . Isles of Bermuda* (1725). His "Verses on the Prospect of planting Arts and Learning in America," written in 1726, end with the quatrain that predicted greatness for North America:

Westward the Course of Empire takes its Way;
The four first Acts already past,
A fifth shall close the Drama with the Day;
Time's noblest Offspring is the last.[1]

Berkeley sailed for Rhode Island in 1728 with a small group of supporters, intending to proceed to Bermuda as soon as he raised money. After the plan for the college failed for lack of funds, Berkeley returned to London, donating his American farm and large library to Yale College. In 1734 he was appointed Bishop of Cloyne.

Scottish artist John Smibert met Berkeley in Italy in 1720. They were reacquainted in London in 1726, where Smibert was enjoying "very good business" as a painter, according to London engraver George Vertue. Berkeley invited Smibert to join his American venture as artist and teacher of art at the new missionary college. The portrait, painted in London before their departure for Rhode Island, shows Berkeley pointing to a promontory that is believed to represent Bermuda, a place that he and Smibert would never see.

Smibert, trained in Edinburgh, London, and Rome, had a careful style of painting that was more precise and less dramatic than that of many contemporaries. The portrait of Berkeley exists in two versions, of which the first is owned by the National Portrait Gallery, London; this is the second. These are probably the two portraits listed in Smibert's notebook as "Mr. Dean Berkeley K C 25-4-0" (in June 1726) and as "Doctor Berkeley Dn. of Dy. Cop o.s. 12-12-0" (June 1727). While later dates of 1730 and 1732 have been proposed for these portraits, Berkeley does appear to be younger in this image than he does in Smibert's best-known painting, *The Bermuda Group* (Yale University Art Gallery), which celebrates the arrival of the group in New England in early 1729.[2]

Soon after arriving in Rhode Island, Smibert settled in Boston, one of the first professionally trained portrait painters to practice in the North American colonies. His work and his collection of paintings influenced a number of Boston-area artists of the next generation, including John Greenwood and John Singleton Copley. ✳

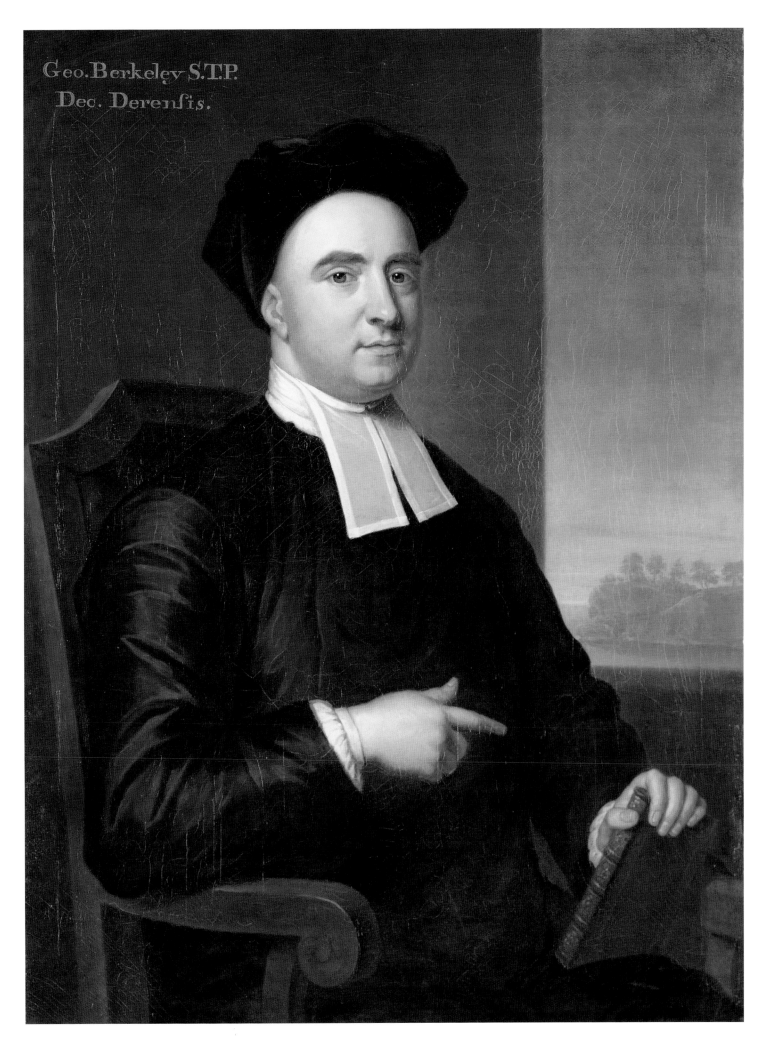

Geo. Berkeley S.T.P.
Dec. Derensis.

2

Andrew Oliver 1706–1774
Colonial statesman

John Singleton Copley 1738–1815
Oil on copper, 12.1 x 10.2 cm
(4³/4 x 4 in.), circa 1758
NPG.78.218

In his portrait of Andrew Oliver, the young colonial artist John Singleton Copley reveals his talent for capturing lifelike likenesses. Oliver seems older than his fifty-plus years, and as stern as his formal wig, direct gaze, and arched eyebrows communicate. The twenty-year-old artist painted Oliver's portrait in oil on copper, a form of miniature that he employed at this early stage of his career, following the example of John Smibert [see Cat. no. 1], a Boston resident. It is one of three miniatures that he painted of Oliver at about this time. The other two are smaller and are paired with miniatures of Oliver's wife, Mary Sanford. The larger size may indicate that it was painted to match a similarly scaled oil on copper miniature of Oliver's deceased brother, Daniel Oliver Jr., painted by an unidentified British artist in 1727.[3] Copley's other portraits of the Oliver family include an oil on copper of Andrew Oliver's brother Peter on this larger scale. The Oliver family commissioned "almost two-thirds of Copley's work in this medium."[4] The portrait is in its original frame and probably had a glass cover.[5]

Andrew Oliver was the son of Boston merchant Daniel Oliver and his wife Elizabeth, the sister of Massachusetts governor Jonathan Belcher. A graduate of Harvard College, Andrew became a successful merchant. Married twice, he was the father of seventeen children. He was an active member of city and church committees, served as Boston delegate to the House of Representatives for three terms, and represented Massachusetts at the Iroquois conference at Fort Frederick in 1748. He served on the Massachusetts Council, the governor's advisory body, beginning in 1746, and was appointed secretary of the province in 1756, shortly before Copley painted this portrait.

Oliver was an ally of the British Crown in the events leading to the American Revolution, together with his brother Peter and his brother-in-law, Thomas Hutchinson. He was appointed distributor of tax stamps following the British Parliament's passage of the Stamp Act in 1765. Despite his personal opposition to the tax, he became its most visible symbol, and when Bostonians rose up in protest against it, a mob strung his effigy from the city's newly designated Liberty Tree. In 1770, as secretary of the province, he wrote an account of the Boston Massacre that was politically unacceptable to the radical members of the council, which reprimanded him. In 1771 he became lieutenant governor of the colony when Hutchinson was made governor. He died three years later, the subject of continued verbal attacks about his allegiance to the Crown. *

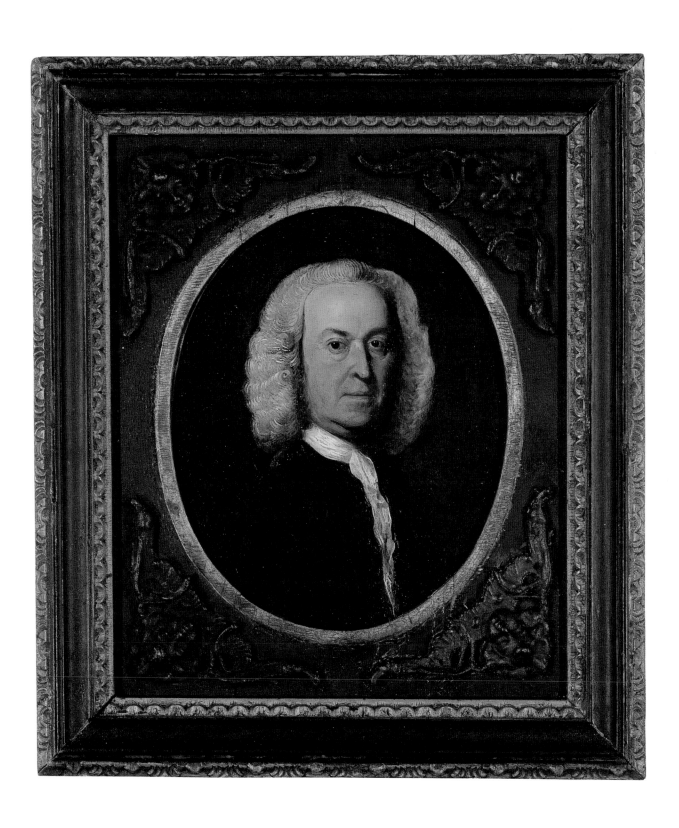

3

Anne Green CIRCA 1720–1775
Printer, publisher

Charles Willson Peale 1741–1827
Oil on canvas, 92.1 x 71.1 cm
(36¼ x 28 in.), 1769
Gallery purchase with funding from the Smithsonian
Collections Acquisitions Program and gift from the
Governor's Mansion Foundation of Maryland

NPG.91.152

Anne Catharine Hoof Green became publisher of the *Maryland Gazette* in 1767, upon the death of her husband Jonas Green, who had published the weekly since 1745. At his death she also became manager of his printing shop, and she was soon appointed the official printer of documents for the colony of Maryland, a position also held by her husband. One of a small number of women in the printing trade in colonial America, she ran the business for eight years, at times in partnership with one of two sons. (The Greens had fourteen children, six of whom survived to adulthood.) Under her editorship, the *Gazette*—Maryland's only newspaper—published local, colonial, and overseas news, as well as local advertisements. It also served as a public forum for news and debates concerning the growing hostilities with England and the political future of the colony.

In this portrait by Charles Willson Peale, Green holds a copy of the *Gazette*, displaying the last page, with part of the colophon legible: "ANNAPOLIS: Printed by." On actual copies of the paper, this is followed by her name, subscription and advertising information, and other details about the printing office. During completion of the portrait, Peale repositioned Mrs. Green's right hand. Its original, slightly raised position is indicated by the shadow-like traces of the first two fingers. They were once covered by pigment and have become visible over time.

Circumstances suggest that this undated portrait was among the first that Peale painted after returning from London in 1769. He listed it first in his itemized account of works painted between his return and his move to Philadelphia at the end of 1775. And in 1788, when Peale cleaned the painting for Green's son Frederick, he recalled that he had painted it "about 18 or 19 yrs. past," that is, in 1769 or 1770.[6] The relationship between the Peales and the Greens began in 1740, soon after Jonas and Anne Green, recently married, moved to Annapolis from Philadelphia. In 1740, Jonas Green paid the bond for the marriage license of Peale's father Charles to Margaret Triggs.[7] Later, Charles Peale advertised his Chestertown school in the *Gazette*. His son continued the contact, advertising as a saddler, his first profession, in 1762. These close ties continued after Green's death, which occurred while Peale was in England. The *Maryland Gazette* for June 8, 1769, noted Peale's return from London, and a week later printed a notice about Peale's engraving of his full-length painting of William Pitt. Three poems published in 1771 and 1773 praised portraits by Peale.

Mrs. Green died in 1775. Her obituary described her as "relict of the late MR. JONAS GREEN, Printer to the Province," and referred not to her professional accomplishments, but only to her personal traits: "She was of a mild and benevolent Disposition, and for conjugal Affection, and parental Tendernes [*sic*], an Example to her Sex."[8] ✳

4

Charles Cotesworth Pinckney
1746–1825
Revolutionary War officer, statesman

Henry Benbridge 1743–1812
Oil on canvas, 76.2 x 63.5 cm
(30 x 25 in.), circa 1773
NPG.67.1

Charles Cotesworth Pinckney was born in Charleston, South Carolina, and in 1753 moved with his parents to England. He was educated at Christ Church, Oxford, and as a lawyer at the Middle Temple of the Inns of Court, London. He also attended the Royal Military Academy in Caen, France. He returned to Charleston in 1769, and was soon elected to the South Carolina Commons House of Assembly. Over the next few years, in the growing discord with Britain, his allegiance clearly was with the colonies. In 1775, as a member of the first Provincial Congress of South Carolina, he was appointed to a secret committee whose members seized munitions for the American forces. He became a captain in the First South Carolina Regiment, organized by the Provincial Congress in June 1775, and was promoted to colonel when the regiment became part of the Continental army in 1776. In 1780 he was captured when the British seized Charleston, and imprisoned for two years. In 1783, at the end of the war, he was promoted to brigadier general, and thereafter was often referred to as "General Pinckney." Pinckney served as a delegate to the Constitutional Convention of 1787, and as minister to France from 1796 to 1798. He was an unsuccessful candidate for the vice presidency of the United States in 1800, and for the presidency in 1804 and 1808.

This portrait by Henry Benbridge dates from about 1773, the year that Pinckney married Sarah Middleton. Benbridge also painted her portrait (Gibbes Museum of Art) at this time. A Philadelphian, Benbridge had spent part of his inheritance to study painting in Italy in 1765–1769 and in London in 1770. After returning to Pennsylvania, he moved to Charleston in 1772 to earn his living as a portrait painter. With his sophisticated knowledge of Italian colors and compositions—and with little competition—he painted numerous portraits of Charlestonians on the eve of the Revolution. He remained in the city during the war and, like Pinckney, was imprisoned by the British when they captured the city in 1780. He was last documented there in the census of 1790.

Benbridge initially painted Pinckney in a scarlet coat trimmed with a black velvet collar and cuffs, the uniform of the Light Infantry Company of the Charleston militia. Pinckney became a lieutenant in the militia on May 17, 1773. Two years later, when Pinckney became a captain in the First South Carolina Regiment, the coat and trim were repainted, presumably by Benbridge, to represent the regiment's new uniform: blue with red cuffs, collar, and facings. A close study of the portrait shows traces of the earlier red uniform along the edges of Pinckney's left sleeve, underneath the blue paint. X-radiography reveals an earlier insignia on the cap, which was changed, and a light flintlock or fusil resting in the crook of Pinckney's right arm, which was painted out. ✷

5

John Singleton Copley 1738–1815
Artist

Self-portrait
Oil on canvas, 45.1 cm (17¾ in.) diameter
(image size), 1780–1784
Gift of The Morris and Gwendolyn Cafritz
Foundation with matching funds from
the Smithsonian Institution
NPG.77.22

This has been long treasured as one of four self-portraits by John Singleton Copley, the talented American-born artist who is admired today for his realistic depictions of colonial American sitters and for his important history paintings, painted in London. This self-portrait is the only one that depicts Copley turned away from the viewer, looking off to the side. In the others, painted during his American years and in his first year in London, he poses self-consciously, looking out at the viewer, presenting an image that is elegantly dressed and coiffed. Here, instead, the composition focuses on the head, with the neckwear sketchily painted and the rest of the canvas unfinished. The air of confidence is still present, despite the change in composition.

By the late 1750s, Copley had eclipsed the local talent in Boston with works such as *Andrew Oliver* [Cat. no. 2]. He dominated portrait painting in the city and nearby areas by the 1760s, and by 1771 his reputation had spread to New York and further south. His ambition to study painting in Europe, and the increasingly tense events prior to the American Revolution, made him leave for London and Italy in 1774. He spent the second half of his career in London, where beginning in 1776, he painted important history paintings and portraits, exhibiting the narrative paintings in venues outside the Royal Academy to increase his reputation and income.

The pose and the strong highlighting and contrasting shadows of this self-portrait suggest that Copley was using himself as a model on which to practice technique. These stylistic features suggest a date in the early 1780s, at a time when Copley was at work on *The Death of Major Pierson* (1782–1784; Tate Gallery, London), the largest, most complex history painting that he had attempted to that time. The subject is the British defeat of the French forces on the Isle of Jersey in 1781, and the heroic death of the British officer Major Pierson. Copley may have used his wife and young son—and namesake—as models for the figures in the right foreground, as he had earlier used his wife and newborn daughter Susanna as models for the figures of Mary and the infant Jesus in his *Nativity* (1776–1777; Museum of Fine Arts, Boston). It has been suggested that as Copley adjusted to larger canvases with many figures, he adjusted his more meticulous, careful colonial painting style to a looser, broader technique, in keeping with British fashion in the 1780s, and practiced this technique with his own self-portrait. This use of himself as a model was certainly in keeping with the practice of other artists. Perhaps Copley used two mirrors to accomplish such a dramatic pose; it would be difficult to achieve this image using only one mirror, the usual method for making a self-portrait. *

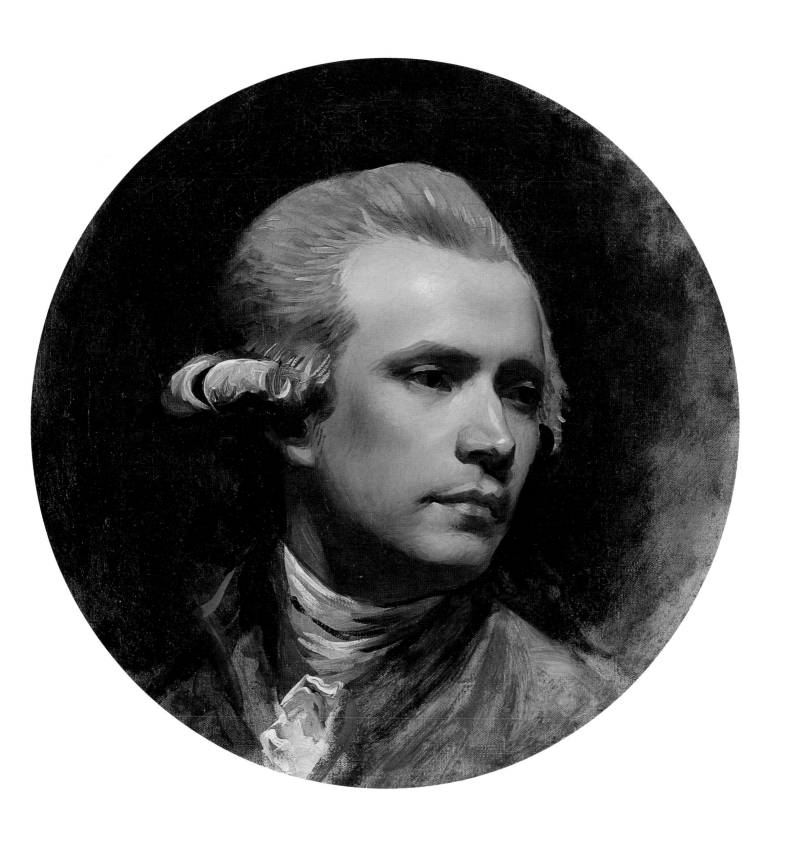

6

John Jay 1745–1829
Statesman

Gilbert Stuart 1755–1828 and
John Trumbull 1756–1843
Oil on canvas, 128.3 x 101.6 cm
(50¹/₂ x 40 in.), begun in 1784;
completed by 1818

NPG.74.46

A New York lawyer whose father was a wealthy merchant and landowner, John Jay served during the American Revolution in the First and Second Continental Congress, and was appointed minister plenipotentiary to Spain in 1779. He was summoned to Paris in 1782 to serve as joint commissioner, with Benjamin Franklin, Henry Laurens, and John Adams, to negotiate the Treaty of Paris, which marked the end of the Revolution. When Jay visited London in the winter of 1783–1784 after leaving Paris, he commissioned Gilbert Stuart to paint his portrait. One version would be for himself, and the other was intended as a gift for his political ally William Bingham.[9] However, Stuart left the portraits unfinished. Many years later, in 1818, John Trumbull told the story of their subsequent history to Horace Holley, who recounted it to his wife. Writing to her about a visit to the Trumbulls in New York City on February 11, Holley praised Trumbull's paintings, including one of Jay:

The John Jay, which Mr Trumbull has, is the painting of himself and of Mr Stewart. Mr Trumbull bought it for ten guineas of a broker in London, who had it in pledge among many others. Mr Stewart painted the head, and Mr Trumbull the rest. It is nearly the whole length, a sitting figure. The face was painted in 1784. Mr. Jay had paid Mr Stewart for two half lengths, but neither was finished till Mr Trumbull found them at a broker's, & gave twenty guineas for the two. Mr Jay has the other one himself.[10]

Exactly when Trumbull completed the Gallery's painting is unknown. Estimates range from about 1785 in London to 1794 or 1808 in the United States. The earlier date and place are more likely because of the style of the clothing and the details of the artists' careers. Jay wears a frock coat with a pointed collar, tight sleeves, and no lapel, a fashion of the 1780s; it seems unlikely that Trumbull would have painted Jay wearing this style of suit at a later date. Stuart could have left the pictures unfinished in 1787, when he moved to Dublin. Trumbull could have completed the portrait when he was in London from 1784 to 1789, although he could also have done this when he returned there with Jay in 1794, serving as Jay's secretary during the negotiations with Great Britain that led to Jay's Treaty. In 1794 Stuart, who had arrived in New York from Dublin the previous year, completed a different portrait of Jay, showing him wearing red robes as Chief Justice of the Supreme Court (on loan to the National Gallery of Art from Peter A. Jay). He also painted three portraits of Jay in a black suit that are similar, but not identical, to the Gallery's painting, and are traditionally dated to that year. While in New York, Stuart obtained a letter of introduction from Jay to George Washington, which he needed to fulfill his plan to paint the first President. Jay served as Chief Justice of the Supreme Court until his election in 1795 as governor of New York, the position he held for the last six years of his public life. ✱

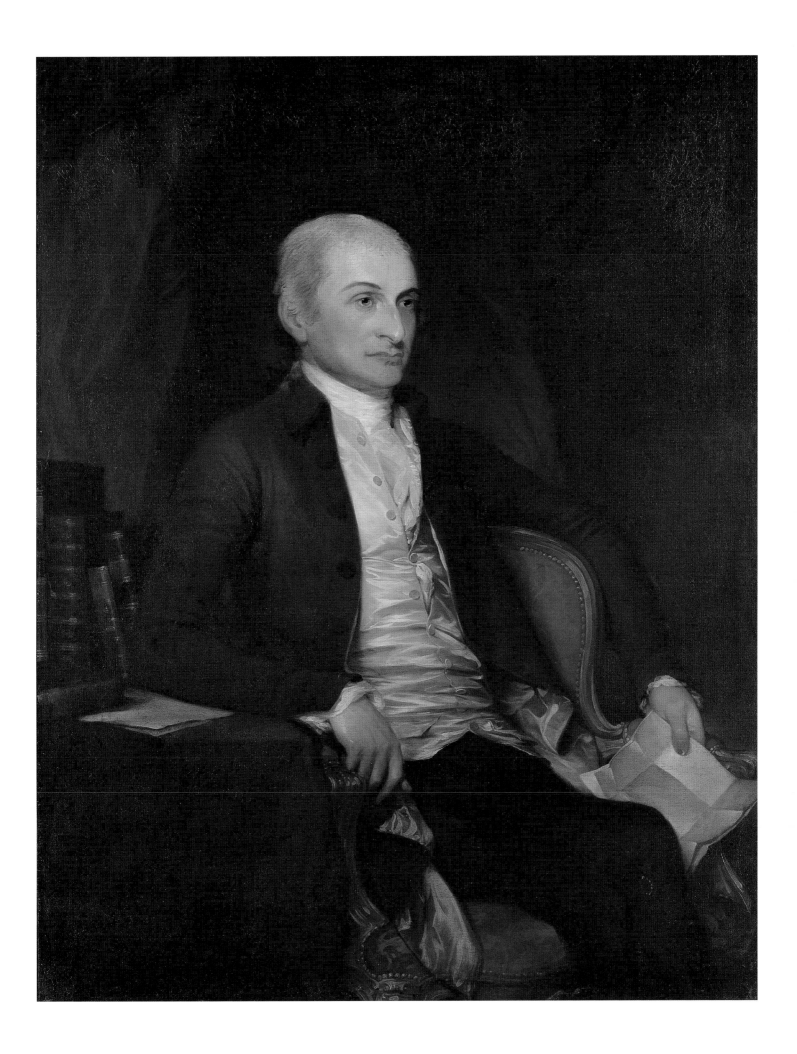

7

Benjamin Franklin 1706–1790
Author, statesman, scientist, diplomat

Joseph Siffred Duplessis 1725–1802
Oil on canvas, 72.4 x 59.7 cm
(28½ x 23½ in.), circa 1785
Gift of The Morris and
Gwendolyn Cafritz Foundation

NPG.87.43

This portrait of Benjamin Franklin dates from his years in France, when he represented the interests of the Revolutionary American government to the French court, America's ally in its war of independence from the British. Franklin's reputation as a writer, scientist, and businessman was well established by the time of his arrival in France in December 1776. Armed with an urbane wit and intuitive sensitivity to the subtleties of Continental diplomacy, he succeeded brilliantly in his mission. At the same time, the disarming simplicity of his manner, combined with his keen intellect, made him a source of such fascination that there was a brisk demand in French society for his portraits.

Joseph Siffred Duplessis, painter to Louis XVI and his court, first depicted Franklin in an oil portrait showing Franklin in a red coat with a fur collar (Metropolitan Museum of Art). The painting was commissioned by Franklin's admirer, Jacques Donatien Le Ray de Chaumont, who provided him with a home in Passy, near Paris. Exhibited in 1779 at the Salon du Louvre, the biennial exhibition in Paris, it caught every visitor's eye. Comments by Pierre Samuel du Pont show how contemporaries interpreted Franklin's appearance: "His large forehead suggests strength of mind and his robust neck the firmness of his character. Evenness of temper is in his eyes and on his lips the smile of an unshakeable serenity."[11] A second, similar, portrait by Duplessis, in pastel (New York Public Library), depicts Franklin in a gray coat. Franklin gave the pastel to his friend Louis Guillaume Le Veillard, the mayor of Passy, when he returned to America in 1785. The Gallery's portrait is similar to the pastel. Its early owner was Mme. Brillon de Jouy, Franklin's neighbor in Passy. Mme. Brillon, a talented musician, charmed the statesman, who was forty years her elder. Their flirtatious relationship continued through Franklin's years in France. *

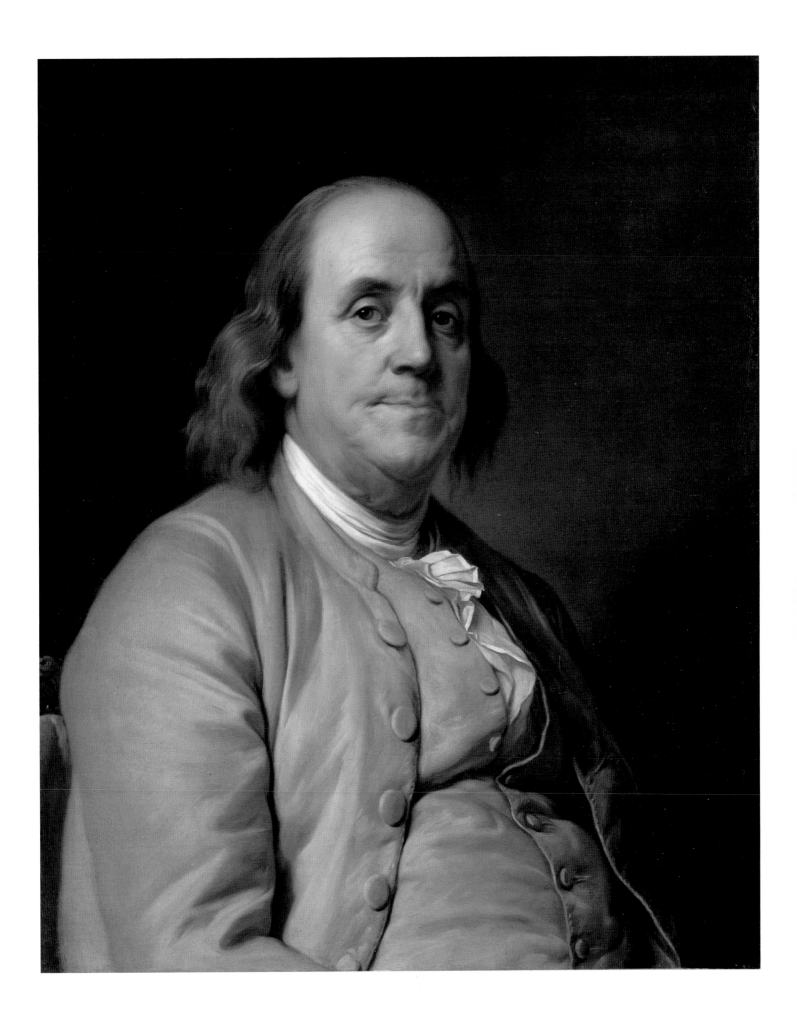

8
Charles Willson Peale 1741–1827
Artist

Self-portrait
Oil on canvas, 65.1 x 51.7 cm
(25⅝ x 20⅜ in.), circa 1791
NPG.89.205

Maryland artist Charles Willson Peale, his wife Rachel Brewer Peale (1744–1790), and their two young children, Raphaelle and Angelica Kauffmann, settled in Philadelphia in 1776. The city would be Peale's home for the remainder of his long life. There he continued painting portraits, a profession that led to commissions for miniatures of American army officers during the Revolutionary War, and to depictions of war heroes after the war. He displayed his own collection of these heroes in his portrait gallery, which opened in 1782 in the addition that he built to his house on Lombard Street. The collection, which numbered forty-four portraits in 1784, included images of such men as John Jay, Horatio Gates, the Marquis de Lafayette, Benjamin Franklin, Thomas Paine, and David Rittenhouse. Although the gallery included life-size full-length portraits of George Washington and Conrad Alexandre Gérard, most were smaller, in a bust-size, rectangular format, with the images framed in oval mats.

This self-portrait is similar in size. According to Charles Coleman Sellers, the portrait can be dated in the early 1790s by its similarity "in costume, face, and hair" to a profile drawing by the artist's brother, James Peale. The early history of the self-portrait is unknown. It may have been painted for Peale's new in-laws, the DePeysters of New York, at the time of his marriage in 1791 to his second wife, Elizabeth DePeyster.[12] Peale began painting images of himself as a young artist in the 1760s. Among them are a self-portrait in *The Peale Family* (New-York Historical Society), which Peale began in the early 1770s. By the early 1790s, around the time of this image, Peale was gradually leaving his career as a painter, which became the province of other members of the talented family, and turning to his second profession as administrator of his museum, with its growing collections of natural history specimens and portraits. The museum moved from his home on Lombard Street in 1794 to Philosophical Hall, Philadelphia. ✳

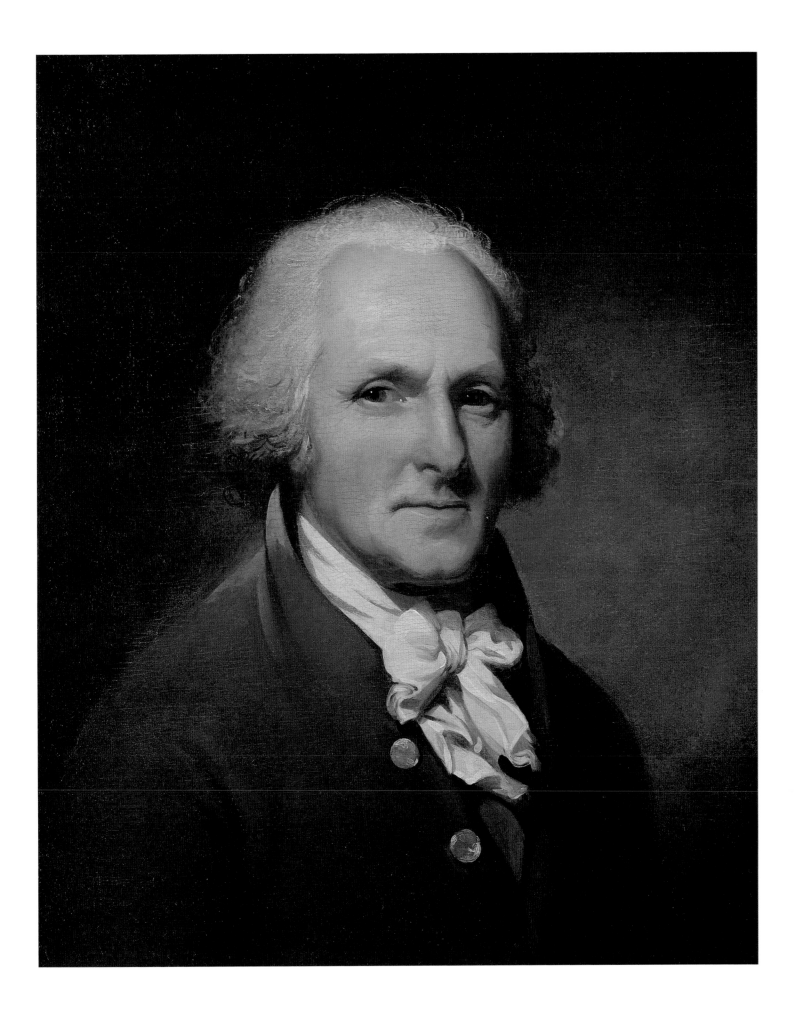

9

Rubens Peale 1784–1865
Museum administrator

Rembrandt Peale 1778–1860
Oil on canvas, 66.7 x 54.6 cm
(26¼ x 21½ in.), 1807
Gift of Mrs. James Burd Peale Green
and Gallery purchase
NPG.86.212

Rubens Peale was one of the children of artist and naturalist Charles Willson Peale and his first wife Rachel Brewer, who died when Rubens was a child. Like most of his siblings, he was named after a famous artist; in his case it was Peter Paul Rubens, the seventeenth-century Flemish painter. Rubens Peale was small for his age, with poor eyesight that prevented him from following a career as an artist, like his brothers Rembrandt and Raphaelle. From an early age, however, he was remarkably successful with the care of plants and animals. He turned to managing the family's Philadelphia museum of art and science. By 1810 he was its administrative proprietor, and in 1825 he established his own Peale Museum in New York City. Believing that museums needed to entertain as well as educate, Rubens proved to be an astute practitioner in the art of attracting audiences. In 1815, for example, with attendance lagging at the Philadelphia museum, he introduced the novelty of gas lighting to its galleries and in the process boosted his visitor receipts by nearly 50 percent.

This is the second portrait of Rubens that his older brother Rembrandt Peale painted. It shows him wearing lenses with strong magnification that noticeably enlarge the inner corner of his left eye and the outer area of his right eye. Like the earlier portrait, *Rubens Peale with a Geranium* (1801; National Gallery of Art), it captures his quiet strength, and reflects his brother's fondness for him. The portrait bears two inscribed dates, 1807 and 1821. The first is the actual date of the portrait; the second may have been added by a later member of the family because the earlier date was covered by a frame. The earlier date was discovered when the painting was cleaned in 1989 after it was acquired by the National Portrait Gallery. ✳

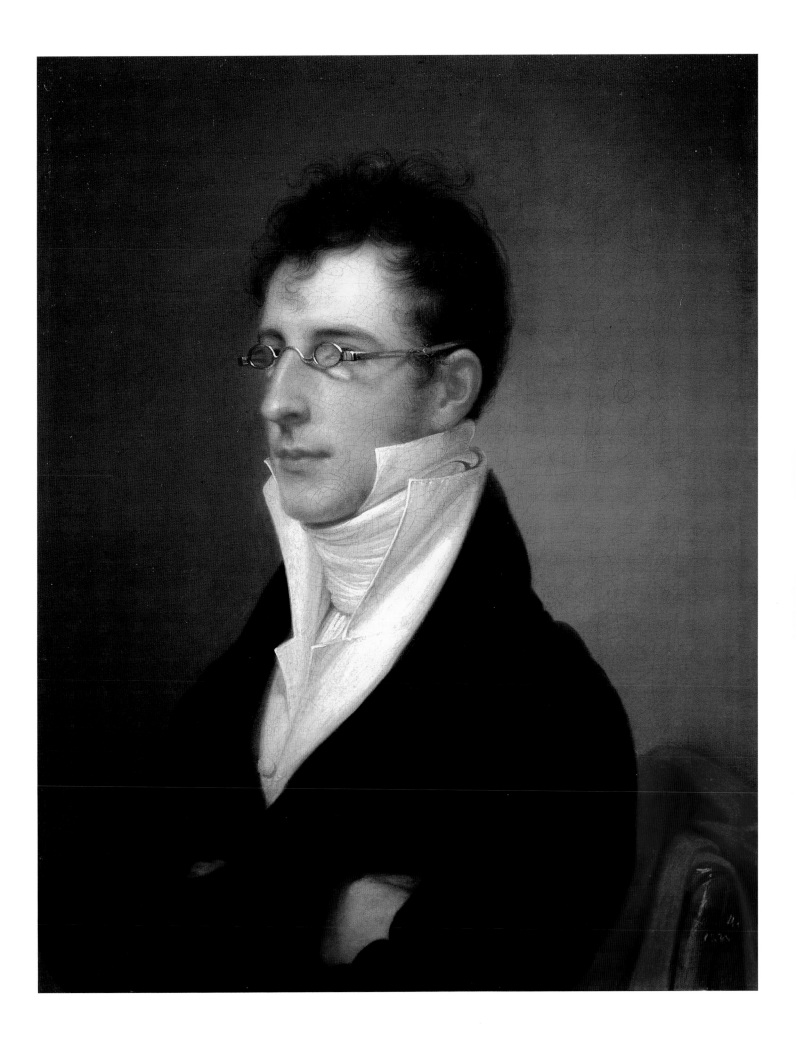

10

William Wirt 1772–1834
Lawyer

Cephas Thompson 1775–1856
Oil on canvas, 76.2 x 63.5 cm
(30 x 25 in.), circa 1809–1810
NPG.89.11

William Wirt yearned to make his mark as a writer. However, financial needs forced him to focus most of his energy on making his living as a lawyer, and his only contribution to early American literature remembered today is *Sketches of the Life and Character of Patrick Henry* (1817). Widely revered as a lawyer of uncommon ability, he participated in many of the most important Supreme Court cases of his day. As United States attorney general from 1817 to 1829, he is also credited with transforming this minor cabinet position into one of considerable influence. Finally, as the presidential candidate of the Anti-Masonic Party in 1832, Wirt claimed the distinction of being the first White House aspirant of a so-called "third party." Wirt never wanted this last honor, however, and when it was clear that his chances of election were nil, he confessed that he felt like a "culprit pardoned at the gallows."

This portrait of Wirt, along with that of his second wife, Elizabeth [Cat. no. 11], was made by self-taught artist Cephas Thompson. At the time he painted these portraits, he was at the height of his career as an itinerant artist traveling in the South. From November of 1809 until February of 1810, Thompson "commenced business in the house opposite the Swan Tavern" in Richmond, Virginia, where these portraits were probably made.[13] Thompson had carefully chosen the location of his studio. The Swan Tavern was famous for the politicians, lawyers, and other public officials who frequented it. Before painting the Wirts, Thompson had painted portraits of Chief Justice John Marshall, as well as Elizabeth Wirt's parents, Robert and Catherine Gamble, who could have recommended Thompson to their daughter and son-in-law. Thompson portrayed William Wirt in what appears to be a draped Roman toga, possibly a reference to Wirt's skilled oratory as a member of the prosecution during Aaron Burr's trial in Richmond in 1807. Also, Wirt had recently completed a term in the Virginia House of Delegates when he sat for the portrait. Although Thompson did not employ this device elsewhere, the toga was often introduced in early nineteenth-century American portraiture, especially in sculptures of public figures, as a means of identifying subjects with the much-admired public virtues of Republican Rome. ✳

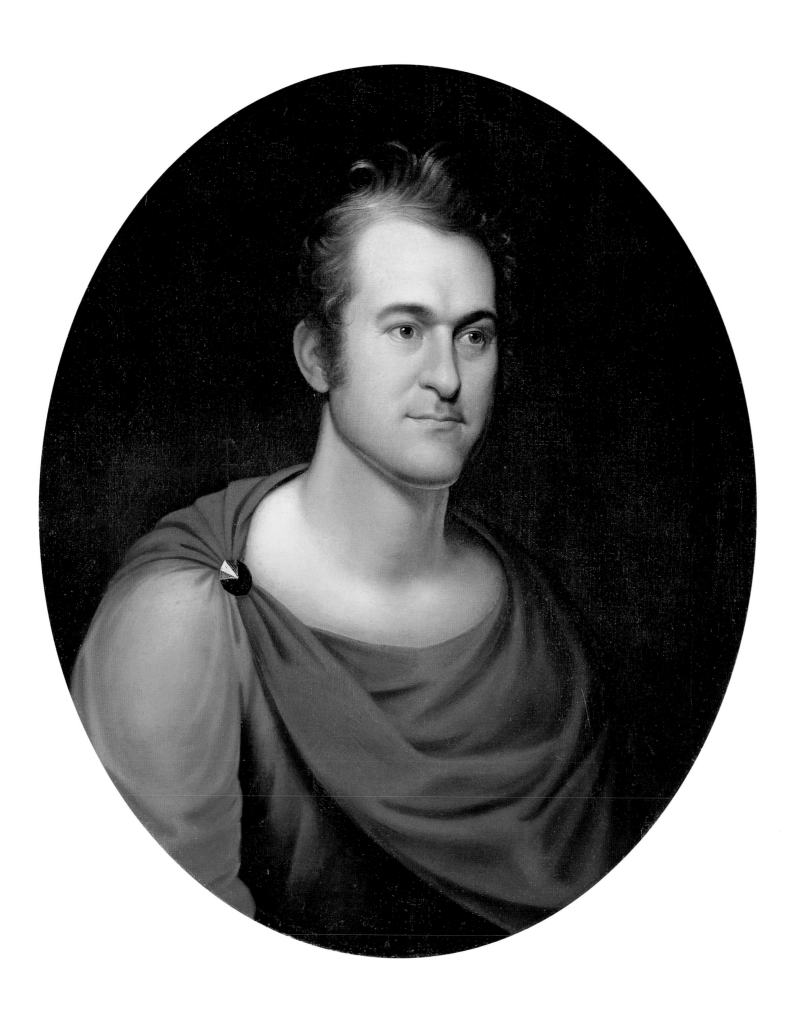

Elizabeth Wirt 1784–1857
Author

Cephas Thompson 1775–1856
Oil on canvas, 76.2 x 63.5 cm
(30 x 25 in.), circa 1809–1810
S/NPG.89.12

Elizabeth Washington Gamble, daughter of Robert and Catherine Gamble of Richmond, married William Wirt in 1802 as his second wife. After living in Norfolk, they returned to Richmond, purchasing a house there in 1808 with the financial assistance of Elizabeth's parents. Mrs. Wirt "took the lead in renovating" the house, supervising the workmen, and at times overriding her husband's instructions.[14] Their family, which included three children by 1809 (three others had died), would eventually number ten offspring.

The Wirts sat to Cephas Thompson for their portraits sometime during the itinerant artist's two seasons in Richmond, in the winters of 1809–1810 and 1810–1811. The Wirts' signatures appear in his "Memorandum of Portraits," where they are among the last in the section entitled "A List of Names of those who engage there [sic]

Portraits in Richmond."[15] Originally painted in the rectangular format typical of this artist's work, the portraits were later trimmed to their present oval shape and reframed. In her portrait, Elizabeth Wirt is shown in a high-waisted dress, seated in an Empire chair that appears in other portraits by Thompson.

Married to a man with literary talents, Elizabeth Wirt compiled a manuscript of favorite quotations about flowers, one of the earliest American examples of a type of book that was very popular in the Romantic era. The manuscript was written "with no idea of publication, merely for the amusement of her own large family and . . . for her own entertainment."[16] After she made copies for others, the book was published anonymously in 1829 as *Flora's Dictionary*. Later editions identified the author as "Mrs. E. W. Wirt of Virginia." ✳

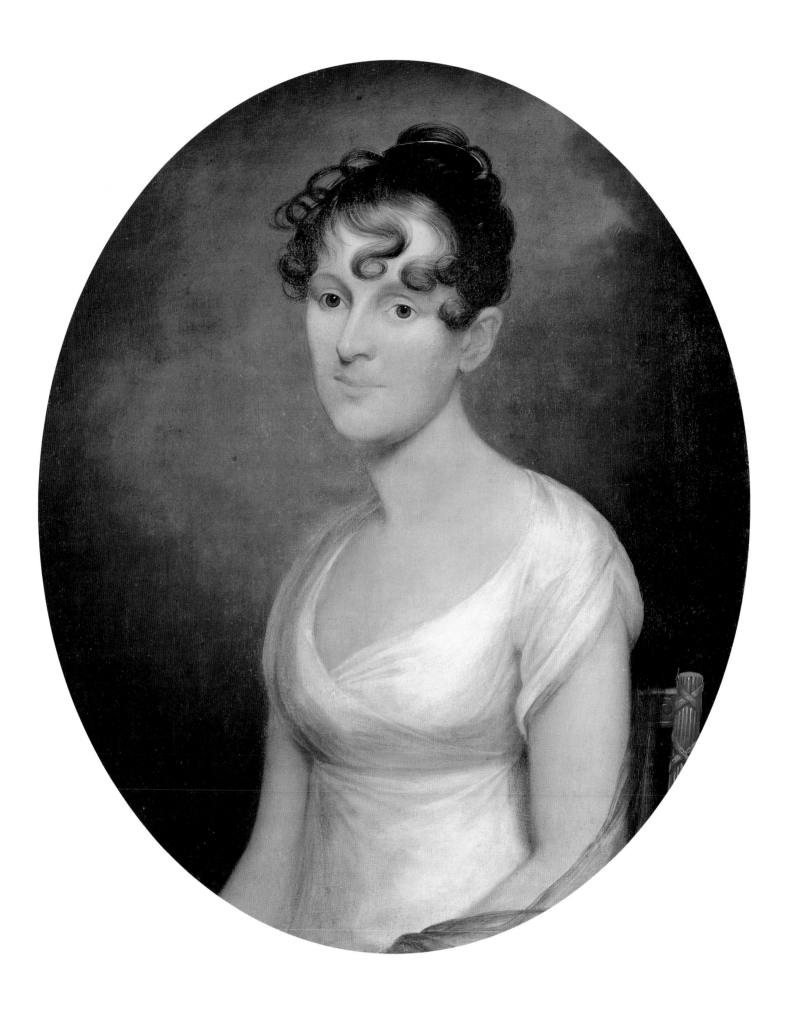

12

Juliana Westray Wood 1778–1836
Actress

Rembrandt Peale 1778–1860
Oil on canvas, 76.2 x 63.5 cm
(30 x 25 in.), circa 1811
NPG.81.120

Born in England, Juliana Westray came to the United States with her parents and two sisters in the 1790s. She made her dramatic debut in 1797 at Boston's Haymarket Theatre. Soon after, she and her sister Ellen were appearing in New York City, where Juliana established a solid reputation in supporting roles in *The Merchant of Venice* and in John Dent's *The Telegraph, or, A New Way of Knowing Things* (1795). In 1803, Juliana joined the acting troupe of William Burke Wood, an actor, director, and theater manager in Philadelphia. As part of Wood's troupe, she was soon playing leading roles to rave reviews. In 1804, she and William Wood were married. "Soon after his return from England," reported one newspaper, "Mr. Wood married Miss Juliana Westray, who was then rising rapidly into distinction, and is now an excellent actress on our boards. He was thus rescued from all danger of falling again into his habits of dissipation, and henceforward devoted himself entirely to his profession and his family."[17] For the next twenty years Juliana Wood was a preeminent actress, best known for her performances in *Macbeth*, Sir Walter Scott's *Heart of Midlothian*, and Richard Sheridan's comedy of manners, *School for Scandal*.

This portrait was probably painted in 1811, soon after Rembrandt Peale's return from his second trip to Paris. David Edwin's engraving of the portrait was published in the March 1811 issue of *The Mirror of Taste, and Dramatic Censor*, a short-lived Philadelphia periodical. The engraving is one of several portraits of actors published in the magazine, which featured essays on the history of the stage, theater reviews, and the texts of plays. In the section on the history of the British stage, there would be "portraits of the most celebrated poets, authors, and actors who have flourished on it, and strictures on the professional talents of the latter, illustrated by parallels and comparisons with those who have been most noted for excellence on the American boards."[18] Public interest in the private lives and morality of actors and actresses was hinted at in the text that accompanied the engraving of Mrs. Wood. Calling the image "a striking likeness," the author noted that

the portrait of Mrs. Wood comes from the pencil of PEALE *and the graver of* EDWIN; *and will no doubt be acceptable to our subscribers, not only as a handsome specimen of American arts, but as a striking resemblance of a lady whose public talents and private virtues have raised her to a very high rank in public estimation.*[19]

The painting shows Mrs. Wood in front of a stage setting, with a curtain and ropes, as well as a landscape, visible behind her. The engraving, however, shows only the figure of the actress, perhaps underlining her private morality by removing the visual references to the theater. ✻

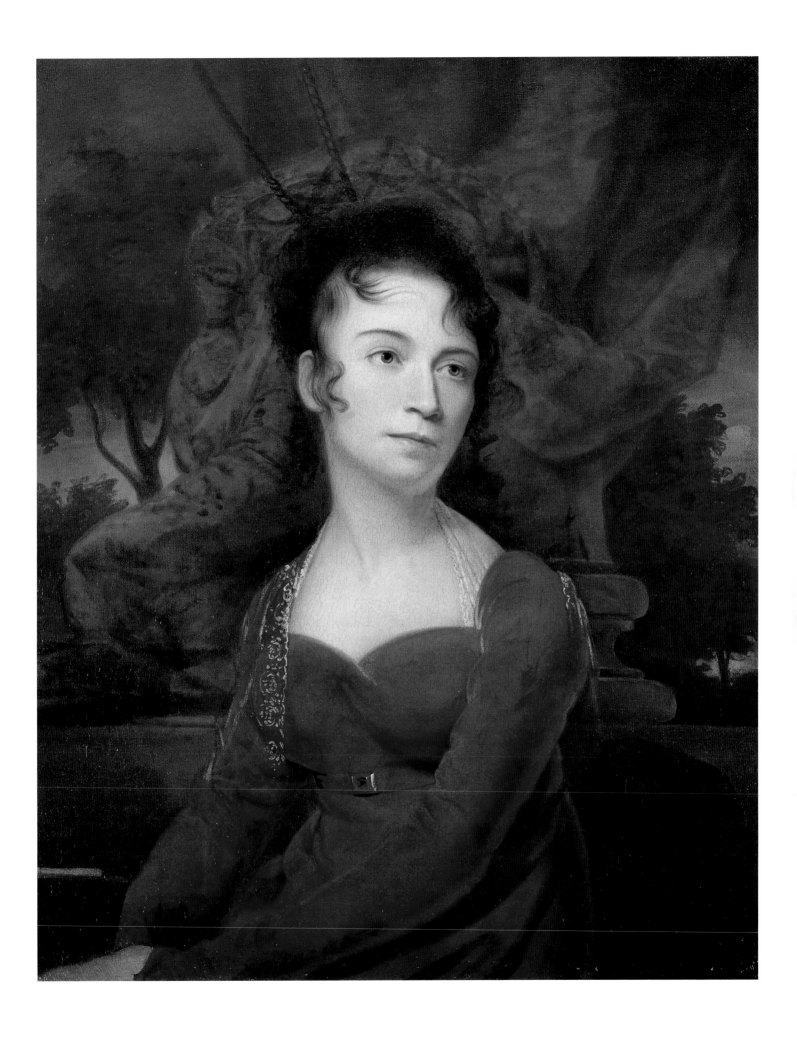

13

Samuel F. B. Morse 1791–1872
Artist, inventor

Self-portrait
Oil on millboard, 27 x 22.5 cm
(10⅝ x 8⅞ in.), 1812
Acquisition made possible by a
generous contribution from the
James Smithson Society
NPG.80.208

Best known as the inventor of the telegraph, Samuel Finley Breese Morse first pursued a career as an artist. After graduating from Yale in 1810, he went to England, where he studied with Washington Allston and Benjamin West. Soon after his arrival, he wrote to his parents on January 30, 1812, that he had completed five pictures, including a self-portrait, which is believed to be the Gallery's painting. He wrote: "I have painted 5 pieces since I have been here, 2 landscapes and 3 portraits, one of myself, one a copy from Mr. West's copy from Vandyke, and the other a portrait of Mr. Leslie, who is also taking mine."[20] A larger version (Addison Gallery of American Art) is believed to have been painted a year or two later. The profiles, unusual compositions for self-portraits, may result from the influence of Allston, who had painted a similar portrait of Francis Dana Channing in Boston in 1808–1809 (private collection). The cape or robe that he wears has not been identified.

On his return to the United States in 1815, Morse became a successful portrait painter. In 1824 New York City became his permanent home. Part of the younger generation of artists who objected to the pro-patron emphasis of the American Academy of the Fine Arts, he became a founder of the National Academy of Design in 1826. Among his most notable paintings was a full-length image of the Marquis de Lafayette (1825–1826; New York City Hall). Another was the *House of Representatives* (1822–1823; Corcoran Gallery of Art), which includes more than eighty portraits. His return to Europe in 1829 culminated in his painting of the *Gallery of the Louvre* (Terra Museum of American Art).

By the early 1830s, Morse turned from art to conducting a series of electrical experiments, which culminated in 1838 with a model for the modern telegraph. By 1844, he was seated in the United States Capitol tapping out the first long-distance telegraph message—"What hath God Wrought!"—in a code that still bears his name. Today, Morse's reputation rests almost entirely on that accomplishment. Nevertheless, art historians also regard him as one of this country's significant artists of the romantic school. ✳

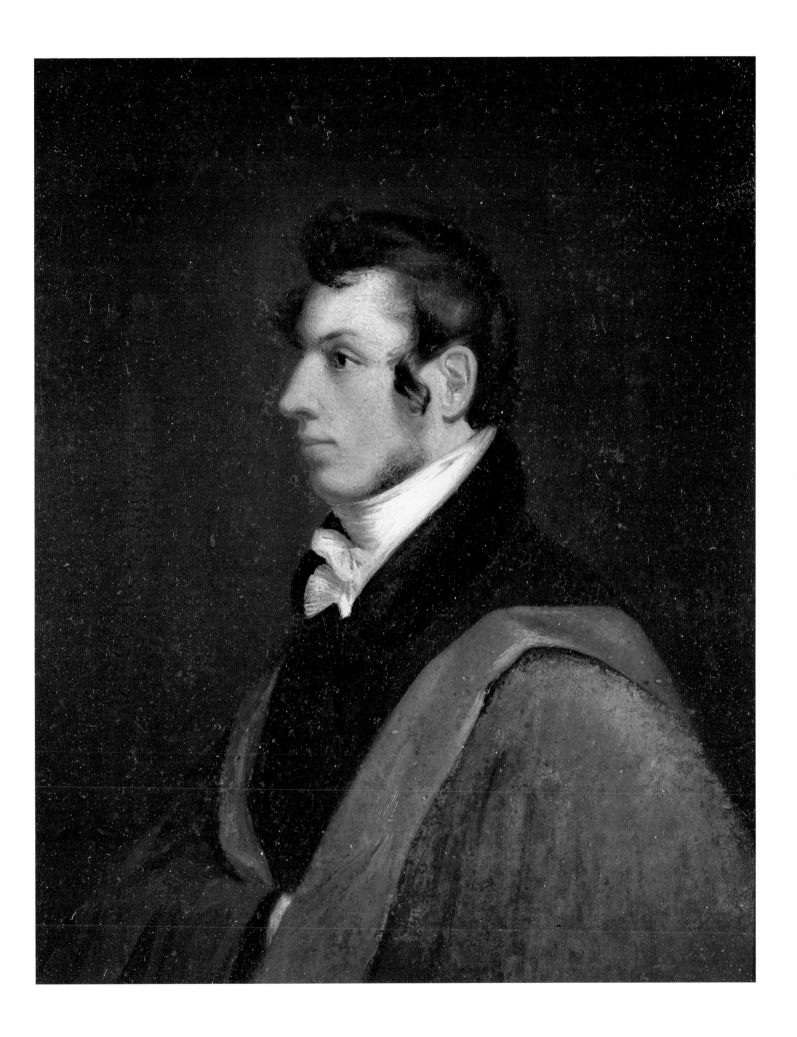

Rufus King 1755–1827
Statesman

Gilbert Stuart 1755–1828
Oil on panel, 76.2 x 62.9 cm
(30 x 24¾ in.), 1819–1820
Acquisition made possible by a
generous contribution from the
James Smithson Society

NPG.88.1

A leading member of the early conservative political coalition known as the Federalists, Rufus King was among the most persuasive orators at the Constitutional Convention of 1787. After serving as one of New York's first United States senators, he became America's minister to Great Britain. Serving in that post from 1796 to 1803, King was in England at a time when conflicts over sea and trading rights were threatening Anglo-American peace almost daily. It was largely to his credit that these constant frictions between the two powers never erupted into open war. Returning to the Senate in 1813, King could claim no significant accomplishments during his last years in public office. Nevertheless, his eloquence in debate impressed many. In 1814 Daniel Webster, who was himself to become a legendary orator, wrote of King: "You never heard such a speaker. In strength, and dignity, and fire . . . he is unequalled."[21]

Painted in 1819–1820 by Gilbert Stuart, this portrait was commissioned as part of a portrait exchange between King and his friend Christopher Gore, also a longtime Federalist. A prominent lawyer and one-term governor of Massachusetts, Gore had been King's classmate at Harvard. Their friendship grew during the late 1790s, when both men held diplomatic appointments in England. John Trumbull painted portraits of both men at that time. By 1819, Gore and King were among the Federalist Party's elder statesmen. Desiring likenesses of each other, they agreed to a portrait exchange. In 1819, King sat for Stuart while visiting Gore in Boston. A few weeks later, Gore wrote, "Forget not my picture and pray press on Stuart its early completion. It will gladden my remaining days, be they few or many."[22] After seeing the portrait, Gore wrote to King: "We have been highly gratified with your Picture—It is a good Picture, and on the whole a Likeness, though I think in this Respect subject to some Criticism—one Eye is drawn down as to give, in a small Degree, the appearance of squinting."[23] Stuart made two versions of the portrait. While the original (Museum of the City of New York) went to Gore, King acquired the replica, the painting now owned by the Gallery. The second half of this portrait exchange was completed when John Trumbull painted a portrait of Gore, which unfortunately was destroyed by fire in 1948 or 1949. ✳

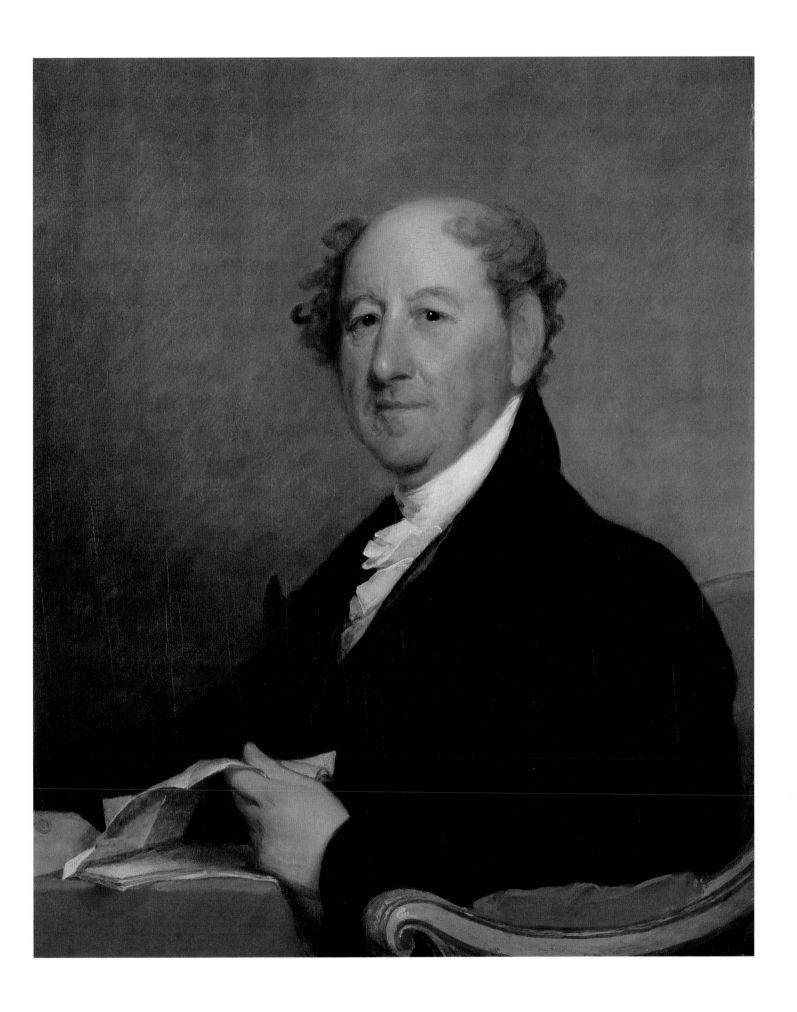

15

Loammi Baldwin 1780–1838
Engineer

Chester Harding 1792–1866
Oil on canvas mounted on aluminum,
90.8 x 70.5 cm (35¾ x 27¾ in.), 1823
NPG.85.6

A historian once observed of Loammi Baldwin that "no man so well deserves the name of Father of Civil Engineering in America." Indeed, in the early 1800s, when this country generally relied for its public improvements on "men of strong minds" but "little practice," Baldwin was one of the few to approach civil engineering as a professional discipline unto itself. Though trained for the bar, Baldwin soon realized that engineering was his real calling, and in 1807 he was crossing the Atlantic to prepare for his new endeavors by inspecting public works projects in Europe. Among his accomplishments over the next three decades were the construction of a fort at Boston Harbor and plans for improving river and road transportation in Virginia. One of his most formidable enterprises was the construction of the Union Canal in Pennsylvania in the 1820s.

This portrait was painted in 1823 during Baldwin's second trip to England, and artist Chester Harding's first. These two rising stars from Massachusetts knew each other through their mutual friend, artist Washington Allston.

Harding, who had arrived in the country only two weeks prior to painting Baldwin, was eager to show off his talent. The portrait, with its dramatic crossed-arm pose and adept brushwork, is evidence of a rapid improvement in Harding's skills, as well as the influence of viewing portraits in English collections. Five days before beginning his portrait of Baldwin, Harding had visited the renowned collection of John Julius Angerstein, where he saw "for the first time an original Vandyke" and pronounced it "masterly indeed." In his journal, Harding noted on September 2 that he "Commenced the head of Mr. Baldwin for myself."[24] A week later he recorded his judgment of the painting: "Finished the portrait of Mr. Baldwin. Not entirely satisfied with it, but by no means discouraged; for I daily behold worse paintings than I ever painted, even in Pittsburg [sic]."[25] Harding made two versions of the portrait, exhibiting one at the Boston Atheneum in 1827. The original, now owned by the Portrait Gallery, came down through the Baldwin family, while the replica (Massachusetts Institute of Technology) once hung at the Engineers Club in Boston, a tribute to the self-taught engineer. ✳

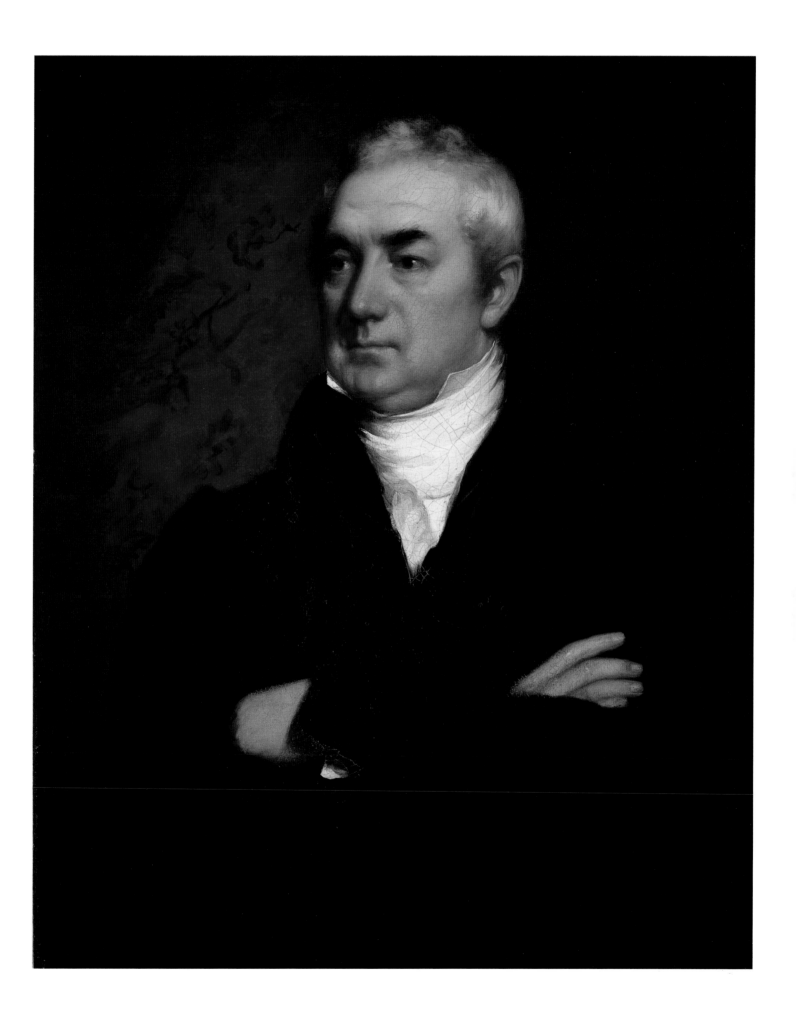

16

Samuel Ringgold 1796–1846
Mexican War officer

John Vanderlyn 1775–1852
Oil on canvas, 71.1 x 58.8 cm
(28 x 23⅛ in.), circa 1825
Gift of the William Woodville Estate

NPG.96.93

Major Samuel Ringgold became a national hero following his death in 1846 from injuries suffered at the Battle of Palo Alto, in the Mexican War. Born in Washington, D.C., Ringgold graduated from the United States Military Academy at West Point in 1818, a member of its first graduating class, and entered the army as lieutenant of artillery. General Winfield Scott immediately selected Ringgold for his staff. After Ringgold served with Scott during the Florida Indian War of the late 1830s, he was cited for "meritorious service" and promoted to major general. The promotion was an indirect acknowledgment of his military innovations: the McClelland military saddle and the idea of flying artillery, a tactical concept employing artillery pieces that moved quickly from place to place. When the Mexican War broke out, Major Ringgold was put in charge of the artillery regiments that were part of General Zachary Taylor's invading force. On May 8, 1846, in the first clash of the war, near the town of Palo Alto, Ringgold employed his famous flying artillery, which helped a much smaller American force win a decisive victory. Wounded in the battle, Ringgold died three days later. News of his death created an explosion of national pride across the United States, and he quickly became a much-celebrated hero.

This portrait of Ringgold was made by New York artist John Vanderlyn around the year 1825. Ringgold is depicted wearing a staff officer's blue dress uniform. The bullet or ball buttons, the herringbone twill fabric, and the "V"-neck collar are all features in use during 1821–1827, as is the shape of the sleeve seam on the shoulder. It is possible that the red collar of Ringgold's cape is an artillery designation, since the color red was usually used to indicate artillery. Vanderlyn's early training with Gilbert Stuart and at the École des Beaux-Arts, Paris, was sponsored by Aaron Burr. After a brief return to the United States in 1801, Vanderlyn was in Europe from 1803 until 1815. When he returned to the United States, he hoped to be rewarded with a federal commission for a painting for the Capitol Rotunda. Instead, he encountered failure in his self-financed attempts to exhibit his historical works and large, panoramic views called cycloramas. In the 1820s, he set up a studio in New York City and began to paint portraits to make a living. Young artillery officer Samuel Ringgold, stationed in New York State as part of General Scott's staff, was one of his sitters during this time, as Vanderlyn mentioned in a letter to C. Edwards Lester decades later:

I have the prospect of some portraits, & have been so fortunate as to [benefit] from the acquaintance of Capt. Ringold of the Navy. I had painted the portrait of a brother of his, Major Ringold, who unfortunately fell in one of the first battles on the Rio grand, it was painted some 25 or 26 years ago when he was quite a young man & aid to Genl. Scott.[26]

Ringgold owned the portrait until his death when, according to the will that he wrote on the morning of the Battle of Palo Alto, it went with all of his possessions to his sister, Mrs. William Schley. ✳

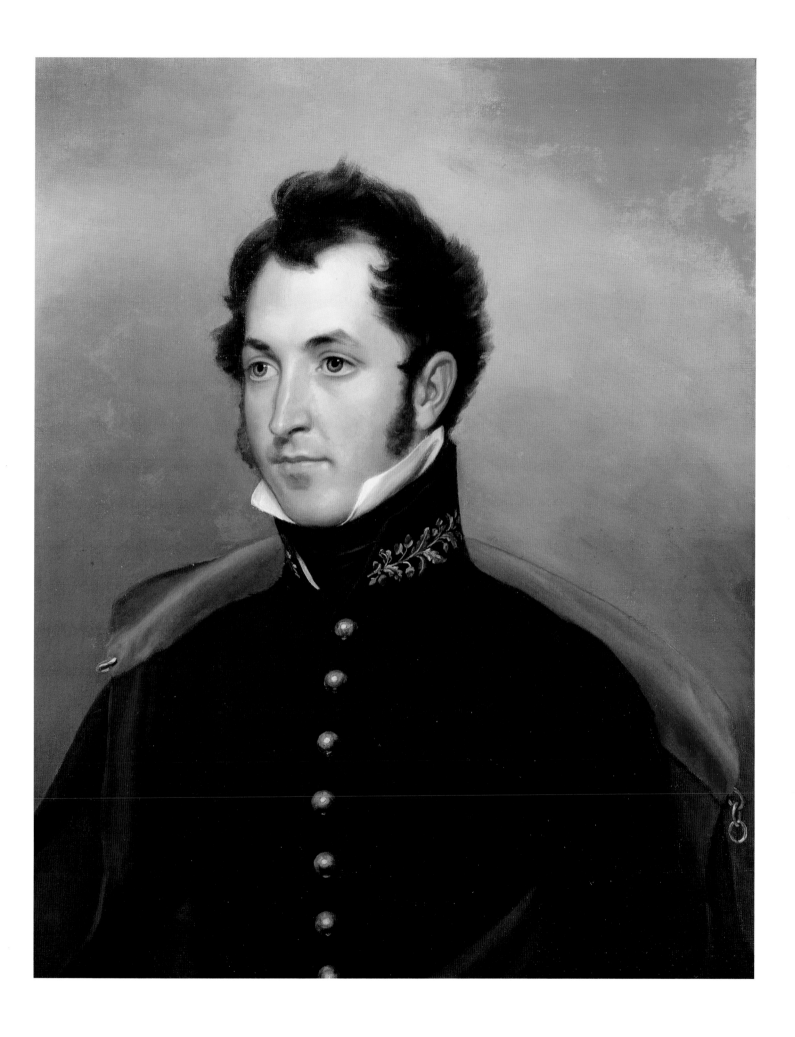

17

Thomas Paul 1773–1831
Clergyman

Thomas Badger 1792–1868
Oil on panel, 20.3 x 16.2 cm
(8 x 6⅜ in.), circa 1825
NPG.70.45

Founder of the African Baptist Church in Boston in 1805, Thomas Paul began the movement toward independent black Baptist churches in the United States. Until that time, African Americans had worshiped as "segregated brethren" within white congregations, a situation that became increasingly awkward because of a conservative reaction following the American Revolution and the increased migration of free blacks to the North. Paul's eloquence as a preacher brought him invitations to speak throughout the country and wherever African Americans were attempting to organize their own churches. In 1809 he helped establish the Abyssinian Baptist Church in New York City, which later became the largest Baptist congregation in the world. Paul served as pastor of the First African Baptist Church until 1829, when he resigned because of poor health.

This portrait of Paul was painted by miniaturist and portrait painter Thomas Badger around 1825. Born in South Reading, Massachusetts, Badger began painting portraits in Boston in 1814. For most of his career, he painted in Boston, but also made painting trips to Maine. In 1857, Andrew Walker, a resident of Kennebunk, wrote that Badger was "then called an excellent painter . . . and now is supposed to be as good if not the best artist in the city [of Boston]."[27]

The portrait, which depicts Paul in the act of preaching, is listed in Badger's checklist of portrait commissions (private collection, 1986). The notebook, dated 1833, contains transcriptions from an earlier list begun in Boston in 1814. Near the end of that earlier list, which typically gives only the sitter's name, is the entry: "Revd. Thomas Paul." The setting for the portrait could be the African Meeting House on Beacon Hill in Boston, constructed in 1806 by the First African Baptist Church. A portrait engraving by J. Hopwood Jr., after a drawing by J. Palmer, which was published in London in 1816, depicts Paul as a younger man, in a similar interior, making the same gesture. ✳

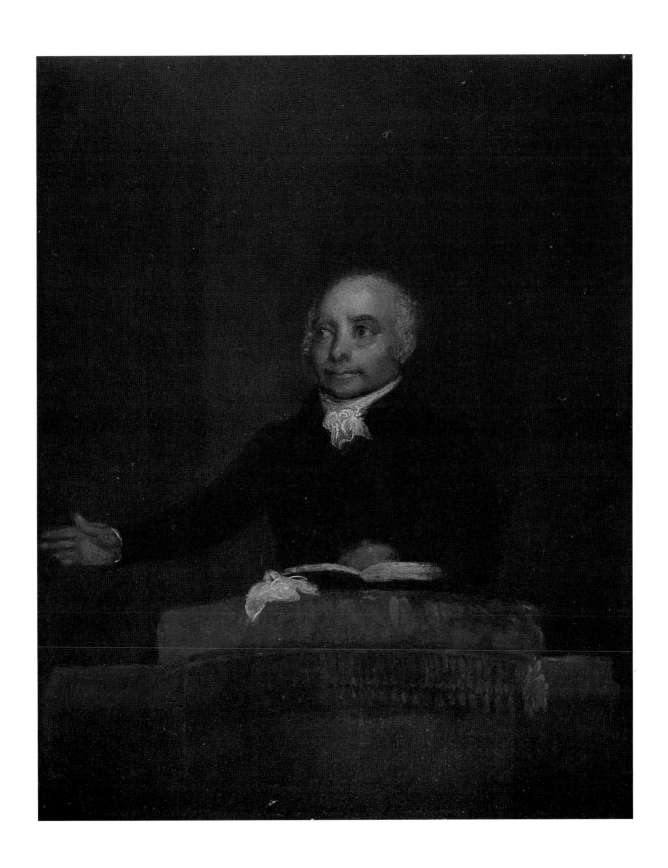

Sequoyah 1770?–1843
Native American statesman

Henry Inman 1801–1846, after Charles Bird King
Oil on canvas, 76.5 x 63.5 cm
(30^{1}/$_{8}$ x 25 in.), circa 1830
NPG.79.174

Sequoyah became interested in developing an alphabet, or table of characters, for the eighty-five or eighty-six syllables in the Cherokee language after he had been crippled by a hunting accident in 1809. By 1821 his task was completed and approved by the Cherokee chiefs, with the result that in a short time thousands of his people learned to read and write. After moving to Oklahoma with the western Cherokee of Arkansas, he encouraged the printing of books and a newspaper in Cherokee and became active in the political life of his tribe. Sequoyah's fame is perpetuated in the name of the genus of California's giant redwoods.

This portrait of Sequoyah is a copy of a painting by Charles Bird King that was made when the Cherokee leader was in Washington, D.C., in 1828 to negotiate a treaty. It depicts Sequoyah holding a tablet with his Cherokee alphabet and wearing a peace medal around his neck. King's original portrait was part of the larger effort conceived by Thomas Loraine McKenney, commissioner of Indian affairs from 1824 to 1830, to record the culture and prominent figures of the Native American tribes. McKenney's collection eventually grew to include more than 140 portraits of Native American leaders. McKenney also published a three-volume *History of the Indian Tribes of North America, with Biographical Sketches and Anecdotes of the Principal Chiefs* (Philadelphia, 1838–1844) with co-editor James Hall. The book included hand-colored lithographs of 120 of the paintings. Henry Inman copied the originals as part of the lithographing process. McKenney was clearly pleased with Inman's work. He declared that the copies were "more impressive than any thing I ever saw. Inman you know is a Master."[28] King's originals later belonged to the Smithsonian Institution, where they remained on display until a fire destroyed most of them in 1865. ✳

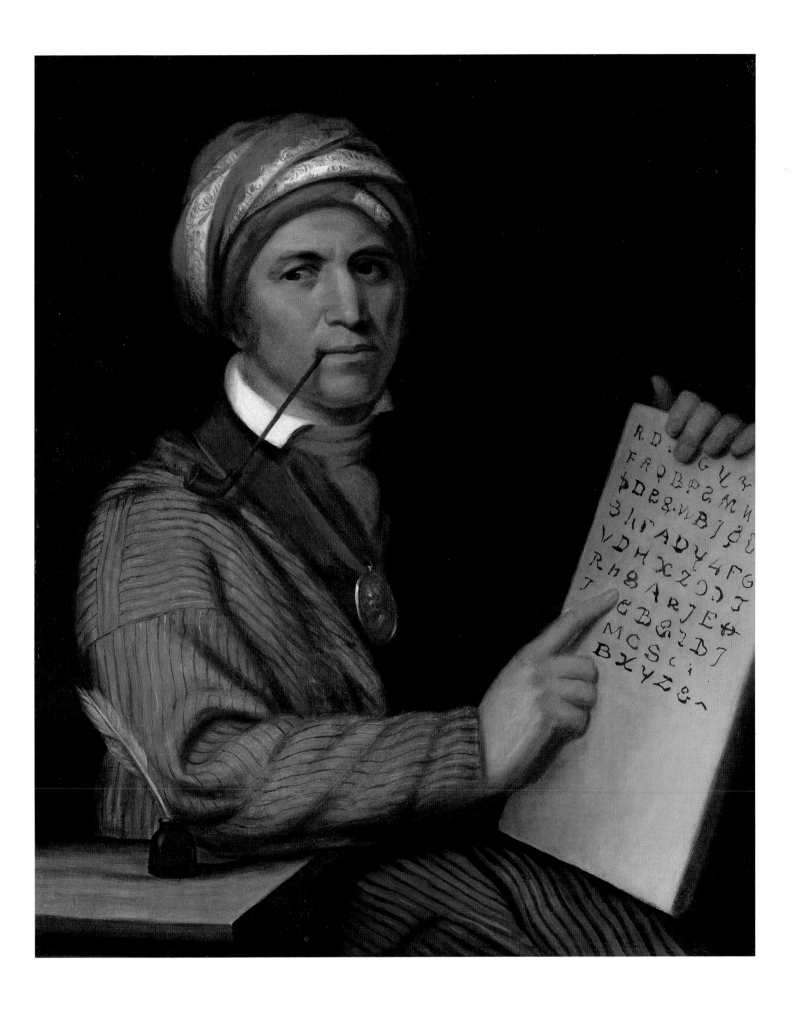

19

William Lloyd Garrison 1805–1879
Abolitionist

Nathaniel Jocelyn 1796–1881
Oil on panel, 76 x 63.2 cm
(29¹⁵/₁₆ x 24⁷/₈ in.), 1833
Bequest of Garrison Norton

NPG.96.102

In the upsurge of northern opposition to slavery that began in the 1830s, there was no more important catalyst than William Lloyd Garrison, editor of the abolitionist newspaper *The Liberator* and a key figure in the American Anti-Slavery Society. In *The Liberator*'s first issue in 1831, Garrison declared that in the fight against slavery, "I will not excuse—I will not retreat a single inch—*and I will be heard!*" He remained true to those words. His unstinting dedication to abolition ended only with the demise of slavery more than thirty years later.

Garrison's militance initially inspired hostility, even in his native New England, where a mob once came close to hanging him. But inevitably he was most hated in the South. Beginning in 1831, there was in Georgia a standing offer of a $5,000 reward for his capture.

This portrait by New Haven, Connecticut, painter and engraver Nathaniel Jocelyn was commissioned by the artist's brother Simeon Smith Jocelyn, also an engraver. Both were ardent abolitionists. In March 1833, Simeon Jocelyn wrote to Garrison:

I am desirous to have you sit to my brother for a portrait before you leave for England. . . . It is my design to engrave yours whilst you are in England, and publish the print. I have long thought that your friends and foes would view your portrait with interest; and as the Lord has been pleased to give you a head bearing none of the destructive disposition *which opposers ascribe to you, it may not be amiss to lead them by a view*

of the outward man to a more favorable examination of your principles. I am confident that this is the effect where your face is seen, and why not where its imitation should be viewed?[29]

Simeon planned to sell the engraved image of Garrison to raise money for the abolitionist movement, as well as to heighten Garrison's public image. Garrison, in a letter to Harriet Minot a month later, noted his hesitation about the plan to have his portrait made:

To-morrow I start for New Haven, in which place I shall stay two or three days, in order to have my portrait taken and engraved upon steel. This I do reluctantly; but my friends are imperious, and I must gratify them. This sticking up one's face in print-shops, to be the "observed of all observers," is hardly consistent with genuine modesty, but I can in no other way get rid of the importunities of those who would pluck out their eyes to give me.[30]

En route to England later, he wrote to Harriet Minot about the portrait: "I think [Jocelyn] has succeeded in making a very tolerable likeness. To be sure, those who imagine that I am a monster, on seeing it will doubt or deny its accuracy, seeing no horns about the head; but my friends, I think, will recognize it easily."[31] Garrison wrote to abolitionist Robert Purvis in a similar tone: "I am happy to inform you that Mr. N. Jocelyn had completed what is deemed a good likeness of the madman Garrison."[32] Purvis later commissioned Nathaniel Jocelyn to paint Cinque, the leader of the African mutineers aboard the *Amistad* in 1839. ✷

20

Davy Crockett 1786–1836
Frontiersman

Chester Harding 1792–1866
Oil on canvas, 76.2 x 63.5 cm
(30 x 25 in.), 1834
Future bequest of Ms. Katharine Bradford

L/NPG.I.88

Davy Crockett, the famous frontiersman from Tennessee, served in the United States House of Representatives for two terms from 1827 to 1831, and quickly became well known in the capital for his self-promoting tall tales. Returning to the House in 1833 after a two-year hiatus, he went the following year on a speaking tour of eastern cities, which was designed to promote the interests of the anti-Jacksonian Whig Party. During his stay in Boston, he sat for his portrait to Chester Harding, the city's most popular portrait painter. Crockett arrived in Boston on May 3, and "next morning I was invited by Mr. Harding to visit his gallery of paintings, where he had a great many specimens of the fine arts; and finally he asked me to sit for him until he could get my likeness, which I did, during my stay, and he has it now, hung up among the rest of the fine arts."[33] The sitting took place on May 6, as reported in the *Boston Transcript*. The image agrees with a contemporary description:

Colonel Crockett is an uncommonly fine looking man. His face has an exceedingly amiable expression and his features are prominent and striking. He wears his hair which is black, (with a light shade of brown) parted down the centre of his forehead, combed back from his temples, and ending in a slight curl at the neck—not unlike the simple manner of many of the clergy.[34]

Harding's painting is one of five portraits that Crockett sat for in 1833 and 1834, a testimony to his growing fame. While the circumstances for the other portraits are not fully known, at least two were intended to be reproduced in prints, which indicates a popular market for Crockett's image. For one of these, a portrait by Samuel Stillman Osgood that was lithographed by the Philadelphia firm of Cephas G. Childs and George Lehman in 1834 (National Portrait Gallery, Smithsonian Institution), Crockett wrote a testimonial as part of the caption on the plate: "I am happy to acknowledge this to be the only correct likeness that has been taken of me. David Crockett." Less than two years later, in 1836, Crockett met his untimely death during the war of Texas independence from Mexico, at the Battle of the Alamo. A legend already in his own lifetime, he became a hero after his dramatic death. ✱

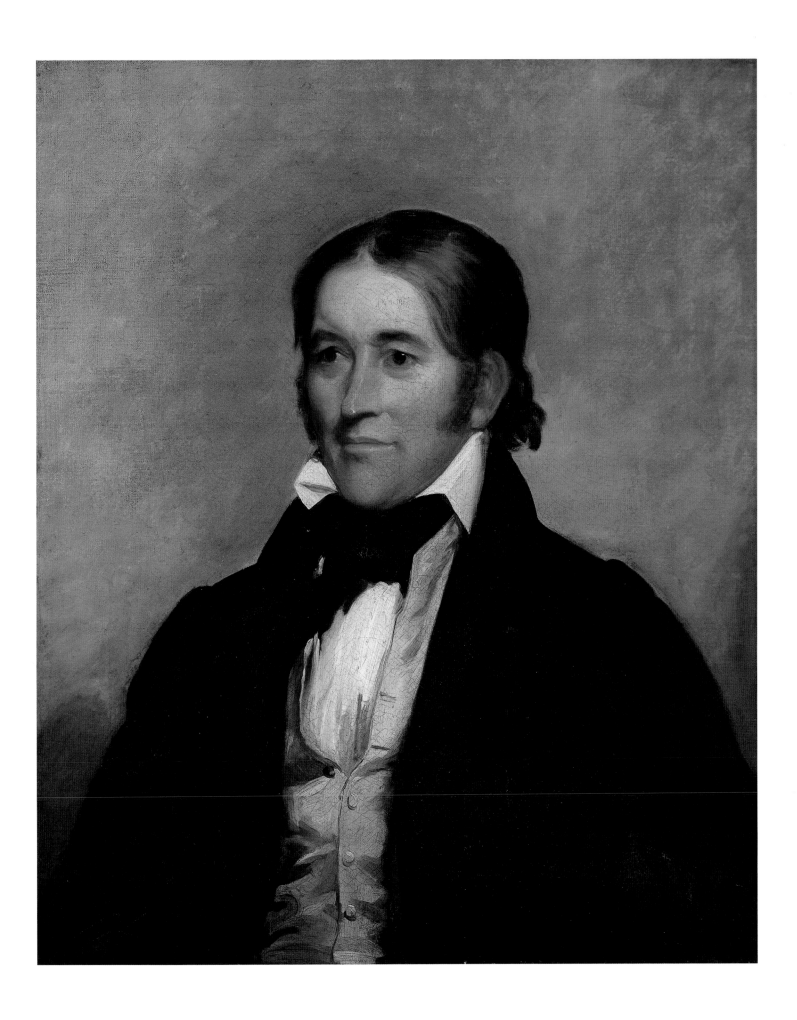

21

Henry Clay 1777–1852
Statesman

John Neagle 1796–1865
Oil on canvas, 70 x 54.5 cm
(27⁹/16 x 21⁷/16 in.), 1842
NPG.93.476

His admirers called him "Gallant Harry," and his impetuous charm made him quite possibly the most beloved politician of his generation. But the real legacy of Kentucky's Henry Clay was his unstinting devotion, in the House of Representatives and later in the Senate, to maintaining a strong American union. In the early 1830s, as southern states threatened to nullify federal authority over a bill promising high tariffs detrimental to their plantation economies, it was Clay who set aside his own preference for the new law to orchestrate a compromise. In 1850, with the North and South on the verge of armed conflict over the extension of slavery into new western territories, it was Clay again who stepped in with proposals that, temporarily at least, satisfied both sections. This last act of his career earned him the title of Great Pacificator.

In the fall of 1842, fifteen Philadelphia Whigs who were supporters of Henry Clay commissioned artist John Neagle to paint a full-length portrait of Clay, whom they hoped would be their party's presidential candidate in 1844. Neagle, one of the city's leading portrait painters, shared many of Clay's political views, notably those on protective tariffs. Clay gave Neagle several sittings at Ashland, his home in Kentucky. First the artist completed this bust portrait, as well as a number of sketches. On the back of the Gallery's portrait, he wrote, "Painted from life by John Neagle. November 1842. at Ashland." Neagle then used this portrait and the sketches to complete the full-length of Clay, which was exhibited in Lexington and Frankfort the following spring, before it was brought to Philadelphia. Clay wrote to Neagle on May 29, 1843:

In returning to the City of Philadelphia, you will naturally desire to carry with you, along with the full length portrait of me, which you have taken at this place, some evidence of the opinion which is entertained of it in Kentucky. I know that you took the greatest pains to produce a perfect likeness, studying thoroughly your subject, and carefully examining all the previous pictures of it, which were accessible to you. And it is the judgment of my family and friends that you have sketched the most perfect likeness of me that has been hitherto made. My opinion coincides with theirs. I think you have happily delineated the character, as well as the physical appearance, of your subject.[35]

The men who had commissioned the portrait presented it to the National Clay Club at a public ceremony in Philadelphia. The imagery in the painting conveyed to viewers a summary of Clay's political positions and accomplishments, and a widely distributed engraving of the portrait by John Sartain helped to promote Clay's candidacy for President. Despite this grand imagery, however, Clay did not win the 1844 election. In the wake of the Whig Party's subsequent collapse, Clay's portrait, which was in the care of the Germantown (Pennsylvania) Clay Club, eventually became the property of the Union League of Philadelphia. It hangs in the league's building to this day. A second version is at the United States Capitol. The Gallery's life study was subsequently owned by Philadelphia newspaper editor and publisher Morton McMichael, who was one of the original subscribers for the commission. He served as mayor of Philadelphia from 1866 to 1869, and was a founder and early president of the Union League. ✳

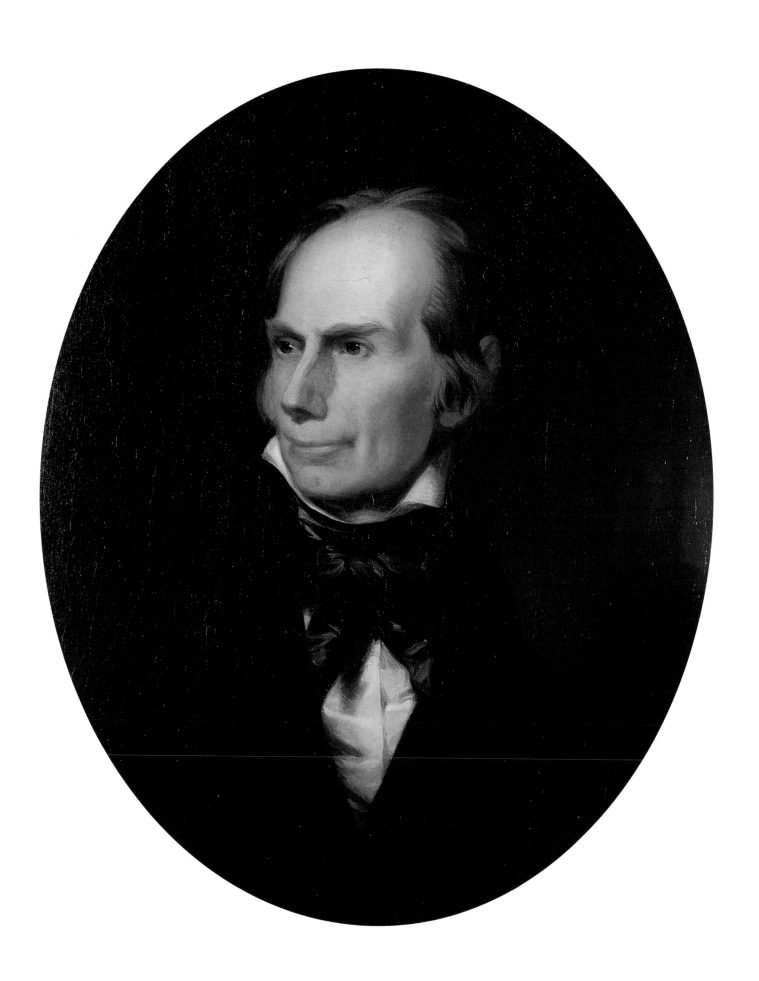

Frederick Douglass 1818–1895

Abolitionist, statesman

Unidentified artist
Oil on canvas, 69.9 x 57.1 cm
(27$^{1/2}$ x 22$^{1/2}$ in.), circa 1844
NPG.74.45

Born into slavery on Maryland's Eastern Shore, Frederick Douglass was determined by his early teens to escape his bondage, and in 1838, he fled northward to settle in Massachusetts. He soon joined the antislavery movement, and by the mid-1840s his commanding eloquence in offering firsthand testimony to the oppressions of slavery had transformed him into one of the movement's most persuasive spokesmen. Recalling the figure that Douglass cut at abolitionist gatherings, Elizabeth Cady Stanton wrote: "He stood there like an African prince, majestic in his wrath, as with wit, satire, and indignation he graphically described the bitterness of slavery."[36] Douglass's reforming zeal remained strong all his life. After the Civil War put an end to slavery, he continued to be a leading defender of the rights of African Americans in an era where all too often those rights were ignored.

The identity of the artist who painted this portrait is not known. It was first recorded in 1902, when it was given to the Rhode Island Historical Society by Lewis Janes from the estate of his father, Alphonso Richard Janes (1804–1892). The elder Janes, a friend of Douglass's, was treasurer of the Rhode Island Anti-Slavery Society for many years. After its acquisition by the National Portrait Gallery, the painting was attributed to Elisha Hammond, a painter who lived in Florence, Massachusetts, the communal society that Douglass visited in 1844. However, it is now clear that this could not be Hammond's portrait, which Douglass owned until his death in 1895 and specifically bequeathed to his daughter, Rosetta D. Sprague.

The Gallery's portrait is very similar to the engraved likeness that appeared as a frontispiece to Douglass's autobiography, *Narrative of the Life of Frederick Douglass, an American Slave* (Boston, 1845). The painting was probably based on the engraving, or on the unlocated daguerreotype from which the engraving was no doubt made. One possibility is that the painting is the work of African American artist Robert Douglass (1809–1887), a Philadelphia portrait painter, daguerreotypist, and illustrator. Douglass exhibited a portrait of Frederick Douglass, who was not a relative, at the Pennsylvania Academy of the Fine Arts in 1878. None of his paintings are located today. When the artist went to the West Indies in 1848, Frederick Douglass wrote:

It will interest our readers to know that Robert Douglass is an artist of skill and promise, who, in this country, was unable to gain a livelihood by his profession, though he added to it that of Daguerreotypist; and has therefore emigrated to a country where he hopes the colors he uses, and the way he uses them, will be the test of his merit, rather than that upon his own body, which he neither put on nor can rub off.[37]

However, Robert Douglass's portrait of Frederick Douglass was offered for sale in Philadelphia in 1894, making it unlikely that it was the painting in Janes's estate. Another portrait of Douglass that is unlocated today was referred to in *The Liberator* for January 23, 1846, as a "kit kat portrait of Frederick Douglass, by W. P. Brannan, a very promising young artist of Lynn, in whose studio it may be seen, and, as we understand, purchased." Possibly this is Cincinnati artist William Penn Brannan (1825–1866). ✳

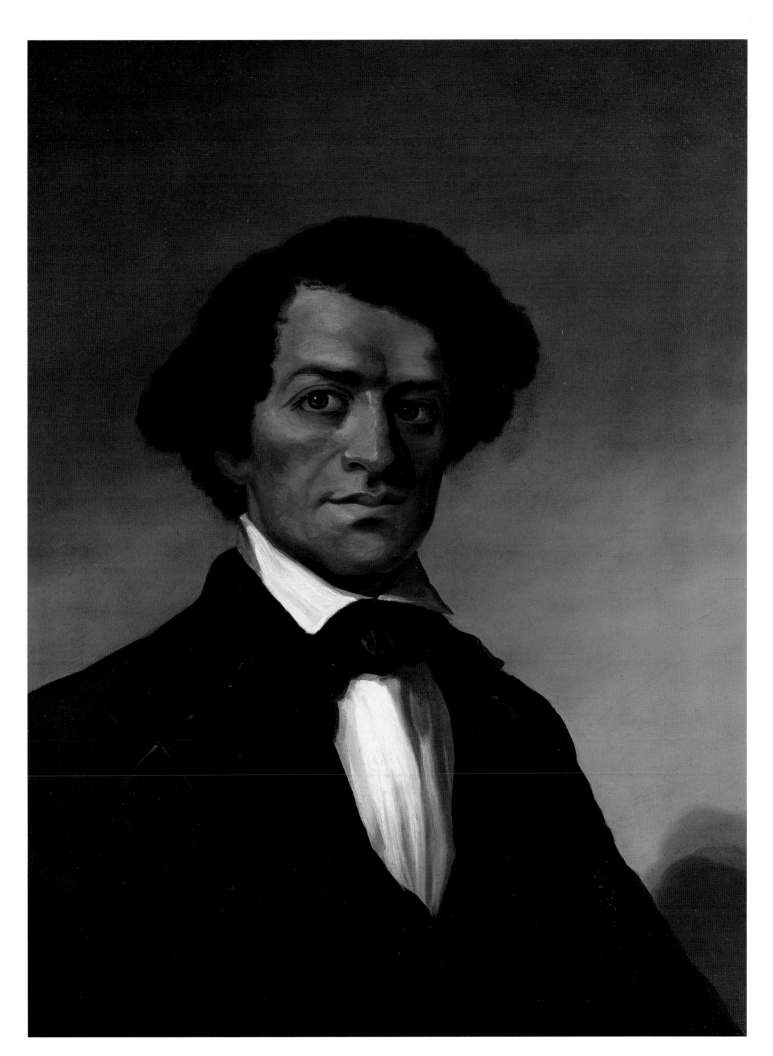

John C. Calhoun 1782–1850
Statesman

George Peter Alexander Healy 1813–1894
Oil on canvas, 91.5 x 73.7 cm
(36 x 29 in.), circa 1845
NPG.90.52

South Carolina's John Caldwell Calhoun was a formidable presence in American politics for nearly four decades. In that time, he served twice as Vice President—under John Quincy Adams and Andrew Jackson—and in two cabinets. It was during his later years in the Senate, from 1832 to 1843 and again from 1845 until his death, however, that he had his greatest impact as a champion of southern interests and formulator of the states'-rights theory of America's political union. But even as he defended the South against attempts to curb slavery and argued for the right of states to negate federal policies, he sensed that he was fighting a losing battle. His dying words in 1850 were "the South, the poor South."

The austere, dark-eyed Calhoun began his career as an ardent nationalist, in league with Henry Clay. By the mid-1830s, however, his unswerving localism had placed the two men at opposite poles. Yet like many of Calhoun's other opponents, Clay harbored an abiding respect for his adversary. At the time of the South Carolinian's death, Clay observed, "I was his senior . . . in years—in nothing else."[38]

At the time Healy painted Calhoun, the Boston-born artist was enjoying great success as a portrait painter in Paris. Accepting a commission from King Louis-Philippe to paint a series of portraits of American statesmen, Healy came to the United States in 1845 to paint former President Andrew Jackson, who was then near death. He probably painted the life portrait of Calhoun on the same trip; one of the four bust-length versions of the Gallery's portrait is signed and dated 1845 (Greenville County [South Carolina] Museum of Art). The second, painted for Louis-Philippe, is dated 1846 (Musée National du Château de Versailles). The third, which is undated, repeats the composition of the first two (Virginia Museum of Fine Arts), while the Gallery's slightly larger version, also undated, is the only one that includes Calhoun's left arm and hand. Healy also used the image to paint a full-length portrait of Calhoun, which was commissioned by the Charleston City Council shortly after Calhoun's death in 1850 (Charleston, South Carolina, City Hall). When he received that commission, Healy responded: "With the greatest pleasure I accept this commission to paint a man for whom I entertained so deep an admiration, and in whose society I derived so much benefit."[39] The portrait that the Gallery owns was given by Calhoun's widow to her husband's longtime friend Henry Gourdin. Although the Portrait Gallery owns other likenesses of Calhoun, Healy's portrait is particularly successful in its characterization of Calhoun's fiery spirit. *

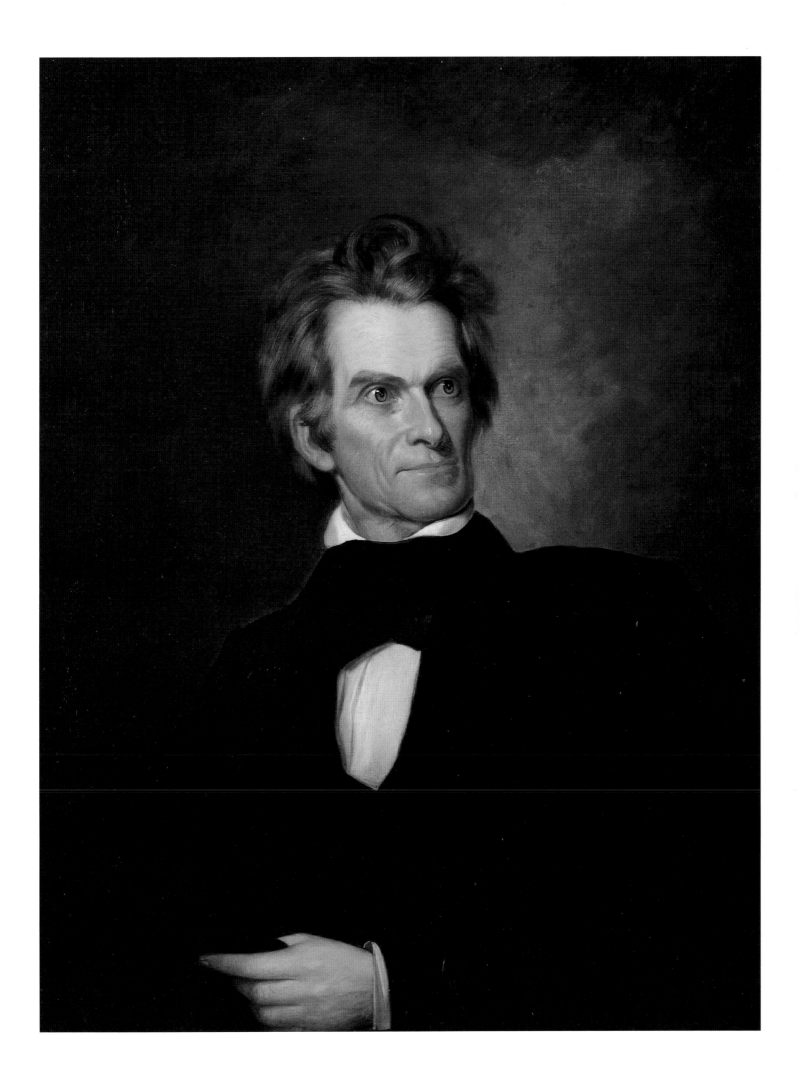

24

Dolley Madison 1768–1849
First lady

William S. Elwell 1810–1881
Oil on canvas, 76.2 x 63.5 cm
(30 x 25 in.) feigned oval, 1848
NPG.74.6

Of all the presidential first ladies, perhaps none is more fondly regarded than Dolley Payne Todd Madison. Serving as White House hostess during the administrations of both the widowed Thomas Jefferson and her own husband James, she invested Washington's social life with an elegance and gaiety that it had never seen before and that has rarely been equaled since. Though capable of winning over friend and foe alike with her unpretentious friendliness, she assiduously avoided enlisting her charms for partisan ends. Nevertheless, her effervescence provided a refreshing counterpoint to her husband's introspective nature and doubtless accounted, in part at least, for the popularity of Madison's presidency in its last several years.

After James Madison's presidency ended in 1817, the couple returned to Montpelier, their Virginia home. Dolley helped her husband put his papers in order, and after his death in 1836, she sold a portion of them to the United States Congress and moved back to Washington. In her later years she was frequently the guest of honor at White House affairs and continued her lavish entertaining, despite her mounting debts.

William S. Elwell, a gifted painter who never attained major fame, was from Brimfield, Massachusetts, and had studied with Chester Harding in Springfield. Apparently his first appearance in the South was in Richmond, Virginia, where he advertised as a painter in December 1847. His likeness of Dolley Madison, painted the following February in Washington, D.C., is considered his best work. Elwell's portrait offers a glimpse of the aging first lady's appearance and enduring personality. The black velvet gown that she is wearing was no longer in fashion, nor is her white silk turban, which she considered her signature piece of clothing. Her age—almost eighty—is somewhat misrepresented by her fake black curls and the heavy rouge on her cheeks. Elwell described her in his diary as "a very Estimable lady—kind & obliging—one of the Old School. Fluent in her conversation—interested in all the events of the day, as lively and as blooming as a Miss of 16. Tho this bloom was artificial, the *Rouge* being applied in a Most delicate & artistic manner." When she recalled how she rescued the full-length portrait of George Washington from the White House during the War of 1812, he noted that she was "a heroic noble woman." During the sittings Madison expressed sympathy with "the struggling artist" and offered to help "if in her power." Perhaps Elwell took her up on her offer of help, for by 1853 he settled in Washington, where he worked as a clerk in the Auditor's Office of the Treasury Department. However, two years later he suffered a stroke that left him partially paralyzed. In his diary, he noted that the portrait was "afterwards sold to Mr Wm Seaton . . . for 100 dollars."[40] Dolley Madison's longtime friend William Winston Seaton had been editor and co-owner of the Washington, D.C., *National Intelligencer* since 1812, and served as mayor of the city from 1840 to 1850. He inscribed on the back of the portrait the words: "Mrs. Madison aged 83 painted by W. S. Elwell in 1848. A faithful portrait W.W.S." ✳

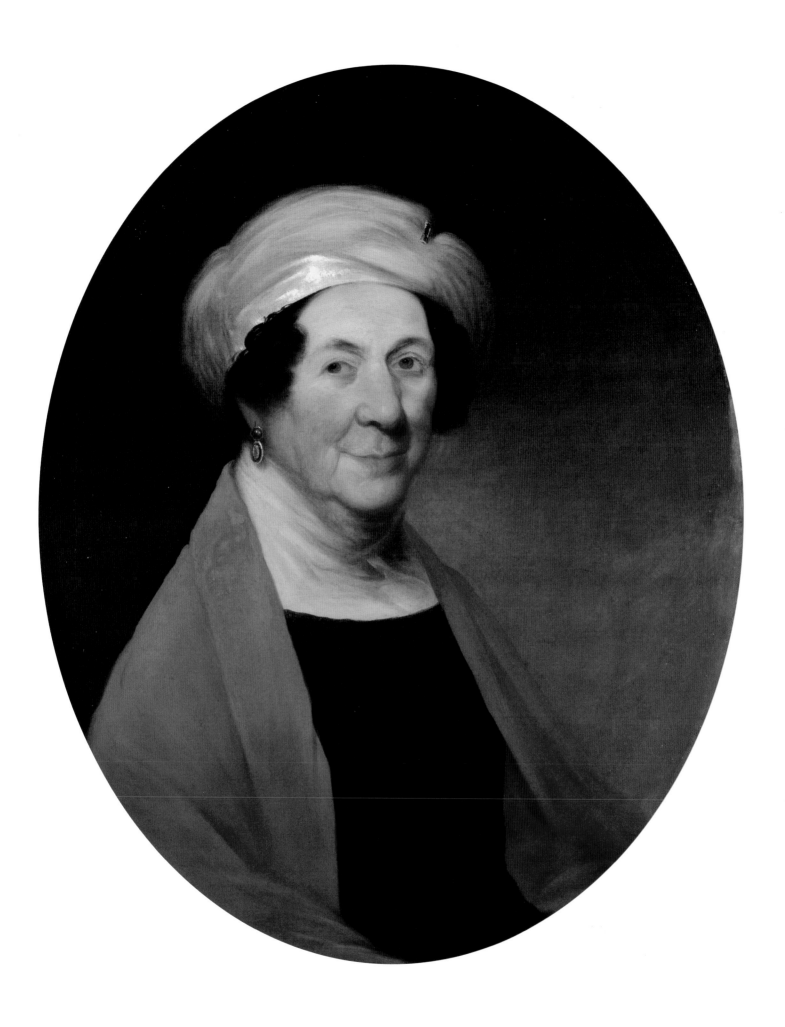

25

George Catlin 1796–1872
Artist

William Fisk 1796–1872
Oil on canvas, 127 x 101.6 cm
(50 x 40 in.), 1849
Transfer from the National Museum of
American Art; gift of Miss May C. Kinney,
Ernest C. Kinney, and Bradford Wickes, 1945
NPG.70.14

After observing an Indian delegation on its way to Washington in the 1820s, George Catlin was haunted by the memory of these "lords of the forest." In 1830, determined to become their historian before white civilization destroyed their way of life, he abandoned his career as a conventional portraitist and set out to the wilderness. For the next six years, Catlin devoted himself to painting portraits of Indian leaders and drawing sketches of tribal life. The pictorial record of his travels constitutes one of the most remarkable archives of the American Indian ever assembled, numbering around five hundred paintings.

It was Catlin's hope that his collection would become the nucleus of a federally financed national museum. To win congressional approval for this plan, the artist exhibited his paintings in many eastern cities. Congress, however, proved indifferent, and in 1839 Catlin took his Indian gallery to Europe. There he published his two-volume *Letters and Notes on the Manners, Customs, and Condition of the North American Indians* (London, 1841), illustrated with engravings after his paintings. Despite great acclaim in London and Paris, mounting debts eventually forced him to sell most of his collection in 1852. The largest portion of his Indian portraits fell

into the hands of Philadelphia businessman Joseph Harrison, whose heirs donated them to the Smithsonian Institution in 1870.

British artist William Fisk painted this portrait of Catlin, his exact contemporary, in England in 1849. The artist and his daughters had fled from France with his Indian gallery after the overthrow of King Louis-Philippe the previous year. Although Catlin was still well known in England at the time of this sitting, enthusiasm for his gallery had lessened, and he was making a living selling copies of his originals. Fisk was a popular painter of portraits and historical works. His likeness is a historicizing image, depicting Catlin as if he is in America, at work on his paintings of Native Americans. In this setting, next to Catlin to the left are the Blackfoot warrior Iron Horn and The Woman Who Strikes Many, also a Blackfoot. These images duplicate the portraits that Catlin had painted in 1832 at Fort Union, in present-day North Dakota. The originals were on display at Catlin's gallery and are listed in his *Descriptive Catalogue of Catlin's Indian Collection . . .* , published by the artist in London in 1848.[41] The result is a portrait that brings to mind Catlin's younger days on the American frontier. ✳

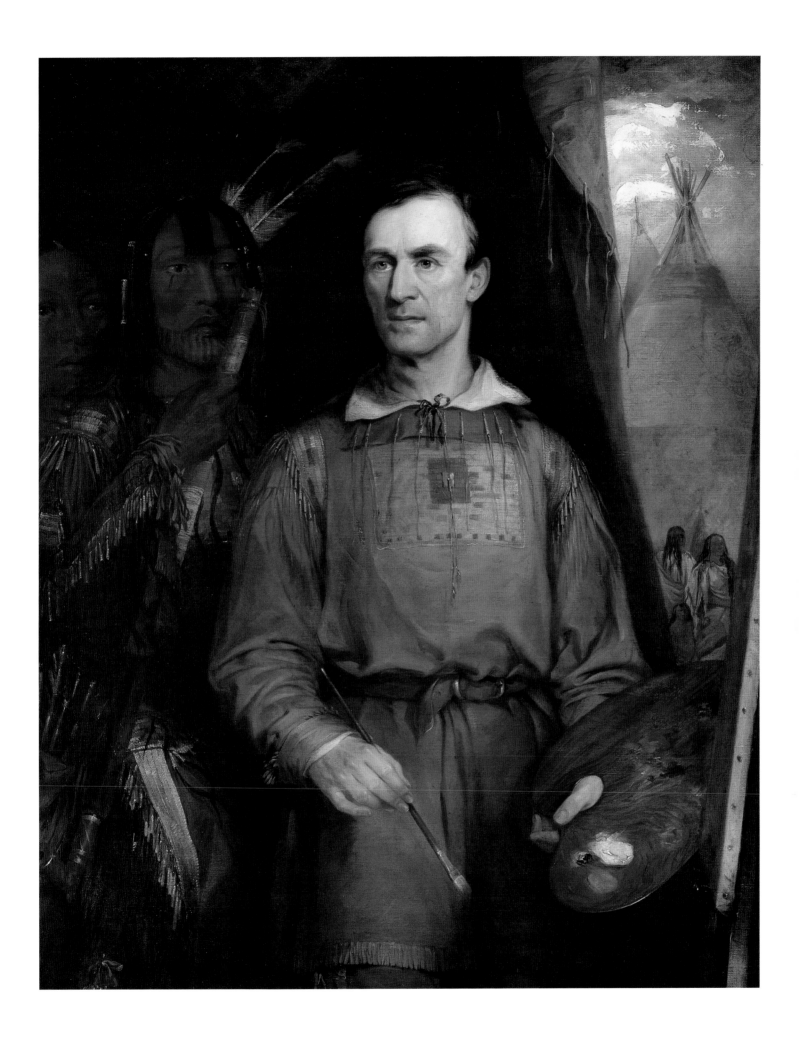

Harriet Beecher Stowe 1811–1896
Author, reformer

Alanson Fisher 1807–1884
Oil on canvas, 86.4 x 68 cm
(34 x 26¾ in.), 1853
NPG.68.1

Harriet Beecher, the daughter of Congregationalist minister Lyman Beecher, was raised in Connecticut, where her literary abilities brought early recognition. She moved with her family to Cincinnati, Ohio, in 1832, when her father became president of the Lane Seminary. Working as a teacher, she published her first book, *Primary Geography*, in 1833. Fiction written during these years was published in 1843 as *The Mayflower; or, Sketches of Scenes and Characters Among the Descendants of the Pilgrims*. In 1835 she married Calvin Ellis Stowe, a professor at the Lane Seminary. When her husband accepted a position at Bowdoin College in 1850, they moved to Maine with their family.

As a resident of Cincinnati, Stowe came in contact with slaves escaping northward, and learned about their lives in the South. In response to passage of the Fugitive Slave Law in 1850, which guaranteed federal backing for the return of runaway slaves, she began writing *Uncle Tom's Cabin*, which was serialized in the *National Era* in 1851–1852 before it was published as a book in 1852. The story describes the lives of three slaves: Tom, who dies of a beating in Louisiana at the hands of Simon Legree, and Eliza and George Harris, who escape from Kentucky to freedom. Its success was immediate; the book sold more than three hundred thousand copies during its first year of publication.

When the story of Uncle Tom was adapted as a play in 1853, this portrait was commissioned by Alexander H. Purdy, owner of the National Theatre in New York, where the play was produced. According to the *Evening Post* (New York), "the manager of the National incurred the expense in consequence of the great success of *Uncle Tom's Cabin*." The paper noted that in addition to the gilt frame on the portrait, "another frame of polished mahogany . . . with a plate glass front, protects it from injury."[42] The *Evening Post* quoted a letter from Stowe's husband, which noted that he was

better satisfied with Mr. Fisher's portrait of Mrs. Stowe than with any other attempt of the kind which he has seen. Every feature is exactly copied, and the general expression is pleasant, life-like and natural. On the whole, to his eye, it is a handsome picture and a good likeness.[43]

Purdy also commissioned a replica (Stowe-Day Foundation, Hartford).

Alanson Fisher, a New York artist, painted this portrait in Andover, Massachusetts, where the Stowes had moved when Calvin Stowe joined the faculty of the theological seminary there. In 1854 Fisher exhibited the portrait at the National Academy of Design in New York, of which he was a member. Stowe's modest appearance was surprising to many. On a trip to England in 1853, she noticed lithographs of herself displayed in shop windows. She reacted that the "horrid pictures do me a service, and people seem relieved when they see me; think me even handsome."[44] When she and Abraham Lincoln met at the White House during the Civil War, in 1862, he is reported to have said, "So you're the little woman who wrote the book that started this great war!"[45] ✽

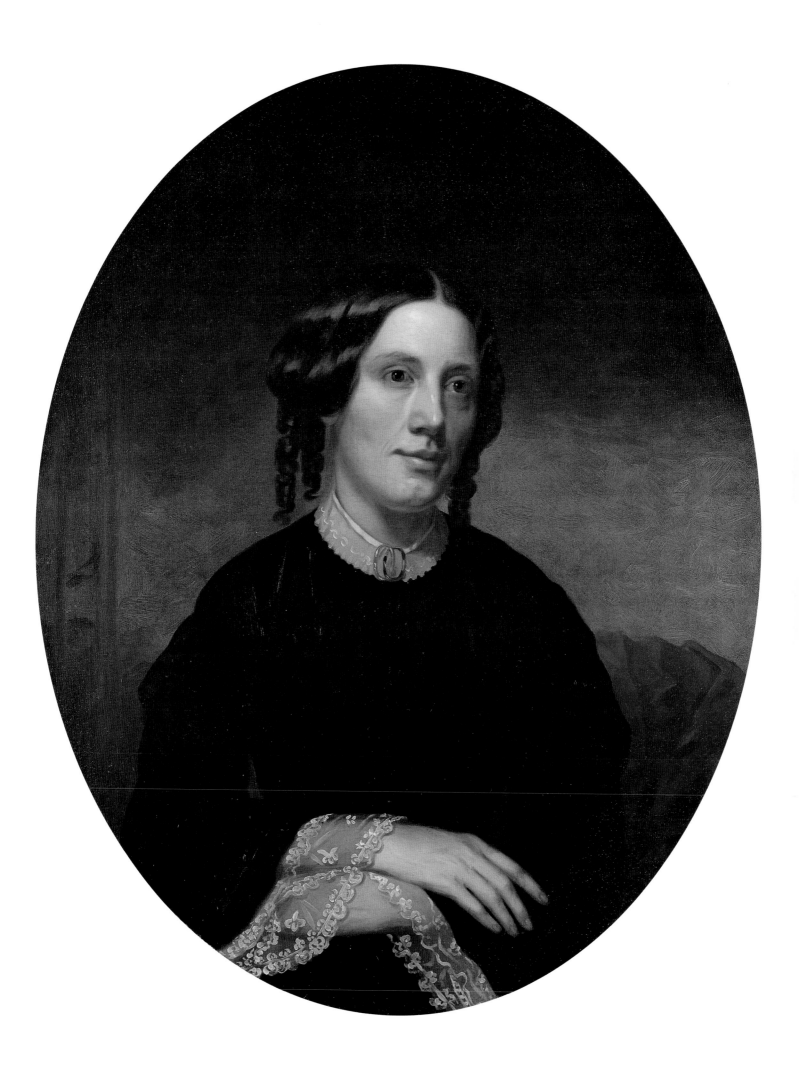

27

Winfield Scott 1786–1866
Mexican War officer

Robert Walter Weir 1803–1889
Oil on canvas, 86.4 x 69.2 cm
(34 x 27¼ in.), circa 1855
NPG.95.52

Later called "Old Fuss and Feathers" for his strict codes of military conduct and dress, Winfield Scott first rose to prominence in the War of 1812. Quickly elevated to the rank of major general, he was, along with Andrew Jackson, the most notable of the military men of that era. Unlike many of them, however, he displayed a genuine belief in using force only as a last resort. Over the course of his career, he also transformed a ragtag army into a professional fighting force. Made general-in-chief of the army in 1841, Scott gained particular fame in the Mexican War, when he invaded Mexico by sea in 1847 and conquered Mexico City. In 1852 he was the Whig Party's unsuccessful candidate for President. When the Civil War began, Scott, in his seventies and in poor health, planned the defense of Washington, D.C., but soon retired.

Robert Walter Weir, a successful painter of portraits, landscapes, and historical works, was professor of drawing at the United States Military Academy at West Point when he painted Scott's portrait for the second time in 1855. The likeness may have been occasioned by Scott's promotion to lieutenant general, making him the first person to hold the rank since George Washington. Weir was at work on the life portrait on September 24, 1855, when John Gross Barnard, the superintendent of West Point, wrote to Scott for permission to have Weir paint the copy for the academy:

I called last evening to pay my respects & to ask your permission to have taken for the Academy, a copy of the Portrait of yourself which Mr. Weir is now painting.

The features of one who has done so much for his country, and so much to illustrate, before that Country, the value of the Military Academy, should be familiar to every Cadet and had in remembrance by every Graduate, and I deem the present opportunity to obtain a delineation of them too favorable to be permitted to escape.[46]

In addition to the academy's version (West Point Museum), there are four very similar versions of this image. The largest—owned by the United States Soldiers' and Airmen's Home in Washington, D.C., of which Scott was an early supporter—is almost a three-quarter-length composition, and includes a view in the background that may represent Mexico City. The other three are slightly smaller and virtually identical. The examples owned by the Gallery and by the Julia L. Butterfield Memorial Library in Cold Spring, New York, have arched upper borders, while the version at the Metropolitan Museum of Art (like that at the West Point Museum) is rectangular. Which of these is the life portrait has not been determined, although "the modeling of the face of the Butterfield library painting most closely resembles the small pen and ink sketch, recently discovered in one of Weir's sketchbooks."[47] The freshness of execution and vividness of detail of the Gallery's version mark this portrait as characteristic of Weir's efforts to document the forceful personality of his sitter. ✴

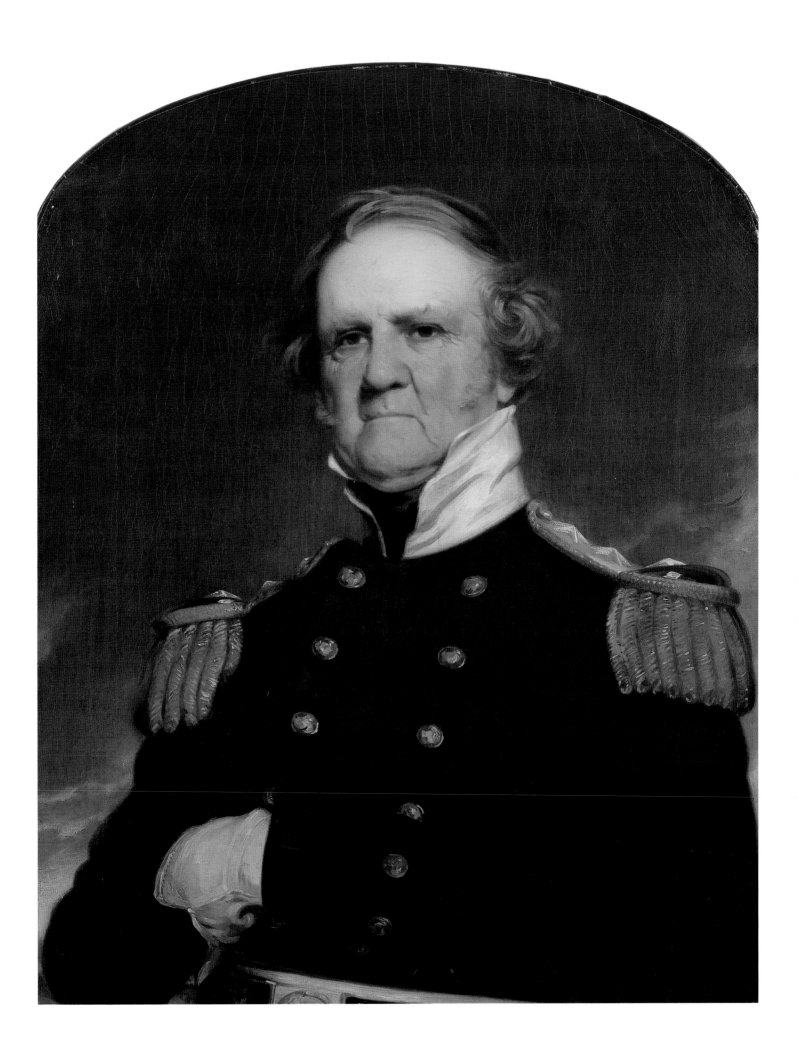

Bayard Taylor 1825–1878
Author

Thomas Hicks 1823–1890
Oil on canvas, 62.2 x 75.6 cm
(24½ x 29¾ in.), 1855
NPG.76.6

Bayard Taylor, poet and travel writer, produced popular mid-nineteenth-century chronicles of his journeys at home and abroad, as well as numerous novels and collections of poetry. As a student in Chester County, Pennsylvania, Taylor studied foreign languages and literature. The publication of his first volume of verse, *Ximena; or, The Battle of the Sierra Morena, and Other Poems*, in 1844 enabled him to arrange travel to Europe on advances from the *Saturday Evening Post*, the *United States Gazette*, and Horace Greeley's *New York Tribune* in exchange for publication rights to his travel letters. On his return to New York in 1846, he published *Views A-Foot; or, Europe Seen with Knapsack and Staff*, and soon established a more lasting relationship with the *Tribune*. Greeley sent him to California to report on the gold rush in 1849, a trip that provided the material for his *Eldorado; or, Adventures in the Path of Empire* (1850). In 1851 he set out for the Middle East, India, and China, and from there went to Japan as a member of Commodore Matthew Perry's expedition. Returning to New York in 1854, Taylor published his most popular book of poetry, *Poems of the Orient* (1854), as well as the three volumes that mark his zenith as a travel writer, including *The Lands of the Saracen; or, Pictures of Palestine, Asia Minor, Sicily, and Spain* (1855). During the Civil War, he served as Washington correspondent for the *Tribune* until he was appointed secretary of legation under the United States minister to Russia at St. Petersburg in 1862. One of his later accomplishments was a metrical translation of Goethe's *Faust*, considered for many decades the best English translation.

This portrait of Taylor was painted in 1855 by his friend Thomas Hicks, nephew of Quaker artist Edward Hicks and a successful portrait painter in New York City. A member of the National Academy of Design, Hicks exhibited many of his portraits there, including this work, exhibited in 1856 as *A Morning in Damascus*. Hicks painted the city, depicted in the middle right distance, from Taylor's drawings. Taylor described his clothing, actually acquired in Egypt, when writing about Achmet, his longtime servant on his Middle East travels:

My dragoman is a man who makes himself respected everywhere, and makes the Arabs respect me. He always speaks of me to them as "His Excellency." I am now wearing one of his dresses: a green embroidered jacket, with slashed sleeves; a sort of striped vest, with a row of about thirty buttons from the neck to the waist; a large plaid silk shawl as belt; white baggy trowsers, gathered at the knee, with long, tight-fitting stockings and red morocco shoes.[48]

After the painting was in progress, Taylor decided that Achmet should be included. "Hicks has nearly finished the Oriental portrait. It is one of the most charming things you ever saw. I found at Taunton, Mass., a daguerreotype of Achmet . . . and borrowed it to get a copy made. I shall get Hicks to put Achmet into my picture."[49] Both artist and sitter were pleased with the finished painting. Taylor proclaimed it "one of the finest paintings you ever saw. Everybody is delighted with it, and I would not take any amount of money for it. [Hicks] says it is the best thing he has ever done."[50] ❋

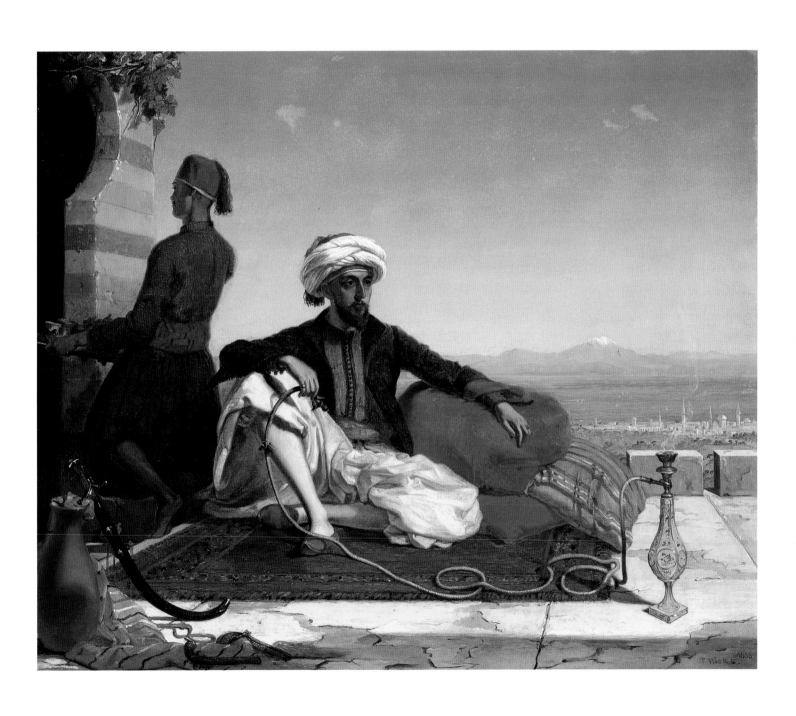

Gulian Verplanck 1786–1870
Author

Daniel Huntington 1816–1906
Oil on canvas, 116.8 x 99 cm
(46 x 39 in.), 1857
NPG.70.48

Politician and writer Gulian Verplanck, a descendant of early settlers in New York, inherited considerable wealth. He studied law and was admitted to the bar in 1807. Elected to the U.S. House of Representatives in 1824, Verplanck served four terms and was pivotal in the 1831 establishment of improved copyright protection for authors. Unsuccessful as a mayoral candidate for New York City in 1834, Verplanck later returned to elected office when he served in the New York Senate from 1838 to 1841. A preeminent man of letters, Verplanck was a member of the Knickerbocker group of New York writers that included Washington Irving, James Fenimore Cooper, and William Cullen Bryant, with whom he co-edited *The Talisman*, a literary gazette (1828–1830). In 1847 Verplanck published his best-known work, *Shakespeare's Plays: With His Life*, then considered the best edition of the English playwright's work by an American.

When Daniel Huntington painted Verplanck's portrait in 1857, the artist was at the height of his career. After studying with New York painters Samuel F. B. Morse and Henry Inman, he went to Europe, where he studied portraiture and history painting. Returning to New York in 1840, he established his reputation with the painting *Mercy's Dream* (1841; Pennsylvania Academy of the Fine Arts), a subject from John Bunyan's *Pilgrim's Progress*. After a major exhibition of his paintings in 1850 received critical praise, Huntington increasingly took up portraiture, spending additional time in Europe, especially England. In 1861 he completed his large history painting *The Republican Court* (Brooklyn Museum), which imaginatively represents a state reception during George Washington's presidency. A member of the National Academy of Design from 1839, Huntington served as its president twice.

Huntington and Verplanck first met in about 1830, when they were members of the Sketch Club, an artists' group. More than twenty-five years later, Huntington painted Verplanck's portrait for the Commissioners of Emigration, the state board that oversaw immigration and provided relief for immigrants. Verplanck's concern for the welfare and education of immigrants had led to his selection as one of the original commissioners, and he served as president of the board from 1848 until his death. The portrait includes a view of New York harbor with Castle Garden, the primary point of arrival for immigrants. Completion of the first version of the portrait (unlocated today) received notice early in 1857:

Huntington has just completed an excellent portrait of the venerable Gulian C. Verplanck. . . . Mr. Verplanck is the best living representative of the old Dutch gentleman; his physiognomy and tastes proclaim his affinities with the genial landholders who colonized Manhattan. . . . In the winter . . . his usual evening haunt is the rooms of the Century Club, where he entertains artists and authors by the hour.[51]

Huntington exhibited the portrait at the National Academy of Design in New York. He made a replica that is probably the version exhibited at the Exposition Universelle in Paris in 1867. The Gallery purchased the replica from Verplanck's descendants. *

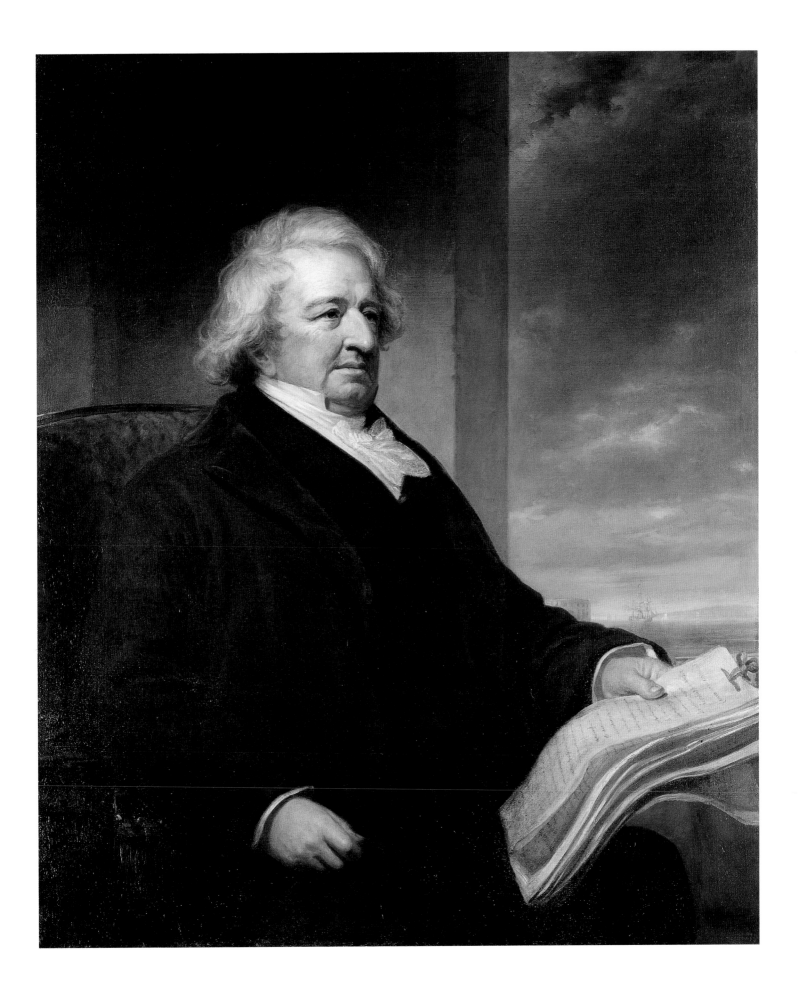

30

William James 1842–1910
Philosopher

John La Farge 1835–1910
Oil on cardboard, 65.7 x 55.2 cm
(25⅞ x 21¾ in.), circa 1859
Gift of William James IV
NPG.91.6

William James earned a medical degree at Harvard in 1869 and began his working life as a teacher of physiology there. He gradually acquired an interest in the infant discipline of psychology, and he is generally regarded today as this country's first psychologist. But his inclination toward wide-ranging speculation drew him to philosophy as well. By the 1890s, he was a leading exponent of the school of thought known as American pragmatism, which holds that truth can only be derived through experience and that, as human experience changes, so can truth.

From the spring of 1858 to September 1859, when the family was living in Newport, Rhode Island, William James and his younger brother Henry studied painting with American artist William Morris Hunt. In Hunt's studio they met John La Farge, who had recently been an art student in Paris. Upon La Farge's arrival in 1859, William James is said to have reported to his brother: "There's a new fellow come to Hunt's class. He knows everything. He has seen everything—paints everything. He's a marvel."[52] Henry James later wrote, "He [La Farge] was quite the most interesting person we knew."[53] The beginning of their long friendship is documented by this early portrait of William James in the act of painting. La Farge also painted a smaller profile of Henry James in 1862 (Century Association, New York).

Apprehensive about William's "attraction to painting," and hoping instead "that his career would be a scientific one," the elder Henry James moved his family to Geneva, Switzerland, in the fall of 1859.[54] However, William announced the following summer that he wished to return to Newport, to paint in Hunt's studio and determine whether he could be an artist, arguing that he received from art "spiritual impressions the intensest and purest I know."[55] He explained his decision to his friend Charles Ritter in July 1860: "I shall know definitely whether I am suited to it or not. If not, it will be easy to withdraw. There is nothing on earth more deplorable than a bad artist."[56] James continued his studies with Hunt for six months, from October 1860 until the spring of 1861, when he decided to give up the idea of being an artist. He later gave as one explanation for his decision, that although he had skill as a draftsman, he lacked the gift of visualization, or thinking in images. ✴

Nathaniel Hawthorne 1804–1864
Author

Emanuel Gottlieb Leutze 1816–1868
Oil on canvas, 75 x 63.5 cm
(29 1/2 x 25 in.) oval, 1862
Transfer from the National Gallery of Art;
gift of Andrew W. Mellon, 1942
NPG.65.55

Raised in Salem, Massachusetts, writer Nathaniel Hawthorne was steeped as a youth in the Puritan traditions of his community. It was in that heritage, with its emphasis on original sin and piety, that he found the themes for much of his fiction. Among his most noted works were *The Scarlet Letter*, a story of adultery set in the New England wilderness, and *The House of the Seven Gables*, whose plot centered on the curse of a falsely convicted witch from Salem's colonial past.

Emanuel Leutze painted this portrait of Hawthorne during the Civil War in Washington, D.C., where he was at work on a mural for the United States Capitol called *Westward the Course of Empire Takes Its Way*. Hawthorne, in poor health, had come to the capital at the invitation of his Bowdoin College classmate Horatio Bridge. The portrait was painted in early April. Hawthorne wrote his wife on April 1:

I have now seen almost everything of interest in and about Washington, and begin to long for home. It has done me a great deal of good, this constant activity of mind and body; but being perfectly well, I no longer need it as a medicine. Another reason intervenes for a little longer stay, however; for Leutze wishes to paint a portrait of me, and is to have the first sitting to-day. Three or four sittings will finish it, no doubt; so that I expect to start for home early in next week.

He added: "The world is not likely to suffer for lack of my likeness. I had a photograph of imperial size taken yesterday (a thirty-dollar photograph) and the artist promises to give me a copy."[57] He wrote about the sitting the next day:

I stay here only while Leutze finishes a portrait—which I think will be the best ever painted of the same unworthy subject. . . . One charm it must needs have—an aspect of immortal jollity and well-to-do-ness; for Leutze, when the sitting begins, gives me a first-rate cigar, and when he sees me getting tired, he brings out a bottle of splendid champagne; and we quaffed and smoked, yesterday, in a blessed state of mutual good-will, for three hours and a half, during which the picture made a really miraculous progress.[58]

Hawthorne also described his visits to Leutze's studio in "Chiefly About War Matters," an article that he published in the *Atlantic Monthly* in July. About Leutze's now-famous image, *Westward the Course of Empire Takes Its Way*, he wrote: "The work will be emphatically original and American, embracing characteristics that neither art nor literature have yet dealt with, and producing new forms of artistic beauty from the natural features of the Rocky-Mountain region." Seeing Leutze at work gave Hawthorne hope for the future of the country.

It was delightful to see him so calmly elaborating his design, while other men doubted and feared, or hoped treacherously, and whispered to one another that the nation would exist only a little longer. . . . But the artist keeps right on, firm of heart and hand, drawing his outline with an unwavering pencil, beautifying and idealizing our rude, material life, and thus manifesting that we have an indefeasible claim to a more enduring national existence.[59]

Leutze kept the portrait, which was purchased from his estate in 1869 by landscape painter John F. Kensett. ✳

Men of Progress

Christian Schussele 1824–1879
Oil on canvas, 130.5 x 195 cm
(51⅜ x 76¾ in.), 1862
Transfer from the National Gallery of Art;
gift of Andrew W. Mellon, 1942
NPG.65.60

Christian Schussele's *Men of Progress* was described in 1862 as a painting of "the most distinguished inventors of this country, whose improvements . . . have changed the aspect of modern society, and caused the present age to be designated as an *age of progress*."[60] The nineteen men portrayed posed individually and were brought together only in the artist's imagination. They are (*left to right*): Dr. William Thomas Green Morton (1819–1868), the dentist with a strong claim to the discovery of anesthesia; James Bogardus (1800–1874), a creative mechanic best known for his cast-iron buildings; Samuel Colt (1814–1862), Hartford armor manufacturer and inventor of the revolving pistol; Cyrus Hall McCormick (1809–1884), inventor and promoter of a mechanical reaper; Joseph Saxton (1799–1873), superintendent of weights and measures for the United States Coast Survey and holder of patents for an anthracite coal-burning stove, a hydrometer, and an ever-pointed pencil; Charles Goodyear (1800–1860), whose accidental discovery of what he called vulcanization brought rubber products into common use; Peter Cooper (1791–1883), philanthropist, and designer and builder of the first successful railway locomotive in America; Jordan Lawrence Mott (1799–1866), proprietor of an iron works in Westchester County, New York, and developer of a coal-burning cooking stove; Joseph Henry (1797–1878), a pure research scientist whose electromagnetic studies had made the telegraph possible; Eliphalet Nott (1773–1866), president of Union College in Schenectady, New York, and holder of thirty patents designed to utilize the properties of heat for stoves and steam engines; John Ericsson (1803–1889), designer and builder of the ironclad battleship *Monitor*; Frederick Sickels (1819–1895), whose inventions focused on improving the steam-engine gear and steam-steering apparatus of ships; Samuel Finley Breese Morse (1791–1872), the erstwhile artist brought to fame as the inventor of the electric telegraph; Henry Burden (1791–1871), inventor of, among other things, a machine that could produce sixty horseshoes per minute; Richard March Hoe (1812–1886), inventor of the rotary press, which revolutionized the newspaper business; Erastus Bigelow (1814–1879), who devised a power loom for the manufacture of patterned carpets; Isaiah Jennings (1792–1862), a Tennessee dentist whose inventions included a threshing machine, a repeating gun, and a friction match; Thomas Blanchard (1788–1864), the holder of more than two dozen patents, including one for an irregular turning lathe capable of cutting a three-dimensional copy of a model; and Elias Howe (1819–1867), awarded a patent in 1846 for a "new and useful machine for sewing seams" and recognized after years of litigation as the primary inventor of the sewing machine. In the background appears a portrait of Benjamin Franklin, the patron saint of American science and invention.

That first version of the painting (Cooper Union) was exhibited shortly after its completion in 1862 and was immediately engraved by Schussele's friend John Sartain. Schussele also executed this smaller version for Jordan Mott. It remained for many years in the Mott family and was purchased by Andrew W. Mellon in 1937. Among his acquisitions intended for a future national portrait gallery, it came into the fledgling Gallery's collection in 1965. Appropriately, among the figures pictured is the first Secretary of the Smithsonian Institution, Joseph Henry. ✳

33

Orestes Brownson 1803–1876
Religious philosopher

George Peter Alexander Healy 1813–1894
Oil on canvas, 146.1 x 114.3 cm
(57$^{1}/_{2}$ x 45 in.), 1863
NPG.79.207

Born and raised a Vermont Calvinist, Orestes Augustus Brownson spent his seventy-three years on a religious pilgrimage that included Presbyterianism, Universalism, his own Society for Christian Union and Progress, and finally, Roman Catholicism. In his philosophical wanderings, Brownson reflected the vitality and restlessness of pre–Civil War America. He wrote prodigiously on such topics as labor and social reform, transcendentalism, states' rights, nativism, and emancipation; and he demonstrated his versatility in the writing of mystical poetry. In 1844 he turned his back on his earlier intellectual life. Concluding that for him anchorage lay with faith and authority, not reason, he converted to Roman Catholicism and devoted his journal, *Brownson's Quarterly Review*, to the spread of Catholic doctrine. He recounted his inner experiences in *The Convert; or, Leaves from My Experience* (1857).

In Healy's portrait, Brownson looks out at the viewer with a directness that undoubtedly reflects the conversations about Catholicism that he had with the artist during the sittings. Healy painted the portrait in Chicago in the winter of 1863. According to the artist's friend Eliza Allen Starr, "Mr. Healy's portrait I consider little less than a miracle, which was replied to by Mr. Healy in this wise, 'then it is a likeness, for Dr. Brownson is only less than a miracle.' You know he is an enthusiastic admirer of Dr. Brownson."[61]

Healy's letter of February 11, 1863, to Brownson indicates that he was actually working on two portraits, one for Brownson and one for himself, which he exhibited at the National Academy of Design in New York in 1863:

After you left us I discovered I had the head too large for your body in my picture. I kept yours, & have repainted mine, which I now like & I hope you will also, when you see it in the N.Y. exhibition. Your portrait left here last night by express. I hope it may reach you in safety & please your family. . . . Your words linger in my mind like a strain of music, & your acquaintance has been one of the greatest pleasures of my life. The Bishop has been to see your portrait & is pleased.[62]

In 1869 the sitter's wife, Sally Healy Brownson (not related to the artist), wrote to their daughter Sarah about the portrait owned by the family: "Healy's picture is a very exact likeness, but it is not his best expression a hundred years hence, if no other likeness was taken, it would not do him justice."[63] This portrait is the one now owned by the Gallery, and was acquired from the sitter's great-granddaughter. After Healy's death, his widow gave Healy's copy of the portrait to the Museum of Fine Arts, Boston. There are slight differences between the two paintings, notably in the face of the sitter, which appears narrower in the Gallery's portrait, and in the position of the sitter's right hand, which in the Museum of Fine Arts' portrait is raised, resting on top of a walking stick. ✳

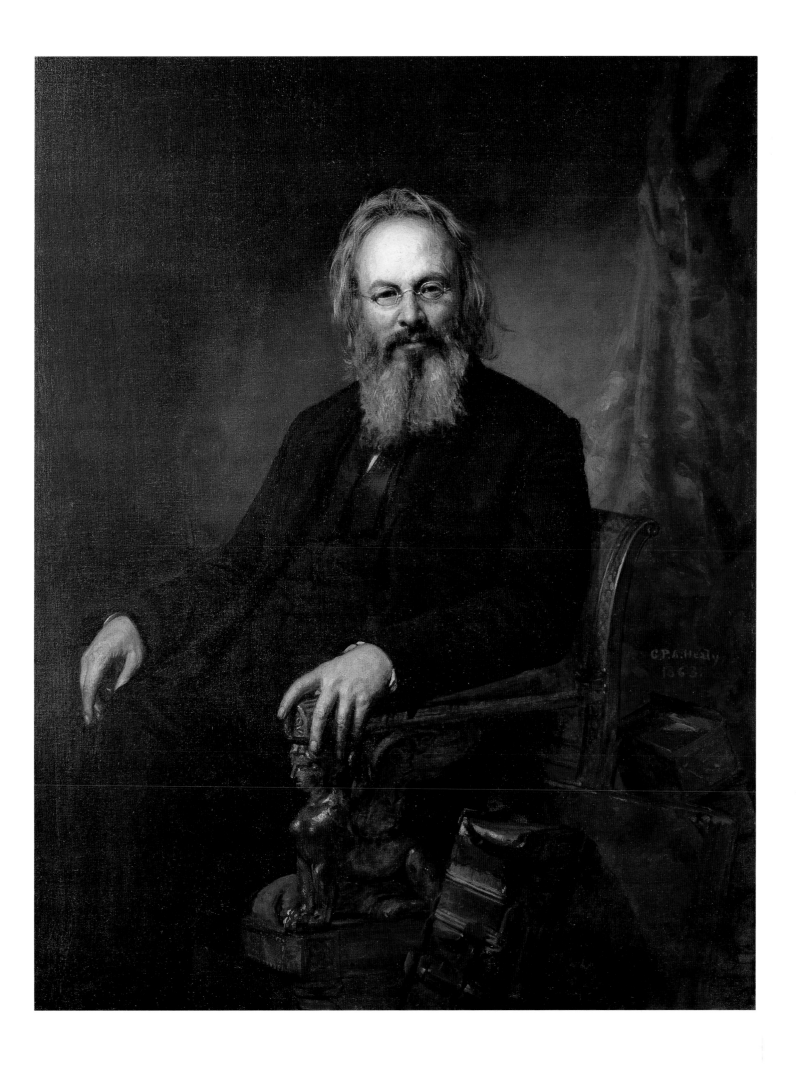

34
William T. Sherman 1820–1891
Union general

George Peter Alexander Healy 1813–1894
Oil on canvas, 158.8 x 97.2 cm
(62½ x 38¼ in.), 1866
Transfer from the National Museum of
American Art; gift of P. Tecumseh Sherman, 1935
NPG.65.40

A pioneer of modern warfare, General William Tecumseh Sherman is a major figure in American military history. Named Tecumseh after the Shawnee chief, Sherman graduated from the United States Military Academy at West Point in 1840. He served in Florida during the Seminole War (1840–1842), as well as in Charleston and Mobile. He began his Civil War career as a colonel, commanding a brigade in the first Battle of Bull Run in 1861. Promoted to brigadier general, he was assigned as General Robert Anderson's second-in-command in Kentucky, and took command in October 1861, when Anderson broke under pressure. Appointed a divisional commander under Ulysses S. Grant, he distinguished himself in the Battle of Shiloh and was promoted to major general. Their careers were thenceforth closely linked. Their success in the Vicksburg and Chattanooga campaigns displayed their military genius and made them rising stars in the North. Sherman, as commander of the Military Division of the Mississippi, captured Atlanta in September 1864. The fall of the city, a major industrial center and rail hub, was a great blow to the Confederacy and was a significant factor in Lincoln's reelection in November. Sherman then implemented his army's notoriously destructive march through Georgia to Savannah, in what has come to be known as his "March to the Sea." In 1865, Sherman and his men carried out a similar march across the Carolinas. After the war, Sherman supported the old-line leaders of the South, arguing against many Reconstruction policies. When Grant became President in 1869, Sherman succeeded him as commander-in-chief of the army.

Healy's portrait of Sherman was painted in 1865 in Chicago. The image of the victorious general is both heroic and contemplative. The Gallery's example is dated 1866 and is one of three that are virtually identical. It belonged to Sherman, who commissioned a pendant portrait of his wife from Healy in 1868 (National Museum of American Art). The second example of Sherman's portrait (Museum of Art, United States Military Academy, West Point) may be the one that Healy painted for a charity raffle to aid wounded veterans of the Civil War. The third (Newberry Library) is probably the one that Healy painted for the Exposition Universelle in Paris in 1867. When refusing Julian Alden Weir's request that he sit for a new portrait in 1890, Sherman wrote to the artist, "if there is any single thing on which I am resolved, it is never again to sit for a portrait or bust." He described Healy's portrait, "which is in my house here," as one of the two "Standards," the other being a portrait by Daniel Huntington. "I have been caricatured by many, but have drawn the line."[64]

Healy painted Sherman again in 1868, for his painting *The Peacemakers on Board the River Queen*, which depicts a historic meeting between Abraham Lincoln and his three military commanders—Sherman, Grant, and Admiral David Dixon Porter—during the last days of the Civil War. ✳

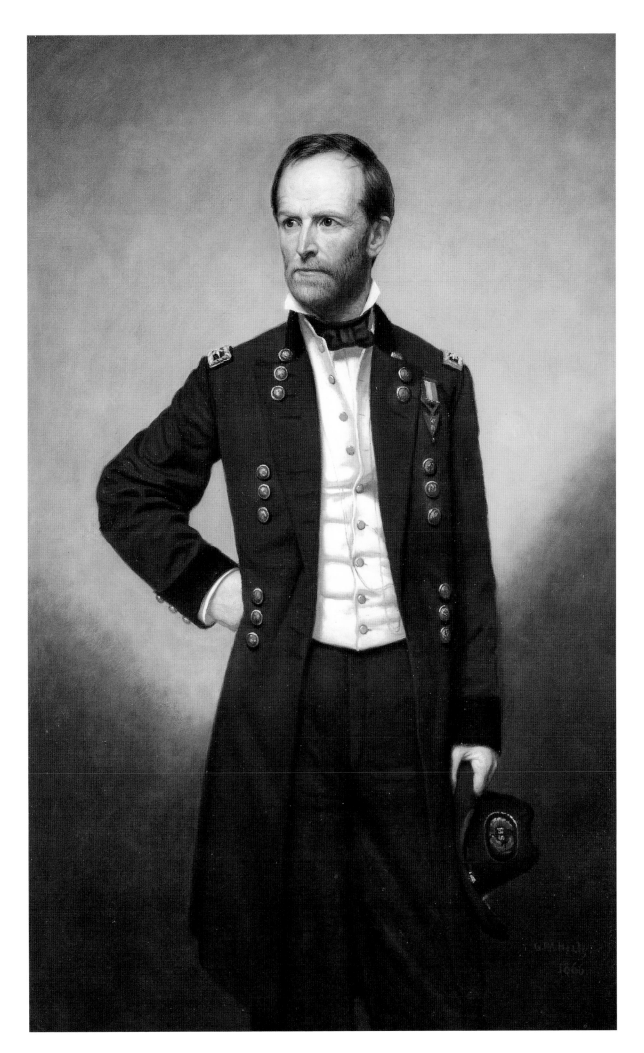

Edith Wharton 1862–1937
Author

Edward Harrison May 1824–1887
Oil on canvas, 73 x 59.7 cm
(28³⁄4 x 23¹⁄2 in.), 1870
NPG.82.136

Chronicler of New York's elite society and "its power of debasing people and ideals," Edith Newbold Jones Wharton was perhaps the most celebrated American woman author of the late nineteenth and early twentieth centuries.[65] From her beginnings as the youngest child born to an affluent New York couple, Wharton led an exciting life—winters in Paris, summers in Newport, Rhode Island, and an array of New York's elegant dinner parties and gatherings. By the age of sixteen she had written her first novel, published several poems, and developed a taste for "pretty clothes, pretty pictures, [and] pretty sights."[66] Preferring European scenery to New York's "intolerable ugliness," Wharton chose to spend much of her life in France. There she surveyed her native country from afar, the distance permitting poignant comments on American high society that manifested themselves in novels like the Pulitzer Prize–winning *Age of Innocence* (1920). A kindred spirit of expatriate Henry James, she shared a lifelong friendship with the renowned novelist, who greatly admired her work.

British-born Edward Harrison May also spent his childhood in New York but was eventually lured away by the charms of Paris. In 1851 he entered the studio of Thomas Couture, painting portraits and submitting his works to the Paris Salon. He served in the Franco-Prussian war as captain of the American ambulance corps and was awarded a medal of the Legion of Honor, as was Wharton for her service establishing schools and orphanages for Belgian refugees in Paris during World War I. Although the artist later devoted himself to producing history and genre paintings, his portraits remained highly valued and are an important index of his talent.

Wharton's portrait was painted several times throughout her lifetime, the first being a miniature by an unidentified artist, made when she was just three years of age. May's portrait of Edith was probably completed during the last year of the Joneses' two-year stay in Paris. (The family divided its time between France, Germany, Italy, and Spain between 1866 and 1870.) It is a testament to Wharton's privileged childhood and captures her during the happy time in Europe when she remembered being surrounded by things of "immortal beauty and immemorial significance."[67] The image also belies the profound disjuncture that would come to define Wharton's adolescent years; her literary interests would be deemed inconsonant with her mother's idea of what a young woman's purpose should be. In the early 1920s Wharton described herself as having been a deeply anxious child because of her mother's cold distance, and it was around the time of May's portrait that she invented the intensely active form of storytelling—what she termed "making up"—that provided a retreat where expressive powers were given free rein. ✳

James McNeill Whistler 1834–1903
Artist

Walter Greaves 1846–1930
Oil on canvas, 81.3 x 55.9 cm
(32 x 22 in.), 1870
NPG.91.125

James Abbott McNeill Whistler had a peripatetic child-hood, and he spent his adult life toggling between Paris and London. Born in Lowell, Massachusetts, to the son of a civil engineer, he lived from 1843 to 1848 in Russia, where his father oversaw the construction of the Moscow to St. Petersburg railroad. After his father's death, the family returned to the United States. In 1851 he entered the United States Military Academy at West Point, but three years later he was dismissed for failing chemistry. Attracted to art as a child, Whistler was able to study with painter Robert W. Weir at West Point. He further enhanced his drawing skills and learned etching when he worked briefly as a cartographer for the U. S. Coast and Geodetic Survey in Washington, D.C.

Disenchanted with his lifestyle and eager for additional artistic training, Whistler left America for France in 1855, never to return. He studied first at the École Impériale et Spéciale de Dessin in Paris and in the atelier of academic painter Charles Gabriel Gleyre. But always a rebel, personally and professionally, Whistler soon became his own most important instructor, absorbing myriad influences from the richly textured world of contemporary French art. His 1862 painting *Symphony in White, No. 1: The White Girl* (National Gallery of Art) established his visibility in the art community. Rejected first from the annual exhibition at the Royal Academy in London and then from the official

1863 Paris Salon, it became a great attraction at the Salon des Refusés, the show held to exhibit work that did not conform to traditional academic standards. It was also the first major piece in a lifetime body of work that would focus on the purely artistic arrangement of forms, on the "poetry of sight," rather than on specific descriptive or narrative details. Although Whistler's evocative paintings incensed the English art critic John Ruskin, who declared that the artist had flung "a pot of paint" in the face of the public, the artist had many champions both in America and in Europe, and significantly influenced numerous artists.[68]

Whistler first moved to London in 1859. When, in 1863, he settled at 7 Lindsey Row on the Thames in Chelsea, his neighbors included the Greaves family, whose two young sons, Walter and Henry, had an interest in art. Skilled as watermen and boat builders, they not only escorted Whistler on his painting forays on the Thames, but they soon became his pupils. The brothers, totally devoted to their mentor, soon adopted his painting style as well as his manner of dress. The numerous portraits that Walter did of Whistler are a reflection of the affection and esteem the two had for the charismatic artist. To the brothers' bitter disappointment, the relationship ended abruptly in about 1878, as Whistler's wife Beatrice Godwin did not particu-larly care for them.[69] *

38

Francis Millet 1846–1912
Artist

George Willoughby Maynard 1843–1923
Oil on canvas, 151.1 x 97.1 cm
(59½ x 38¼ in.), 1878
Bequest of Dr. John A. P. Millet
NPG.78.205

Upon graduating from Harvard in 1869 with a master's degree in modern languages and literature, Francis Davis Millet began his career as a writer and editor for three Boston newspapers—the *Daily Advertiser*, the *Saturday Evening Gazette*, and the *Courier*. Simultaneously, Millet studied lithography and soon went to Antwerp for further training at the Royal Academy, where he earned two prizes for his work. He returned to the United States in 1876 and assisted John La Farge in his mural decoration of the Trinity Church in Boston while also reporting for the *Advertiser*. Possessed of an inherent wanderlust, Millet readily accepted the opportunity, one year later, to cover the Russo-Turkish War for the *New York Herald*. His vivid descriptions of combat action and wartime conditions were published in *The War Correspondence of the "Daily News,"* 1877–78.

Upon the war's end Millet traveled and exhibited widely. He was asked to serve on the fine arts jury at the 1878 Paris exposition, an honor he would be asked to repeat twenty years later. He returned to the United States in 1879, and soon resumed his journalistic activities, reporting for *Harper's Magazine* in the Baltic region and along the Danube River. Millet's journey down the Danube became the subject of his first book, *The Danube from the Black Forest to the Black Sea* (1892).

Always enthusiastic about each new endeavor, Millet earned the admiration of his peers as well as the American public. "The wonderful characteristic of Millet," wrote a friend after his death, "was the whole-souled and disinterested ardor with which he threw himself into everything that he undertook never sparing himself, or counting any labor or sacrifice too great to accomplish the object in view."[73] Millet's many civic contributions include his murals and decorations for various capitol buildings, his service as director of decorations and exposition functions at the 1893 World's Columbian Exposition, and his establishment of the Federation of Arts and the National Commission of Fine Arts in 1910. After spending a year in Italy as the director of the American Academy in Rome during 1911, Millet booked passage back to America on the *Titanic* and was one of the 1,513 passengers who perished when it sank.

George Willoughby Maynard met Millet while they were both studying at Antwerp's Royal Academy. He had previously trained at the National Academy of Design in New York and in Italy with his mentor, the history painter Edwin White. Maynard and Millet soon became close companions, traveling together across southeastern Europe in 1873. Three years later, the two worked in Boston on the decorations for Trinity Church, and in 1878 they found themselves both in Paris. Later, Maynard would return to America to paint several murals for important civic buildings, including the exterior decoration of the Agricultural Building at the Columbian Exposition.

In this portrait of Millet completed in Paris, Maynard portrays his friend as a foreign correspondent, dressed in a bulky fur coat and wearing his recently awarded Russian and Romanian medals. Millet confronts the viewer with a self-assured posture and a watchful eye; it is not hard to imagine why he was awarded three official decorations for bravery under fire. *

Mary Cassatt 1844–1926
Artist

Edgar Degas 1834–1917
Oil on canvas, 71.4 x 58.7 cm
(28¹⁄₈ x 23¹⁄₈ in.), circa 1880–1884
Gift of The Morris and Gwendolyn
Cafritz Foundation and the
Regents' Major Acquisitions Fund,
Smithsonian Institution
NPG.84.34

The fourth child and second daughter of a wealthy Pennsylvania banker, Mary Cassatt began her artistic training in Philadelphia at the Pennsylvania Academy of the Fine Arts. Eager to continue her studies abroad, she and classmate Eliza Haldeman (initially accompanied by Cassatt's mother) left for Paris in December 1865. The following November, she was admitted to the studio of Jean-Léon Gérôme, an academic painter known for his genre and history paintings. In 1870, the Franco-Prussian War forced Cassatt to return to America. But by 1872, Cassatt was back in Europe, where her studies took her first to Parma, Italy, and later to Spain. She ultimately settled in Paris in 1874 and, with the exception of two trips to America in 1898 and 1908, lived abroad for the remainder of her life.

Cassatt and Edgar Degas, a leading figure among the French Impressionists, became friends sometime in the late 1870s. The exact circumstances of their initial encounter are unknown, as the correspondence between the two no longer exists.[74] However, in about 1877 Degas, who had previously admired Cassatt's work, suggested to the young American that she participate in future exhibitions of the Impressionists, which she did in 1879, 1881, and 1886. Also in 1877 Cassatt first recommended a painting by Degas to her close friend, American collector Louisine Elder (later Havemeyer).

The two artists remained lifelong friends. Although their relationship had its share of tempestuous moments, the late 1870s and early 1880s marked a time of Degas's intense involvement in Cassatt's work. Under his guidance, she adopted the fresh colors and effects of light that were central to the new Impressionism and also began to employ a more animated compositional structure in the paintings of domestic life for which she is so well known. Intrigued by his etchings and by Japanese woodcuts, Cassatt also became a masterful printmaker. She was well aware of the radical nature of Degas's approach to painting, both stylistically and in terms of modern subject matter, for she once remarked to Havemeyer, "Degas's art is for the very few . . . for painters and connoisseurs."[75]

As a token of their friendship, Degas portrayed Cassatt on several occasions. Judging from her appearance, this painting, like his prints of her at the Louvre, was probably done in the early 1880s. Its free brushwork and muted color relate closely to Degas's other work from this period. While Cassatt admired the picture's artistry, she was displeased with her pose and seriousness. She owned the painting until at least 1913, when she asked a Paris dealer to sell it but to make sure that it did not go to an American collection, where friends and family might see it. ✳

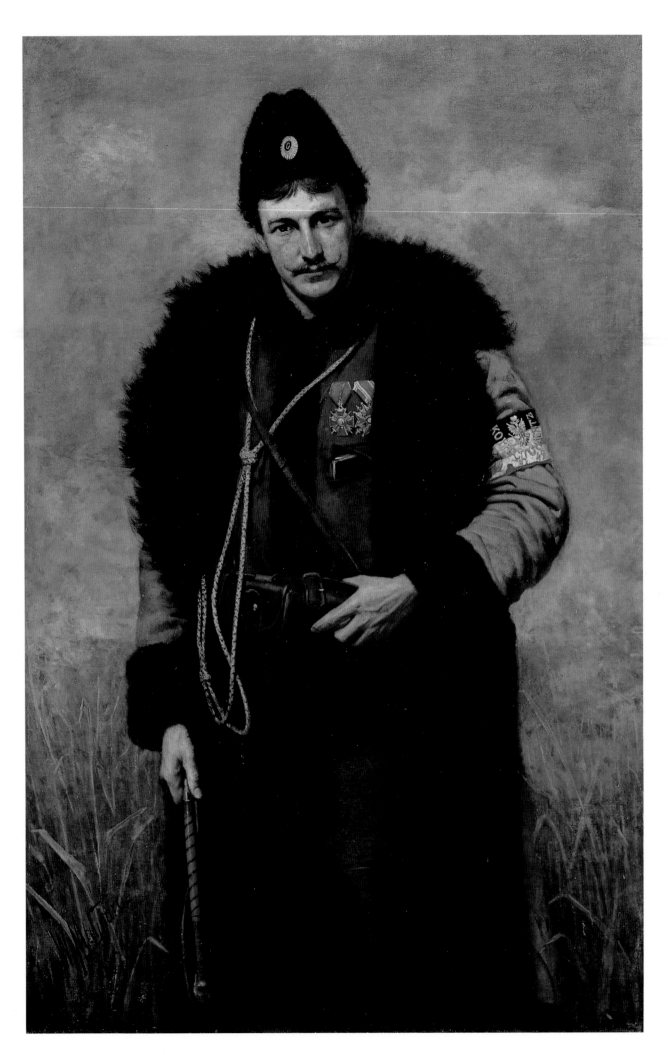

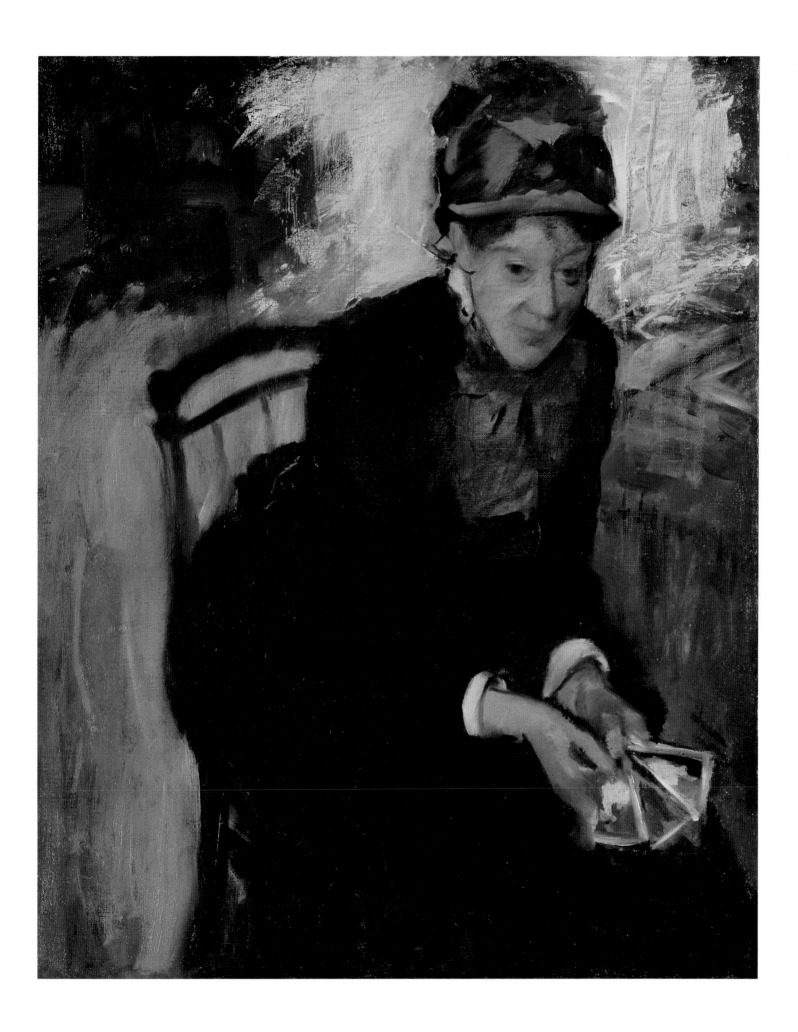

Bret Harte 1836–1902
Author

John Pettie 1839–1893
Oil on canvas, 111.7 x 73.6 cm
(44 x 29 in.), 1884
NPG.69.52

Francis Bret Harte was born in New York State, but in 1854, after the death of his father, his family moved to California. During the first few years of his residence there, Harte did odd jobs, attempted to open a school in the town of Sonora, worked as a type compositor in a newspaper office in Eureka, and was a miner. In 1857 he moved to San Francisco, where he composed type for the magazine *Golden Era*. Clever sketches of frontier life, initially submitted anonymously, attracted the attention of the editor, who then hired Harte for the staff. By 1863 his stories had attracted attention in the East, and in 1864 he was named secretary of the U. S. Mint's branch in San Francisco, a political appointment that permitted Harte more time for his literary efforts.

With the publication of his short stories "The Luck of Roaring Camp" and "The Outcasts of Poker Flat" in the late 1860s, Harte provided ample proof of the rich literary potential that was to be found in the rough-hewn life of his state's gold-mining frontier. Harte left for the East in 1871. Initially, in both Boston and New York he found himself lionized as the West's most brilliant and promising writer. But Harte never felt any real kinship with the crude world he portrayed, and his later western stories became pale reflections of the poignant and crisply narrated tales that had made him a celebrity.

A restless soul, Harte took a position as U.S. commercial agent in Crefeld, Germany, in 1878. He transferred to Glasgow, Scotland, in 1880, but bored by the town and his duties, he made frequent trips to London. When his government appointment ended with the inauguration of Grover Cleveland in January 1885, Harte returned to London, where he remained for the rest of his life.

John Pettie, a Scotsman, exhibited exceptional artistic talent as a young man and enrolled in 1856 at the Trustees' Academy in Edinburgh to study with painter Robert Scott Lauder. He concentrated on historical genre painting and became a master of this romantic and antiquarian style, which found its subjects in British history, literature, and legend. Pettie first exhibited at the Royal Academy in London in 1860. Encouraged by his reception, he moved to this city in 1862. Prolific, industrious, and popular, he was made a full member of the Royal Academy in 1873. In his later years, he turned to portraiture with great success, and often portrayed his friends in historical costume.

Harte and Pettie appear to have met and become friends shortly after the writer's arrival in London. According to the artist's biographer, Pettie, who was known for his ability to rapidly capture a likeness, spent many sessions with Harte working on his portrait because the two so thoroughly enjoyed each other's company. Clearly, Pettie's penchant for rendering opulent materials also meshed with Harte's taste for sartorial elegance. The artist was proud of this portrait, which he gave to his friend as a gift, for he exhibited it at the Royal Academy in 1885 and at the Jubilee exhibition in Berlin the following year. ✷

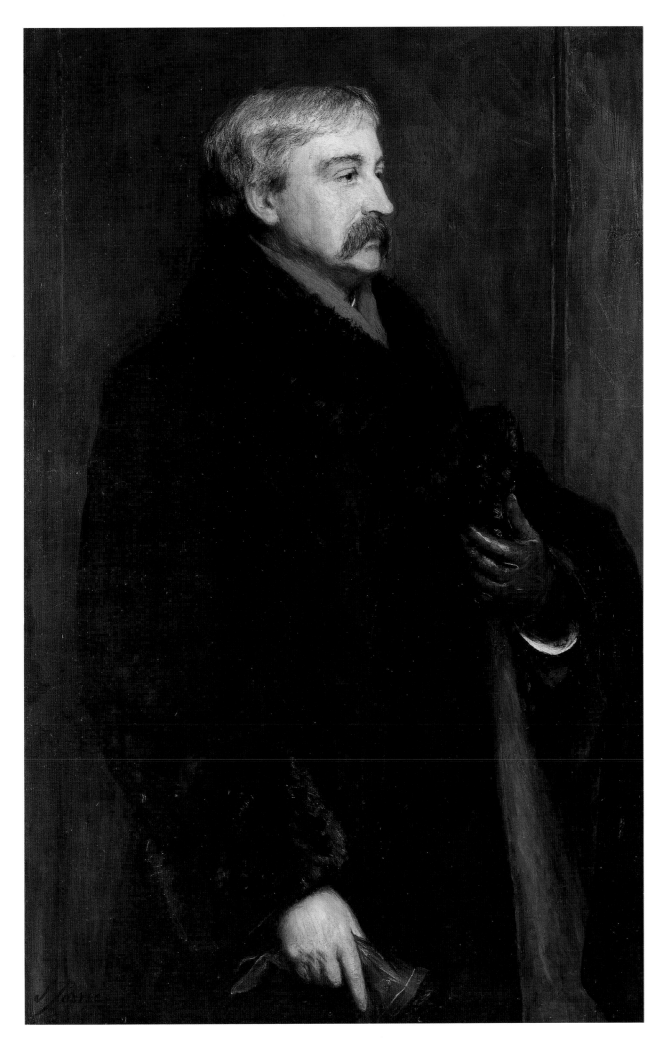

41
Thomas B. Clarke 1848–1931
Art collector

Charles Frederick Ulrich 1858–1908
Oil on panel, 21.3 x 15.2 cm
(8⅜ x 6 in.), 1884
NPG.89.202

Thomas B. Clarke, a lace and linen manufacturer in New York, began buying works of art in 1872. Within a decade he was this country's foremost collector of contemporary American art, lending legitimacy to and stimulating interest in the work of native artists who for nearly a century had lived in the shadow of their European cousins. He frequented artists' studios and arrived early at exhibitions to secure the best works for his collection. He initiated close friendships with American painters and lobbied tirelessly on their behalf. "I never for a moment have forgotten you in connection with what success I have had in art," Winslow Homer wrote to Clarke in 1892. "I am under the greatest obligation to you, and will never lose an opportunity of showing it."[76] Other artists felt similarly obliged to him.

As treasurer of the National Society of Arts, chair of the Union League Club's art committee, and president of the New York School of Applied Design for Women, Clarke was extremely influential in the New York art world. He also acted as an unpaid agent, buying paintings for friends and the Union League Club, and he helped found the National Sculpture Society in 1893, as well as the National Arts Club in 1899. When Clarke auctioned off the majority of his American paintings in the last year of the century, it was clear from the record prices fetched that American art had finally arrived. Clarke deemed the sale a victory for the country's artistic tradition. "I should persuade American artists that they need not fear prejudice or failure of appreciation," he is quoted as saying. "Justice comes quickly to the men who work patiently, if there be merit in them."[77] Thereafter Clarke turned his attention to historical American portraiture, rekindling popular interest in these earliest examples of the American painting tradition.

Born in New York, Charles Frederick Ulrich spent most of his career in Europe. After studying at the National Academy of Design, he moved to Munich in 1875, where he enrolled in the Royal Academy. He returned to the United States in the early 1880s and exhibited his peasant and genre scenes at the National Academy of Design. When in 1884 Ulrich's painting *In the Land of Promise— Castle Garden* made him the academy's first recipient of the Thomas B. Clarke Prize for Best American Figure Composition, the artist painted this portrait of the collector as an expression of his gratitude. A charming likeness, the modest portrait attracted the attention of at least one local newspaper columnist, who praised the artist's "management of light" and "truthful" rendering: "The character and spirit of the sitter are fixed with a fidelity and sympathy which will strike everyone acquainted with him."[78] After presenting Clarke with his portrait in April of 1884, Ulrich embarked on a second trip to Europe, where he would paint some of his most important works, including *Glass Blowers of Murano* from 1886, now in the Metropolitan Museum of Art. ✳

42

H. H. Richardson 1838–1886
Architect

Sir Hubert von Herkomer 1849–1914
Oil on canvas, 109.2 x 142.2 cm
(43 x 56 in.), 1886
On extended loan from Mrs. Henry H. Richardson III
L/NPG.I.99

Born in Priestley Plantation, Louisiana, Henry Hobson Richardson received his undergraduate education at Harvard University. While an undergraduate, he decided to become an architect. As there were no schools in the United States at the time that taught this profession, he received his training at the École des Beaux-Arts in Paris, studying there between 1860 and 1862. He remained in France for three additional years, working for French architect Théodore Labrouste. When he returned to America, he first settled in New York City, where in 1867 he formed a partnership with Charles D. Gambrill.

Richardson's career spanned little more than two decades, but in that time, he became the most admired American architect of his day and remained a dominant influence in his profession well after his death. Richardson found much of his inspiration in the medieval Romanesque style, but he infused his borrowings from the past with innovations that transformed many of his buildings into masterpieces of originality that are still revered today. One of his most celebrated accomplishments is Boston's Trinity Church (1872–1877). A key building using the Romanesque Revival style for which he became famous, it won the architect numerous awards. Three artists in the National Portrait Gallery's collection—John La Farge, George Willoughby Maynard, and Francis Davis Millet—were among those commissioned to work on its richly decorated interior. The success of this church also brought Richardson many clients in the region, and in 1874 he moved his practice from New York to the Boston suburb of Brookline, where he estab-

lished a home and studio, which has remained in the family until recently. Other award-winning buildings by Richardson include the Allegheny County complex in Pittsburgh and the Marshall Field Wholesale Store in Chicago (demolished in 1930), which was considered one of the finest examples of nineteenth-century commercial structures in America. Numerous railroad stations in the Northeast also reflect his signature. Equally noteworthy were many of his private homes, where he demonstrated a genius for adapting his designs to geographical sites.

The English painter Sir Hubert von Herkomer, who lived the first six years of his life in the United States, was on his second painting expedition to America when he painted this likeness in Richardson's Brookline studio. A prize-winning artist in England, Herkomer first attracted attention in America when his large painting *Applicants for Admission to a Casual Ward*, which showed paupers standing outside a workhouse seeking shelter, was shown in the British section at the 1876 Philadelphia Centennial Exposition and received favorable comment. While painting the portrait, which was completed in about nine hours during two or three sittings, Herkomer noted in his diary that Richardson was "as solid in his friendship as in his figure. Big-bodied, big-hearted, large-minded, full-brained, loving as he is pugnacious."[79] In the background are actual objects from the sitter's collection, including a blue vase still in the possession of the architect's heirs. In payment for the picture, Richardson drew up exterior designs for the artist's projected English country house, which was built in the 1890s. •

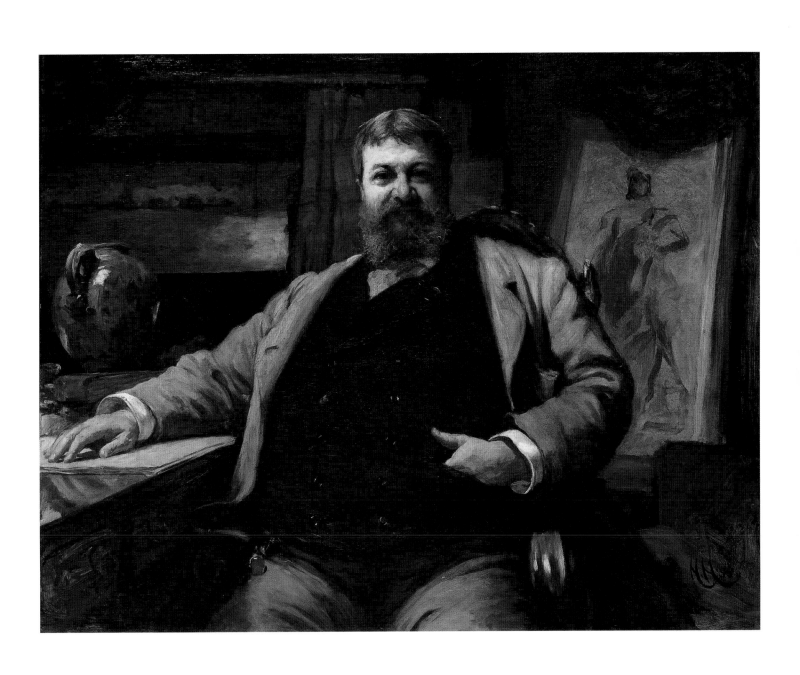

43

Juliette Gordon Low 1860–1927
Founder of the Girl Scouts of America

Edward Hughes 1832–1908
Oil on canvas, 132.3 x 97.1 cm
(52⅛ x 38¼ in.), 1887
Gift of the Girl Scouts of the
United States of America
NPG.73.5

Admired for her charm and vivacity, Juliette Gordon Low, or "Daisy" as she was known to her southern family, was a model nineteenth-century debutante. Expensively educated and widely traveled, Low sealed her aristocratic status with her marriage in 1886 to William Mackay Low, the wealthy son of a family well established in both England and the United States. Low spent most of her nine-year marriage in England, serving as a hostess for the highest-ranking members of British society and hobnobbing with the Prince of Wales at balls, dinners, and events at court. At the loss of her husband, her marriage, and her pride—Low's husband died in 1905, before the couple's impending divorce, leaving his entire estate to his mistress—Juliette sank into a deep depression and began to reappraise her role in life. She found a new purpose when she met General Sir Robert Baden-Powell, founder of the British Boy Scouts. "A sort of intuition comes over me," Low wrote in her diary, "that he [Baden-Powell] believes I might make more out of life, and that he has ideas which, if I follow them, will open a more useful sphere of work before me in [the] future."[80] Attracted by the mission of the Boy Scouts and its female equivalent, the Girl Guides, Low organized her first group of scouts among the poor girls living near her estate in Scotland in 1911. She formed two groups in London and one in her hometown of Savannah, Georgia, the following year. Troops rapidly sprang up across the United States, due in no small part to Low's tireless efforts. Childless and thus on the fringe of nineteenth-century

standards of acceptable womanhood, Low committed herself with unmatched zeal to her troops. "She did not wish girls to become useless pampered ornaments," one scholar has noted. "She herself had had a bitter taste of that kind of life and was not inclined to recommend it."[81] Low's Girl Scouts of America, an organization in the vanguard of the early moments of the woman suffrage movement, continues to inspire girls between the ages of five and seventeen with "the highest ideals of character, conduct, patriotism, and service that they may become happy and resourceful citizens."[82]

A precocious painter of portraits and historical subjects, London artist Edward Hughes was awarded the silver medal of the Royal Society of Arts at the age of fourteen. He became an exceedingly popular portrait painter in European high society. His commissions included the Prince of Wales, his brother Prince Albert, and his sister Princess Mary, among innumerable other royals and persons of wealth. Low asked Hughes to paint his new bride's portrait just after the couple's move to England in 1887. His wife is the image of demure feminine winsomeness. Her status as a member of the privileged class (she would be presented to Queen Victoria in two years' time) is made clear by her elaborate gown, ostrich-feather fan, and the simple yet elegant bracelets adorning her wrist. Of the painter's work, Sir John Everett Millais noted: "Very many artists can paint the portrait of a man, but very few can paint the portrait of a lady, and Edward Hughes is one of those few."[83] ✳

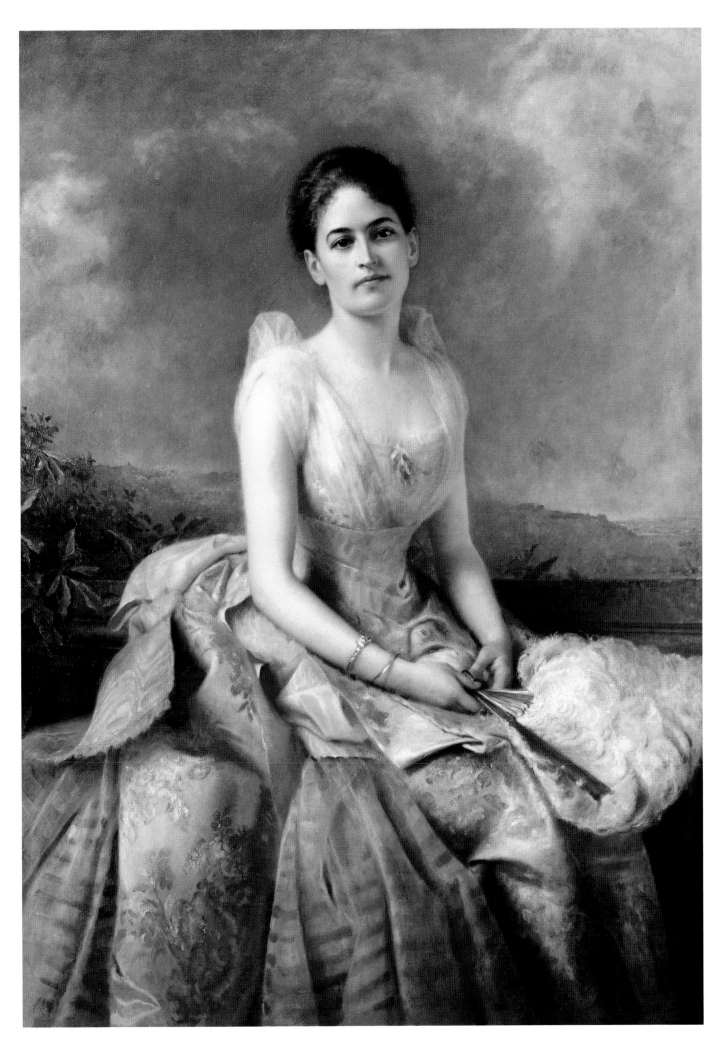

44

Talcott Williams 1849–1928
Journalist

Thomas Eakins 1844–1916
Oil on canvas, 62.2 x 50.8 cm
(24½ x 20 in.), 1889
Gift of the Kate and Laurens Seelye family and the
James Smithson Society, and Gallery purchase.
Acquisition made possible by a generous
contribution from the James Smithson Society
NPG.85.50

Endowed with a far-ranging intellectual curiosity, Talcott Williams began his career in journalism in the early 1870s. In 1881 he was named an editor of the *Philadelphia Press*. A notable political journalist, he also wrote penetrating reviews on art, literature, and drama. In 1912 Williams became the first director of the Columbia School of Journalism. His massive file of news clippings, gathered over thirty years, became the foundation of the school's morgue. At Columbia, Williams set high standards for his profession, constantly reiterating his conviction that good journalism required not only writing ability but also a wide breadth of knowledge.

During the 1880s Williams made the acquaintance of the Philadelphia-born, French-trained painter Thomas Eakins, and in 1887 took him to nearby Camden, New Jersey, to meet the venerable poet Walt Whitman. Whitman recounted their meeting to a friend: "[Eakins] came over with Talcott Williams: seemed careless, negligent, indifferent, quiet: you would not say retiring, but amounting to that."[84] Three weeks later, Eakins returned. He "carried a black canvas under his arm: said he had understood I was willing he should paint me: he had come to start the job. I laughed: told him I was content to have him go ahead: so he set to: painted like a fury."[85] Eakins, eccentric and indifferent to

social amenities, often asked his friends and acquaintances to pose, but rarely sought or accepted commissions. His portraits were not necessarily conventional; Williams's wife stopped posing for Eakins when her portrait was far from complete, because it did not conform to her desire for a proper, fashionable image. Nevertheless, when he painted persons of accomplishment and determination in the worlds of science, the arts, education, and even sports, he often found kindred spirits who appreciated his work. Whitman preferred Eakins's bust portrait of him above all others, and Talcott Williams must have approved of this portrait, for according to Williams's wife, he gave the painter more than fifty sittings.

In his many bust portraits of friends, Eakins is noted for the variety of treatment and composition he was able to achieve in this limited format. In Williams's likeness, for which he sat in fall 1889, the painter has used a meticulous rendering of detail and dramatic lighting to animate his subject. By depicting Williams with an expression of intense concentration on his face, and his mouth open as though in conversation, Eakins succeeded in suggesting the energy, quick wit, and lively intelligence of his subject, who was known among friends as "Talk-a-lot" Williams.[86] ✶

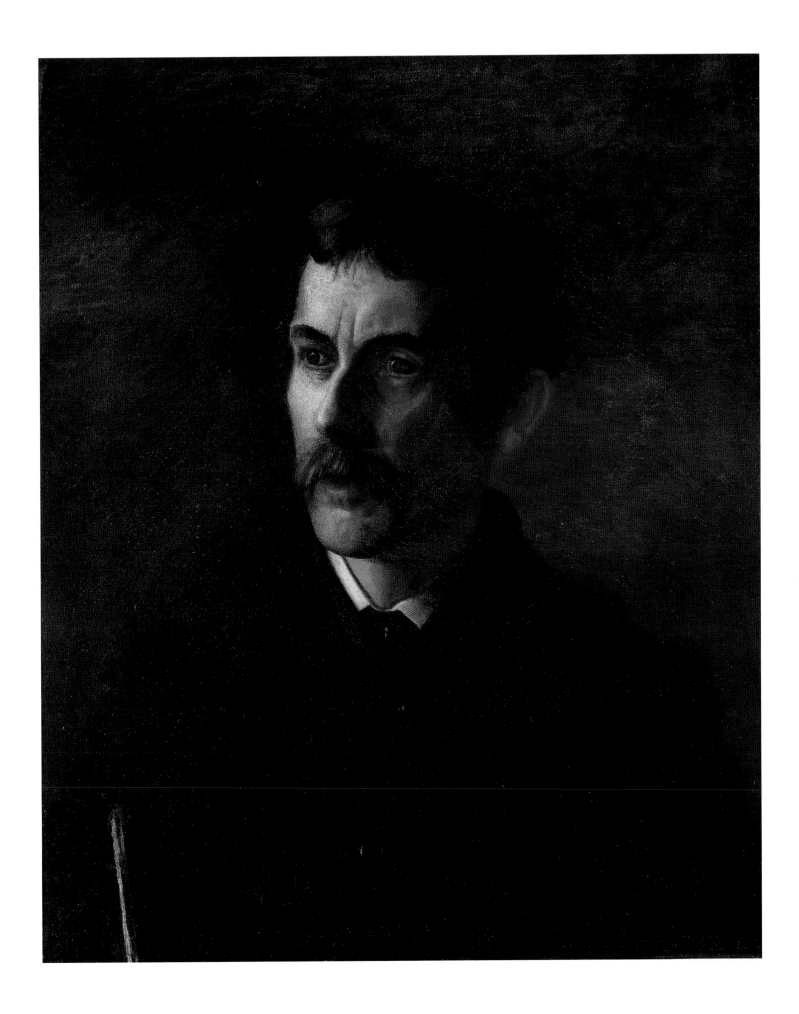

45

Henry Cabot Lodge 1850–1924
Statesman

John Singer Sargent 1856–1925
Oil on canvas, 127 x 86.4 cm
(50 x 34 in.), 1890
Gift of the Honorable Henry Cabot Lodge
NPG.67.58

Henry Cabot Lodge exuded all the confidence that his distinguished New England ancestry, Harvard education, and wide circle of wealthy and influential friends could bestow. In 1887, armed with these most crucial assets, he began his career in Congress, where he quickly overcame his outsider's reputation to become a power in the Senate and one of the Republican Party's most respected leaders. Noteworthy was his scorn for the alliance between big business and corrupt politicians.

In the early phase of his public life, Lodge, who saw himself as a statesman rather than a mere politician, joined with his close friend Theodore Roosevelt in espousing a larger role for the United States in world affairs and was a central influence in the buildup of its navy. Ironically, however, he is best remembered for successfully spearheading Senate blockage of American membership in the League of Nations after World War I, on the grounds that its covenant threatened American sovereignty. Thus, this man who had prepared his country for international leadership ultimately came to be regarded as an isolationist.

His portraitist, John Singer Sargent, was born in Florence to parents who had left Philadelphia to live a fashionable life in Europe. He remained, like his parents, a devoted expatriate. Still, he became intrigued by Americans and the American art world as a young man, and he returned to the United States frequently later in his life. Sargent, who studied art briefly in Italy, entered the Paris studio of Carolus-Duran in 1872. A precocious talent, he was well established as a portraitist by the early 1880s. In 1884, he secured his reputation beyond a small circle of knowledgeable patrons when he exhibited the frankly seductive portrait *Madame X* (Madame Pierre Gautreau) at the Salon.

Sargent was eminently suited to paint Lodge, as they both came from the same aristocratic world. The two met during Sargent's second trip to America, which began in 1889. Sargent, who had established a New York studio, was a frequent visitor to Boston. He had received the commission for the murals in the Boston Public Library, and he was often called upon to assist the architectural firm of McKim, Mead & White in raising subscriptions for this project. In August 1890 he traveled to Nahant, the elite summer colony just north of Boston, to visit his friend and former client Charles Fairchild. There he befriended Lodge, who then sat for him. The resulting portrait has an aloofness that often typifies Sargent's likenesses of wealthy individuals. In Lodge's case, this is a fairly accurate reflection of the "unapologetic superiority" with which he carried himself, but it does not tell the whole tale. For Lodge, either despite his upbringing or because of it, was a champion of the disenfranchised. Shortly before the 1890 congressional summer recess, Lodge had given a rousing speech defending the right of blacks to vote. Although his bill was not passed, his "manly speech," wrote noted poet and abolitionist John Greenleaf Whittier, "has the ring and is worthy of the best days of Massachusetts—of Webster and Sumner and John Quincy Adams."[87] ✳

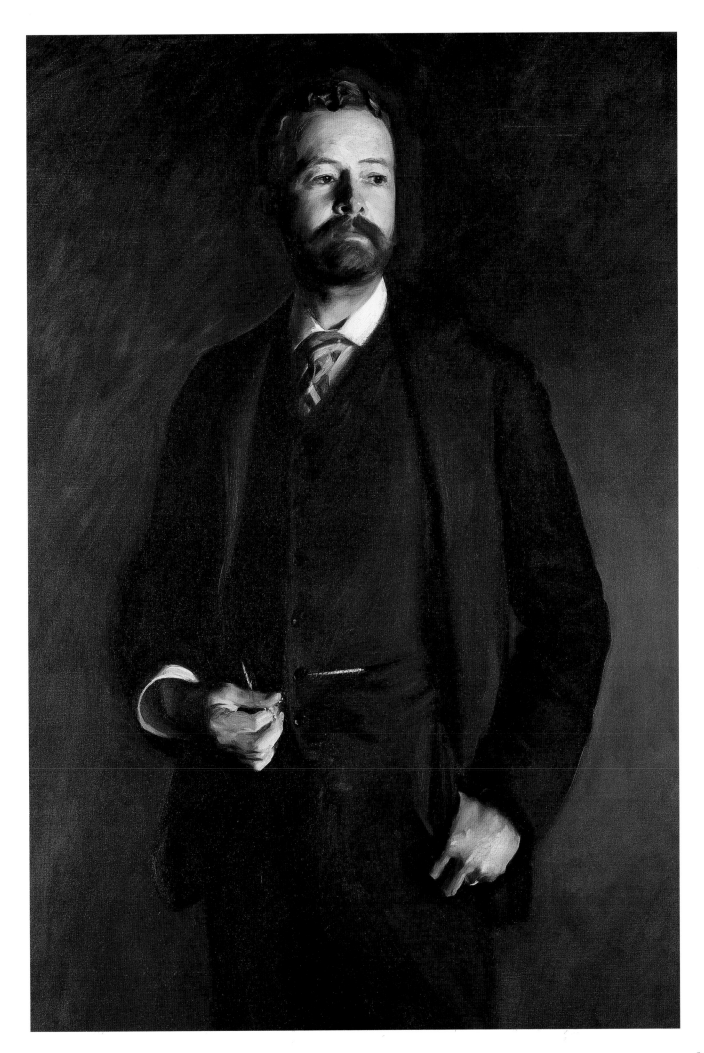

Paul Wayland Bartlett 1865–1925
Artist

Charles Sprague Pearce 1851–1914
Oil on canvas, 108.6 x 76.2 cm
(42¾ x 30 in.), circa 1890
Transfer from the National Museum of
American Art; gift of Caroline Peter
(Mrs. Armistead Peter III), 1958
NPG.65.20

Born in New England, Paul Wayland Bartlett was sent to Paris at the age of nine because his father, sculptor and art critic Truman H. Bartlett, considered Paris the only place to get the proper artistic education he wanted for his son. In France, the young Bartlett studied with the sculptors Emmanuel Frémiet and Auguste Rodin, and had a bust of his grandmother exhibited at the prestigious Salon des Beaux-Arts when he was only fourteen years old. He entered the École des Beaux-Arts the following year, where he continued his study of sculpture. Bartlett earned an early reputation for his animal studies, especially for *Bear Tamer*, a bronze of a man standing over two cubs, which won an honorable mention at the 1887 Salon. When exhibited in Chicago at the 1893 World's Columbian Exposition, *Bear Tamer* brought him his first artistic recognition in America. In the late 1890s, Bartlett received further renown for his heroic bronze statues of Italian sculptor Michelangelo and explorer Christopher Columbus that he executed for the rotunda of the Library of Congress. In about 1900, he began to experiment with architectural ensembles of sculpture. Among the best known of these works are the six allegorical figures he created for the New York Public Library, and the sculpture for the pediment of the House of Representatives' wing of the United States Capitol.

Bartlett lived most of life in France, where he received numerous awards, including the Legion of Honor. His friend and portraitist, Boston-born Charles Sprague Pearce, also named an Officer in the Legion of Honor, came to Paris in 1873. His training included three years in the studio of famed portrait painter Léon Bonnat. He settled in Auvers-sur-Oise in 1885, just after his first real successes at the salons. Pearce was known for his landscape and figure subjects, particularly paintings of pensive women alone in rustic landscapes. The meticulously painted figures were often placed against a more loosely brushed background with muted colors.

Pearce's portrait of Bartlett is an outgrowth of their mutual affection, for Bartlett is said to have made a bust of Pearce at about the same time, in 1891 or 1892. Pearce depicts Bartlett in a dramatic profile pose, cigarette in hand, and affecting a loose tie, a detail of dress often associated with artists during the late nineteenth century. His portrait captures both the Gallic insouciance of his friend's bearing, as well as the pensive, almost melancholy side of Bartlett's character. ✳

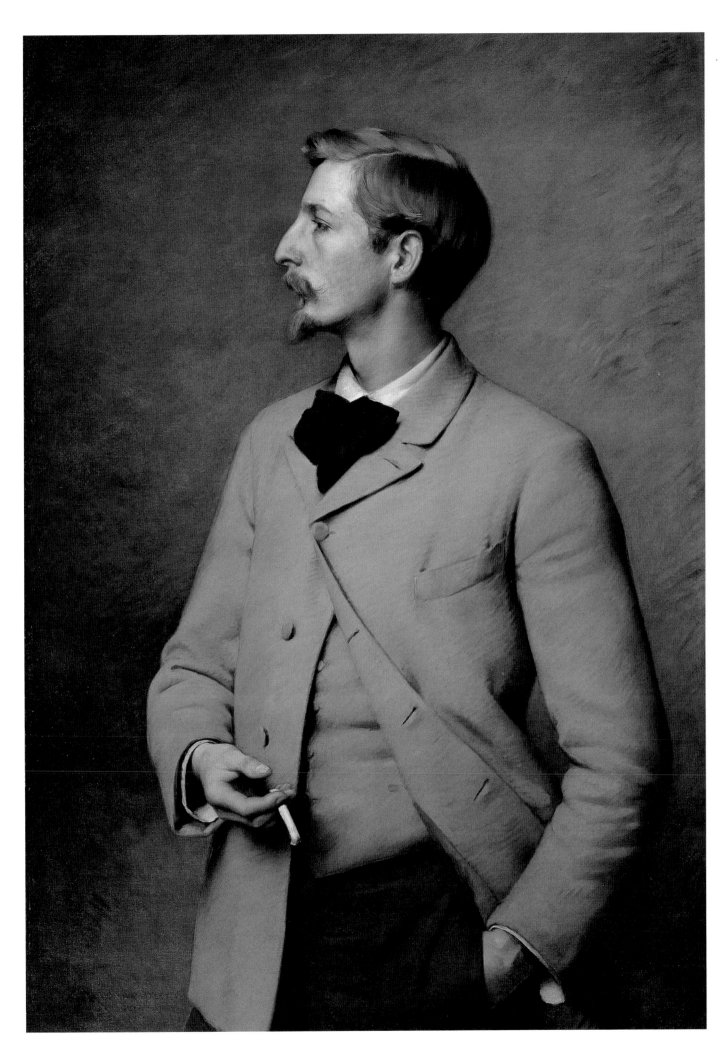

47

Charles Yerkes 1837–1905
Financier

Jan Van Beers 1852–1927
Oil on panel, 30.5 x 24.8 cm
(12 x 9¾ in.), circa 1893
Gift of Mrs. Jay Besson Rudolphy

NPG.76.28

Investment banker and traction entrepreneur Charles Tyson Yerkes was one of the most notorious American financiers of his day. He began his career as a brokerage clerk in Philadelphia at the age of seventeen and soon established his own investment bank, specializing in high-risk deals. His financial gambling landed him in jail after the panic of 1871, when he was found guilty of embezzling the city's funds. After serving only seven months of his nearly three-year sentence, Yerkes emerged unshattered and soon rebuilt his fortune. Spurred in part by a scandalous divorce, the financier departed for Chicago with his new bride in 1882. There, using bribery and political manipulations with consummate skill, Yerkes gained control of the city's major streetcar lines within five years. To his credit, Yerkes effectively modernized Chicago's transit system, leading the efforts to convert horsecar lines to cable traction and devising the ingenious downtown "Loop," which still provides this district with its nickname. His other legacy to the city stems from his 1892 donation of funds to the University of Chicago for the construction of the Yerkes Observatory and the world's largest telescope. When in 1899 the city legislators were meeting to discuss the Allen Law—a measure that would have allowed Yerkes to renew his Chicago franchises without payment—a mob of angry citizens surrounded City Hall with guns and nooses. The besieged tycoon sold his holdings that same year and moved to London, where he headed the syndicate that built the London Underground. His career inspired Theodore Dreiser's novels *The Financier* (1912), *The Titan* (1914), and *The Stoic* (1947).

Yerkes was as influential in the art world as he was in the realm of business. One of the key figures who ensured that the Columbian Exposition be held in Chicago, Yerkes contributed large sums of money to support it, served on the Committee on Fine Arts, and searched European art centers for prospective exhibitors. His own art collection, one of the finest in the nation, consisted of lavish decorative objects and paintings by important European and, to a lesser degree, American masters. The Belgian artist Jan Van Beers, deemed "distinctively Parisian" by one Chicago newspaper and renowned for his portraits and female figure studies, was a favorite artist of Yerkes.[88] The two may have first met during Yerkes' travels in Europe. The financier's collection included more of Van Beers's work than that of any other artist, and he commissioned from him portraits of both himself and his wife. This portrait, executed in about 1893, portrays the magnate in his role as connoisseur. He is the image of cultivated gentility, urbanely posed within a refined interior composed of an ornate table, an open catalogue of pictures, and an expansive landscape painting, which frames the sitter's head. It was exhibited at the fair along with other works by Van Beers that Yerkes had loaned. Witness only to the generous and beneficent side of Yerkes, Van Beers evidently felt amicably towards his patron. His portrait of Mrs. Yerkes is inscribed, "Presented to my friend, C. T. Yerkes."[89] ✳

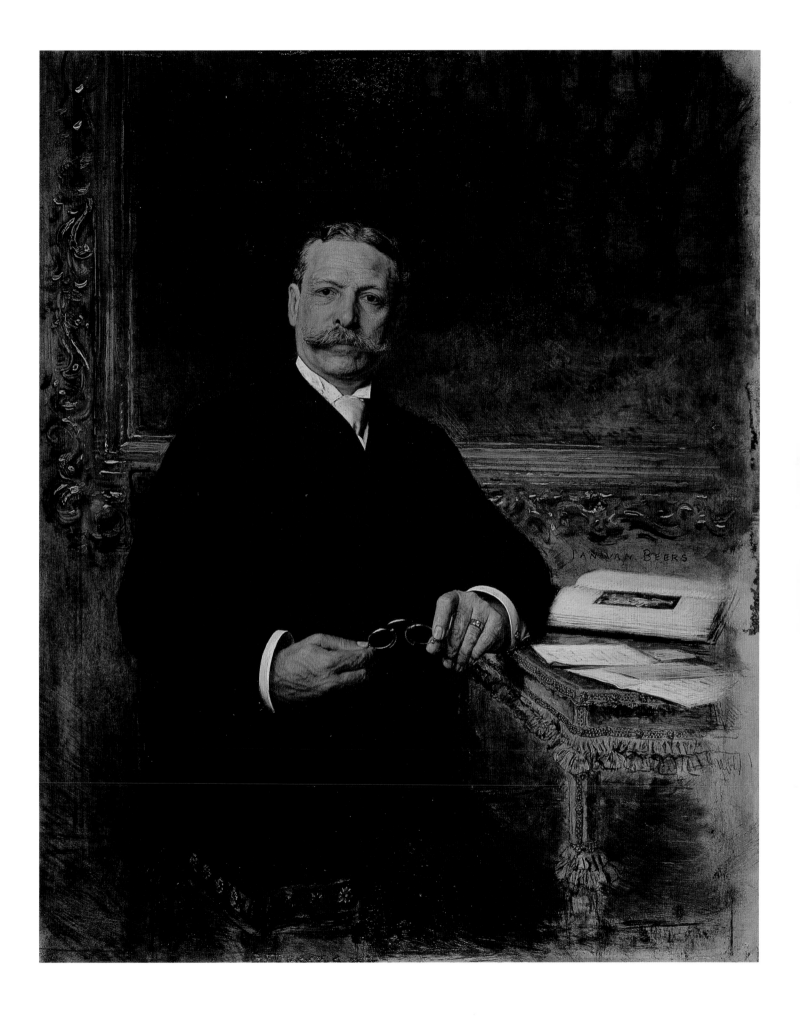

Richard Watson Gilder 1844–1909
Editor, poet

Cecilia Beaux 1855–1942
Oil on canvas, 116.5 x 87.6 cm
(45⁷/8 x 34¹/2 in.), 1902–1903
Gift of Rodman and Mary Ellen Gilder
NPG.98.77

For nearly three decades Richard Watson Gilder held one of the most prestigious and influential positions in American publishing, as editor-in-chief of the *Century Monthly Magazine*. He began his career in journalism at the age of twenty, reporting for the *Newark Daily Advertiser*. In 1869 he was hired as editor of Charles Scribner and Company's *Hours at Home*, and with this magazine's demise the following year, he was promoted to assistant editor of the more ambitious replacement, *Scribner's Monthly Magazine*. For more than ten years Gilder contributed to the journal's growth, championing the early efforts of realism and acknowledging the genius of Walt Whitman when most of literary New York rejected him. Promoted to editor-in-chief of the newly renamed *Century Monthly Magazine* in 1881, Gilder remained committed to elevating the status of American literature. He printed excerpts from Mark Twain's *Huckleberry Finn* as a teaser before the book was published, and solicited Henry James for contributions until the unsuccessful serialization of *The Bostonians* in 1885–1886.

Hosting Friday-evening gatherings for artists, writers, and musicians at their Manhattan residence, Gilder and his wife, the artist Helena de Kay, exerted considerable influence in New York cultural circles. They were founding members of the Author's Club and the Society of American Artists. In the 1890s, Gilder was elected chair of the Tenement House Commission and was instrumental in achieving copyright legislation as a member of the American Copyright League.

Cecilia Beaux, an artist of international renown during the late nineteenth and early twentieth centuries, was one of America's most sought-after portraitists. She trained at the Pennsylvania Academy of the Fine Arts and at the Académies Julian and Colorossi in Paris. Her portraits are noted for their calculated but seemingly spontaneous craftsmanship, and for their "strong, self-assured, potent and convincing" quality.[90] Beaux was recognized with numerous awards during her lifetime.

The Gilders were close friends of Beaux, especially Richard and Helena's daughter, Dorothea. She stayed with them in New York for a brief period during the 1890s and benefited greatly from contacts made there. Gilder also published several of Beaux's portrait sketches in the *Century*. In 1902 Beaux began this portrait of the editor, which she had "long desired to do," in her Washington Square studio.[91] To contemporary viewers, this sympathetic rendering of the editor conveyed the close rapport between sitter and artist. One critic praised the "affection and understanding" with which Beaux rendered her friend, finding "the spirit of the artist in the picture [to be] wonderfully close to the spirit of the sitter."[92] The artist, for her part, must have been satisfied with her work; she painted a replica of the portrait thirty years later when her painting activities had virtually ceased. ✳

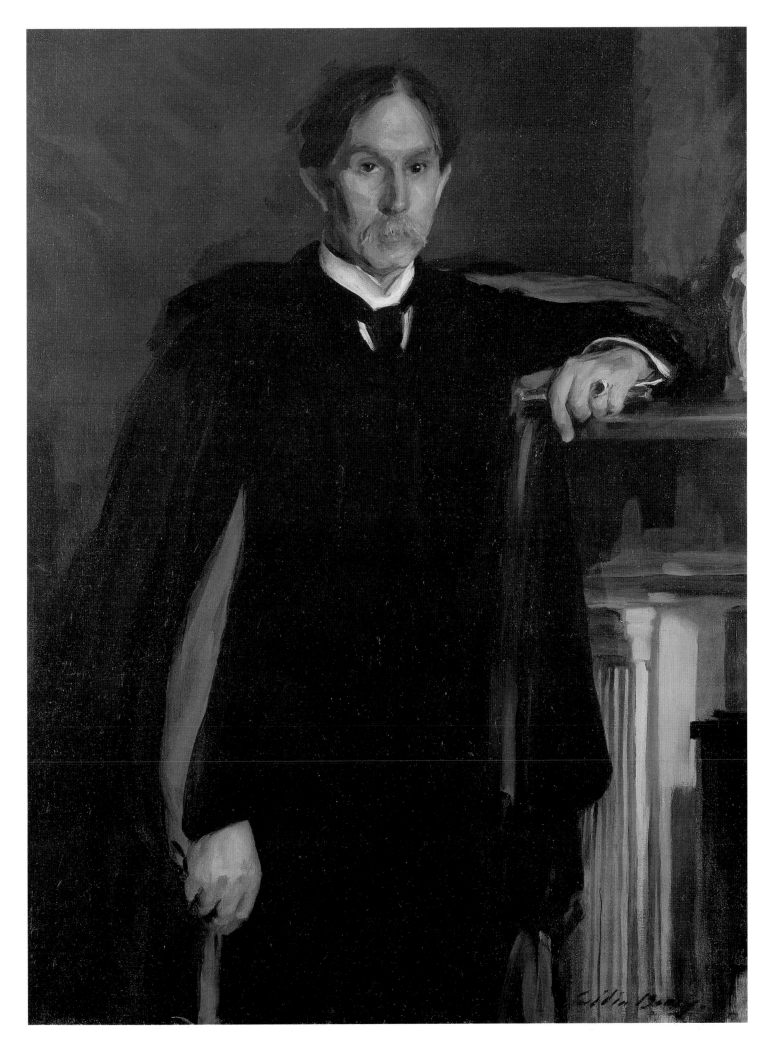

Samuel L. Clemens
(Mark Twain) 1835–1910
Author

John White Alexander 1856–1915
Oil on canvas, 191.7 x 91.4 cm
(75¹/₂ x 36 in.), circa 1902
NPG.81.116

Better known by his pen name, Mark Twain, satirist Samuel Langhorne Clemens spent much of his youth in Hannibal, Missouri, the Mississippi River town that was to inspire many of his writings. After a checkered existence as a gold prospector, river pilot, and newspaper reporter, Clemens published his first major work of fiction, *The Celebrated Jumping Frog of Calaveras County and Other Sketches*, in 1867. With the appearance two years later of *The Innocents Abroad*, a mocking account of his trip to the Mediterranean and the Holy Land, Clemens's reputation as a humorist was secure. In succeeding years, he continued to draw on his own experiences for material, and his three next works—*Roughing It*, *The Gilded Age*, and *The Adventures of Tom Sawyer*—were all set in the West of his youth. He found his greatest critical success in *The Adventures of Huckleberry Finn*, which, like *Tom Sawyer*, recalled the author's boyhood days in Hannibal.

Born in western Pennsylvania, John White Alexander moved to New York City in 1875 to work as an illustrator for *Harper's Weekly*. In about 1877 he joined a group of Americans, including William Merritt Chase and Frank Duveneck, who were training at the Royal Academy in Munich. In 1879, he journeyed with some of his fellow students to Venice and Florence, where he met the painter James McNeill Whistler, whose softly focused and tonally restricted art would prove important in the development of Alexander's own style. Alexander returned to New York in 1881, where he taught, worked as an illustrator, and made a name for himself as a portraitist. In 1891 he moved his family to Paris, where he spent a productive decade creating the decorative, carefully composed images of women for which he is remembered today. After his return to America in 1901, he continued to do fashionable portraiture and his more poetic compositions.

The precise circumstances of Clemens's sittings are not known. Alexander did, however, paint Clemens's daughter Clara in Paris between 1898 and 1900, and he was in touch with Clemens as late as 1905, since he was invited to the writer's seventieth birthday party. Alexander chose an animated pose for the aging raconteur and employed a decorative use of darks and lights, together with long, sweeping brush strokes, to characterize Clemens's inherent energy. As one admirer wrote, Alexander had "that sense of synthesis, that regard for simplicity, that striving to invest every figure with some special quality other than that which is apparent to all at first sight, that sane logical method of composition which belongs by right to the decorative painter."[93] ✳

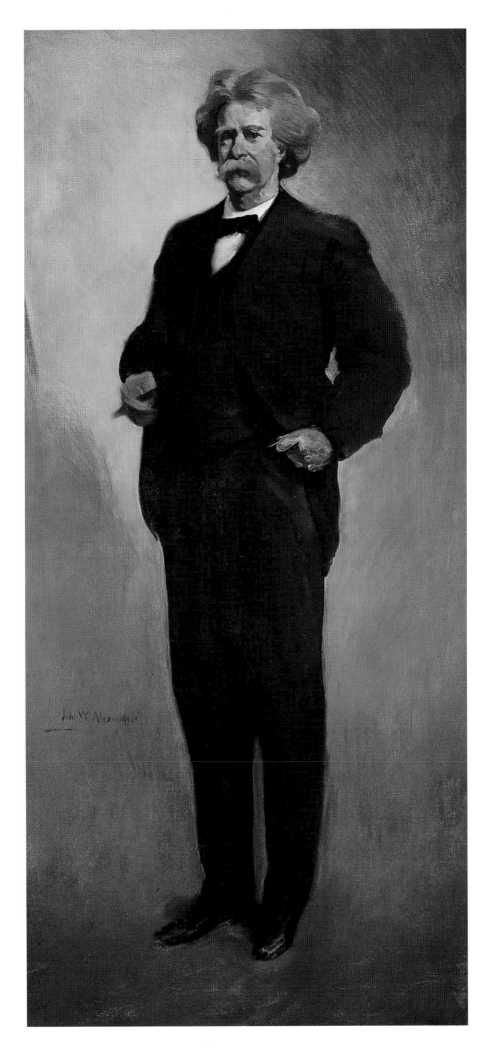

Henry James 1843–1916
Author

Jacques-Émile Blanche 1861–1942
Oil on canvas, 99.6 x 81.3 cm
(39¼ x 32 in.), 1908
Bequest of Mrs. Katherine Dexter McCormick

NPG.68.13

The son of a wealthy New Yorker who was determined that his children should receive a cosmopolitan education, Henry James spent a large part of his childhood in Europe. As a student at Harvard between 1861 and 1865, he came under the influence of author and editor William Dean Howells, who encouraged James's literary talents and ultimately convinced him to make writing his career.

In 1876, after a decade of alternating between Europe and America, James settled permanently in England, where he began a series of novels dealing with the relationship between the European and the American, and the moral questions that such encounters created. *Roderick Hudson*, *The Americans*, and *Daisy Miller* were followed by *Washington Square* and *The Bostonians*. James reached the height of his literary craftsmanship after 1900, with publication of three of his most elaborately structured works, *The Ambassadors*, *The Wings of the Dove*, and *The Golden Bowl*.

James moved in affluent, fashionable circles in New York, England, and Paris. His portraitist was part of the same social set. At the time Jacques-Émile Blanche painted him in 1908, James was engaged in preparing a collected edition of his works of fiction, an arduous task that "so paralyzed me—as a panic fear—that I have let other decencies go to the wall."[94] In April of 1908, however, he traveled to France in order to visit his longtime friend, American author Edith Wharton. There Blanche entertained him at Passy, a suburb of Paris, and at Wharton's suggestion, James agreed to pose for the artist.

Although Blanche claimed to have had very little formal artistic education, he had been thoroughly exposed to the artistic influences of both France and England, and counted among his acquaintances such painters as James McNeill Whistler, Walter Sickert, and Edgar Degas. An amiable *bon vivant*, Blanche entertained and painted many of the artistic and literary figures of his day, including writer Thomas Hardy and composer Claude Debussy.

His initial portrait of James, done full-face, was not pleasing to either the author or the artist; James worried that it made him look "very big and fat and uncanny and 'brainy' and awful."[95] Blanche then painted this second, profile, likeness, completing it in time for a London exhibition in the autumn of 1908. He described this portrait as "a Poet-Laureate, with a faraway, meditative look, against a William Morris wallpaper of gilded vine leaves and grape clusters—the sort you'd find in the study of an Oxford or Cambridge don."[96] Edith Wharton thought it the "only one that renders him as he really was," and even James felt that "it has, a certain dignity of intention and indication—of who and what, poor creature, he 'is'! It ought to be seen in the U.S."[97] ✳

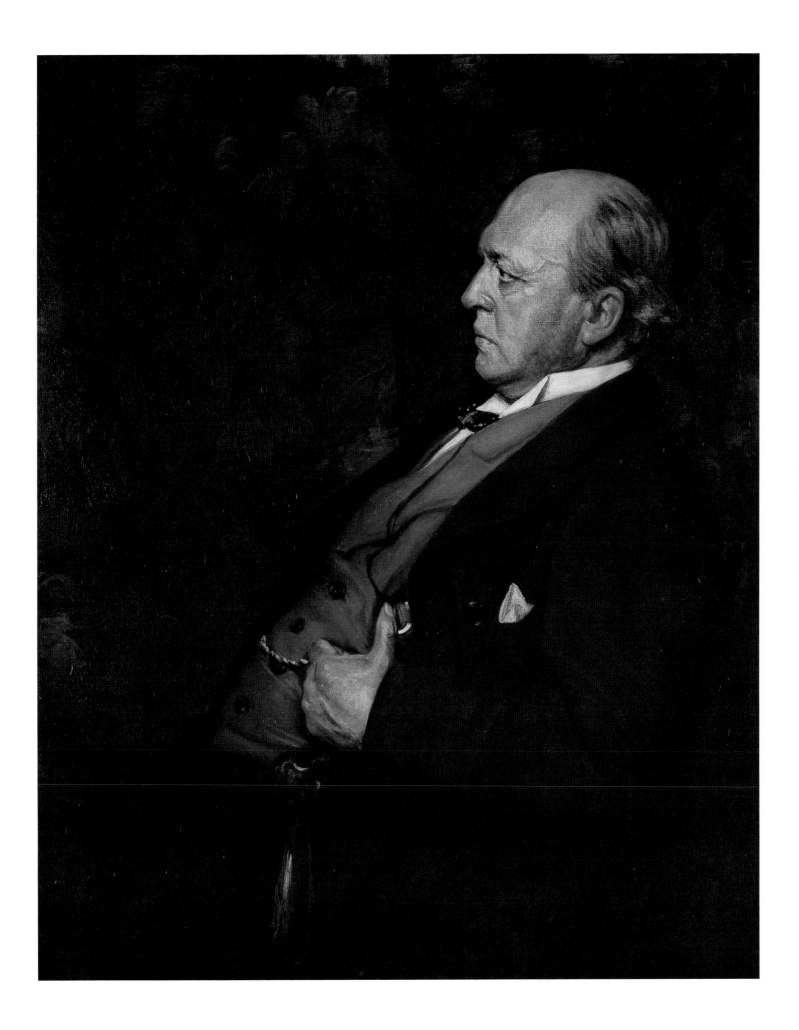

Lee Simonson 1888–1967
Scenic designer

Self-portrait
Oil on canvas, 101.9 x 81.6 cm
(40⅛ x 32⅛ in.), circa 1912
Gift of Karl and Jody Simonson
NPG.77.239

Lee Simonson, a major force in American scenic design, discovered in his youth what the "painters' and designers' vision could do to revivify the theater."[98] Raised in a family that valued the arts, Simonson attended Harvard, where he pursued rival interests in painting and drama. After graduating magna cum laude in 1909, he went to Paris hoping to become a mural painter. He studied painting and formed friendships with such expatriate Americans as writer and collector Gertrude Stein and painter Stanton MacDonald-Wright. He also attended some of the most experimental European theatrical productions. When he returned to New York in 1912, he was determined to launch his career as a set designer.

After the First World War, Simonson became cofounder in 1919 of New York's Theatre Guild. With his friend Lawrence Langner and others, he began twenty-one years of design production for that organization; by the time that he resigned his directorship in 1940, he had designed more than seventy-five stage productions. He later created sets for the opera and museum exhibitions, and also published his memoirs, various essays, and several volumes on theater design.

Acclaimed as "the artist who created sets for some of the history-making productions of the American theater,"

Simonson defined his art as "the creation of plastic forms and spaces that are an integral part of the acting of any play and project its meaning." The business of a stage designer, he believed, was "not to create a work of art that can be judged as having a life of its own as a more or less beautiful picture but to bring to life the world as pictured by the play."[99]

Simonson may have still been in Paris when he painted this self-portrait. The canvas, with its areas of pure, vibrant color, is similar to a now-lost portrait of Stanton MacDonald-Wright and his friend Simonson that MacDonald-Wright painted at this same time. Both were acquainted with avant-garde European trends in painting, writing, and drama. Both admired post-Impressionist painters such as Paul Cézanne and Paul Gauguin, as well as many of their French contemporaries, and saw that the arts were in a period of transition. As Simonson wrote in 1914, "For the moment, painting is sealed in a test-tube of esthetic experiment where form and color gleam and float in fiery disintegration."[100] Ultimately, MacDonald-Wright chose to explore color abstraction, whereas Simonson left easel painting behind altogether and concentrated on bringing the vision of a modern painter to the American stage. ✳

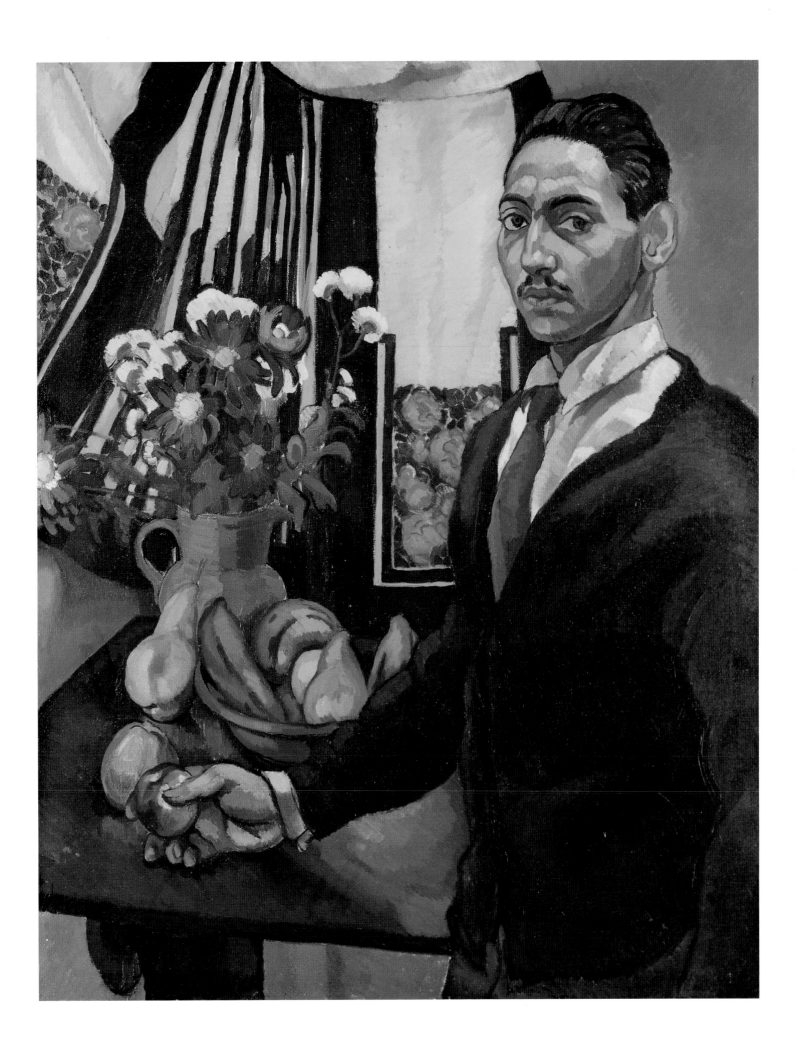

52

Nelson Aldrich 1841–1915
Statesman

Anders Leonard Zorn 1860–1920
Oil on canvas, 130.8 x 97.8 cm
(51½ x 38½ in.), 1913
Gift of Stephanie Edgell in memory of
Elsie Aldrich Campbell

NPG.69.85

Essentially a self-made man, Nelson Wilmarth Aldrich rose from service in the Civil War and partnership in a wholesale grocery business to become one of Rhode Island's foremost financiers and the premier spokesman of Old Guard politics during the McKinley, Roosevelt, and Taft administrations. As part of the Senate's Republican "Big Four," along with John C. Spooner of Wisconsin, William B. Allison of Iowa, and Orville H. Platt of Connecticut, Aldrich championed the industrial and financial interests of the Northeast, cleaving to the plutocratic ideology that what was good for big business was good for the nation. A consummate strategist, the senator was known for his undaunted courage, indifference to public opinion, and enjoyment of a fight. He served in the Senate for thirty years, thwarting democratic progressivism, lobbying for banking reform, and paving the way for the creation of the Federal Reserve System, which regulates America's monetary system to this day.

The Swedish painter, etcher, and sculptor Anders Zorn was first introduced to the American public in 1893 when he was appointed Swedish commissioner to the World's Columbian Exposition. Well-traveled and personable, Zorn was soon initiated into the inner circles of America's rich and famous. Three Presidents—William Howard Taft, Theodore Roosevelt, and Grover Cleveland—were among the important statesmen he painted during his seven visits to the United States. In these and other portraits, critics usually praised his impressionistic style and his ability to capture the momentary expressions of his sitters.

"Of all the sitters I ever had," Zorn confessed, "Senator Aldrich is the most difficult because of the expression of his eyes—it is so hard to get."[101] This challenge to capture what has been called the "tense alertness of a thoroughbred race horse" may have been why Zorn's first attempt at creating the senator's likeness in 1911 was rejected by the family.[102] Painted just after Aldrich's return to Washington from a brief, restful retreat at Jekyll Island, the portrait may have reflected some sense of the senator's wavering health.

Zorn's second effort, begun in Paris the following year, was more successful. Depicted at the age of seventy-two, just two years after his retirement from the Senate while on a book-buying journey across Europe, the Aldrich of this second portrait seems to embody that cocksure intrepidity that so many of his peers assigned to him. His self-satisfied posture is not without justification: his years of lobbying for banking reform and efforts as chairman of the National Monetary Commission had finally come to fruition in the Federal Reserve Act of 1913. He also elicited the admiration of the artist as well—once the sittings were finished, Zorn wrote to Isabella Stewart Gardner, remarking that Aldrich was a "delightful modell [*sic*]."[103] ✴

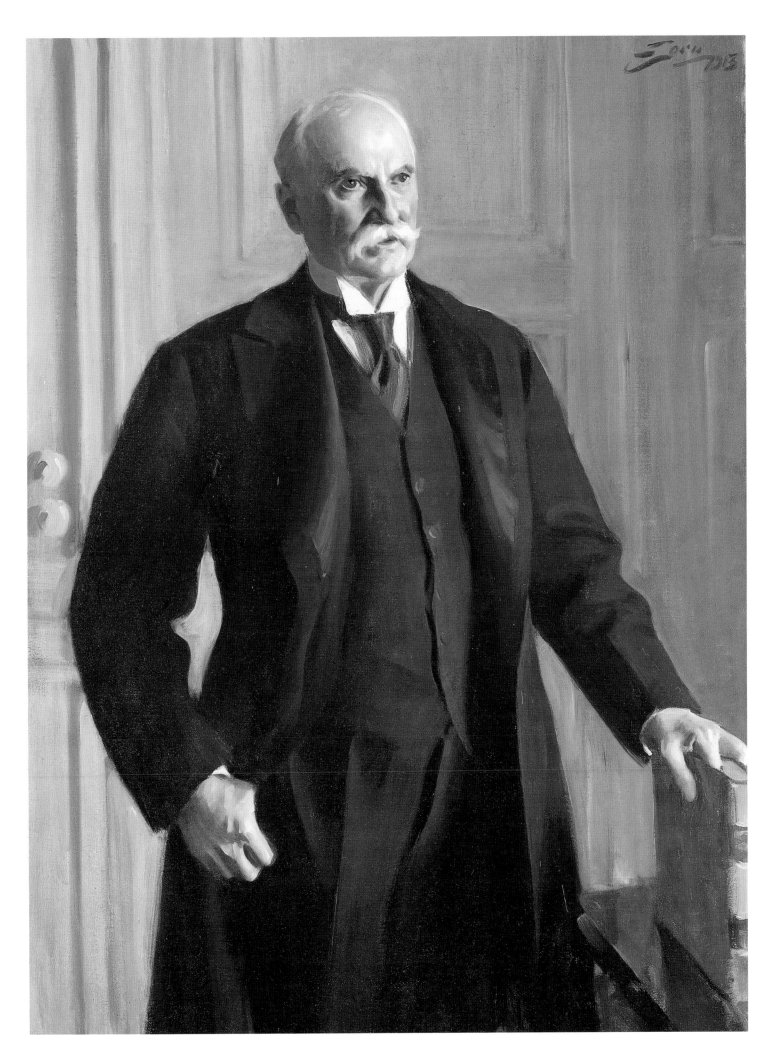

Willard Huntington Wright
(S. S. Van Dine) 1887–1939
Author

Stanton MacDonald-Wright 1890–1973
Oil on canvas, 91.4 x 76.2 cm
(36 x 30 in.), 1913–1914
Acquisition made possible by a generous
contribution from the James Smithson Society
NPG.86.7

Willard Huntington Wright began his career in California, writing book reviews for the *Los Angeles Times*. In 1911 he moved to New York and was soon named editor of the monthly magazine *The Smart Set*. During his tenure, he attempted to attract such first-rate contributors as D. H. Lawrence, W. B. Yeats, and Theodore Dreiser, in an effort to transform the magazine from a sophisticated, fashionable repository for light satire, poetry, and short stories into a more serious literary journal. His most important early work, however, was as an art critic. In *Modern Painting* (1915) and *The Future of Painting* (1923) Wright championed the modernist trends of the day. The publication of several volumes on philosophy, including *What Nietzsche Taught* (1915), also punctuated these years. A nervous breakdown sparked a new phase in Wright's literary career in the mid-1920s. Confined to his bed for two years, he sought relaxation in fiction and became a master of the detective novel. His first effort, *The Benson Murder Case* (1926), sold out in a week. In the next ten years one success followed another, and today Wright is best remembered for his detective stories written under the pseudonym S. S. Van Dine.

A label on the back of the canvas, which reads "Paris 1913/14," suggests that the portrait may have been begun while Wright was visiting the artist, his brother, in Paris during the summer and fall of 1913, and finished after both men had returned to Paris in April of 1914, following a short stay in New York. The two remained abroad until the outbreak of war in August 1914.

Stanton MacDonald-Wright had moved to Paris with his young wife in 1907, at the age of seventeen. He studied at the Sorbonne, the Académie Julian, and at various other schools before enrolling in classes taught by E. P. Tudor-Hart, a Canadian. There he learned much about modern painting and color theory and met artist Morgan Russell, with whom he developed a type of abstraction based solely on color and shape, called Synchromism. Willard Huntington Wright journeyed to Paris in 1913 to see his brother's and Russell's exhibitions of Synchromist works in Munich. Wright's article, "Impressionism to Synchromism," published in New York in December of that year, did much to pave the way for the showing of that exhibition in Paris in March 1914.

MacDonald-Wright's portrait of his literary sibling is unlike any of his Synchromist works, but it does reveal the artist's interest in the style of French painter Paul Cézanne, where colors are laid on in broad, flat, planar areas. MacDonald-Wright's careful, rhythmic balancing of primary and secondary colors in this likeness also suggests that he was aware of the work of a group of French painters known as the Fauves, or "wild beasts." Although the portrait's style is very contemporary, the likeness of Willard Huntington Wright is traditional in its depiction of a writer lost in contemplation, seated at his desk and surrounded by an ample supply of books. ✳

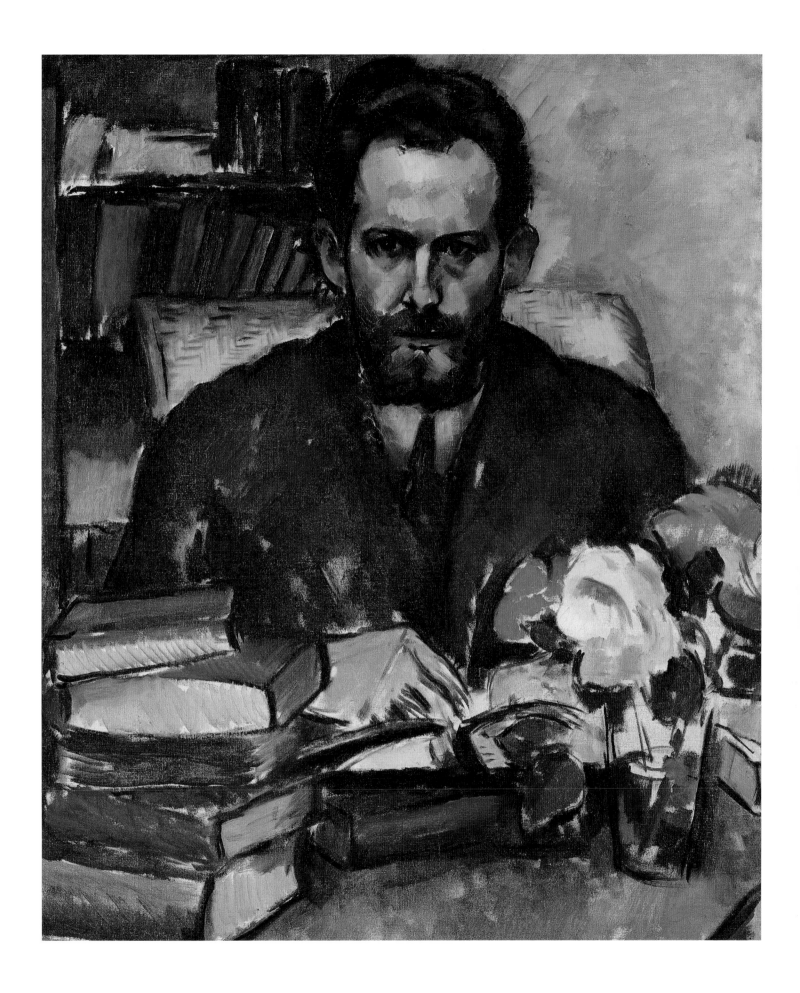

Francis P. Garvan 1875–1937
Collector

Philip Alexius de László 1869–1937
Oil on canvas, 76.2 x 63.5 cm
(30 x 25 in.), 1921
Gift of Mrs. Anthony Nicholas Brady Garvan
NPG.96.131

One of the century's most prominent collectors of early American paintings, prints, and decorative arts, Francis Patrick Garvan had an earnest faith in the moral value of art patronage. After attending Yale University and New York University Law School, Garvan was appointed assistant to the district attorney of New York County in 1901. As head of the Homicide Bureau, one of his more notable trials was the prosecution of Pittsburgh millionaire Harry K. Thaw for the murder of architect Stanford White. In 1910 Garvan entered private practice, and with the advent of World War I, he became chief of the United States Bureau of Investigation in New York. As Alien Property Custodian in Washington, D.C., Garvan discovered that the majority of chemical patents in the United States were held by foreigners, especially Germans. In 1919 he founded the Chemical Foundation to encourage research and strengthen America's chemical industry.

With Garvan's marriage in 1910 to Mabel Brady, the daughter of a wealthy entrepreneur, he turned to art collecting. The couple began buying antique English furniture while on their honeymoon. After discovering several fakes, they began to collect American objects exclusively. "I had eight years' experience in the District Attorney's office here in New York," Garvan said, "and I try every piece as I would a murderer. It must be proved innocent of every charge that can be brought against it before I accept it."[104] In 1930 Garvan gave Yale University approximately five thousand objects; at the time of his death in 1937, the collection totaled ten thousand objects of American painting, prints, silver, pewter, furniture, and other decorative arts. Today, Yale's Mabel B. Garvan collection stands as one of the most comprehensive collections of early American arts and crafts in the nation.

The Hungarian artist Philip Alexius de László trained in Budapest, Munich, and at the Académie Julian in Paris. He exhibited widely in Europe and was recognized with several honors, including gold medals at the 1899 and 1900 Paris Salons. In 1907 he settled in England and quickly established a reputation as a painter of kings, emperors, and society dignitaries. In the spring of 1921, de László paid a three-month visit to the United States, where he completed fourteen portraits, including those of President and Mrs. Warren G. Harding and General John J. Pershing. The Garvans were among de László's clients that year, and the artist painted an enormous family portrait of Mrs. Garvan and her four children (Philadelphia Museum of Art), along with this portrait of the family patriarch. The loose handling of paint and the bright palette provide a sense of active, unsullied optimism that is evocative of Garvan's personality. ✴

Thomas Hart Benton 1889–1975
with his wife, Rita

Artist

Self-portrait
Oil on canvas, 125.7 x 101.6 cm
(49½ x 40 in.), 1922
Gift of Mr. and Mrs. Jack H. Mooney
NPG.75.30

This double portrait depicts the artist and his wife, Rita Piacenza Benton, on South Beach, Martha's Vineyard, Massachusetts, where they spent many summers. Although the subjects are casually attired in bathing suits, the monumentality of the figures and the intensity of their expressions suggest that this was intended as a commemorative work, perhaps a marriage portrait, since it was painted in the year they were married. Benton recalled his deep affection for Martha's Vineyard in his memoir, *An Artist in America* (1937), calling it "that little Massachusetts island [that] freed me from its [painting's] illusions and opened my mind to receive the great American world beyond it."[105] It seems that in the quiet atmosphere of his summer house, Benton was able to break away from the modernist abstraction that had interested him earlier in his career, and begin to forge his own representational, sculpturally conceived style.

Born in the Midwest, Benton received his formal training at the Art Institute of Chicago and, after 1909, at the Académie Julian in Paris. There he absorbed the theories of avant-garde painting, and upon his return to New York, he joined with the American Synchromists, a group of artists concerned with the explication of form through color. Benton's own distinctive style emerged only after he became a draftsman in the navy in 1919. His accurate drawings of naval yard activities and his growing interest in American history and culture led him to advocate and make naturalistic paintings of American subjects. Traveling around the country, Benton, then politically a Progressive, absorbed and sketched his impressions of everyday life in small towns, farm country, and elsewhere. The resulting memories and sketches formed the basis for his numerous paintings and murals, including works for the New School for Social Research (1930), the Whitney Museum Library (1932), the Missouri State Capitol (1935), and the Truman Library in Independence, Missouri (1959). In 1933 Benton won a gold medal from the Architectural League of New York for his work in mural painting, an art form that underwent a forceful revival during the Depression as the result of government subsidization of such projects.

In order to develop a style of representational solidity and articulation, Benton combined his contemporary sense of abstract composition with a study of sixteenth-century Italian Renaissance technique, including the practice of making small, three-dimensional clay models of his compositions. These studies honed the skills that Benton needed to paint pictures such as this double portrait, an early example of his mature style, and to paint the landscapes and genre scenes that made him America's foremost regionalist painter during the 1930s. ✳

Marianne Moore 1887–1972
and her mother
Poet

Marguerite Zorach 1887–1968
Oil on canvas, 102.2 x 76.2 cm
(40¼ x 30 in.), 1925
NPG.87.217

The recipient of virtually every major literary award that the United States had to offer—including the Pulitzer Prize and the National Book Award—Marianne Moore was acclaimed by such contemporaries as T. S. Eliot for the "original sensibility and alert intelligence" of her poetry.[106] Educated at Bryn Mawr and Carlisle Commercial College, Moore was initially attracted to biology and art—interests that are reflected in numerous poems. Her innovative, witty, and often ironic verse, composed of unconventional metrical schemes and concerned with such no-nonsense virtues as courage, loyalty, and patience, secured for Moore a leading position among modernist writers of the early twentieth century. Indeed, Moore's supreme status among the artists and authors living in Greenwich Village during the 1920s prompted poet William Carlos Williams to proclaim her their "saint."[107]

Marguerite Zorach, who fell under the spell of cubism and fauvism during four profoundly influential years in Paris (1908–1912), was one of the first members of the New York avant-garde to achieve popular success. She exhibited her boldly colored works at the infamous Armory Show in 1913, and was in the vanguard in the applied arts with her needlework and textile designs. Moore was introduced to Zorach as early as 1915, when she saw a joint exhibition of William and Marguerite Zorach's work at the Daniel Gallery in New York. It may even have been at one of the couple's gatherings that Moore met such artists and writers as Marsden Hartley, Max Weber, Gaston Lachaise, Alfred Kreymborg, and William Carlos Williams, to whom she became so important.

Born two months apart, Moore and Zorach had a certain kinship, and the artist made at least three portraits of Moore during the 1920s: two pencil sketches and this double portrait of the poet and her mother. Completed the same year as Gaston Lachaise's sculptural portrait of Moore (also in the National Portrait Gallery's collection), Zorach's painting records the poet at an important moment in her rise to fame—*Observations* had been published in 1924, she had just won the *Dial* award, and she was shortly to become that magazine's acting editor. Its distinction also rests in the artist's perceptive rendering of Moore's complex relationship with her mother. The committed team of poet and editor/censor shared an apartment in New York until Mary Moore's death in 1947, and the influence of the "pious, possessive schoolteacher" is everywhere apparent in her daughter's poetry.

Zorach's portrait of the poet is one of resolute confidence; her unwavering posture and fire-red hair contrast strikingly with the muted tones and relaxed posture of her mother behind her. The artist's boldly colored idiom can also be said to be particularly suited to the bright optimism of Moore's poems and the intensity with which they touched her public. "We can be grateful," remarked then-President Richard Nixon at Moore's death in 1972, "that the splash of color and enchantment which she added to the Western world will brighten our landscape for many years to come."[108] ✳

Edward Weston 1886–1958
Photographer

Peter Krasnow 1890–1979
Oil on canvas, 127 x 96.5 cm
(50 x 38 in.), 1925
Gift of the artist
NPG.77.35

Edward Weston began his career working in the soft-focus, sentimental photographic style in vogue around 1900. By 1920 his work was internationally known, although his mature style did not emerge until a three-year stay in Mexico (1923–1926), when he came under the artistic influence of painter Diego Rivera. The brilliant light of Mexico seemed to demand a sharply focused image, and this influence, combined with the impact of modernist painting and the revolutionary photographs of Paul Strand and Charles Sheeler, led Weston to create images—whether portraits, still-lifes, nudes, or landscapes—that were precise and without artifice. His consummate craftsmanship was intentionally linked to his aesthetic ideals, and Weston spent the rest of his career in relentless pursuit of his artistic goals.

Long recognized on the West Coast as a leading modernist, Weston achieved national prominence in 1937 as the first photographer to receive a Guggenheim Fellowship. His career reached its climax in 1946 with a retrospective exhibition at New York's Museum of Modern Art. Two years later, crippled by Parkinson's disease, Weston retired.

Russian-born painter and sculptor Peter Krasnow studied at the Art Institute of Chicago until 1915 and later spent two years in New York City, where he learned about European modernism and met avant-garde artists. He moved to the Los Angeles area in 1922 and immediately became close friends with Weston, a neighbor and fellow artist with whom he held joint exhibitions. In 1931 Krasnow had a one-man show at the California Palace of the Legion of Honor. Its great success enabled him to travel to France, where he spent three years in the Dordogne region, working primarily in watercolor. He returned to California in 1934, where he continued to paint but also began to create abstract forms in sculpted wood. His later work became increasingly abstract, and much of it was inspired by his Jewish faith.

Weston returned briefly to Los Angeles from his seminal stay in Mexico during the first few months of 1925. He noted in his daybook for that time that Krasnow was "the first of all my friends" to see his new work.[109] Krasnow must have painted this portrait during the months of Weston's stay in California. It is a striking, somber image, with its startling juxtaposition of Weston's black cape against the pale aquamarine sea in the far background. The division of the pictorial "space" into separate entities and the rounded, carefully delineated, and subtly colored forms are typical of Krasnow's work during the early 1920s. ✻

Tallulah Bankhead 1902–1968

Actress

Augustus John 1878–1961
Oil on canvas, 121.9 x 62.2 cm
(48 x 24$^{1/2}$ in.), 1930
Gift of the Honorable and Mrs. John Hay Whitney
NPG.69.46

During a popular 1946 revival of Noel Coward's *Private Lives*, one New York theater critic noted that what the crowds wanted to see was not the play but the star, "a remarkable personality with a remarkable name: Tallulah Bankhead."[110] Bankhead, famous for her sultry voice, began her stage career in London during the 1920s. Known as much for her languorous sophistication as for her acting, Bankhead had a magnetic quality that made her a popular success. In America she won the coveted New York Drama Critics Award in 1939 for her powerful performance as Regina in *The Little Foxes*. Three years later, she took the same prize for her role as Sabina in *The Skin of Our Teeth*. In 1952 she published a witty, best-selling autobiography, *Tallulah*. Her talents were further employed during the 1950s in both radio—as mistress of ceremonies for NBC's Sunday-night *Big Show*—and television—in NBC's *All Star Review*.

While performing in London, Bankhead decided to "consent to immortality" and sit for the talented and flamboyant artist Augustus John. "At that time," she confided in her autobiography, "I was the toast of London and that was some toast, dahling."[111] John, a recently elected member of the Royal Academy, was the talk of London himself. He was known for his uninhibited manners and lifestyle, which added notoriety to the deserved praise for his paintings. By 1930, careless living had consumed him, and as a friend observed, "he seemed old, his hair was grey, his eyes bloodshot."[112]

The artist, who had been educated at the Slade School of Fine Art, had asked Bankhead to pose several years before he painted her, but she refused, unaware of his prominence as an artist. When she later accepted his offer, she made John promise to sell her the finished portrait for a thousand pounds. Executed in the loosely brushed, delicate style he then used for many of his likenesses, it caused a stir when exhibited at the Royal Academy. The soulful attitude of the sitter and the evanescent pink of the negligee (which Bankhead had worn in the farcical comedy *He's Mine*) caused one critic to compare it to the manner of the seventeenth-century Spanish painter El Greco: "wispy, a little gaunt and eerie." Another reviewer called it "the greatest portraiture since Gainsborough's *Perdita*."[113]

Bankhead kept her portrait on display in her bedroom, where both business associates and friends gathered to visit the incessantly smoking, charismatic actress. She considered the portrait her most valuable possession, and although she remained a wealthy woman until her death, she once remarked, "Even though I get down to living in a hall bedroom and cooking on a Sterno, I'll never part with that picture."[114] ✳

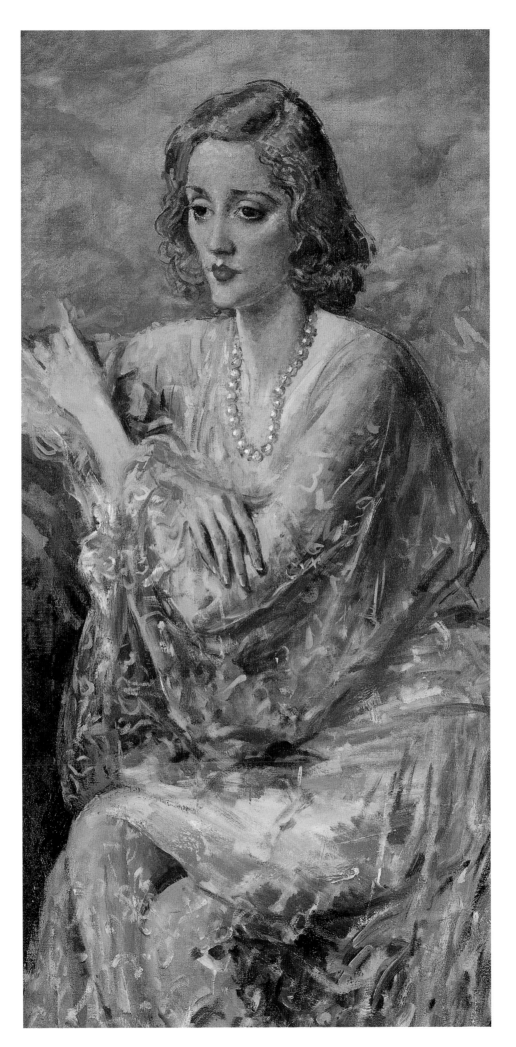

59

George Gershwin 1898–1937
Composer

Arthur Kaufmann 1888–1971
Oil on canvas, 91.4 x 61.6 cm
(36 x 24¼ in.), 1936
NPG.73.8

George Gershwin bridged the distance between popular song and serious concert music, retaining his inventiveness, energy, and vitality in both realms. Born to immigrant parents of Russian-Jewish descent, Gershwin so assimilated contemporary American tastes and national traditions that he was able to create folk and popular music, as well as symphonic works that captured the American imagination. "True music," he once wrote, "must repeat the thoughts and aspirations of the people and the time. My people are American. My time is today."[115]

Gershwin's short career was launched at age fifteen, when he worked for a music publisher. By the time the young jazz composer was twenty, he had written a score for a Broadway show and composed "Swanee," a song made famous by singer Al Jolson. Between 1924 and 1935, Gershwin collaborated with his lyricist brother Ira on more than a dozen musicals and, in doing so, produced such eminently memorable songs as "Fascinating Rhythm," "Embraceable You," and "I Got Rhythm." Even in his own day, Gershwin was viewed as substantially more than the author of infectiously popular tunes. As one contemporary put it, his work marked "the beginning of the age of sophisticated jazz," and his concert pieces—among them *Rhapsody in Blue* (1924), *Concerto in F* (1925), and *An American in Paris* (1928)—transformed jazz into a serious art form.[116] Perhaps Gershwin's greatest triumph was his opera *Porgy and Bess*. Although it proved a failure when it opened in 1935, in time many came to see *Porgy*'s richly complex score as the culmination of Gershwin's singular genius.

The German-born artist Arthur Kaufmann had only brief academic training as a painter. Following a few years at the Dusseldorf Academy, he spent time traveling in France and Italy, as well as two years in England, where he worked as a "lightning caricaturist" on variety-show stages. After World War I, during which he was a mapmaker, Kaufmann helped organize several artists' associations and large exhibitions in Germany before accepting a position as professor in the School of Applied Art in Dusseldorf in 1929. In 1933 he was discharged from that position for being a "non-Aryan." He immigrated to the Netherlands, visited the United States in 1935, and moved there in 1936—the same year he painted Gershwin, with whom he had become friends. As he wrote in his letter of condolence to Gershwin's brother Ira, "I personally owe much to him, for it was through George's affidavit that I was able to enter this country."[117]

The portrait of Gershwin is typical of Kaufmann's expressionistic style, which he applied most frequently to portraiture. As one admirer of Kaufmann's work noted, "He sees his models with the utmost exactitude and clarity and transfers his impressions to canvas with decisive brushwork and glowing, vital colors."[118] Here, Gershwin's dark hair and strongly modeled features stand out against a pale background, while his expressively painted hands, casual pose, and sartorial disarray give an awkwardness and immediacy to the image, which connote Kaufmann's clarity of observation. After Gershwin's untimely death, the artist offered the portrait to the composer's mother, who rejected it because she did not wish to remember her son dressed in the casual clothing that was, nevertheless, his trademark. ✳

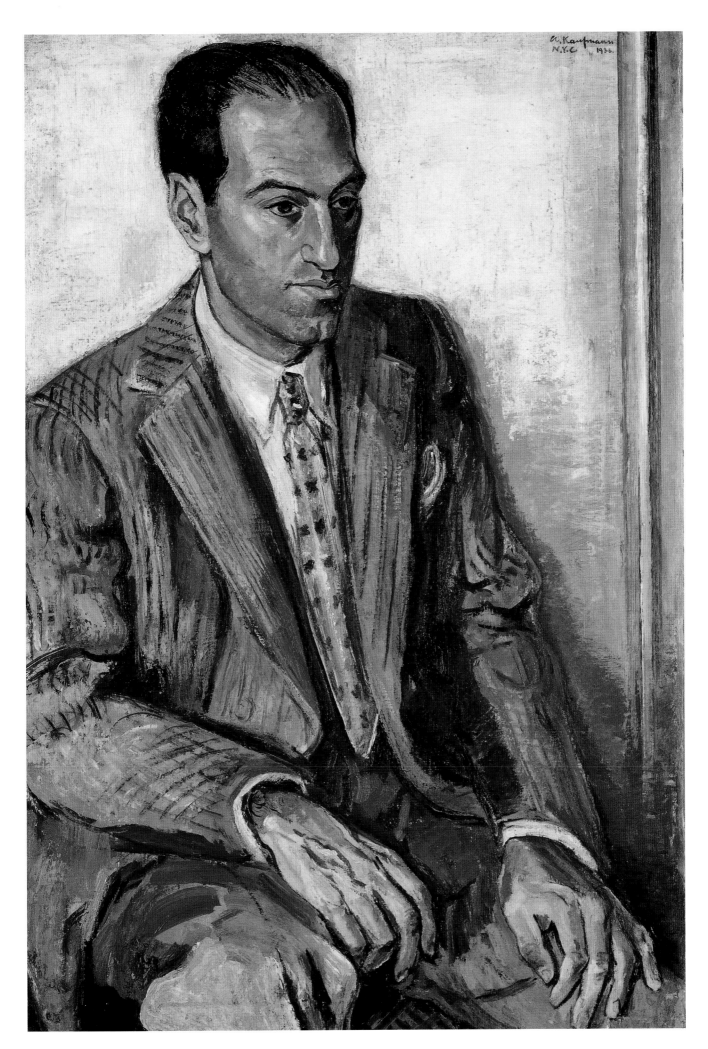

60

Martha Graham 1894–1991
Dancer, choreographer

Paul Meltsner 1905–1966
Oil on canvas, 106.6 x 81.3 cm
(42 x 32 in.), circa 1940
T/NPG.73.41.01

Martha Graham's career as a pioneer in modern American dance spanned more than six decades. Her initial introduction to dance came in 1916 when she enrolled in the Denishawn School in Los Angeles. After studying for several years with Ruth St. Denis and Ted Shawn, and touring with his company, she began to independently explore new methods in dance while teaching at the Eastman School of Music. The revolutionary elements of her style, which first emerged in such works as *Immigrant*, *Revolt*, and *Heretic*, generated much controversy in the 1920s and 1930s. During the 1930s, productions such as *American Provincials*, *Frontier*, and *American Document* were derived from American Indian material and from other elements of American heritage and culture. In the years following, as Graham and her company turned to more ambitious works such as *Letter to the World*, *Appalachian Spring*, and *Clytemnestra*, her originality began winning broad acceptance. In 1984 a dance critic called her "one of the greatest artists America has produced," and declared her "raw, powerful and dynamic" technique the "first lasting alternative" to classical ballet ever to be developed.[119]

A native New Yorker, Paul Meltsner had achieved a prominent position in the art world by the mid-1930s. He was known for his lithographs and watercolors, but even more for his carefully composed, dramatic, even ponderous oils, many of which portrayed scenes of industry and workers. Around 1939, Meltsner began to exhibit portraits of actors and other performers, including Carmen Miranda, Lynn Fontanne, Gertrude Lawrence, and Howard Lindsay and Dorothy Stickney, stars of the hit play *Life with Father*. Portraits of Martha Graham were given a prominent position in these exhibitions. In fact, contemporary reviews of Meltsner's paintings often noted that Graham was his "favorite subject."[120]

Although Meltsner's work was characterized as overly posed and mannered, it was praised for its well-balanced composition and rich colors. The artist was commended for being a "steady and serious draughtsman, more dependent on earnest concentration than on a facile handling of forms."[121] This portrait of Graham is perhaps the strongest and simplest of his group of celebrity likenesses. Meltsner omitted all extraneous details or references, concentrating on the striking crisscross arrangement of the dancer's controlled figure and the dramatic effect of the picture's rich, resonant blues and dark reds, contrasted with Graham's pale skin and stark profile. Meltsner is said to have portrayed her here as she appeared in "Tragic Holiday," from her work *Chronicle*, which was first performed in December 1936. ✳

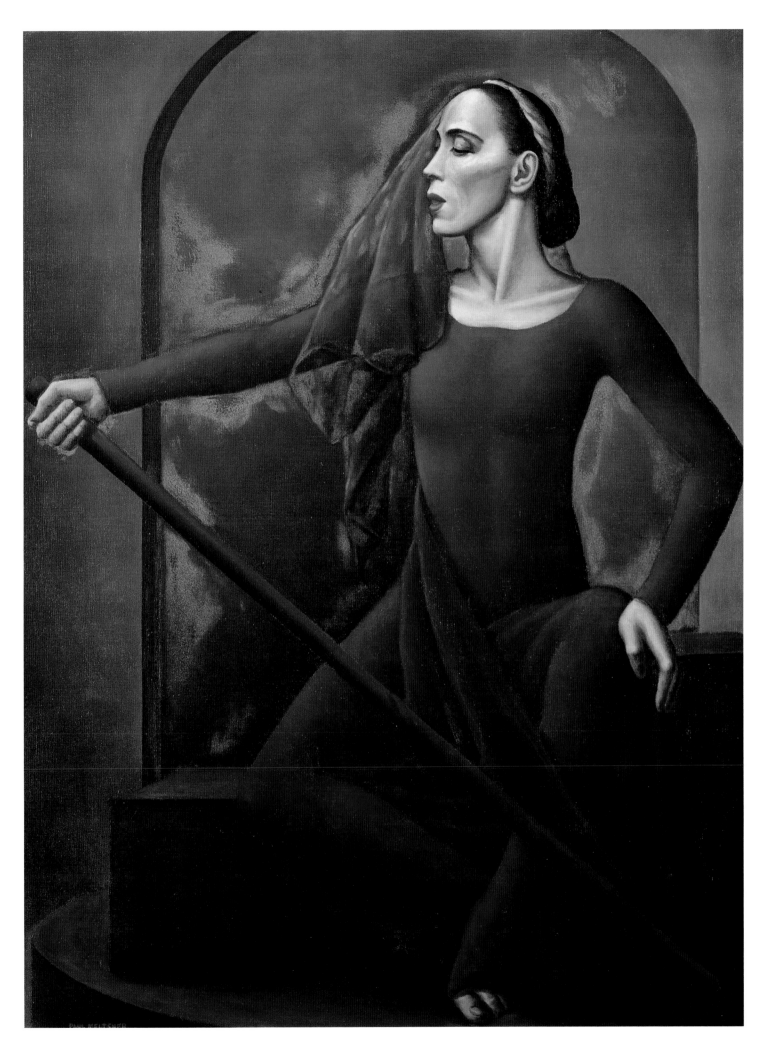

George Washington Carver 1864–1943
Scientist

Betsy Graves Reyneau 1888–1964
Oil on canvas, 112.4 x 88.9 cm
(44¼ x 35 in.), 1942
Transfer from the National Museum of
American Art; gift of the George Washington Carver
Memorial Committee to the Smithsonian Institution, 1944
NPG.65.77

George Washington Carver was born a slave in war-torn Missouri and died an honored scientist. Overcoming numerous obstacles, he received his master's degree from Iowa State University in 1896. Soon thereafter, he accepted an offer from the famous black educator Booker T. Washington for a post at Tuskegee Institute in Alabama, which Washington had founded in 1881. Carver spent nearly forty years at Tuskegee conducting research and teaching scientific agricultural methods.

Carver's main contribution to science was the extraction of new products from previously untapped sources; he found in the peanut and the sweet potato more than four hundred synthetic products, ranging from margarine to library paste. His work gave the South agricultural alternatives to soil-exhausting cotton and brought Carver international recognition. During the early years of World War II, when he was nearly eighty years old, he produced five hundred dyes of different shades to replace those formerly supplied to the United States by Europe.

Betsy Graves Reyneau painted this portrait in 1942, a year before Carver's death. Reyneau had studied painting at the Boston Museum of Fine Arts School and then worked in Italy and England for about eleven years. When she returned to the United States in 1939, she found social conditions and racial prejudice intolerable: "I had come home to a perfect Fascist setup. I was determined to fight in any way [I] could."[122] Through contacts with the Harmon Foundation, she began a series of portraits of prominent black Americans that would be exhibited throughout the country in order to help counter negative racial stereotypes. The first to be painted was this portrait of Carver. By 1944 she had painted nineteen likenesses. With the addition of several portraits by black artist Laura Wheeler Waring, the exhibition, "Portraits of Leading American Negro Citizens," was first displayed in 1944 at the Smithsonian Institution. For the next nine years, the exhibition traveled extensively in the United States.

Carver had refused all requests for portrait sittings until he saw an example of Reyneau's work. Reyneau, he concluded, painted "the souls of people."[123] Thus persuaded, he agreed to pose informally; as the artist recalled, he "gave me no regular sittings. . . . He'd just come and sit in the sun when he felt like it."[124] He is depicted in an outdoor setting, wearing a laboratory apron and examining a red and white amaryllis, a hybrid that he developed as part of a lifelong hobby. Reyneau used clear, seemingly uncomplicated colors—blue, bright and dark green, pinks, red, rich browns, and white—and a simple composition, with a diagonal emphasis that recalls a snapshot, to capture Carver's sympathetic character and gentle but formidable intelligence. ❋

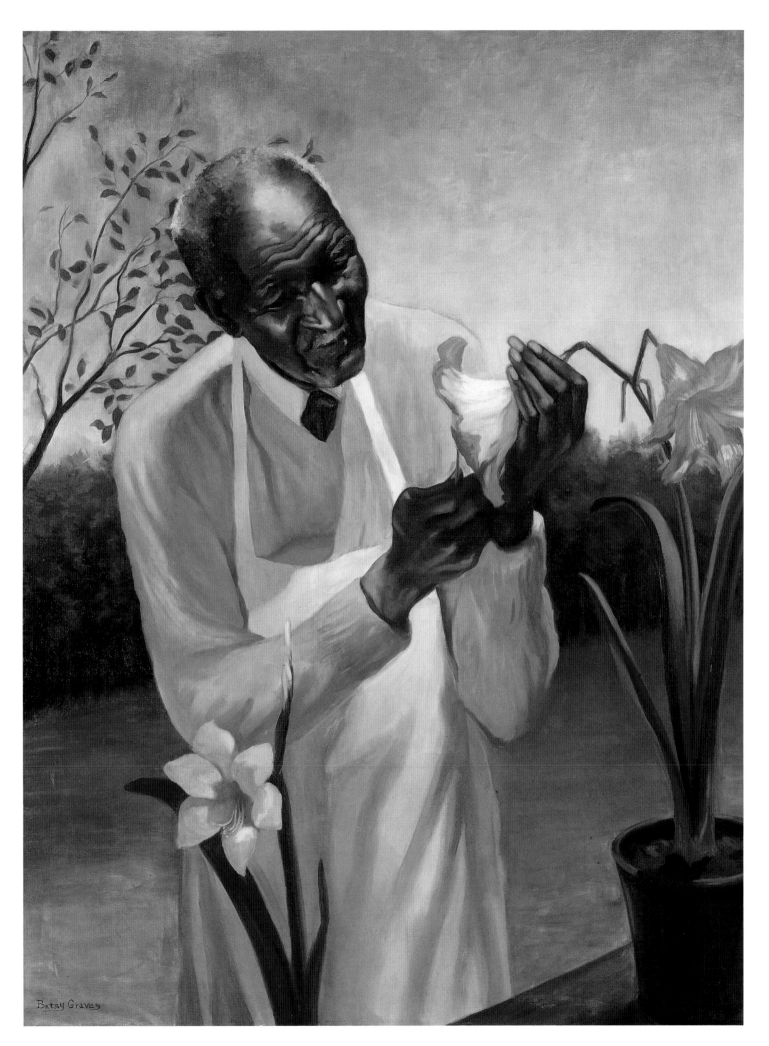

Betsy Graves

George S. Patton 1885–1945
World War II general

Boleslaw Jan Czedekowski 1885–1969
Oil on canvas, 127 x 101.6 cm
(50 x 40 in.), 1945
Gift of Major General George S. Patton,
U.S.A., Retired, and the Patton family
NPG.99.5

Nicknamed "Old Blood and Guts," General George S. Patton had a penchant for colorful commentary and outspokenness, which frequently made him the object of controversy during his long and impressive career. Born in San Gabriel, California, and a 1909 graduate of the United States Military Academy at West Point, Patton first went to Europe in 1917 as part of General John J. Pershing's staff. There he directed the American Tank Center in France and was head of the 304th Brigade of the Tank Corps. For his successful deployment of tanks against the Germans, he won a Distinguished Service Cross.

Among Patton's tasks in 1941, when he became the commanding officer of the First Armored Corps, was to take these divisions to California to prepare for desert warfare. His knowledge and experience with tanks led General Dwight Eisenhower to place him in charge of one of the three task forces invading North Africa. In the Allied drive against Axis forces, his gift for instilling discipline was critical in shaping unseasoned American soldiers into effective fighting units. When the major desert battles in Africa began to wind down, Patton occupied himself with training and then supervising the successful landing of the Seventh Army in Sicily. Again, his leadership proved crucial. But Patton's finest moment came during the massive German counteroffensive in the Ardennes in 1944–1945. By the time the Allies had repelled the Germans there, his reputation as one the most brilliant field commanders of the war was unassailable. Known as a tough taskmaster, Patton had an enviable record, marred only by an incident in Sicily in which he struck a shell-shocked soldier whom he thought to be a malingerer.

Patton sat for this portrait at his military headquarters in Germany shortly after the German surrender in May 1945. The picture's maker was Boleslaw Czedekowski, a Polish artist who had painted many European notables, including Austria's last Habsburg emperor. A stickler on military dress, the tall, imposing general is seen wearing the ivory-handled pistol that was one of his sartorial trademarks. In the upper left is a cartouche inscribed with his declaration that the greatest honor of his career had been leading the "incomparable group" of soldiers that had served under him during the war.

Six months after the end of the war, Patton was on his way to shoot pheasants near army headquarters in Heidelberg when he broke his neck in an automobile accident. While on the mend, he contracted a respiratory infection and died. He was buried in Hamm, Luxembourg, along with others of the Third Army who had lost their life in Europe. ✳

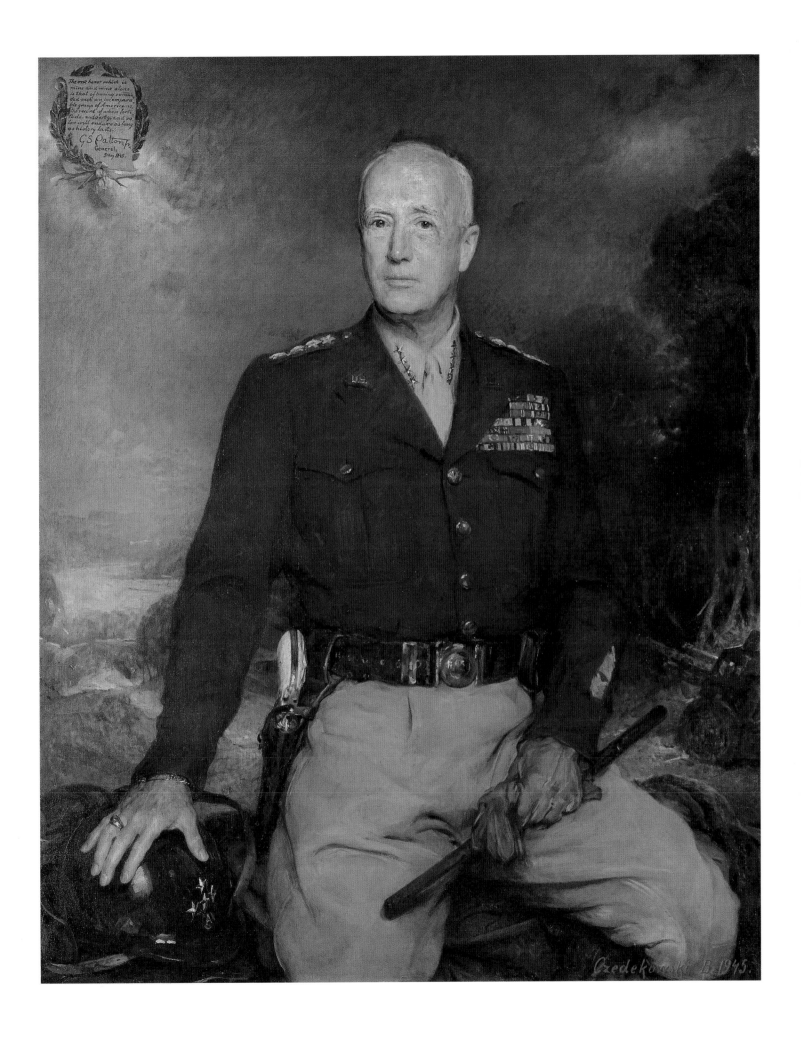

The one honor which is mine and mine alone is that of having commanded such an incomparable group of Americans, the record of whose fortitude, audacity, and valor will endure as long as history lasts.

G S Patton,
General,
3 May 1945.

Czedekowski B. 1945.

Elaine de Kooning 1918–1989
Artist

Self-portrait
Oil on Masonite, 76.8 x 58.1 cm
(30¼ x 22⅞ in.), 1946
Courtesy Elaine de Kooning Trust

NPG.94.81

When twenty-one-year-old art student Elaine Marie Fried moved into the West Twenty-second Street loft of Willem de Kooning in 1939, two years after she had met the artist and not long after she has begun her artistic career working in a social realist vein at the American Artists School in Manhattan, she explained the amount of time spent away from her Brooklyn home by telling her parents that she was taking private drawing lessons from the thirty-four-year-old Dutchman. While true, this was by no means the whole story! Subsequently, however, she attributed her assurance as a portrait painter to those intense lessons, during which Willem insisted on linear precision and careful, articulate modeling. In this self-portrait at age twenty-seven, she reveals not only her skill as a draftsman and her debt to the stylistic interests of Willem in the early 1940s, but also her intrinsic beauty. Indeed, no acquaintance who has written about Elaine has failed to remark on either her grace and elegance, or her wit and charm.

Convinced, from the time she first met de Kooning, whom she married in 1943, that he was "the most important person I would ever know," Elaine's energies in the 1940s and 1950s were, to a large extent, diverted to championing her husband's career.[125] She used her considerable personal talents to both enlarge the circle of artists who came to admire Willem's work and to introduce de Kooning to the critics, such as Harold Rosenberg and Tom Hess, whose writings would enhance his reputation. While she exhibited from time to time during the late 1940s and early 1950s,

her own career as a painter did not flourish until she and Willem separated in 1957.

Elaine de Kooning's interest in figure painting was jump-started in the mid-1940s, after seeing a portrait her friend Fairfield Porter was making of his wife. Until that point she had been focusing primarily on the formal problems inherent in still lifes, largely under the influence of her husband, who encouraged her in that direction. During a period when money was particularly tight, she and another friend, painter Joop Sanders, saved money on models by posing for each other. This experience led her in about 1946 to begin a series of self-portraits, which includes the one now in the National Portrait Gallery's collection. Here she portrays herself in an artist's smock, seated in a domestic interior and pausing between the pages of a book. The coffee cup and ashtray casually left on the floor by her feet indicate the sitter's ownership of this carefully decorated space. She stares fiercely at the viewer as a woman self-assured of her artistic and intellectual capacity. It is an image devoid of any feminine winsomeness or fragility—qualities so long applied by male artists to their female sitters.

Portraiture became a major facet of de Kooning's later oeuvre. Her major sitters included dealer Leo Castelli, choreographer and dancer Merce Cunningham, and, in 1962, President John F. Kennedy. "Portraiture is the kind of thing that liberates her talent," Fairfield Porter wrote in 1961. It is "what she uniquely can do."[126] ✳

Lena Horne BORN 1917
Singer, actress

Edward Biberman 1904–1986
Oil on canvas, 129.5 x 78.8 cm
(51 x 31 in.), 1947
T/NPG.85.2

From the age of sixteen, Lena Horne has captivated audiences in one artistic medium or another. She began her stage career as a chorus girl in Harlem's Cotton Club, but soon moved on to appearances on Broadway and featured roles in nightclubs. In 1942 she became the first black woman in almost thirty years to sign a term contract with a major Hollywood film studio. Horne's beauty, natural grace, and apparently limitless talents opened doors that were otherwise closed to many gifted African American performers. Her advantageous position in the entertainment world made her a symbol for the aspirations of the African American community, and her encounters with racism—first as the only black member in Charlie Barnett's band and then in Hollywood—led her to become a vocal spokesperson for the civil rights movement of the 1960s. In spite of the challenges Horne faced throughout her career, from racism as well as from her refusal to accept stereotypical roles, she has maintained a strong sense of justice and of her personal identity. Among her notable honors are two Grammy Awards, a Tony Award, and the Kennedy Center Honors Award for Lifetime Contribution to the Arts.

Painter and graphic artist Edward Biberman studied art in Paris and at the Pennsylvania Academy of the Fine Arts after receiving a degree in economics from the University of Pennsylvania. He moved permanently to Los Angeles in 1936, after spending time and exhibiting his work in Europe and New York during the 1920s and early 1930s. Biberman was introduced to Horne in southern California in 1947. She had just returned from her first singing tour of Europe, where she had secretly married white musician Lennie Hayton. The marriage lasted until his death in 1971, although it incurred much criticism both from the black and white American communities. Admiring her beauty, Biberman asked Horne to pose. She stands in the crook of a grand piano, beating time with her left hand. Biberman intended this action to signify Horne's vitality as a performer, while letting her calm, cool comportment reflect a quiet, intellectual personality. Painted the same year as his portrait of Paul Robeson (who was a close friend of Horne's and also largely responsible for fueling her commitment to the cause for racial equality), Biberman's image of Horne celebrates the sophistication for which she was known. It also portrays the persona adopted by the entertainer in her efforts to move beyond stereotypical constructions of black performers: "The image that I chose to give them was of a woman who they could not reach."[127] ✳

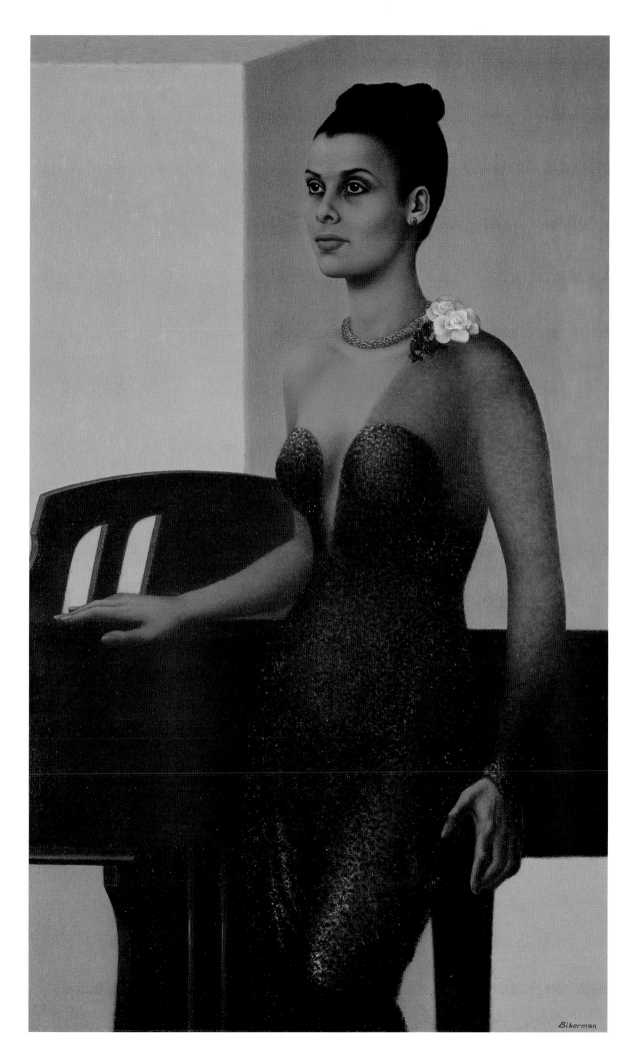

65

Harold Rosenberg 1906–1978
Author, critic

Elaine de Kooning 1918–1989
Oil on canvas, 203.2 x 149.5 cm
(80 x 58⅞ in.), 1956
Courtesy Elaine de Kooning Trust

NPG.94.14

The most vocal proponent of the Abstract Expressionist movement and the originator of the term "action painting," Harold Rosenberg was renowned for his fiercely intellectual criticism on art, politics, and society. "He seemed to have thought about everything—philosophy, poetry, the meanings of the creative act, literature, art, anti-Semitism, mysticism, culture—in ways entirely his own, and was writing about them in precise, supple prose which clarified every side of his subject."[128] Before he turned his attention in the late 1940s to the work of his artist friends and neighbors living in New York, Rosenberg was already an accomplished writer of poems, essays, and reviews appearing in a variety of American magazines. He also served as editor of the Works Progress Administration's American Guide Series and *Art Front* during the 1930s, and during World War II he was deputy chief of the Domestic Radio Bureau at the Office of War Information, writing plays that were broadcast nationwide. After the war, Rosenberg was a program consultant for the War Advertising Council, a post he held until 1973. He became art critic of *The New Yorker* in 1967 and published several collections of his essays—*Artworks and Packages* (1969), *Act and the Actor* (1970), *The De-Definition of Art* (1972), *Discovering the Present* (1973), *Art on the Edge* (1975)—and three monographs on artists—Arshile Gorky, Willem de Kooning, and Saul Steinberg—during his lifetime (a monograph on Barnett Newman was published posthumously in 1979).

Above all else, Rosenberg is remembered for his eloquently stated expositions on Abstract Expressionism, "the most vigorous and original movement in art in the history of this nation."[129] Locating the work of art's supreme value in the act of creation—the circumstances of the artist's life leading to a specific expression in paint—Rosenberg positioned himself squarely opposite the formalist critic Clement Greenberg and gained instant notoriety in art circles. His 1952 article for *ARTnews*, entitled "The American Action Painters," was adopted as Abstract Expressionism's manifesto, and had a profound effect on the artistic landscape of 1950s New York.

First introduced to the theories of abstract painting through Willem de Kooning in the 1930s, Rosenberg was a lifelong friend of the artist and his wife, Elaine de Kooning, also an artist working in the Abstract Expressionist vein. If Willem was "the king of art" for Rosenberg, the singular genius against whom all others were measured, then Elaine was his educator, the person who taught him how to develop his eye. "He knew almost everything," she once said of the critic, "except how to look at a painting."[130] Rumored to have had an affair during the 1950s, Rosenberg and Elaine de Kooning shared a relationship that was stimulated by involved intellectual conversations and debates on artistic theory. In this portrait, de Kooning portrays Rosenberg's bulky frame and piercing gaze amid a frenzy of broad gestural brushwork, evoking a summary of the critic's intense personality rather than providing a precisely detailed study of his figure. ✳

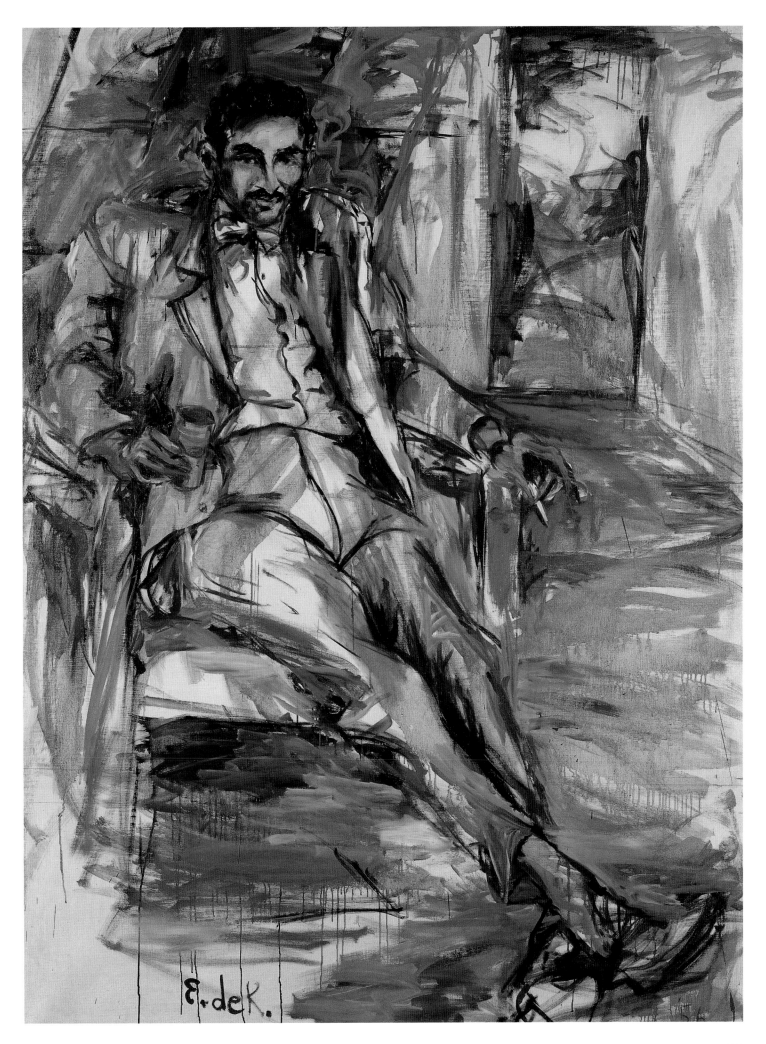

Elsa Maxwell 1883–1963
Society hostess

René Bouché 1905–1963
Oil on canvas, 122 x 56 cm
(48 x 22 in.), 1959
NPG.91.80

"Are your parties dull affairs? Why not have someone enter the room suddenly while the dinner, dancing, or bridge is in progress, and address the hostess in a clear, cold voice: 'Pardon, Mrs. Smith, but a dreadful thing has happened. Somebody has been murdered in the front bedroom upstairs.'"[131] So read the party prescriptions that made Elsa Maxwell an international hostess of royals and beauty queens, actors and statesmen. She virtually invented the murder mystery party and codified the scavenger hunt, delighting her selected guests with "come as your opposite" and "come as the person you least like" parties. Launched into the entertainment world in her early twenties as a member of a touring Shakespeare company, Maxwell went on to play piano in nickelodeon theaters and at private parties, where she met wealthy benefactors along the way. Also a successful songwriter and lecturer, Maxwell discovered her true calling when she hosted her first triumph in 1919—an exquisite dinner at the Ritz Hotel in Paris for Arthur Balfour, England's secretary of foreign affairs. She soon gained an international reputation as an imaginative hostess given easily to self-mockery. Maxwell's mastery of "the neglected art of conversation" and her ability to clown made her an antic-prone star of a string of 1930s films loosely based on her adventures in high society, a captivating host of her own radio program called "Elsa Maxwell's Party Line," and a lively guest on Jack Paar's "Tonight" show. The four books she published during her lifetime—*Elsa Maxwell's Book of Etiquette, R.S.V.P.: Elsa Maxwell's Own Story, How to Do It;*

or *The Lively Art of Entertaining,* and *The Celebrity Circus*—are filled with amusing anecdotes affirming that this star of stage, screen, radio, and, of course, her own parties, was equally charming through her words on the page. As she declared, "not bad, for a short, fat, homely piano player from Keokuk, Iowa, with no money or background, [who] decided to become a legend and did just that."[132]

Born in Prague, René Bouché immigrated to the United States to escape persecution during World War II. Having achieved success as an illustrator for *Vogue* in Paris, Bouché continued to work for the magazine in New York. His painting was predominantly figurative until the late 1940s, when he joined a group of Abstract Expressionist painters in the Eighth Street Avant-Garde Painters Club. Losing interest in the movement within a few years, the artist turned to portraiture, painting innumerable celebrities of the era.

In his portrait of Maxwell, Bouché portrays a more somber sitter than the one who was most often pictured laughing or talking. Maxwell, who is probably dressed in a gown supplied to her by the French couturier Jean Dessès, is stuffed into the narrow vertical canvas, her serious comportment mitigated by the suggestion of disarray seen in her fallen shoulder strap. "A court jester" is how the artist described the professional party-giver, "but also a desperately serious woman who considers herself a serious critic of society."[133] ✳

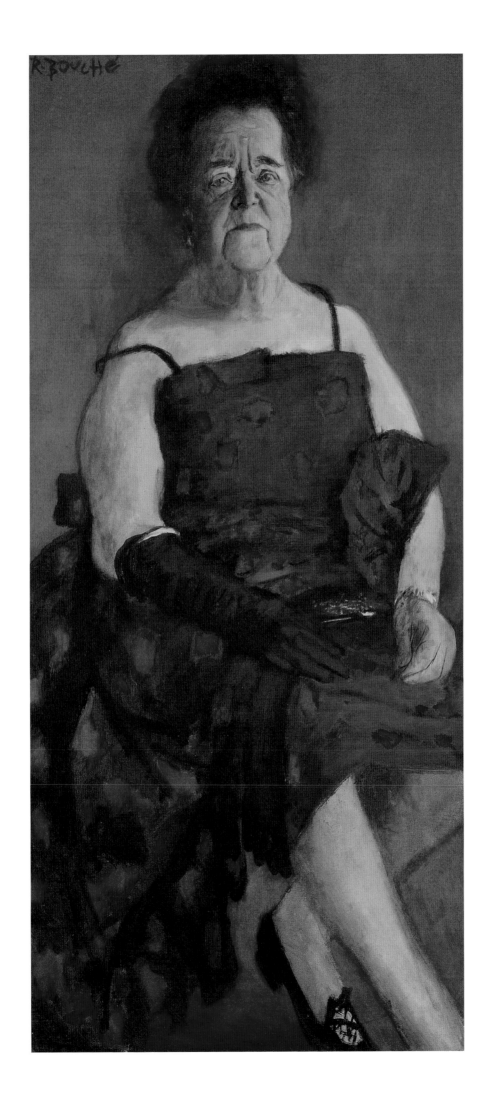

Carl Sandburg 1878–1967
Poet

William A. Smith 1918–1989
Oil on canvas, 101.6 x 91.4 cm
(40 x 36 in.), 1961
Gift of the Kent-Lucas Foundation
NPG.80.39

John F. Kennedy said of Carl Sandburg, "His has been the role of the poet in the best of ages, the interpreter of the nation's traditions and the shaper of its great myths."[134] Sandburg found beauty in the ordinary language of the people, the "American lingo," as he called it, and used that language to interpret the republic's frontier past and set it in the context of an industrial present.

Born in Galesburg, Illinois, of Swedish immigrant parents, Carl Sandburg served in the Spanish-American War, attended Lombard College, and worked as a laborer and a journalist before he gained recognition as a poet. The publication in 1914 of his poem "Chicago," which won the Levinson Prize, and the appearance two years later of *Chicago Poems,* marked Sandburg's emergence as an important American figure.

Sandburg became associated with a group of Chicago writers in a literary movement called the Chicago Renaissance. Three more volumes of poetry continued the theme of Chicago: *Poems: Cornhuskers* (1928), *Smoke and Steel* (1920), and *Slabs of the Sunset West* (1922). Although *Good Morning America* (1928) seemed hesitant and pessimistic, Sandburg reaffirmed his faith in the collective wisdom of the people with *The People, Yes* (1936), which has been called one of the great American books. In 1940 he achieved further recognition with the Pulitzer Prize for his monumental biography, *Abraham Lincoln: The War Years* (1939).

An outspoken, opinionated man capable of great anger and sarcasm, Sandburg was also amiable and sympathetic. He was a close friend of William Smith, and sat for many portrait sketches, as well as this painted likeness, while visiting the home of the artist in Pineville, Bucks County, Pennsylvania. Smith, who was born in Toledo, Ohio, moved to New York City in 1937, where he studied at the Art Students League. He maintained a studio there until 1956, when he left the city for rural Pennsylvania. Well known for his work as an illustrator and in the watercolor medium, as well as for his abilities as a portraitist, Smith also undertook a large mural for the state of Maryland in the 1960s. In 1973 he designed eight stamps related to the American Revolution for the United States Postal Service.

Smith had known the poet for a decade when this portrait was painted. This enabled him to portray his subject's characteristic attitude, arresting scowl, and trademark—a colored kerchief or scarf wound loosely around his neck—with great precision and sympathy. The sketchlike appearance of most of the canvas appealed to Sandburg, who stated, "I like it, Bill. It has some of the chaos that is in everything you do!"[135] •

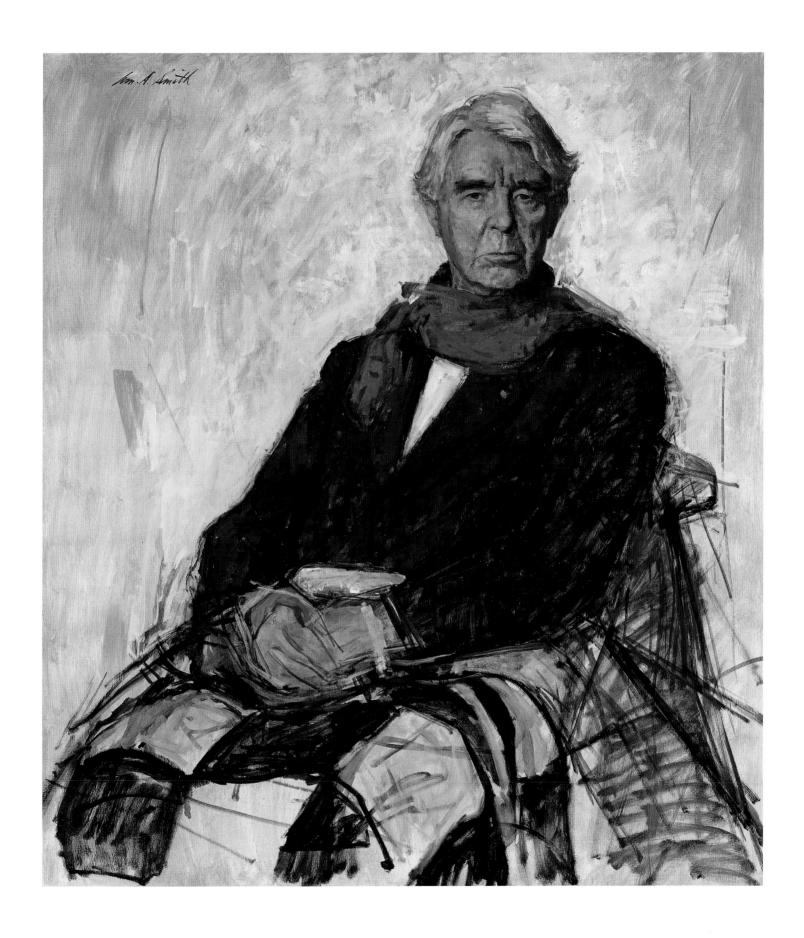

T. S. Eliot 1888–1965
Poet

Sir Gerald Kelly 1879–1972
Oil on canvas, 114.6 x 94 cm
(45^{1}/$_{8}$ x 37 in.), 1962
Gift of the National Portrait Gallery Commission
and senior staff in memory of Donald P. Klopfer
and Gallery purchase
NPG.86.88

After reading Thomas Stearns Eliot's "The Love Song of J. Alfred Prufrock," which the St. Louis–born Eliot had composed a few years before settling in England, his fellow poet Ezra Pound pronounced it the best poem by an American that he had ever read. In 1922 this high regard for Eliot's talent became widespread with the publication of *The Waste Land*. Hailed as a watershed in twentieth-century literature, the work established Eliot as a poet of the first rank on both sides of the Atlantic. Later, he also achieved eminence as a literary critic and playwright. Both *Murder in the Cathedral* (1935) and *Cocktail Party* (1949) were huge theatrical successes.

In 1927 Eliot became a British citizen and was confirmed in the Anglican Church, which had become a spiritual haven for him and an inspiration for his work. *Ash Wednesday* details his conversion. He was awarded the Nobel Prize for literature in 1948. As Cynthia Ozick observed of his career a year after the centennial of his birth,

how he became a commanding literary figure, who had no successful rivals, and whose formulations were in fact revered—is almost as mysterious as how in the flash of half a lifetime an immutable majesty was dismantled, an immutable glory dissipated. It is almost impossible nowadays to imagine such authority accruing to a poet. No writer today—whether or not a Nobel winner—holds it or can hold it.[136]

Known from the 1920s as a fashionable portraitist, Sir Gerald Kelly painted artists and entertainers, socialites and aristocrats. He was a formidable champion of the arts and friend to fellow painters; he served as president of the Royal Academy of Arts from 1949 until 1954, when he retired at the age of seventy-five. A lively, temperamental man who earned considerable wealth from his art, he was known for his highly detailed, conscientiously crafted paintings. Many of these have a quality of flatness and lack of spatial depth, possibly because Kelly often made use of photographs in his work.

Eliot had known Kelly for some years before he began posing for this portrait in 1960. The painter was over eighty at the time, and ill health caused postponement of the remaining sittings until well into the next year. Eliot purchased one version of the portrait for his wife. He called it a "masterpiece" in his thank-you letter to the artist, adding, "I shall never have a better portrait, even from yourself."[137] The likeness exhibited here is more elaborate; the artist has posed his subject in front of a collection of the poet's books, carefully selected and delineated to reveal something of Eliot's taste for art and literature. This convention of portraying men of letters with their books was used by Kelly in other portraits, but it is further personalized here with the inclusion of a card table and an interrupted game of solitaire, which directs attention to the poet's attitude of contemplation and reverie. ❋

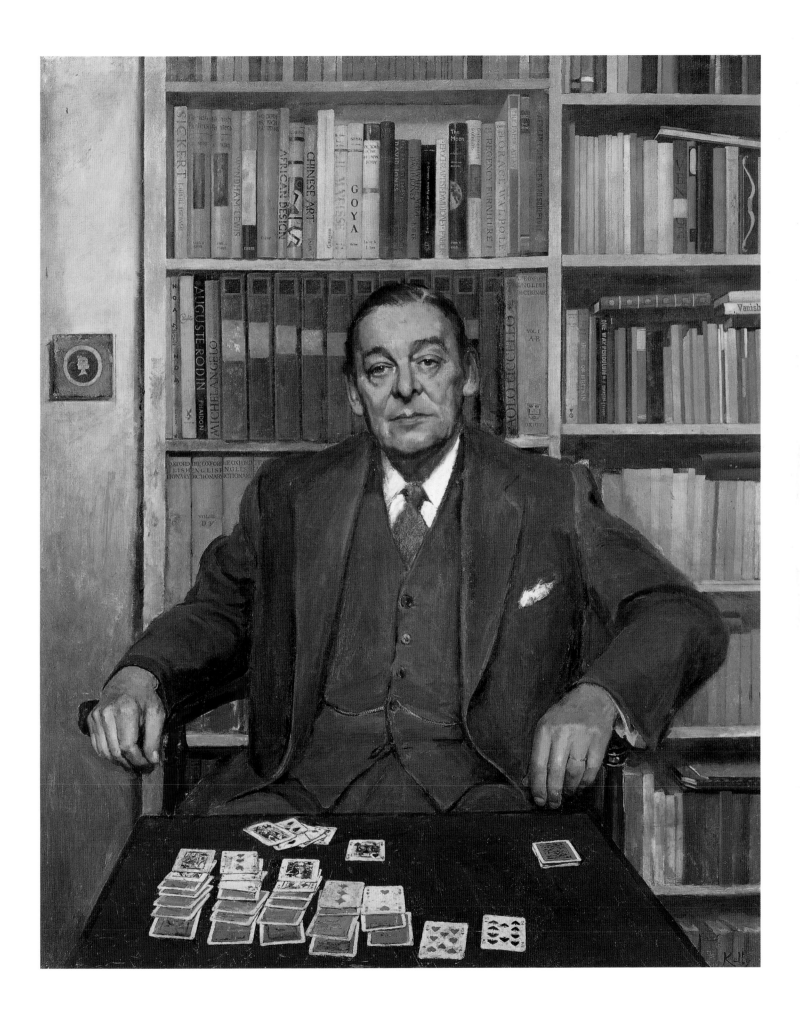

Alice Roosevelt Longworth 1884–1980
Socialite

Peter Hurd 1904–1984
Tempera on Masonite, 61 x 76.2 cm
(24 x 30 in.), 1965
Gift of Joanna Sturm

NPG.81.115

In Washington, D.C., in 1965, eighty-one-year-old Alice Roosevelt Longworth, the daughter of President Theodore Roosevelt and the wife of the influential Ohio congressman Nicholas Longworth, sat for her portrait. For eight decades, long after the death of her husband in 1931, her acerbic yet brilliant conversation and irreverent sense of humor made her one of the capital city's most colorful and oft-quoted social fixtures. By the time of her own death, her epigrammatic barbs at Presidents and other public figures had become something of a legend. Of her gift for amusing commentary, Longworth herself once said, "I'm not witty. I'm funny. . . . I give a good show—just one of the Roosevelt show-offs."[138]

The spirit of an exuberant young girl, whose love for a particular shade of gray-blue sparked the turn-of-the-century hit tune "Alice Blue Gown," shines quietly in Peter Hurd's serene portrait of the aged but sprightly Mrs. Longworth. The colors of her costume echo her love of those hues, while the broad-brimmed hat was her sartorial trademark. Her face, with its calm gaze betrayed by a hint of a smile, is accentuated with a cool, bright light. This light was one of the lifelong artistic fascinations of her portraitist.

Peter Hurd was born in New Mexico, but received his education in Pennsylvania, where he later apprenticed himself to artist-illustrator N. C. Wyeth. A few years after marrying Wyeth's daughter Henriette in 1929, they returned to New Mexico to a life of ranching and painting. Hurd was well known for his landscapes of the Southwest, as well as for his portraits. Although he used watercolor, his name was more often associated with the revival and refinement of the traditional Renaissance medium of egg tempera. As Hurd wrote about his delight with this technique, "I have been able to get a *colour quality* and *flatness* hitherto unknown to me . . . remarkable brilliance and complete flatness—with absolutely no shine in any light!"[139] In his quest for mastery of this time-honored technique, Hurd also used Italian Renaissance compositional motifs for portraits, isolating his sitters in front of a very simple backdrop, as in the Longworth picture, or in front of a distant landscape background. He painted meticulously, using "little tiny brush strokes, hundreds and hundreds of them, particularly with the portraits."[140] In this way Hurd captured the delicacy, reserve, and vibrant elegance of Mrs. Longworth, Washington's professional wit and "whip-cracker." ✳

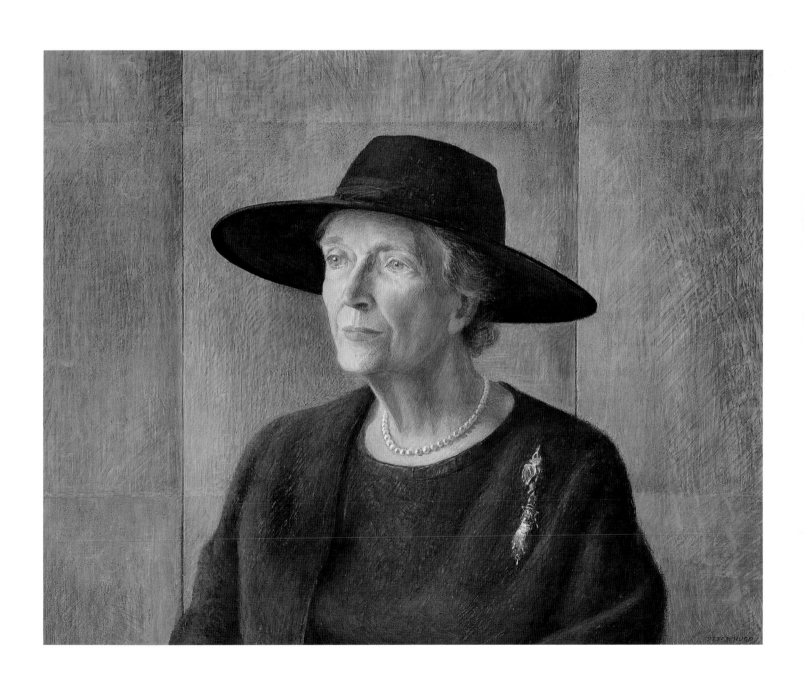

Lincoln Kirstein 1907–1996
Impresario

Jamie Wyeth born 1946
Oil on canvas, 97.1 x 76.2 cm
(38¼ x 30 in.), 1965
Bequest of Lincoln Kirstein
© Jamie Wyeth
T/NPG.96.97.06

Lincoln Kirstein was the quintessential renaissance man, who "dreamed dreams for other people and made them happen."[141] At Harvard University during the late 1920s, Kirstein, along with two fellow undergraduates, founded the Harvard Society for Contemporary Art, which exhibited the work of cutting-edge artists at a time when other museums and galleries often dismissed contemporary art. He maintained a lifelong commitment to modern art and frequently curated exhibitions of young artists at the Museum of Modern Art.

Kirstein also garnered attention for his literary pursuits; the magazine he founded at Harvard, *Hound & Horn,* published the work of James Joyce and Gertrude Stein, among others, and earned a reputation as "the most serious magazine printed in America."[142] Some thirty-odd books and hundreds of articles on art, architecture, literature, and dance bear Kirstein's name.

Kirstein is perhaps best known for his pioneering efforts in the development of ballet in the United States. While traveling abroad, Kirstein was introduced to George Balanchine, then choreographer for the Diaghilev Ballet. Inspired by the modernity of his choreography, in 1933 Kirstein persuaded Balanchine to join him in founding the School of American Ballet and to become its director. Kirstein also formed the Ballet Caravan in 1936 and the Ballet Society in 1946. The latter, in addition to providing ballet performances, sponsored lectures and films, and published the Dance Index. The New York City Ballet Company evolved from the Ballet Society, with Kirstein in the post of general director. Kirstein can be credited, too, with the creation of a truly American tradition of ballet with his storylines for *Billy the Kid, Yankee Clipper,* and others, which merged European classical style with spirited American subject matter.

Jamie Wyeth was born into a well-known American artistic dynasty; his grandfather, N. C. Wyeth, delighted children with fanciful book illustrations, and his father, Andrew Wyeth, was noted for his realistic figure studies and landscapes. Trained largely by his aunt, Henriette Wyeth Hurd, who was also a painter, Jamie demonstrated a precocious understanding of art that led him to quit school at the age of eleven to follow in the family tradition.

Kirstein was an old friend of Jamie's father, and it was on Andrew Wyeth's suggestion that he commissioned his sixteen-year-old son to paint his portrait. Achieving what Kirstein called "a mix of Eakins and Sargent," Wyeth's portrait was exhibited at his first one-man exhibition in 1966 and thereafter flanked the fireplace in Kirstein's home.[143] The artist first made two sketches of Kirstein—one frontal, the other this unconventional pose with his hands clasped behind his back. The pose, like that of a ballet master, gives the portrait its regal air, befitting Kirstein's aristocratic persona. Deemed by an acquaintance to be "so big that he has the air of protecting everybody, of holding up the world," Kirstein in Wyeth's rendering is possessed by an aura of mystery and resolve that is befitting this intellectual genius of artistic affairs.[144] •

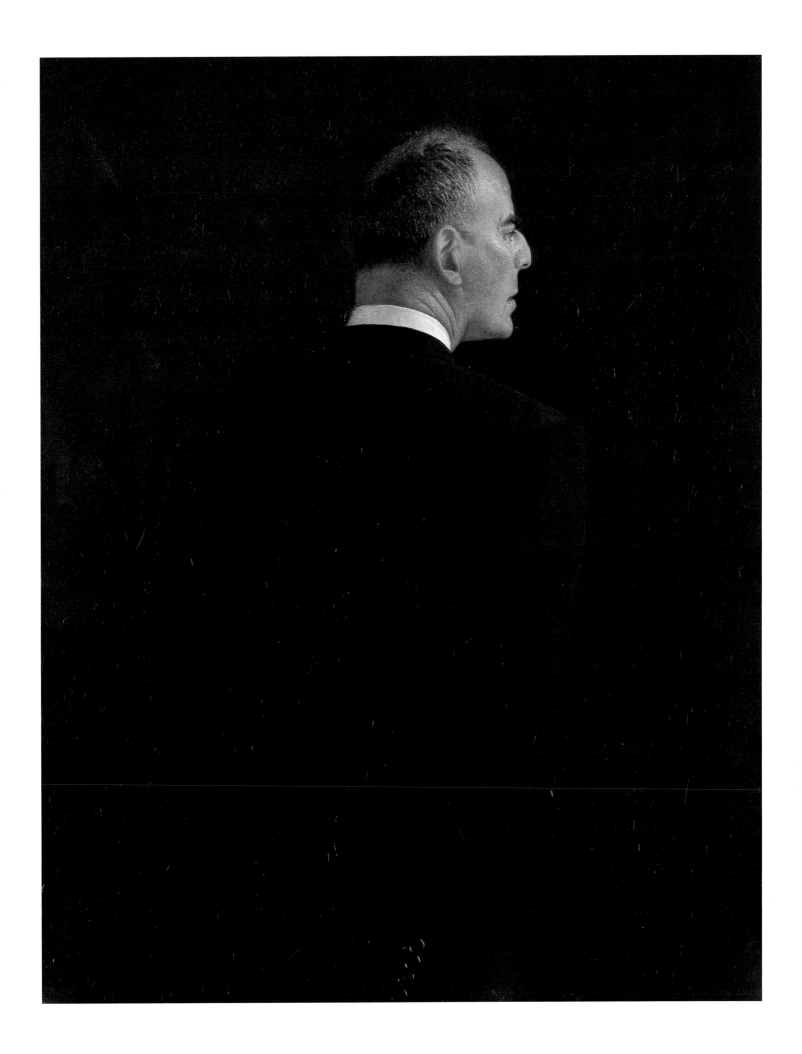

Virgil Thomson 1896–1989
Composer, critic

Alice Neel 1900–1984
Oil on canvas, 121.9 x 96.5 cm
(48 x 38 in.), 1971
© Estate of Alice Neel

NPG.84.70

[Not at all venues]

Composer Virgil Thomson began his musical train-ing at age five, and by his twelfth year he was per-forming professionally on both piano and organ. In the mid-1920s he settled in Paris, where he began to compose original works, including the ultramodern *Symphony on a Hymn Tune.*

While in Paris he also became part of the cosmopolitan group of avant-garde musicians, writers, and painters then dominating the cultural life of the city. One of his closest friends in that circle was the expatriate American writer Gertrude Stein, who wrote the librettos for his operas *Four Saints in Three Acts* and *The Mother of Us All*, the latter based on the life of suffragist Susan B. Anthony. By the late 1930s, Thomson was writing music for movies, and in 1948 his score for the film *Louisiana Story* won a Pulitzer Prize. In addition, he composed more than one hundred musical "portraits" of such personalities as Picasso and Aaron Copland. His last opera, *Lord Byron*, was written in 1968.

Thomson was also a major spokesman for the new direc-tions of twentieth-century music. As critic for the *New York Herald-Tribune* from 1940 to 1954, he did "more for con-temporary music," as one observer noted, "than any [other] man of his time."[145]

Alice Neel painted many of her colleagues in the world of arts and letters, particularly those in New York City, her home for many years. This portrait of Thomson is typical of her expressive manner, where exaggeration and awkwardness are used to enhance the confrontational verisimilitude of the likeness. The pastel hues and high tonal values used by the artist contrast with the crudeness of delineation found in the facial features and meticulously observed hands. As she painted, Neel sometimes exaggerated the effect that the body or expression of her sitter had on her own mind. After Thomson's sitting, she wrote, "When I painted the trousers I must confess I thought of elephants—so that is the color they really are."[146]

Essentially, Neel attempted to paint the complete person, inside and out. Through expressive means, she presented the characteristic demeanor of the sitter, but not without cost to herself. On her intense "identification" with her subjects, she noted, "I get so identified when I paint them, when they go home I feel frightful. I have no self—I've gone into this other person. And by doing that, there's a kind of something I get that other artists don't get."[147] ✳

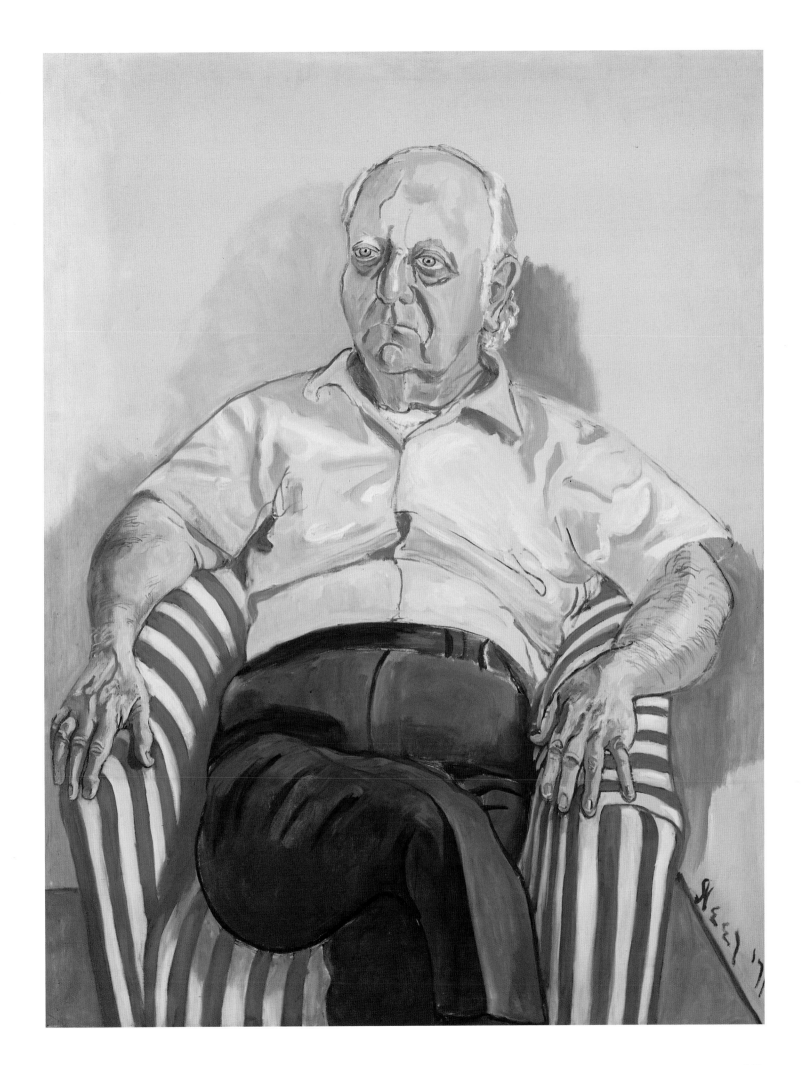

Eliot Porter 1901–1990
Photographer

Fairfield Porter 1907–1975
Oil on canvas, 147.3 x 81.3 cm
(58 x 32 in.), 1975
NPG.93.25

Well educated and gifted, the brothers Eliot and Fairfield Porter shared a fascination with nature, the ability to reveal extraordinariness in ordinary life, and a reputation in the American art world as stubborn independents who refused to conform to the methods and practices of their contemporaries. Their father's influence as an amateur photographer and science enthusiast led to Eliot's interest in nature photography, but before devoting himself to it fully, Eliot first earned a degree in chemical engineering from Harvard College and an M.D. from Harvard Medical School. From 1929 to 1939 he taught at Harvard University and did research in bacteriology and biophysics. His commitment to photography grew steadily during these years, however, and in 1939, when Alfred Stieglitz gave him a one-person exhibition at his New York City gallery, Eliot promptly quit his teaching post and brought photography to the foreground of his life.

Porter is best known for his ornithological photographs and his pioneering use of color when black and white was the norm for artistic photography. Awarded successive Guggenheim Fellowships for his work in developing new methods to create the rich, saturated colors of his photographs, Eliot fused his interests in science and photography and subsequently established color nature photography as a valid artistic genre. His work also contributed to the environmentalist cause in heightening public awareness about the need for wilderness preservation. *The Place No One Knew: Glen Canyon on the Colorado* (1963), published by the Sierra Club, brought this organization a new international reputation and had a hand in quelling some of the unnecessary damming of America's western rivers.

Fairfield Porter, who adhered to representational subjects during the heyday of Abstract Expressionism and formalist art criticism, claimed that he painted in a figurative style throughout his life because he had once overheard critic Clement Greenberg tell Willem de Kooning that it was passé. Unlike his brother, Fairfield "was an artist from the time he was born."[148] He studied fine art at Harvard and spent two years studying painting under Thomas Hart Benton at the Art Students League in New York. Influenced by the work of Édouard Vuillard and Pierre Bonnard, Fairfield focused on color relations and the effect of light in his eternally sunlit domestic scenes and figure studies drawn from the experience of the everyday. Also a gifted writer and critic, Fairfield was editorial associate at *ARTnews* from 1951 to mid-1959. He contributed widely to other art periodicals, and served as art critic for *The Nation* in the early 1960s.

This portrait of Eliot was painted by Fairfield just months before the artist's death in 1975. It captures the celebrated photographer in a quiet moment on Great Spruce Head Island in Maine's Penobscot Bay, where the two had grown up, and documents the sympathetic relationship that the brothers forged later in life. Lacking common ground in their early years, the two began to exchange notes on science, nature, and artistic theory once Eliot committed himself wholeheartedly to photography. ✳

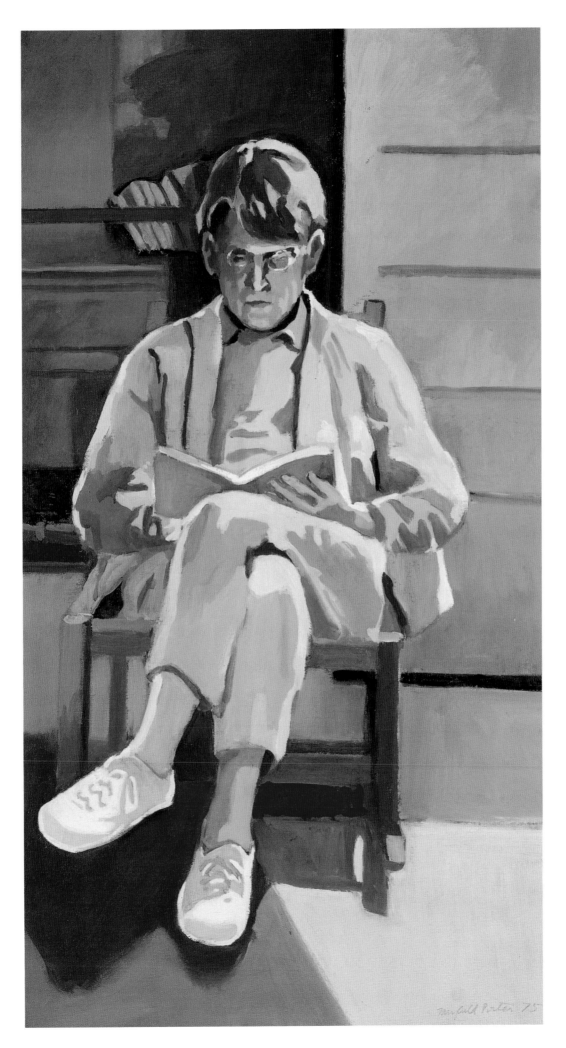

73

Alice Neel 1900–1984
Artist

Self-portrait
Oil on canvas, 137.1 x 101.6 cm
(54 x 40 in.), 1980
© Estate of Alice Neel

NPG.85.19

[Not at all venues]

At the age of seventy, Alice Neel said that the closest she ever came to a self-portrait was the image of an empty chair by an apartment window.[149] Five years later she began this shocking, endearing, and unconventional portrait, a project that took another five years to complete. "I liked to put the flesh dropping off my bones," she said of the painting, "and the reason my cheeks got so pink was that it was so hard for me to paint that I almost killed myself painting it."[150] A striking challenge to the centuries-old convention of idealized femininity, Neel's only painted self-portrait is wonderfully suggestive of the artist's bohemian, bawdy character.

Raised in what she described as the "puritanical" town of Colwyn, Pennsylvania, Neel studied art at the Philadelphia School of Design for Women from 1921 to 1925. She moved to New York in 1931 after suffering a nervous breakdown and attempted suicide when her first husband, a Cuban artist, left with their only surviving child (their first child died of diphtheria at a young age). There she painted, along with genre and street scenes, the picturesque characters of Greenwich Village and the poverty-stricken inhabitants of Spanish Harlem. "I love to paint people mutilated and beaten up by the rat race in New York," she once said of her subjects.[151] A string of lovers—including "an intellectual left-wing sailor and opium smoker," what she called a "super-aesthete," a Puerto Rican nightclub entertainer, and a Russian filmmaker—left Neel with two sons, a situation that made life even more challenging when her support from the Works Progress Administration ceased in 1943.[152]

Never one to conform to established norms or follow traditional paths, Neel adhered to a representational idiom in the midst of the Abstract Expressionist movement. She was consequently ignored by the art world until shortly before her 1970 exhibition at the Pennsylvania Academy of the Fine Arts and her 1974 retrospective at New York's Whitney Museum of American Art, which signaled her long-overdue arrival on the art scene. "Life begins at seventy!" she said of the transformation her career took during these years. "Better late than never!"[153]

Neel aimed to capture in her figure studies (she disliked the term portraiture because of its connotations of flattery and idealization) the very essence and immediacy of each person she portrayed. An expressionistic brush stroke, manipulation of scale, and almost intuitive reading of body language allowed her to create psychologically penetrating yet benevolent renderings of her sitters. "She hurls shafts that hit the mark but do not sting," as one critic observed.[154] Her self-portrait from 1980 is the crowning achievement of more than fifty years of unabashedly honest painting. Depicted with the tools of her trade and gazing sharply at the viewer, Neel makes us question simultaneously our understanding of woman, the modern artist, and the art-historical canon that dictates so much of our aesthetic value system. Painting herself as, in her words, "the last of the buffalo," it is clear that Neel considered this portrait as much a landmark in her personal growth as it was in her artistic development. "I had to do this," she said. "I couldn't have lived otherwise."[155] *

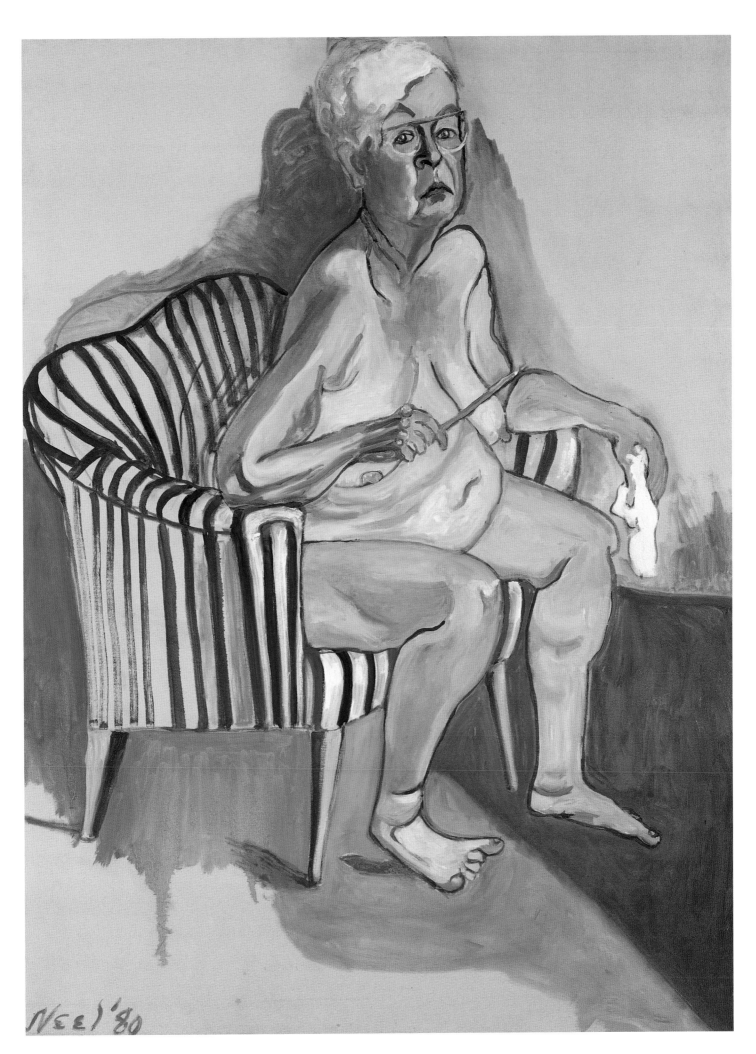

Neel '80

John Updike BORN 1932
Author

As a chronicler of modern life and the anxieties revealed in suburban existence, John Updike has established himself as one of America's most eminent men of letters. His many novels and short stories are written in a prose style characterized by wit, detachment, and a penchant for detailing every aspect of his characters' lives. A prolific writer, Updike has also published much nonfiction and criticism. *More Matter* (1999) is his most recent assemblage of these shorter pieces.

Updike, an only child, grew up in Shillington, Pennsylvania, and received a B.A. in English from Harvard University in 1954. After graduation he studied briefly at Oxford University. While in England, he received an offer to join the staff of the *New Yorker*, a weekly magazine known for its well-written essays. Updike and his wife lived in New York until 1957, when they moved to Ipswich, a small Massachusetts town near Boston.

After publishing a collection of poetry and a highly praised novel, Updike wrote *Rabbit, Run* (1960), which chronicles the life of a former well-known athlete, Harry ("Rabbit") Angstrom, who, unable to recapture success when encumbered by marriage and small-town life, flees these responsibilities. In *Rabbit Redux* (1971), *Rabbit Is Rich* (1981), and *Rabbit at Rest* (1990), he follows the same character throughout his later life. The latter two novels in this series garnered Pulitzer Prizes for the author. Interspersed with this series were two novels set in Pennsylvania—*The Centaur* (1963)

and *Of the Farm* (1965)—and the popular *The Witches of Eastwick* (1984), a contemporary fantasy of three women who acquire magical powers after divorcing their husbands. The movie version of *The Witches of Eastwick* brought Updike's work to the attention of a new audience.

Alex Katz, a New York–based artist, first came to prominence in the early 1960s with the advent of the Pop Art movement. He is known for his larger-than-life portraits of family and friends. Like Updike, Katz creates technically brilliant and provocative works of art from seemingly mundane sources. In devising his images, he also plays with the tension between consumer imagery and the traditions of fine art, as well as with the tension between abstraction and perceptual information. Nevertheless, for him, the quality of a portrait resides in likeness. "If you don't have a good likeness, you don't have a good picture."[156]

Katz was approached by *Time* magazine to paint Updike's portrait, which was featured on its October 1982 cover. The portrait, with its immediacy, flattened forms that fill the canvas, and complex color and tonal relationships, is typical of the artist's work. Although a likeness of Updike is captured, Katz avoids meticulous detail in order to emphasize his interest in pictorial problems. As he noted in 1984, "a lot of great representational art is not involved with being realistic at all. . . . People think realism is details. But realism has to do with an over-all light, and having every surface appear distinctive."[157] ✳

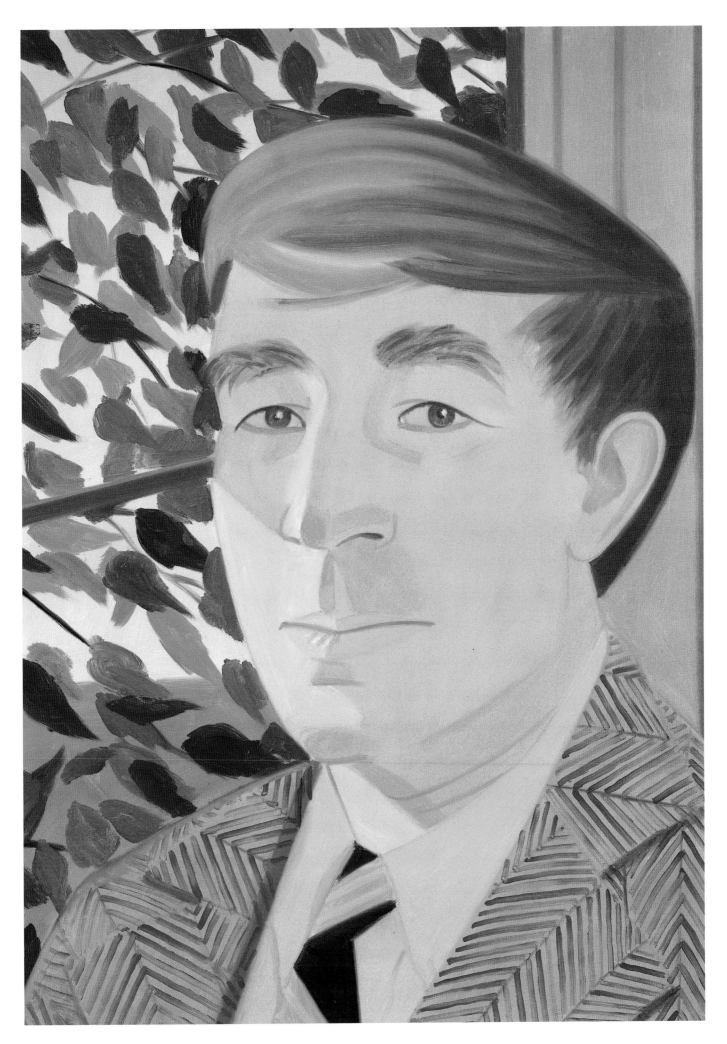

Michael Jackson BORN 1958
Singer

Andy Warhol 1928–1987
Oil on silkscreen on canvas,
76.1 x 66.1 cm (29^{15}/16 x 26 in.), 1984
Time cover, March 19, 1984
Gift of *Time* magazine
© Andy Warhol Foundation for the
Visual Arts/ARS, New York
NPG.86.TC14

Michael Jackson's career as a recording star began at the age of eleven, with the popularity of the first single released by the Jackson 5, a rhythm-and-blues act composed of him and four of his brothers. In 1979 Jackson released his first solo album, and by 1984 he was being touted as the biggest star since the Beatles or Elvis Presley, and as "the most popular black singer ever."[158] In that year, at the peak of his celebrity, he won an unprecedented eight Grammy Awards for his internationally acclaimed album *Thriller*. In his meteoric rise to prominence, Jackson also exploited his aura of innocent eroticism and his androgynous appearance.

Andy Warhol's name is synonymous with the Pop Art movement in America. He developed this style during the early 1960s as a counterpoint to the work of the Abstract Expressionists, such as Jackson Pollock and Willem de Kooning. Rather than strive for the spontaneous, expressive abstraction practiced by these painters, Warhol and the other Pop artists chose to use objects appropriated from popular culture as imagery for fine art. In particular, Warhol favored photographs of celebrities and mundane objects such as Campbell's Soup cans as the basis for paintings. These were reproduced onto his canvases through a silkscreen process. Eschewing other painters' concentration on painterly gesture,

he chose a detached, semi-mechanical approach. After photographing his subjects, photographic labs and assistants created much of the images. Warhol then retouched them. As he put it, "I sort of half paint them just to give it a style."[159]

By the mid-1970s, Warhol had perfected the technique used in Jackson's portrait. The silkscreened photographic image is augmented with flat areas of bright color. More expressive lines, meant to signify the artist's own pencil, are screened over the image in various contrasting hues to capture Jackson's boyishness and electrifying energy.

The choice of Warhol as Jackson's portraitist for the cover of *Time* was appropriate for many reasons. A pop philosopher as well as an artist, Warhol invented the notion that anyone might achieve "fifteen minutes" of fame. This idea was far from futuristic, given the media explosion of the past three decades and America's endless fascination with celebrity and notoriety. As Warhol noted with some irony, "Now it doesn't matter if you came over on the *Mayflower*, so long as you can get into [the New York nightclub] Studio 54. Anyone rich, powerful, beautiful, or famous can get into Society."[160] With these attitudes, Warhol was the perfect artist to record Michael Jackson's famous features as well as his identity as a hero of popular culture. ❋

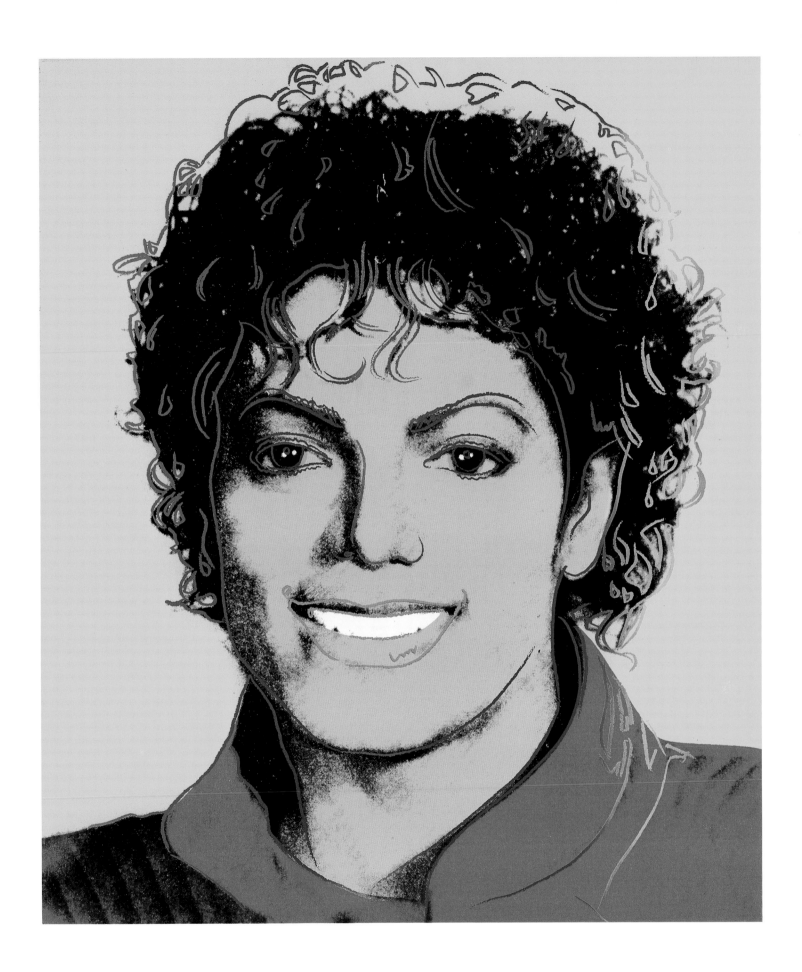

M. F. K. Fisher 1908–1992
Writer

Ginny Stanford born 1950
Acrylic and silver leaf on canvas,
66 x 99 cm (26 x 39 in.), 1991
© Ginny Stanford
T/NPG.92.173.02

Through her artful essays on food and life, Mary Frances Kennedy Fisher transformed the mundane activity of eating into a passion. A unique blend of thoughtful instruction, sense-awakening recipes, and reflections on life's values, Fisher's writing is everywhere informed by her conviction that our basic human needs for love, shelter, and food are indivisibly connected. "When I write about hunger," she once said, "I am really writing about love and the hunger for it, and warmth and the love of it and the hunger for it . . . and then the warmth and richness and fine reality of hunger satisfied . . . and it is all one."[161]

Although her father was a successful journalist and editor, probably the most significant influence upon Fisher's profes-sional direction were three years spent in Dijon, France, during her early twenties. There she learned firsthand about how to enjoy eating. After teaching French for five years at Occidental College and researching gastronomy in her spare time, Fisher published her first collection of essays in 1937, entitled *Serve It Forth*. A favorable review by the leading American food writer, Lucius Beebe, ensured her future success and led to a long career of writing that yielded several magazine pieces and eighteen titles, including *How to Cook a Wolf* (1942), *The Gastronomical Me* (1943), and *Here Let Us Feast: A Book of Banquets* (1946). With works

such as *Map of Another Town: A Memoir of Provence* (1964) and *A Cordiall Water: A Garland of Odd & Old Receipts to Assuage the Ills of Man & Beast* (1961), Fisher transcended the narrow bounds of her specialty, securing a reputation not just as an important American writer on food but as an important American writer. Securing acclaim from literary dignitaries such as W. H. Auden, her prose continues to be praised for its elegance, wit, richness of sensuous detail, and very personal approach.

Ginny Stanford, a self-taught artist who is best known for the dreamlike quality of her figure studies, portraits, and pastoral paintings, was introduced to Fisher in 1991, just one year before the writer's death. Seeking to paint the image of a courageous older woman "who could look unflinchingly at herself," Stanford produced three portraits of Fisher, each exploring a different aspect of her charac-ter.[162] This portrait, the first in Stanford's series, is a testa-ment to Fisher's strength in the face of a string of illnesses, including the Parkinson's disease that eventually stole her voice. She posed for Stanford with "grace and assurance" in her home in California, seated next to a large bouquet of roses that had been sent by one of her many admirers. The dignity of Fisher's image in this portrait belies any notion that illness has weakened her resolve. ✳

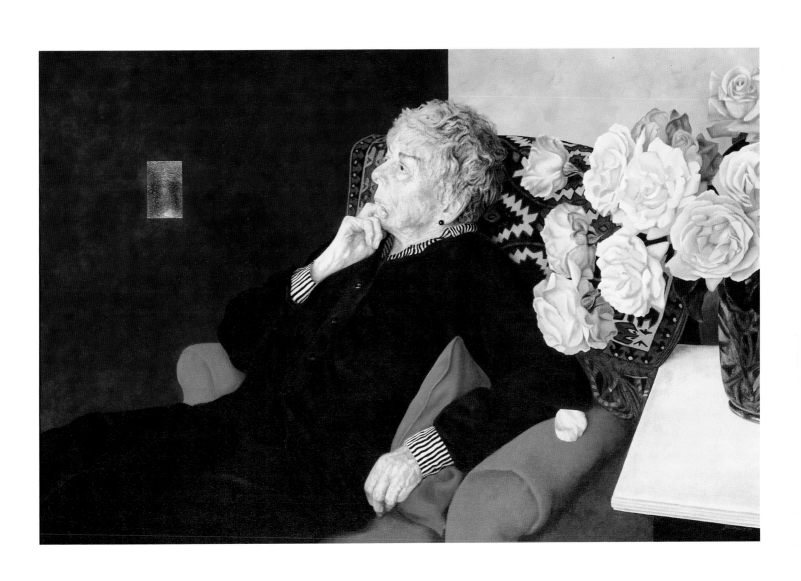

Notes

1 Quoted in Raymond W. Houghton et al., *Images of Berkeley* (Dublin: National Gallery of Ireland and Wolfhound Press, 1986), p. 44, no. 18.

2 Richard H. Saunders, *John Smibert: Colonial America's First Portrait Painter* (New Haven: Yale University Press, 1995), pp. 147–48, nos. 25–26. "Cop. o.s." means "Copy, odd size." The London painting is the same size as this one, measuring 41 x 29½ inches.

3 Theresa Fairbanks, "Gold Discovered: John Singleton Copley's Portrait Miniatures on Copper," *Yale University Art Gallery Bulletin* (1999): 26.

4 Erica E. Hirshler, "Copley in Miniature," in Carrie Rebora et al., *John Singleton Copley in America* (New York: Metropolitan Museum of Art, in association with Harry N. Abrams, 1995), p. 120.

5 Fairbanks, "Gold Discovered," p. 80.

6 Lillian B. Miller, Sidney Hart, and Toby A. Appel, eds., *The Selected Papers of Charles Willson Peale and His Family*, vol. 1: *Charles Willson Peale: The Artist in Revolutionary America, 1735–1791* (New Haven: Yale University Press for the National Portrait Gallery, 1983), p. 499, diary entry dated June 10 [11], 1788. (The bracketed dates are corrections by the editors of the Peale Papers.)

7 Ibid., p. 5.

8 *Maryland Gazette*, March 30, 1775.

9 John Jay to Gilbert Stuart, February 22, 1784, Joseph Downs Collection of Manuscripts and Printed Ephemera, Winterthur Library, Delaware.

10 February 8, 1818, Horace Holley to his wife Mary, with additions at later dates, from Horace Holley Papers, William L. Clements Library, University of Michigan, Ann Arbor, courtesy of Dr. Dorinda Evans.

11 Translation from Charles Coleman Sellers, *Benjamin Franklin in Portraiture* (New Haven and London: Yale University Press, 1962), p. 127, n. 6.

12 Charles Coleman Sellers, *Portraits and Miniatures . . . by Charles Willson Peale*, Transactions of the American Philosophical Society, n.s., vol. 42, pt. 1 (Philadelphia: American Philosophical Society, 1952), p. 159, no. 628.

13 Deborah Sisum, "'A Most Favorable and Striking Resemblance': The Virginia Portraits of Cephas Thompson (1775–1856)," *Journal of Early Southern Decorative Arts* 23, no. 1 (summer 1997): 23.

14 Anya Jabour, *Marriage in the Early Republic: Elizabeth and William Wirt and the Companionate Ideal* (Baltimore, Md.: Johns Hopkins University Press, 1998), pp. 63–65.

15 Sisum, "'A Most Favorable and Striking Resemblance,'" p. 48, where the entries are transcribed, and pp. 26–27 and 100–101 for a discussion of the portraits.

16 Sarah P. Stetson, "Mrs. Wirt and the Language of the Flowers," *Virginia Magazine of History and Biography* 57 (October 1949): 383.

17 "Sketch of the Life of William B. Wood," quoted in William C. Young, *Famous Actors and Actresses on the American Stage: Documents of American Theater History* (New York and London: R. R. Bowker, 1975), vol. 2, p. 1204.

18 *The Mirror of Taste, and Dramatic Censor* 1, no. 1 (January 1810): 5–6.

19 *Mirror of Taste* 3, no. 3 (March 1811): 140.

20 Samuel Morse Papers, Library of Congress, and Paul J. Staiti, "Samuel F. B. Morse's Search for a Personal Style: The Anxiety of Influence," *Winterthur Portfolio* 16 (1981): 264, n. 26.

21 Daniel Webster to Ezekiel Webster, February 5, 1814, in *Dictionary of American Biography*, vol. 5, p. 400.

22 Gore to King, October 18, 1819, from Charles R. King, ed., *Life and Correspondence of Rufus King* (New York: G. P. Putnam's Sons, 1894–1900), vol. 6, p. 231.

23 Gore to King, March 9, 1820, quoted in Charles A. Hammond and Stephen A. Wilbur, *"Gay and Graceful Style": A Catalogue of Objects Associated with Christopher and Rebecca Gore* (Waltham, Mass.: Gore Place Society, 1982), p. 19.

24 Chester Harding, *My Egotistigraphy* (Cambridge, Mass.: John Wilson and Son, 1866), pp. 51, 53.

25 Ibid., p. 53.

26 Vanderlyn to C. Edwards Lester, December 8, 1851, Vanderlyn Archives, New York State Office of Parks, Recreation, and Historic Preservation, Senate House State Historic Site, Kingston, New York, courtesy of Dr. William T. Oedel, who supplied the missing word in the letter.

27 *Thomas Badger (1792–1868): Boston Portrait Painter in Kennebunk* (Kennebunk, Maine: Brick Store Museum, 1964), unpaged, from the diary of Andrew Walker.

28 Herman Viola, *The Indian Legacy of Charles Bird King* (Washington, D.C.: Smithsonian Institution Press, 1976), p. 74.

29 Simeon Jocelyn to Garrison, March 29, 1833, quoted in *William Lloyd Garrison, 1805–1879: The Story of His Life Told by His Children*, vol. 1: *1805–1835* (New York: Century Co., 1885), p. 340.

30 Garrison to Harriet Minot, April 9, 1833, ibid., p. 339.

31 Garrison to Minot, May 1, 1833, ibid., p. 345.

32 Garrison to Purvis, April 30, 1833, Anti-Slavery Collection, Boston Public Library, quoted in Richard J. Powell, "Cinque, Antislavery Portraiture and Patronage in Jacksonian America," in *American Art* 11, no. 3 (fall 1997): 58.

33 *An Account of Col. Crockett's Tour to the North and Down East . . .* (Philadelphia: E. L. Cary and A. Hart, 1835), p. 60.

34 *Boston Transcript*, May 6, 1834, quoted in Frederick S. Voss, "Portraying an American Original: The Likenesses of Davy Crockett," *Southwestern Historical Quarterly* 91, no. 4 (April 1988): 467–68.

35 Henry Clay to John Neagle, May 29, 1843, in Robert Seager II and Melba Porter Hay, eds., *Papers of Henry Clay*, vol. 9 (Lexington: University Press of Kentucky, 1991), p. 822. The painting's imagery is fully discussed by Robert Torchia in his chapter, "The *Henry Clay*: A Political Campaign Portrait," in *John Neagle: Philadelphia Portrait Painter* (Philadelphia: Historical Society of Pennsylvania, 1989), pp. 93–108.

36 Frederick S. Voss, *Majestic in His Wrath: A Pictorial Life of Frederick Douglass* (Washington, D.C.: Smithsonian Institution Press, 1985), p. v.

37 Published in *The North Star*, 1848; quoted from James A. Porter, *Modern Negro Art* (New York: Dryden Press, 1943), p. 33.

38 Unidentified source, NPG history files.

39 Anna Wells Rutledge, *Catalogue of Paintings and Sculpture in the Council Chamber, City Hall, Charleston, South Carolina* (Charleston: City Council, 1943), p. 12.

40 William S. Elwell Diary, Springfield Manuscript Files, Connecticut Valley Historical Society Museum, Springfield, Massachusetts.

41 William H. Truettner, *The Natural Man Observed: A Study of Catlin's Indian Gallery* (Washington, D.C.: Smithsonian Institution Press, 1979), p. 186, nos. 153 and 155.

42 *Evening Post* (New York), January 6, 1854.

43 Ibid.

44 Margaret C. S. Christman, *Fifty American Faces from the Collection of the National Portrait Gallery* (Washington, D.C.: Smithsonian Institution Press, 1978), p. 124.

45 Charles Edward Stowe and Lyman Beecher Stowe, *Harriet Beecher Stowe: The Story of Her Life* (1911), quoted in the entry on Mrs. Stowe by Joan D. Hedrick in John A. Garraty and Mark C. Carnes, eds., *American National Biography* (New York: Oxford University Press, 1999), vol. 20, p. 907.

46 Major General John Gross Barnard to Winfield Scott, September 24, 1855, letterbook, Archives, United States Military Academy, West Point, New York, courtesy of David M. Reel, curator of art, West Point Museum.

47 Kent Ahrens, "Robert Walter Weir (1803–1889)" (Ph.D. diss., University of Delaware, 1972), p. 46. This sketchbook is now owned by the West Point Museum.

48 Letter from Upper Egypt, December 11, 1851, in Marie Hansen-Taylor and Horace E. Scudder, eds., *Life and Letters of Bayard Taylor* (Boston: Houghton Mifflin, 1895), vol. 2, p. 223.

49 Letter from New York, November 16, 1855, in ibid., pp. 308–9.

50 Letter from Augusta, Maine, December 8, 1855, in ibid., p. 309.

51 "Fidelius" [pseudonym], in the *Evening Transcript* (Boston), January 22, 1857, sec. 2, p. 1.

52 Howard M. Feinstein, *Becoming William James* (Ithaca, N.Y.: Cornell University Press, 1984), p. 120, quoting Percy MacKaye, *Epoch: The Life of Steele MacKaye, Genius of the Theatre, in Relation to His Times and Contemporaries* (New York: Boni and Liveright, 1927), vol. 1, p. 76.

53 Henry James, *Notes of a Son and Brother* (New York and London: Charles Scribner's Sons, 1914), p. 85, quoted in Henry Adams, "The Mind of John La Farge," *John La Farge* (New York: Abbeville Press, 1987), p. 13.

54 Henry James Sr. to Edmund Tweedy, July 24, 1860, in Ralph Barton Perry, *The Thought and Character of William James*, 2 vols. (Boston and Toronto: Little, Brown, 1935), vol. 1, p. 192.

55 William James to Henry James Sr., August 24, 1860, ibid., p. 199.

56 William James to Charles Ritter, July 31, 1860, ibid., p. 193.

57 Hawthorne to Sophia Hawthorne, April 1, 1862, MA 611, Pierpont Morgan Library, New York City.

58 Hawthorne to James T. Fields, April 2, 1862, FI 2304, reproduced courtesy of the Huntington Library, San Marino, California.

59 Christman, *Fifty American Faces*, p. 156.

60 "On Exhibition, C. Schussele's Picture of Men of Progress: American Inventors," broadside advertisement (New York: Goupil & Co., 1862), photocopy in NPG curatorial files.

61 Eliza Allen Starr to "Cousin George," April 26, 1863, in Rev. James J. McGovern, D.D., ed., *The Life and Letters of Eliza Allen Starr* (Chicago: Lakeside Press, 1905), pp. 174–75.

62 Healy to Brownson, February 11, 1863, Orestes Brownson Papers, Archives, University of Notre Dame, Notre Dame, Indiana.

63 Mrs. Healy to Sarah Healy, September 26, 1869, Brownson Papers.

64 Sherman to Julian Alden Weir, March 11, 1890, Julian Alden Weir Papers, Archives of American Art, Smithsonian Institution, Washington, D.C.

65 Garraty and Carnes, eds., *American National Biography* vol. 23, p. 111.

66 Scott Marshall, *The Mount, Home of Edith Wharton: A Historic Structure Report* (Lenox, Mass.: Edith Wharton Restoration, 1997), p. 22.

67 Ibid., p. 22.

68 Linda Merrill, *A Pot of Paint: Aesthetics on Trial in Whistler v. Ruskin* (Washington, D.C.: Smithsonian Institution Press, 1992).

69 Eric Denker, *In Pursuit of the Butterfly: Portraits of James McNeill Whistler* (Washington, D.C.: National Portrait Gallery, in association with University of Washington Press, 1995), p. 99.

70 Pennsylvania Academy of the Fine Arts, *The Great National Painting, Sheridan's Ride, by T. Buchanan Read, Now on Exhibition* (Philadelphia, 1870), p. 8.

71 Ibid., p. 11.

72 Eakins to Benjamin Eakins, May 7, 1869, quoted in Lloyd Goodrich, *Thomas Eakins* (Cambridge and London: Harvard University Press for the National Gallery of Art, 1982), p. 47.

73 "Francis Davis Millet in Memoriam," *Bulletin of the Metropolitan Museum of Art* 7, no. 6 (June 1912): 108.

74 George T. M. Shackelford, "*Pas de deux:* Mary Cassatt and Edgar Degas," in Judith Barter et al., *Mary Cassatt: Modern Woman* (Chicago: Art Institute of Chicago, 1998), pp. 109–43.

75 Erica E. Hirshler, "Helping 'Fine Things across the Atlantic': Mary Cassatt and Art Collecting in the United States," in ibid., p. 183.

76 Frederick Baekeland, "Collectors of American Painting, 1813–1913," *American Art Review* 3, no. 6 (November/December 1976): 145.

77 H. Barbara Weinberg, "Thomas B. Clarke: Foremost Patron of American Art from 1872 to 1899," *American Art Journal* 8, no. 1 (May 1976): 67.

78 "Art Babble," *New York News*, April 20, 1884.

79 Lee M. Edwards, "Hubert Herkomer in America," *American Art Journal* 21, no. 3 (1989): 69.

80 Charles E. Strickland, "Juliette Low, the Girl Scouts, and the Role of American Women," in Mary Kelley, ed., *Woman's Being, Woman's Place: Female Identity and Vocation in American History* (Boston: G. K. Hall, 1979), p. 256.

81 Ibid., p. 257.

82 Girl Scouts of the U.S.A. Web page: http://www.gsusa.org.

83 Alice Hughes, *My Father and I* (London: Thornton Butterworth, 1923), p. 42.

84 Carolyn Kinder Carr, "A Friendship and a Photograph: Sophia Williams, Talcott Williams, and Walt Whitman," *American Art Journal* 21, no. 1 (1989): 4.

85 Ibid.

86 Ibid., p. 3.

87 Karl Schriftgiesser, *The Gentleman from Massachusetts: Henry Cabot Lodge* (Boston: Little, Brown, 1944), p. 108.

88 *Chicago Evening Journal*, September 23, 1893.

89 Ibid.

90 Leila Mechlin, "The Art of Cecilia Beaux," *International Studio* 41, no. 161 (July 1910): 3.

91 Cecilia Beaux, *Background with Figures: Autobiography of Cecilia Beaux* (Boston and New York: Houghton Mifflin, 1930), p. 220.

92 *The Craftsman*, April 1910, in Tara L. Tappert, "Choices—The Life and Career of Cecilia Beaux: A Professional Biography" (Ph.D. diss., George Washington University, 1990), vol. 2, p. 368.

93 Ibid.

94 Henry James to Henry James Jr., April 3, 1908, in Percy Lubbock, ed., *The Letters of Henry James* (London: Macmillan, 1920), vol. 2, p. 96.

95 Jacques-Émile Blanche, *Portraits of a Lifetime: The Late Victorian Era, The Edwardian Pageant, 1870–1914*, ed. and trans. Walter Clement (London: J. M. Dent & Sons, 1937), p. 189.

96 Millicent Bell, *Edith Wharton and Henry James: The Story of Their Friendship* (New York: George Braziller, 1965), p. 144.

97 Ibid.; Blanche, *Portraits of a Lifetime*, p. 237.

98 Lee Simonson, *Part of a Lifetime: Drawings and Designs, 1919–1940* (New York: Duell, Sloan, and Pearce, 1943), p. 23.

99 *Current Biography 1947* (New York: H. W. Wilson, 1948), pp. 575, 576.

100 Lee Simonson, "Panic in Art" (1914) in *Minor Prophecies* (New York: Harcourt Brace, 1927), p. 58.

101 Nathaniel Wright Stephenson, *Nelson W. Aldrich: A Leader in American Politics* (Port Washington, N.Y., and London: Kennikat Press, 1971), pp. 269–70.

102 Ibid.

103 Philip Hendy, *European and American Paintings in the Isabella Stewart Gardner Museum* (Boston: Thomas Todd, 1974), p. 300.

104 Charles F. Montgomery, "Francis P. Garvan," *Arts in Virginia* 19, no. 3 (spring 1979): 245.

105 Thomas Hart Benton, *An Artist in America*, 3rd rev. ed. (Columbia: University of Missouri Press, 1968), p. 64.

106 Patricia C. Willis, *Marianne Moore: Vision into Verse* (Philadelphia: Rosenbach Museum & Library, 1987), p. 1.

107 *Marguerite Zorach: The Early Years, 1908–1920* (Washington, D.C.: Smithsonian Institution Press, 1973), p. 53.

108 "Marianne Moore, Famed U.S. Poet, Dies at 84," *Washington Post*, February 7, 1972.

109 Edward Weston, *The Daybooks of Edward Weston*, ed. Nancy Newhall, vol. 1: *Mexico* (New York: Aperture, 1990), p. 113.

110 *Current Biography 1953*, p. 44.

111 Tallulah Bankhead, *Tallulah: My Autobiography* (New York: Harper and Brothers, 1952), p. 176; NPG curatorial files.

112 NPG curatorial files.

113 Bankhead, *Autobiography*, p. 178.

114 Ibid., p. 180.

115 "Gallery of Great Americans" brochure (n.p., n.d.), NPG history files.

116 *DAB*, vol. 4, p. 228, quoting Henry T. Parker in the *Boston Evening Transcript*.

117 Arthur Kaufmann to [Ira] Gershwin, July 15, 1937, NPG curatorial file.

118 Herbert Eulenberg, introduction to "Arthur Kaufmann" pamphlet (n.p., n.d.), NPG/NMAA Library vertical files.

119 Anna Kisselgoff, "Martha Graham," *New York Times*, February 19, 1984.

120 "Other Exhibitions," *London Studio* 119 (May 1940): 190.

121 "Meltsner Who Paints the Drama of Labor," *Art Digest* 11 (May 1, 1937): 15.

122 *Chicago Sun*, January 27, 1946, NPG curatorial files.

123 *New York Herald Tribune*, April 13, 1947, Betsy Graves Reyneau file, NPG curatorial files.

124 *Chicago Daily News*, February 4, 1946, NPG curatorial files.

125 Lee Hall, *Elaine and Bill, Portrait of a Marriage: The Lives of Willem and Elaine de Kooning* (New York: HarperCollins, 1993), p. 29.

126 "Elaine de Kooning's Ode to a Vanquished New York," *New York Observer*, January 18, 1999.

127 Information from a telephone conversation between the artist and Monroe Fabian (undated), NPG curatorial files; Darlene Clark Hine, *Black Women in America: An Historical Encyclopedia* (New York: Carlson Publishing, 1993), p. 582.

128 Ben Raeburn, "Obituary," *Art in America* 66 (September/October 1978): 8.

129 Rosenberg, quoted in Garraty and Carnes, eds., *American National Biography*, vol. 18, p. 881.

130 Hall, *Elaine and Bill*, pp. 72–75.

131 Maxwell, quoted in *Current Biography 1943*, p. 518.

132 Elsa Maxwell, *The Celebrity Circus* (New York: Appleton-Century, 1963), p. 5.

133 *Time*, November 9, 1959, p. 80.

134 "Carl Sandburg Dies: Poet-Author Was 89," obituary, *Evening Star* (Washington, D.C.), July 22, 1967, NPG history files.

135 William A. Smith, "The Carl Sandburg I Know," *Family Weekly*, January 6, 1963, p. 5.

136 Cynthia Ozick, "T. S. Eliot at 101," *The New Yorker*, November 20, 1989, p. 120.

137 Eliot to Kelly, July 29, 1962, in Derek Hudson, *For the Love of Painting: The Life of Sir Gerald Kelly, K.C.V.O., P.R.A.* (London: Peter Davis, 1975), p. 152.

138 *Current Biography 1975*, p. 258.

139 Hurd to Paul Horgan, September 1932, quoted in James K. Ballinger, "The Development of Peter Hurd's Portrait Style," in *Peter Hurd: Insight to a Painter* (Phoenix: Phoenix Art Museum, 1983), pp. 27–28.

140 Martha Hutson, "Peter Hurd: Outside the Stream," *American Art Review* 3, no. 2 (March–April 1976): 103.

141 Clive Barnes of *Dance Magazine*, quoted in the *Encyclopedia of World Biography* (Detroit: Gale, 1998), p. 41.

142 *Current Biography 1952*, p. 311.

143 Lincoln Kirstein, *Quarry: A Collection in Lieu of Memoirs* (Pasadena, Calif.: Twelvetrees Press, 1986), p. 26.

144 Quoted in Nicholas Jenkins, "Reflections: The Great Impresario," *The New Yorker* (date unknown), p. 52, NPG curatorial files.

145 *Current Biography 1966*, p. 407.

146 Alice Neel to Robert G. Stewart, May 14, 1972, NPG curatorial files.

147 Patricia Hills, *Alice Neel* (New York: Harry N. Abrams, 1983), p. 183.

148 Eliot, quoted in *Maine Times* 20, no. 28 (April 15, 1988): 20.

149 Judith Higgins, "Alice Neel: Collector of Souls," *ARTnews* 83 (October 1984): 72.

150 *Alice Neel: Paintings since 1970* (Philadelphia: Pennsylvania Academy of the Fine Arts, 1985), p. 9.

151 Higgins, "Alice Neel," p. 75.

152 Ibid., pp. 73–74.

153 Ibid., p. 77.

154 Piri Halasz, "Alice Neel: 'I have this obsession with life,'" *ARTnews* 73 (January 1974): 49.

155 Higgins, "Alice Neel," p. 79.

156 Irving Sandler, *Alex Katz: A Retrospective* (New York: Harry N. Abrams, 1998), p. 16.

157 Richard Marshall, "Alex Katz: Sources of Style," in *Alex Katz* (New York: Whitney Museum of American Art, in association with Rizzoli International Publications, 1986), p. 15.

158 "Why He's a Thriller," *Time*, March 19, 1984, p. 56.

159 David Bourdon, "Andy Warhol and the Society Icon," *Art in America* 63 (January/February 1975): 44.

160 Andy Warhol with Bob Colacello, "Introduction: Social Disease," in *Andy Warhol's Exposures* (New York: Andy Warhol Books/Grosset and Dunlap, 1979), unpaged.

161 Vineta Colby, *World Authors, 1975–1980* (New York: H. W. Wilson, 1985), p. 242.

162 Ginny Stanford to Robert G. Stewart, November 11, 1992, NPG curatorial files.

Index of Artists

Page numbers in italics refer to illustrations.

Alexander, John White, 40, *41*, 42, 43, 49, 156, *157*

Allston, Washington, 84, 88

Annigoni, Pietro, *54*

Badger, Thomas, 26, 33, 34, 92, *93*

Balling, Ole Peter Hansen, 38

Bartlett, Paul Wayland, 42, 48, 150, *151*

Bartlett, Truman, 42, 150

Beaux, Cecilia, 41–42, 48–49, 154, *155*

Benbridge, Henry, 27, 28, 33, 66, *67*

Benton, Thomas Hart, 50, 168, *169*, 202

Biberman, Edward, 52, *53*, 186, *187*

Bingham, George Caleb, 22, 38

Blackburn, Joseph, 33

Blanche, Jacques-Émile, 49, 158, *159*

Boldini, Giovanni, 45

Bonnard, Pierre, 202

Bonnat, Léon-Joseph-Florentin, 41, 42, 44, 45, *45*, 48, 150

Boott, Elizabeth, 40

Bouché, René, 56, *56*, 190, *191*

Bouguereau, Adolphe-William, 42

Bowen, J. T., Lithography Company, *30*

Brannan, William Penn, 102

Carolus-Duran (Charles-Émile Auguste Durand), 44, 148

Carpenter, Francis Bicknell, 38

Cassatt, Mary, 41, 42, 43, *43*, 48, 136, *137*

Chartran, Theobald, 45

Chase, William Merritt, 40, 42, 156

Colin, Maximilien, 51, *52*

Constant, Benjamin, 42

Copley, John Singleton, 28, 33, 35, 40, 60, 62, *63*, 68, *69*

Couture, Thomas, 34, 41, 48, 128

Czedekowski, Boleslaw Jan, 182, *183*

Dagnan-Bouveret, P. A. J., 42

Degas, Edgar, 43, 48, 136, *137*, 158

de Kooning, Elaine, 55, *55*, 184, *185*, 188, *189*

de Kooning, Willem, 53, 184, 188, 208

de Lászlo, Philip Alexius, 46, *47*, 166, *167*

Dodge, John Wood, *28*

Douglass, Robert, Jr., 25, 102

Duplessis, Joseph Siffred, 28, 33, 35, 72, *73*

Durand, Asher B., 40

Duveneck, Frank, 40, *41*, 156

Eakins, Thomas, 40, 41, 42, 47, 48, 132, 146, *147*

Edwin, David, 30, 82

Elliott, Charles Loring, 38, 40

Elwell, William S., 26, 29, 34, 106, *107*

Fisher, Alanson, 26, 29, 35, 110, *111*

Fisk, William, 29, 38, 108, *109*

Fleury, Tony-Robert, 42

Gardner, Elizabeth, 40

Gérôme, Jean-Léon, 41, 136

Glackens, William, 50, *51*

Gleyre, Charles Gabriel, 130

Greaves, Walter, 43, 130, *131*

Greenwood, John, 60

Hammond, Elisha, 102

Harding, Chester, 29, 34, 35, 38, 40, 88, *89*, 98, 99, 106

Harrison, Thomas Alexander, 42

Healy, George Peter Alexander, 28, 29, 33, 34, 35, 38, 40, 104, *105*, 124, *125*, 126, *127*

Herkomer, Sir Hubert von, 46, 142, *143*

Hicks, Thomas, 27, 34, 38, 40, 114, *115*

Hopper, Edward, 50–51

Hopwood, J., Jr., 92

Hughes, Edward, 45, 144, *145*

Hunt, William Morris, 38, 40, 41, 47, 48, 118

Huntington, Daniel, 27, 34, 35, 38, *39*, 40, 41, 116, *117*

Hurd, Henriette Wyeth, 196, 198

Hurd, Peter, 54, 196, *197*

Inman, Henry, 22, *30*, 94, *95*, 116

Jocelyn, Nathaniel, 25, 30, 34, 38, 96, *97*

John, Augustus, 50, 174, *175*

Jones, Lois Mailou, *51*

Jouett, Matthew Harris, 32

Katz, Alex, 57, 206, *207*

Kaufmann, Arthur, 50, 176, *177*

Kelly, Sir Gerald, 54–55, 194, *195*

King, Charles Bird, 30, 35, 94

Krasnow, Peter, 50, 172, *173*

Lachaise, Gaston, 170

La Farge, John, 33, 34, 40, 41, 42, 47–48, 118, *119*, 142

Lasar, Charles, 42

Lauder, Robert Scott, 138

Lea, Anna, 40

Leutze, Emanuel Gottlieb, 22, 120, *121*

MacDonald-Wright, Stanton, 50, 160, 164, *165*

May, Edward Harrison, 41, 42, *44*, 44–45, 47, 128, *129*

Maynard, George Willoughby, 40, 42, 48, 134, *135*

Meltsner, Paul, 51–52, 178, *179*

Millet, Francis Davis, 40, 42, 48, 134, *135*, 142

Morse, Samuel F. B., 33, 34, 35, 40, 84, *85*, 116

Mount, William Sidney, 22

Neagle, John, 25, 30–31, *31*, 34, 38, 40, 100, *101*

Neel, Alice, 56, *57*, 200, *201*, 204, *205*

Osgood, Samuel Stillman, 98

Peale, Charles Willson, *23*, 25, 26, 33, 35, 40, 64, *65*, 74, *75*, 76

Peale, James, 35

Peale, Raphaelle, 74, 76

Peale, Rembrandt, 30, 33, 34, 35, 76, *77*, 82, *83*

Peale, Sarah Miriam, 38

Pearce, Charles Sprague, 42, 47, 48, 150, *151*

Penniman, John R., 34

Pettie, John, 45, 138, *139*

Porter, Fairfield, 55–56, 202, *203*

Read, Thomas Buchanan, 33, 34, 35, 38, 132, *133*

Reyneau, Betsy Graves, 53, *53*, 180, *181*

Rivera, Diego, 50, 172

Rothko, Mark, 53, 55

Russell, Morgan, 164

Saint-Mémin, Charles B. J. F. de, *24*

Sargent, John Singer, 42, 43–44, *44*, 49, 148, *149*

Sartain, John, 31, *31*, 122

Schussele, Christian, 31, *31*, 38, 122, *123*

Sickert, Walter, 158

Simmons, Edward Emerson, 51, *52*

Simonson, Lee, 50, 160, *161*

Smibert, John, 26, 32, 33, 40, 60, *61*, 62

Smith, William A., 56, 192, *193*

Stanford, Ginny, 56, 210, *211*

Stuart, Gilbert, 26, *27*, 29, 32, 34, 35, 40, 49, 70, *71*, 86, *87*, 90

Sully, Thomas, 33, 34, 35, 40

Thompson, Cephas, 27, 28, 34, 78, *79*, 80, *81*

Trumbull, John, 22, 29, 34, 35, 40, 70, *71*

Tudor-Hart, E. P., 164

Ulrich, Charles Frederick, 49, 140, *141*

Van Beers, Jan, 49, 152, *153*

Vanderlyn, John, 27, 33, 34, 35, 40, 90, *91*

Vuillard, Édouard, 202

Warhol, Andy, 57, 208, *209*

Waring, Laura Wheeler, 53

Weir, Robert Walter, 25, 30, 34, 35, 112, *113*, 130

West, Benjamin, 84

Whistler, James McNeill, 38, 42–43, 49, 130, *131*, 156, 158

White, Edwin, 134

Williams, William Joseph, 25

Wyeth, Andrew, 198

Wyeth, Jamie, 54, 198, *199*

Wyeth, N. C., 196, 198

Zorach, Marguerite, 50, 170, *171*

Zorn, Anders Leonard, 45–46, *46*, 162, *163*